GRIEF

GRIEF

The Biography of a Holocaust Photograph

David Shneer

OXFORD
UNIVERSITY PRESS

OXFORD
UNIVERSITY PRESS

Oxford University Press is a department of the University of Oxford. It furthers
the University's objective of excellence in research, scholarship, and education
by publishing worldwide. Oxford is a registered trade mark of Oxford University
Press in the UK and certain other countries.

Published in the United States of America by Oxford University Press
198 Madison Avenue, New York, NY 10016, United States of America.

Library of Congress Cataloging-in-Publication Data
Names: Shneer, David, 1972– author.
Title: Grief : the biography of a Holocaust photograph / David Shneer.
Description: New York, NY : Oxford University Press, [2020] |
Includes bibliographical references and index. |
Identifiers: LCCN 2019039332 (print) | LCCN 2019039333 (ebook) |
ISBN 9780190923815 (hardback) | ISBN 9780190923822 |
ISBN 9780190923839 (epub) | ISBN 9780197504611
Subjects: LCSH: Baltermants, D. (Dmitri). Gor'e. |
War photographers—Soviet Union—Biography. |
War photographers—Soviet Union—History. | World War, 1939–1945—Photography. |
War photography—Ukraine—Kerch. | Documentary photography—Soviet Union—History. |
World War, 1939-1945—Atrocities—Ukraine—Kerch. | Massacres—Ukraine—Kerch. |
Holocaust, Jewish (1939–1945)—In mass media.
Classification: LCC TR140.B2658 S56 2020 (print) |
LCC TR140.B2658 (ebook) | DDC 779/.99405318—dc23
LC record available at https://lccn.loc.gov/2019039332
LC ebook record available at https://lccn.loc.gov/2019039333

9 8 7 6 5 4 3 2 1

Printed by Sheridan Books, Inc., United States of America

"All photographs unless otherwise specified are courtesy of the Dmitri Baltermants estate, Glaz Gallery,
and Paul Harbaugh."

CONTENTS

INTRODUCTION

INTRODUCING *GRIEF*

I first saw the print hanging in a local photography collector's basement. It was 2003, and I had been connected to this mysterious collector by Simon Zalkind, my next-door neighbor and a local curator, who knew I was in search of great Soviet war photography for a book about Soviet Jewish war photographers that I was working on.

"Do you know Paul and Teresa Harbaugh? If not, you should," he said.

A five-mile drive away, I was greeted at the door by a tall, silver-haired gentleman, a classic image of a patrician American, and his wife, Teresa, a feisty, passionate woman proud of her Lebanese heritage. We descended into their basement to see what would turn out to be one of the largest collections of Soviet photography in the world. The basement is Paul's workspace, cluttered with bric-a-brac and valuable photographic material. (Teresa had a separate workspace down the road at their business, Azusa Publishing, before her untimely death in 2016.) He stored his best material in the laundry room.

"Come in here and take a look," Paul said as he pulled out large prints and laid them flat . . . on the washing machine. He began showing me massive-scale prints by a who's who of Soviet photography, names who at the time were barely recognizable but who would become intimately familiar to me as I worked on my book—Yevgeny Khaldei, Georgi Zelma, Mark Markov-Grinberg, Arkady Shaikhet.[1] They pictured everything from soldiers waving flags over the Reichstag and tanks plowing through the snow in Stalingrad to gruesome images of concentration camps at Stutthof and bodies being dragged on a sleigh through the streets of Leningrad during the siege of the city. And then he paused. "This one is special."

I had never seen anything like what he was showing me at that moment. First was its sheer scale: it was bigger than most photographs from the era, a limited-edition exhibition print measuring approximately

thirty-six by forty inches, printed on heavy, glossy paper. But it was not just the sheer size of the image. Dark clouds hang over the scene, ominously, almost as if they had been placed there to lend the scene a dark air of horror. The sky takes up the top third of the picture, but then my eye was drawn to the woman in shock and sorrow. At first I thought she was alone, as if the photographer had chosen *her* from among all the others, to capture the expression of a woman discovering her husband lying dead in that snow-covered field. The addition of the dark clouds drew me into the image, a way of using perspective that created empathy between the viewer and the subject, whose name I would later learn was P. Ivanova.

Paul then explained that the photographer, Dmitri Baltermants, had been on a field in the southern Soviet city of Kerch to document the aftermath of battle in January 1942. He documented this horrible scene and called it *Grief*. He said that the photograph was suppressed during the war so as not to lower the morale of the Soviet population any further than it already had been in those dark years when the country nearly fell to Nazi Germany. The image made its debut only in the 1960s, during the Thaw, when Nikita Khrushchev finally forced the country to confront the violence of Stalinism.

I stared at the photograph for several more minutes, and I began to notice that the woman was not alone. In fact, Baltermants photographed a whole series of women discovering their loved ones on the battlefield, or so I thought at the time. The photograph clearly resembled classic postbattle imagery, such as the Civil War photographs of Mathew Brady, taken at a time when "postbattle" images were the only kind of war a photographer could capture. By World War II, photographers no longer lugged around huge amounts of heavy equipment, as Brady did. During World War II, such photographers became photojournalists with light-weight portable cameras, albeit still developing their photographs in makeshift darkrooms on the battlefields, like nineteenth-century war photographers. But by World War II, they sent their negatives and notes about the photographs to their editors on airplanes for possible publication.

I was struck by the amazing, ominous sky. "How did Baltermants manage to take photographs of horror on a day when the sky so naturally lent itself to such a scene?" I asked.

"He didn't," Paul replied, as he then explained how Baltermants had collaged two prints together because of damage on the original negative sometime after Joseph Stalin's death, when the photographer began playing around in his archive and then gave the composition its title.

Since that day in 2003, I have seen prints of *Grief*, whose original Russian title was the similarly laconic *Gor'e*, in dozens of places: hanging in galleries in places as far flung as Moscow, Paris, and Berlin and on the sterile white walls of the Museum of Modern Art in New York City. I saw it at the Annenberg

Space for Photography in Los Angeles in an exhibition dedicated to war photography, where it served as one of the signature photographs. It is also one of *Time* magazine's one hundred most influential photographs in the history of photography. Sometimes, *Grief* stood alone, as if it needed no context to explain what was happening in the picture, just the tombstone label: "Dmitri Baltermants, *Grief*, 1942, Kerch, Silver-Gelatin Print, Collection of Teresa and Paul Harbaugh." On other occasions, the exhibition's curator hung *Grief* alongside other photographs to create a visual dialog, juxtaposing it with others that Baltermants took at Kerch or other photographers' images of war. But for the most part, the curator's choices suggested that the image speaks for itself.

After years of researching this image, I have still never seen the damaged negative of the *Grief* photograph. I came close one afternoon in 2008 when I was working in the Baltermants archive in an attic in Scarsdale, New York, at the home of Michael Mattis, a second collector involved with Baltermants and his estate. Mattis had purchased the Baltermants archive, some thousands of negatives in all, in 1999 and hoped to turn a little-known Soviet photographer into the next Robert Capa. He showed me the massive amount of work his research assistants had done cataloguing, labeling, and putting into archival envelopes each and every negative. That day, however, he could not find the negatives from Baltermants's photographs at Kerch. Then, in 2010, as I later learned, he sold the archive back to an investment group in Russia and the negatives have since seemingly disappeared.

This is a book about *Grief*, devoted to exploring a single photograph that has stuck with me ever since I first saw it. Although the emotion itself has a history as old as humanity, *Grief* began its life in January 1942 on a frozen landscape outside Kerch, a port city on the Crimean peninsula, after the Red Army forced the German army, the Wehrmacht, to retreat from the city. The photograph does not, however, reveal the aftermath of battle, as its aesthetics initially suggest. And although it is true that *Grief* has everything to do with World War II, it has little to do with conventional warfare.

It is one of the earliest widely circulated photographs, from the vantage point of the war's eventually victorious Allied armies, of what we now call the Holocaust, the ideologically driven Nazi mass murder of Jews, Soviet prisoners of war, Sinti/Roma, and others in a concerted plan to "fix" the racial makeup of a German-ruled European, and ideally global, empire. This book tells a story of the twentieth and twenty-first centuries through a single photograph by one photographer. It is about Soviet aesthetics and Holocaust memory; it wrestles with the Cold War and with art curators and their role in creating value for the objects in their collection.

My focus on a single photograph allows me to tell this vast and complicated history that traverses several continents, in many languages, through a variety of forms of visual culture, as a single compelling story. Even though it is highly likely that no one pictured in the photograph is Jewish, save the photographer behind the camera, I call this a Holocaust liberation photograph. I do so because the images Baltermants took at Kerch transformed into a shorthand for the larger story of the genocide of peaceful Soviet citizens, most of them Jews, all of them enemies of Nazi Germany during World War II. Finally, I outline what it means to write the biography of an image, and how that history allows me to talk about World War II and the Holocaust, the Cold War and cultural diplomacy, the photograph's appearance in the art photography market, and its contemporary reinterpretation as a Holocaust photograph with no Jews pictured in it.

1

THE MAKING OF A SOVIET WAR PHOTOGRAPHER AND THE GERMAN OCCUPATION OF KERCH

On September 17, 1936, a twenty-four-year-old apprentice working for *Izvestiia* named Dmitri Baltermants had his first photograph appear in the newspaper. It was a momentous occasion for the young photographer, whose family had seen the turmoil and violence of war and revolution. The image captured the zeitgeist of 1930s Moscow, the communist capital of the globe: "On September 15, Pioneers who had been on vacation in the Artek [Sanitorium on the southern coast of Crimea] returned to their homeland, to Moscow. Pictured (from left to right) are Pioneers/award winners: Nishan Kadyrov, Vanya Chulkov, Mamliakat Nakhangova, Barasbi Khamgokov, Misha Kuleshov, and Buza Shamzhanova."[1]

These were not just hard-to-pronounce names of Soviet teenagers from the farthest reaches of the Soviet Union, who all called Moscow their home and had been relaxing in Artek, the first of a network of children's state sanatoria for health, relaxation, and education.[2] Their names may have been challenging to pronounce for a native Russian speaker, but that was the point—to highlight how Soviet communism overcame ethnic differences to build a larger collective in which every person, even a female Tadzhik champion cotton picker like Mamliakat Nakhangova, could achieve greatness. At the time of Baltermants's photograph, Nakhangova was already well known across the country for her cotton-picking prowess, especially after an intimate 1935 portrait of the young girl with Joseph Stalin that was circulated widely.[3]

Baltermants's photograph reflects the classic aesthetics of socialist realism, which defined Soviet photography from the 1930s and which he had clearly mastered even in his first published photographs. Baltermants avoided the raking angles and tight cropping that defined Soviet constructivism, the aesthetic form that emanated in the early years of Soviet Russia from Moscow and Vitebsk, where El Lissitzky

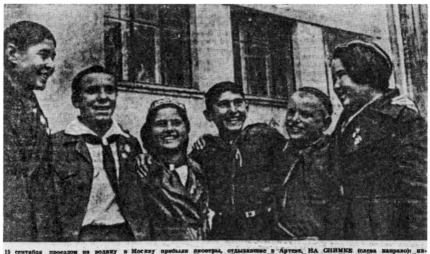

15 сентября проездом на родину в Москву прибыли пионеры, отдыхавшие в Артеке. НА СНИМКЕ (слева направо): пи-онеры - орденоносцы: Нишан Кадыров, Ваня Чулков, Мамлякат Нахангова, Борис Хамгоков, Миша Кулешов и Буаз Шамжанова.
Фото\Д. Бальтерманц.

Dmitri Baltermants, *Photo of Pioneers, Izvestiia,* September 17, 1936, 4

and Kazimir Malevich worked for a time. Their ideology shaped global aes-thetics of the 1920s. Instead of tight cropping, Baltermants photographed these teenagers from afar and importantly from below, in a semicircle, embracing one another. He captured their beaming smiles, some aimed at each other, others at the photographer himself.[4]

Smiles are rarely seen in Russian portraiture, but in Baltermants's photographs, and in much socialist realist photography, the pearly white teeth of Soviet youth become a central aspect of the photograph's aesthetics. They create a visual symbol of the 1935 Stalinist credo: "Life has become better; life has become happier." What better sign of happiness than a beaming smile? Beyond the white teeth, perhaps the most obvious aesthetic markers are the very faces of those pictured, the Kabardinian, Tadzhik, Muscovite, Tulan, and other racialized faces of a socialist country (one might even say a socialist empire) in the making, who gathered for a reunion in the communist capital.

And behind the camera we find Dmitri Baltermants, a Warsaw-born, Soviet Jewish photographer.

Tatiana Baltermants, his daughter, showed me a sepia-toned family photo-graph taken in Warsaw before the outbreak of World War I as she was digging through her family archive in her home on the outskirts of Moscow. She re-ferred to it as a historic Baltermants family photograph, but, in fact, it is not a *Baltermants* photograph.[5] Although the toddler around whom the entire family revolves is young Dmitri, who appears to be about two years old, his last name at the time of the photograph was Stolovitsky.

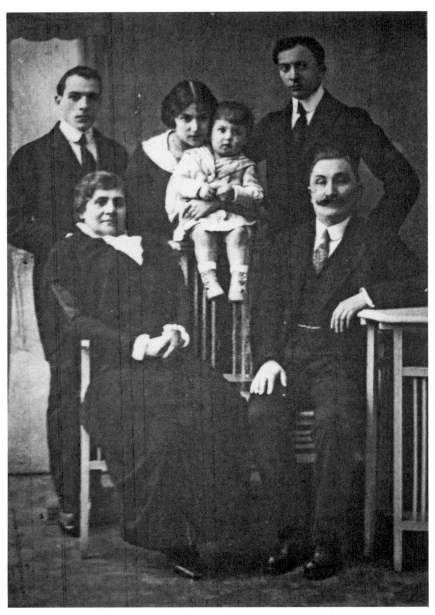

Stolovitsky family photograph, ca. 1914. From left: standing, Grigory Stolovitsky, Sara (Sofia) Khananovna Dvoretskaia/Stolovitskaia holding Dmitri Stolovitsky (Baltermants), Joseph Dvoretsky, brother of Sara; seated, grandparents of Dmitri. *Courtesy of Tatiana Baltermants*

The Stolovitsky family went to a local Warsaw photography studio to make this keepsake, likely for a special occasion. In the middle of the image is young Dmitri, born on May 13, 1912. Feet dangling in the air as he sits on the back of a chair, Dmitri wears a child's dress and stares straight at the camera, all the while being held lovingly by his mother Sara (Sofia) Khananovna Stolovitskaia (Russian last names change endings depending on the person's gender), whose maiden name was Dvoretskaia. Cheek to cheek with her young son, head resting adoringly on his shoulder, Sara holds Dmitri in a warm embrace. The other four adults are dressed in dark suits or dresses offset by a bright white shirt. On the left is Dmitri's father, Grigory Stolovitsky, who Tatiana told me was a Russian Jewish officer in the tsarist army at a time of turmoil for Jewish soldiers in the tsarist army, with some on the far right calling for the removal of all Jewish soldiers from the military due to Jews' disloyalty.[6] Standing to Sara's right is her brother, Joseph Dvoretsky. Seated are Dmitri's grandparents, although Tatiana did not know whose parents they were.

The Stolovitsky family lived in the heart of Warsaw until Dmitri's parents divorced when he was a toddler.[7] On August 1, 1915, when he was just three years old, the German army occupied Warsaw, the capital of the former kingdom of Poland, a territory of the Russian empire. The Russian army suspected Jews living in Russian Poland, as well as the Pale of Settlement to Poland's east, of committing treasonous acts by working in support of the German and Austrian armies, so throughout the summer of 1915, tsarist military authorities forcibly deported around 500,000 Jews from both regions to the east.[8] The now single mother Sara Khananovna and her three-year-old son Dima relocated to Moscow, as did many deported Jews fleeing east from the frontlines in the chaos of war.

In fact, during the Great War, Moscow, a city that had expelled its Jews two decades earlier, became a spontaneous center of Jewish refugee cultural and political activity, including serving as the incubator for revolutionary Hebrew and Yiddish culture.[9] That status only increased when the tsar abdicated in March 1917. The new Provisional Government lifted the 1882 May Laws that had restricted Jews' access to education and other institutions of social advancement. The new government also eliminated the even older residential restrictions, thereby formally dissolving the old Pale of Settlement. Moscow was a seemingly safe place far from the frontlines, at least until the Bolshevik seizure of power in October 1917 and the ensuing civil war, which turned the city upside down and inside out.

Sara Khananovna remarried, to an attorney named Nikolai Baltermants. She took his last name, and young Dima took his patronymic, Nikolaevitch. The relatively privileged family suffered after the Bolsheviks took power in October

1917 and the subsequent dissolution of the Constituent Assembly in January 1918. Dima ended up living in a one-room communal apartment with his mother and stepfather, who was stripped of his family's prerevolutionary legal privilege. Dima's stepfather died shortly thereafter, leaving the family once again to rely on Sara's single income.

She and Dima fended for themselves in the harsh economic environment of 1920s Moscow, a city defined by deep paradoxes. On the one hand, it was the global capital of a messianic revolution when the Bolsheviks took power, promising a global revolution that would shake the world to its core. On the other hand, it was an overcrowded, impoverished city full of refugees, orphans, hunger, and an economy always on the brink of collapse. Sara, who now went by the name Sofia—as was common for Jews wanting to be part of the social revolution taking place in Russia—was an enterprising woman whose multilingualism landed her a job at a foreign-language publishing house.[10] In 1930, as Joseph Stalin became the sole leader and implemented rapid industrialization and the state-sponsored collectivization of agriculture to support crash industrialization, an eager eighteen-year-old Dima landed a job as an apprentice in the *Izvestiia* publishing house doing a variety of tasks, which included typesetting at the print shop and arranging window displays in *Izvestiia*'s new constructivist building, which opened in 1927 to great media attention.[11]

He spent the entire decade working his way up through the *Izvestiia* hierarchy. He learned the craft of photography the old-fashioned way—first as an apprentice, then as an assistant to several more senior photographers. At the same time, *Izvestiia* also sent him to a *rabfak* (*rabochii fakultet*), a workers' training institute connected to Moscow State University (MSU), for a possible professional future teaching mathematics. In 1939, he graduated from the applied mathematics department at MSU, joined the Red Army with the rank of captain, and prepared to teach math to military officers. Baltermants preferred photography, but his higher education ended up making him an exception among photographers, most of whom had barely a high school education.[12]

The majority of Baltermants's biographies date the birth of his photographic career at *Izvestiia* to the June 1941 outbreak of the Great Patriotic War, as World War II is called in the Soviet Union and post-Soviet Russia. Becoming a photographer in the heat of battle makes for a compelling story. Others who go deeper into his photographic past talk about his first photographic assignment for the newspaper, when he was sent to the borderlands city of Lvov in late 1939.[13] As a result of the pact of neutrality between Germany and the Soviet Union known as the Molotov–Ribbentrop Pact, Poland disappeared (once again) from the map as a political entity. The Soviet Union incorporated the eastern part of the country, including Lvov. The Soviet press described the military confrontation as a

"liberation" of local Ukrainians from Polish fascism, which was why Baltermants was sent to document the newly freed city.[14]

None of these stories reflects Baltermants's actual debut in the world of Soviet photography. As we have seen, his own photographs began to appear in the newspaper when he was twenty-four, a major achievement for someone who started working in the newspaper's print shop. Although his first photograph appeared in August 1936, a more important image, the one that opened this chapter about the Pioneers' return to their hometown of Moscow, appeared on the pages of *Izvestiia*. Two weeks after that photograph appeared, Baltermants sealed his reputation as a rising socialist realist photographer with a similarly composed photograph of female construction workers completing a train stop near Moscow.[15]

One of the senior photographers with whom Baltermants apprenticed was Vladimir Musinov. Rumor has it that Musinov was such a control freak that it took years before he let Baltermants do anything more than carry his equipment and set up the lights.[16] Another mentor was Georgi Zelma, born Georgi Zelmanovitch. An Ashkenazi Jew born in Soviet Central Asia, Zelmanovitch— who changed his name to Zelma in 1934 after publishing photographs from the Jewish autonomous region in Birobidzhan—was only six years Baltermants's senior but had been taking photographs since the mid-1920s. *Izvestiia* hired Zelma as a staff photographer in 1934 because of the reputation he acquired photographing for *USSR in Construction*, arguably the leading illustrated magazine in the world in the 1930s.[17] In that work, he, along with El Lissitzky, became a leading advocate of collage (the manual process of "cutting and pasting") and montage (the fusing together of collages to create a work of photographic art).

Zelma and other cutting-edge Soviet image makers mobilized modernist aesthetics in service of the new revolutionary state with Stalin at its helm. Alexander Rodchenko, probably the best-known Soviet photographer, whose facial close-ups and raking angles defined the modernist Soviet aesthetic for Western audiences, proudly accepted a state commission to photograph the slave-labor battalion building the Baltic–White Sea Canal in 1933.[18] Zelma had photographed Stalin at a meeting of the All-Union Congress of Soviets to discuss the planned Soviet Constitution in November 1936, suggesting that Baltermants's master was one of the most important photographers in Stalin's Soviet Union.[19]

On November 11, 1937, a reader would have seen on page one of *Izvestiia* a spectacular image of a 125,000-person gathering of voters on *Spartakovskaia ploshchad'* (Spartacus Square) in central Moscow to call for Stalin's election to the Supreme Soviet. Zelma brought Baltermants to work with him on the photo shoot, in which they documented the demonstration. It was also an opportunity for Zelma to show Baltermants what it meant to photograph such a massive

event. They arrived at Spartacus Square early to prepare for the evening festivities, including setting up a platform from which they would shoot down on the crowd.

By 1937, the mentor Zelma had been rethinking how montage could be used not solely to create brilliant aesthetic arrays of juxtaposed images printed on the page, as he had done in the early 1930s. Now he had in mind a means of capturing the massiveness of rallies that stretched a single photographic frame to its limits. He and his editors struggled to bring together these avant-garde photographic forms as a means of elevating socialism and the leader of global socialism—Stalin.[20]

The panorama montage, shot from above, draws the viewer into the scene for its celebration of spectacle. It emphasizes the mass nature of the gathering in support of Stalin, who is also present in the crowd. He is not there physically, but his face printed on at least two massive banners shows off his immense popularity. In this classic production of his cult of personality, the largest banner frames the right of the photograph as Stalin looms over the masses of his tiny Soviet supporters.

In this photograph Zelma taught Baltermants the ways to use techniques used by the avant-garde such as montage, angle, viewpoint, and framing to produce powerful examples of socialist realism. But even a cursory look shows that this single panorama is in fact four if not five discrete frames that have been printed together. That print then made its way into the newspaper. The photograph is an impressive example of how a daily newspaper incorporated the aesthetic techniques usually reserved for weekly or even monthly illustrated magazines that had defined Soviet photography up until that point.

Baltermants also apprenticed for Samari Gurary, with whom he produced several photographs, including the construction of massive Lenin and Stalin statues along the new Moscow–Volga Canal, one of Stalin's signature 1930s projects. Gurary and Baltermants, according to Baltermants's daughter Tatiana, had been childhood friends in Moscow and continued photographing together for *Izvestiia* for several years.[21]

All of Baltermants's 1930s photography was done in classic socialist realist style. In terms of aesthetics, this could mean shooting either an individual or a small group of people, usually between three and six, from below or at eye level. From this angle, the individual subject is elevated and lionized as a hero of the Soviet Union. In the case of a small group of subjects, whether the multiethnic Pioneers, female pilots, or scholars working around a table, he arranged them in circles and generally had them look away from the camera.

In the Spartacus Square panorama, he shot massive crowds from above to emphasize the collective nature of socialism and the popular nature of the spectacle. As for subject matter, his editors gave him assignments that focused on the ethnic

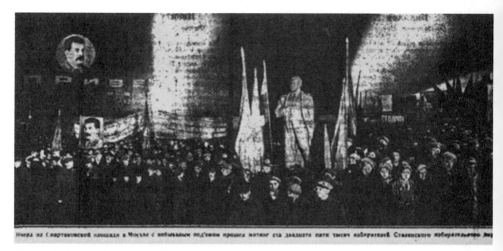

Georgi Zelma and Dmitri Baltermants, *Demonstration on Spartacus Square, Izvestiia*, November 11, 1937

diversity of the Soviet population, the modernization of a formerly backward society, and the perpetual preparation for possible attack from capitalist outsiders, who were suspicious of Soviet success, especially during the Great Depression.

Despite the perpetual war scares that began in the late 1920s and continued through the 1930s, capitalist countries, let alone fascist ones, never invaded the Soviet Union. On the contrary, the United States established formal diplomatic relations in November 1933, normalizing government-level contacts between the leader of global communism and the most important symbol of global capitalism. This meant exchanging ambassadors and creating formal channels for state support for business deals between the two countries. In August 1939, the foreign ministers of Nazi Germany and the Soviet Union signed their own nonaggression pact.

Nevertheless, the Soviet Union publicized its military preparedness through stories and photographs of air force demonstrations, long marches with gas masks, and the physical celebration of the (usually male) body through athletics and other physical displays of strength. In a sign of the times, in November 1940 Baltermants photographed a competition of military preparedness among Muscovite Communist Youth (*Komsomol*) members. The competition included a fifteen-kilometer race, part of which took place with participants wearing stifling gas masks.[22]

Despite fears of foreign invasion, the Soviet press, and the photographers who worked for it, masked low-level violence along its borders in the late 1930s, especially in the Soviet Far East at places like Lake Khasan and Khalkin Gol, when the Red Army fought off Japanese incursions. But those foreign conflicts paled in

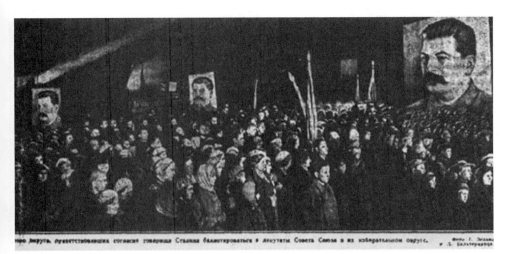

про Дмруть, приветствовавшим согласие товарища Сталина баллотироваться в депутаты Совета Союза в их избирательном округе. Фото Г. Зелма, г .Д. Балтерманца

comparison to another story of violence taking place in the late 1930s to which Baltermants, Zelma, and other Soviet photographers did not get assigned—the massive bloodletting (or, put more simply, the state-sponsored mass murders) that defined Soviet society during the Great Terror.

On the foreign front to the west, the Soviet Union had been in open conflict with several countries since September 1939, a month after it signed the Molotov–Ribbentrop Pact with Nazi Germany. When the media discussed those military operations, it treated them as opportunities to liberate the local population from what the Communist International saw as fascistic authoritarian rule. Those Belorussians, Ukrainians, and others had been trapped in brutal regimes, especially in Poland, that controlled land formerly in the tsarist empire before the disasters of World War I, the civil war, and the Polish–Soviet War shifted the old imperial border to the east. Through the second half of September, after the Red Army moved into these old-new territories, newspapers ran frequent headlines about "friendly meetings" between Belorussians and Russians, along with the occasional photograph of smiling encounters between Red Army soldiers and Belorussians, Jews, and other residents of these new Soviet territories.

Baltermants's photographs from 1939 and 1940 demonstrate his continued commitment to the socialist realist aesthetic that finally earned him a coveted position as a staff photographer at *Izvestiia*. He documented champion chess players and student competitions, celebrations of Armenian culture, and the opening of the Finno-Karelian Soviet Socialist Republic's pavilion at the All-Union Agricultural Exhibition in Moscow. He took pictures of actors in the Gorky Theater and academics from a wide variety of institutes of higher education, the relocation of buildings in the modernization of Moscow, and the celebration of returning heroes who had forged the Arctic Sea. He took frequent photographs

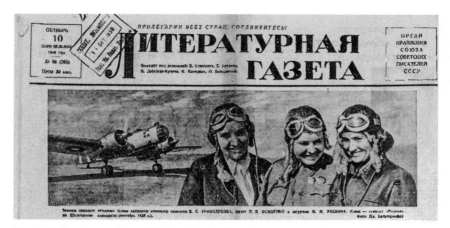

Dmitri Baltermants, *Crew of the* Rodina *Airplane, Literaturnaia Gazeta,* October 10, 1938

inside Moscow's many performance halls, whether the Malyi Theater and its ac-
tors or the Bolshoi Theater and Kalmyk dancers celebrating the five-hundredth
anniversary of the Kalmyk epic "Jangar."[23] In other words, Baltermants did what
he had been doing since 1936—documenting and elevating Soviet daily life under
Stalinism with his camera.

Izvestiia also sent him on assignment outside of Moscow for the first time,
especially to cover the liberation of western Ukraine in the fall of 1939, at least
as the Soviet Union understood what was taking place. His primary assign-
ment was to cover the Sovietization of newly liberated Lvov. Bringing newly
conquered territory into the Soviet Union was rarely a delicate procedure. In fact,
"Sovietization" meant unprecedented levels of state violence to restructure capi-
talist societies in Soviet socialism's image. This meant mass arrests, deportations,
and, as in the case of Polish army officers at Katyn and elsewhere in 1940,
executions of those deemed to be important to the previous state. It also meant
bringing the structures of Soviet life to newly incorporated Lithuania, Latvia,
and eastern Poland, each of which had become independent only since the end
of World War I. Agriculture in these new territories fell under state control as
the Soviet administration introduced the collective farm (*kolkhoz*), and privately
owned theaters became Soviet state institutions.

Not surprisingly, the newspapers covered the glorious transformation of life
under socialism rather than the state violence and repression that accompanied it.
So, while the pages of *Izvestiia* and *Pravda* were full of smiling western Ukrainian
faces welcoming their Soviet Russian brethren, there were no images of
deported Poles, Jews, and others sent to Soviet Siberia. Baltermants documented

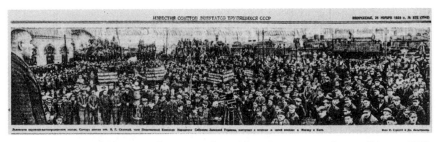

Samari Gurary and Dmitri Baltermants, "In a L'vov Locomotive Repair Factory, V.G. Sadovyi, a smith of the factory and a member of the plenipotentiary commission of the People's Assembly on Western Ukraine gives a report on his travels to Moscow and Kiev," *Izvestiia*, November 26, 1939

order and modernity that the Soviet Union brought to these formerly backward areas in the form of a simple cop directing traffic. He also reminded his editors of his skills in making panoramas as he and Gurary co-produced one of a mass gathering at a Lvov factory listening to one of their own regale the assembled crowd with stories about the wonders of Soviet Moscow and Kiev.[24]

All of this changed on June 22, 1941.

The German army invaded under cover of night, at four in the morning. The first news stories about the invasion did not make it into that day's papers, whose print deadline had already passed. In fact, aside from those experiencing the invasion on the western front, the general Soviet population became aware of the invasion only at noon. At that moment, workers gathered in factory courtyards, and pedestrians stopped on sidewalks to hear Soviet foreign minister Viacheslav Molotov's radio-broadcast announcement about the German invasion:

> Citizens of the Soviet Union: The Soviet Government and its head, Comrade Stalin, have authorized me to make the following statement: Today at 4 a.m., without any inclination of an impending attack presented to the Soviet Union, without a declaration of war, German troops attacked our country, attacked our borders at many points and bombed the following cities from the air—Zhitomir, Kiev, Sevastopol, Kaunas and several others, killing and wounding over two hundred persons.[25]

The central press had known earlier that morning about Molotov's noontime speech and had sent its leading photographers to document this exercise in collective listening . . . and collective shock. As for Baltermants, he joined the ranks of the Red Army that very same day as a lieutenant.[26]

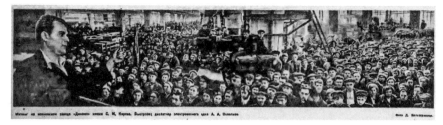

"Demonstration at Moscow's Kirov Dynamo Factory. A.A. Okhlopkov, manager of the electric locomotive plant, gives a speech," June 24, 1939

News about Molotov's announcement appeared one day later, on June 23, but photographs of the announcement did not appear until June 24. That day, from a media perspective, everything changed. Every major newspaper published photographs of hardened Soviet workers listening to Molotov announce the treachery of the enemy. *Izvestiia* published Baltermants's compelling panorama photograph, made from collaging two or more negatives together to produce a montage, of the mass gathering at Moscow's Kirov Dynamo Factory. The factory workforce had gathered to listen to representatives of the leadership relay the news. The photograph reflects Baltermants's mastery of the socialist realist aesthetic, especially of earlier images of mass gatherings he had taken under the tutelage of Zelma. It also demonstrates how he broke out on his own aesthetically.

First, Baltermants seems to be standing *on* the dais, right next to the main speaker, shooting out into the crowd. Such a conspicuous presence of a photographer might not have been surprising to Soviet citizens accustomed to seeing photographers documenting large demonstrations, and thus they seem to pay him no attention. Of course, this is more likely a visual trick of the final photograph, in which Baltermants has inserted the image of the speaker, A. A. Okhlopkov, who looks over the crowd with his hand in a defiant gesture.

Baltermants constructed this panorama from several negatives, with Okhlopkov close up at the left edge of the frame. As our eyes move from left to right, we see a mass of faces looking up at the speaker until we reach the center, a second focal point of the photograph, where several young workers sit, listening attentively to the speaker. Although we cannot hear his words, we know he is organizing the factory's response to Molotov's devastating announcement about the German invasion.

In crafting this photograph, Baltermants may have been inspired by Zelma's photomontage or more broadly by the montage work of the Soviet avant-gardists El Lissitzky or Gustav Klutsis. Or he may have thought about a more painterly approach to scenes of defiance and inspiration from works such as Isaac Brodsky's

Lenin at the Putilov Factory from 1917, in which a mass of workers surrounds the charismatic Lenin. In that painting, Brodsky positions the viewer as part of the crowd gazing at the distant Lenin. Remembering his training in mathematics, Baltermants plays with perspective and shifts our vantage point by putting us on the stage with the speaker. Two days later, Baltermants photographed five stoic Moscow-based soldiers in a semicircle, shot from below, ready to face the enemy.[27]

Despite their stoicism, in its first six months the Soviet Red Army was in near-constant retreat as the German enemy conducted a blitzkrieg against the Soviet Union. That country was, according to National Socialist ideology, the primary front against the global conspiracy of "Judeo-Bolshevism," the belief that Jews were the masterminds behind the insidious views of communism from Karl Marx to Leon Trotsky (ne Lev Davidovitch Bronshtein). During the summer of 1941,

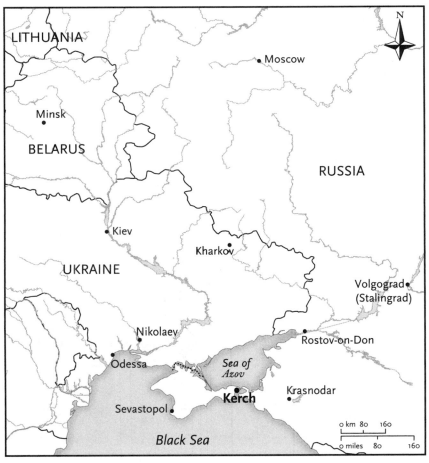

Kerch and other Soviet cities

Germany quickly conquered most of the western Soviet Union. By September, Leningrad was besieged, and Moscow nearly fell in October. Panic reigned in the two major cities as Soviet authorities evacuated all nonessential personnel from Moscow. They attempted to do the same from Leningrad over the ice bridge that provided the only access into the city during the bitterly cold months of the winter of 1941–42. Hitler proudly reported in his December 11, 1941, speech to the Reichstag that war against the Soviet Union had led to the capture of "3,806,865 Soviet Russian prisoners of war."[28]

In southern Russia, by late fall of that year, as days got shorter and the ground got harder, nearly all of Ukraine was in German hands. German forces also expected Crimea and the Black Sea coast, and its important warm-water ports, to fall quickly, given "Judeo-Bolshevism's" inability to mobilize its troops to fight. Simferopol, the second-largest city on the Crimean peninsula, located in the interior, fell on November 1. It became the headquarters of the Wehrmacht as well as the German "special action squad," Einsatzgruppe D, both of which had been located in the city of Nikolaev to the north and west. The main prize, Sevastopol, both the largest city and Crimea's main port, held out and did not capitulate that autumn. Despite Sevastopol's intransigence, the Wehrmacht had its eyes on one other strategically significant city in Crimea—Kerch.

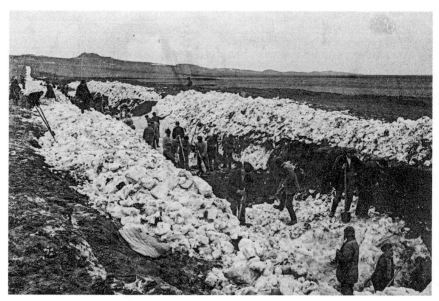

Yevgeny Khaldei, "Soviet citizens dig a trench to prepare for battle, October, 1941." *Courtesy of Anna Khaldei and the Yevgeny Khaldei Archive*

Through late October, after it was clear that Moscow would not fall to the Germans, the Soviet high command turned its sights to the "difficult situation" in the Crimea, where people were frantically digging antitank trenches to slow the forward march of the Wehrmacht's tanks. These would be to little avail. Despite every effort to hold all the major Black Sea ports, there were internal debates about evacuating all nonessential personnel from Kerch. Morale among Soviet troops was dismal, and the Soviet high command suggested that the Crimean Tatars abandoned their posts and in general fought poorly.[29] After occupying a city, the Einsatzgruppe recruited these disgruntled Tatars to become collaborators in their occupation efforts.[30]

On November 13, the Red Army made the decision to evacuate heavy artillery, valuable technology, and other key materiel for the war effort across the Kerch Straits to Taman in the southern Russian region of Krasnodar. Kerch's fall was imminent and, perhaps, evident to all observers as soldiers deserted by the thousands.[31] A report from November 15 talked about heavy fighting in the city itself and the "colossal losses" the Red Army had suffered. Stalin himself finally ordered a military retreat from Kerch, across the straits to the city of Krasnodar, 150 miles east, and to other places in the northern Caucasus. Around noon on November 16, 1941, on a bitterly cold day and after three weeks of intense bombing, the Red Army fully evacuated the city across the churning, stormy waters that separated Kerch from the Taman Peninsula, where the high command reestablished itself.[32] That same day, the Wehrmacht took Kerch.

The 1939 Soviet census reported Kerch's population at about one hundred thousand. Of those, there were an estimated five thousand Jewish residents. But the 1939 census took place during peacetime, when the country was not yet involved in a war that demanded total mobilization of the population. Peacetime censuses become useless in determining population statistics during a war in which the movement of people on the ground, at least on Europe's eastern front, was the rule rather than the exception.[33]

Whether it was state-sponsored evacuation of strategically important people and institutions or spontaneous flight, few civilians wanted to be anywhere near the frontlines. (Nor did many soldiers, but they did not have a choice.) In the particular case of the eastern front of World War II, some civilians feared the arrival of the Wehrmacht even before it came, and they fled in advance of the fast-approaching front. Many of these refugees or evacuees caught up in the chaos of mass flight from areas in Belorussia and Ukraine headed east. Some ended up in larger cities in eastern Ukraine such as Kharkov, others in Russian cities like Rostov-on-Don. Still others headed south toward Kerch, a strategically significant city sitting at the eastern edge of Crimea and a port. Perhaps, they thought,

these cities would be so far east that the front would not arrive. In each case, they were wrong.

As it became clear that the Wehrmacht and the Einsatzgruppe D, which became a mobile killing force after the German invasion of the Soviet Union, were coming to Kerch, many of these refugees tried to keep moving. Some of them were fortunate and fled again in advance of the German army's arrival in November to the same places to which the Red Army evacuated—the northern Caucasus, Krasnodar, or even further east to Central Asia. But flight, especially with the onset of winter, involved huge risk. Sitting at the tip of a tiny peninsula at the edge of the Crimea, Kerch did not offer those wishing to leave the city many options for escape. By late October, the Germans had already occupied territory to the west of the city. Because it was surrounded on three sides by water, the only other option was to cross the Kerch Straits. In the depths of winter, it sometimes froze over, allowing passage on foot, but in November, waters still lapped at Kerch Bay, and boats were required for passage. German reports suggest that those waters froze over after they took the city.

If frigid, stormy waters were not frightening enough, the German Luftwaffe, the fearsome air force that had carried out the initial blitzkrieg against the Soviet Union, had been bombing the region regularly since late October to weaken the city's defenses. It had targeted the strategically significant harbor, but the Germans took aim at any boat, regardless of whether it was military or civilian. Boats sank. People drowned. And given the narrowness of the strait, Kerch residents watched all this happening with their own eyes. The sight of loved ones disappearing beneath the gray waters terrorized the city, all of this *before* the arrival of German troops. Despite the rumors circulating about what Nazi occupation would mean, for most civilians, Jews among them, passage across the straits was too dangerous an option. And then, the option of flight disappeared. With oil derricks aflame, factories in ruins, and the Red Army gone, on November 16, 1941, Kerch residents "greeted" the Wehrmacht.

Little could have prepared them for the realities of living under German occupation. For their part, the German administration had improvised a plan for transforming the city from Soviet to German administration based on its experiences of occupying dozens of previously Soviet cities. In Kerch, the Germans began by taking over the Soviet secret police headquarters and making it SS headquarters. They needed to billet the hundreds of new residents of the city, most connected to the German occupation administration, so they confiscated the empty apartments left by those who had recently fled.

The occupation authorities had devised a method for feeding people based on their racial hierarchy in this new distant outpost of the German Reich's colonial territory, not unlike earlier imperial rule by the British and Germans in Africa.

First to be fed were the new occupation authorities—civilian administrators, Wehrmacht soldiers, and others connected to the occupation. To accomplish this, they did what empires had done in the past when occupying new territory— they confiscated grain, animals, and other sources of sustenance from the local population and redistributed it based on the Nazi formula for food allocation.

Soviet residents learned of the new administration and its operations through orders that appeared on the walls of buildings and at central gathering spots throughout the city. On many mornings in the early days of the occupation, Kerch residents woke up to find new orders that the German occupiers had issued overnight:

> All residents must register with the local authorities.
> All chickens, roosters, geese, and turkeys must be registered.
> All owners of cows must deliver 100 liters of milk per cow.
> No one may be on the streets after dark.

The streets emptied as fear settled over the city. Many residents remember doing their best not to leave their homes in those early days of occupation.[34] Most orders applied to all Soviet residents living in occupied Kerch. Each order ended with a threat that those not carrying it out would be punished "according to German law." In response to partisan activity in most Soviet areas under German control, Erich von Manstein, commander of German forces in the East, gave a speech four days after taking Kerch, arguing that the "German people are in a life and death conflict with the Bolshevik system" and that the "Judeo-Bolshevik system" does not play by European rules of war. Therefore, "the Judeo-Bolshevik system must be eradicated once and for all."[35]

Some of the orders addressed particular segments of the population. According to Soviet sources, on November 24, three hundred copies of Order Number 5 appeared across the city: "All Jews still living in Kerch or surrounding areas must report immediately to 2 Karl Liebknecht Street," which residents knew as the city's former Communist Party headquarters. "Any members of the remaining population knowing where Jews are residing must report this fact to the German security police." This order ended with a different threat than the others: "Anyone not following these orders will be executed." (Internal German reports date the order appearing around town on November 22.) [36]

With Order Number 5, the Germans ordered all Jews, except those legally married to non-Jews, to register with the local Gestapo (an acronym for the *Geheime Staatspolizei*, or the secret state police), housed—not coincidentally—in the Communist Party headquarters, within three days. As with all other orders

Order Number 5. German occupation forces of Kerch. *Courtesy of the USHMM*

relating to the city's Jewish population, failure to comply would result in imme-
diate execution. (The orders were in Russian to ensure maximum comprehen-
sion, and they used the word *rasstrel*, execution by shooting.)

According to a report from the German military administration in Kerch,
the local German authorities registered between ten and twelve thousand Jews
at 2 Karl Liebknecht Street.[37] Seated at a table, a German officer requested the
next person in line to approach, and then asked for their last name, first name,
address, and the number of residents living in the given apartment. These beau-
tifully handwritten ledgers list the Russian Jewish first and last names—"Raja,
Basja, Nata, Meier, Jakob"—and the Russian street names—"Puschkina,
Simowojstr, Potschowja"—but because a German wrote them, they are in
German transliteration.[38]

One eyewitness, Sofia Nikolaevna Lifshits, in a conversation she had with Soviet investigators on January 10, 1942, less than two weeks after Kerch's liberation, suggested that at the registration, the Germans also ordered Jews to wear a "four cornered star" on the left part of the chest.[39] The Extraordinary Commissions, which conducted research at all liberated sites that had been under fascist occupation, conducted a similar investigation in 1944. The local committee's report corrected her by saying it was a six-pointed star. It also noted explicitly that "a new order appeared on November 28 demanding that all Jews without exception and with their entire families appear at *Sennaia ploshchad'* (Haymarket Square), a central commercial hub of the city at the top of Proletarskaia Street. From Haymarket Square all of them were gathered—women, the elderly, and children—and sent to a prison."[40] (An August 5, 1955, redacted Soviet version of the final indictment removed the word "Jew" and referred to them simply as "those ordered to register by the Gestapo."[41])

With the majority of Kerch's Jewish population registered, on the next day, November 28, another poster appeared ordering all registered Jews to report the very next day to Haymarket Square. They were ordered to bring along three days of food and proper clothing. Although the order did not say why the registered Jews should bring these provisions, residents of the city, Jewish or not, assumed that it would feed those being ordered to report while they were in transit to forced

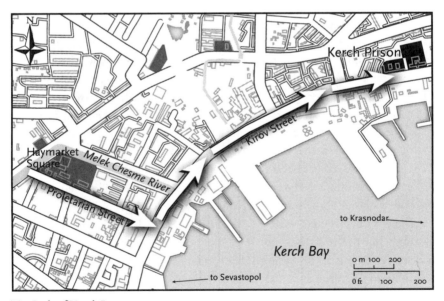

The Path of Kerch Jews

labor, possibly to a nearby collective farm in Mariental (today, Gornostaivka), fifteen miles to the west, to produce food for the occupation authorities.

By noon on November 29, the square was overflowing with the city's Jews and their provisions. One report puts the total number of people on the square at five thousand, nowhere near all of those who had registered.[42] Just after noon, witnesses reported seeing the assembled Jews forcibly marched from Haymarket Square, down Proletarskaia Street toward the Kerch Bay. Near the waterfront, they turned left onto Kirov Street, and ended up at building 75, the location of the Kerch city jail.

There, the Jews who had apartments in the city were forced to turn over their house keys. Those who were refugees with no local address had no such property to hand over. With this information and, importantly, the keys, the local commandant and city administration took over Jewish apartments in Kerch. In addition, they confiscated any and all valuables.

Seventy-five people were kept in each cell at the Kerch jail; many of the women were raped. And then they were left there without food or water. As thirst and hunger became the prisoners' overriding concern, a convoy of trucks began arriving on December 1. The prisoners expected them to deliver relief in the form of food and water. Instead, a convoy of trucks pulled up to the prison.[43] The trucks left the Kerch city jail and headed toward Bagerovo, the route out of town secured by Field Marshall Erich von Mannstein's Eleventh Army. But instead of going to a collective farm for forced labor, they turned right off the road and pulled up to the antitank trench.

The Red Army had originally chosen this site because of its strategic location at the western edge of the city and its proximity to the region's main airfield. In fact, not one but five antitank ditches, intended to halt the forward advance of German tanks, had been dug on the Kerch peninsula prior to the Nazi advance. The Red Army saw an opportunity to defend the city by digging trenches in the soft Crimean soil, but those trenches failed miserably to do their job. With the region in enemy hands, German administrators imagined the Crimean landscape with its defensive trenches differently. The local German occupation authorities, in particular Einsatzkommando 10b, a killing unit of Einsatzgruppe D, under the leadership and following the orders of its commanding officer Alois Persterer, had previously picked a Soviet antitank trench near Bagerovo for its "action."[44]

The Jewish prisoners were forced out and ordered to take off their outer clothing, but not to strip completely. At this point, the prisoners would surely have understood that they were not being transported to a collective farm. There was no farm there, just a trench.

At some point between Haymarket Square and Bagerovo Trench, perhaps the moment they boarded the trucks, responsibility for the city's Jews shifted from

the military occupation authorities to Einsatzgruppe D and Einsatzkommando 10b. Local residents working with both the Wehrmacht and the Einsatzgruppe D, mostly Tatars who were encouraged to collaborate with the German occupation forces and earned the name *Hilfswilliger* (*Hiwis* for short, or those "willing to help"), along with Wehrmacht riflemen kept the panicked victims moving according to plan, from the trucks to the trench. The shooters lined up the disrobed Jewish prisoners in groups of ten (some reports say five), brought them to the edge of the trench, and shot each one with a bullet to the nape of the neck. Their bodies fell in one after the other.

Emptied of their "cargo," the trucks returned to the Kerch jail to pick up the next group of prisoners. Those transported later in the process knew immediately on arrival at the trench what was going to transpire, as they saw a large mound of winter coats on the approaching horizon and heard the sounds of shots being fired.[45] (Transcripts from the 1972 Munich war crimes trials suggest that one of the defendants ordered newly arriving Jews to be unloaded from the trucks before coming upon the killing site to lessen their anxiety. However, there is nothing in any other eyewitness account that corroborates this testimony.) These mass shootings took place over three days, December 1 to 3. This scene repeated itself in several other cities on the Crimean peninsula through December 1941.[46]

Nearby residents heard the shootings and, according to one story, a few victims managed to be saved by throwing themselves into the trench as other bodies fell around them.[47] Alive but suffocating beneath the weight of the dead, they crawled out in the middle of the night and found refuge with locals. Unlike in other locations under German occupation, where Jews who escaped death were just as likely to be turned back in to the authorities by locals, in Kerch some local residents were willing to provide shelter for those Jews who had escaped. A Jewish fisherman, Josef Weingarten, who survived the shooting suggested that 5,000 Jews were shot over the three-day period. (A German report from December 7 put the number at 2,500.)[48]

With the first action complete, rumors circulated across town about what happened to the Jews on Haymarket Square. As one Z. Gold, who lost sixteen family members at the massacre site, recounted the events, "Rumors reached us from eyewitnesses of the beastly execution. They said that the Germans had cordoned off the road to Bagerovo and did not allow the population to walk or drive by the antitank ditch. Collective farmers residing close to Bagerovo heard the machine gun shots, screams of women, children and groans of the wounded."[49] As these sounds pierced the chilly fall air, it is unclear if the Germans minded that such rumors had circulated, or even that collective farmers heard screaming, or whether they may have encouraged the terror that ensued as they established a brutal occupation authority to manage daily life.

In other words, what began as a conquest of enemy territory managed by "Judeo-Bolshevism" needed to become a well-functioning system for administering daily life that would, at least in the minds of the German conquerors, last a thousand years. Part of that millenarian empire meant eliminating any Jewish presence in German-controlled territory. Aware that the number of Jews who registered in November did not match the number of Jews lying in the trench, German authorities knew that there were still Jews in hiding. In addition to rounding them up, the Wehrmacht fought against partisan units—made up of Red Army soldiers and other civilians, who took up arms against the German occupiers—operating in and near Kerch. Moreover, the line between partisan and Jew was blurry, if it existed at all. Through December, the German occupation forces also accelerated the extermination of Jews in the Kerch peninsula, because of a fear of food shortages.[50] Therefore, in early December, after the first "action," rumors of which were circulating in the city, German authorities again ordered all Kerch residents with knowledge of the whereabouts of Jews to report them—or themselves be executed.

So ended the first two and a half weeks of the German occupation of Kerch.

Through the month of December, executions were ongoing through "partisan warfare" against Jews and Judeo-Bolshevism, and the Bagerovo trench was the primary, but not exclusive, site for the killings. Other sites included an antitank trench and pit at the Adzhumishkaiskii quarry to the east of the city. According to one witness, on December 22 fascists shot 160 people on Lenin Street, including "the elderly, women, and breast-feeding children," presumably Jews who had gone into hiding and had been betrayed.[51]

In addition, partisans fighting against Germans in the occupied city who were caught in the catacombs that crisscrossed the hill on which Kerch stood were executed at the trench. According to another witness, Anna Naumova, by December 1941 two thousand Soviet soldiers were imprisoned at a single school; one hundred of them had sustained serious injuries.[52] In theory, farmers who did not supply the necessary quota of crops or animals could have also been executed, although whether this actually took place is not clear. Several reports included in the 1944 investigation by the Soviet People's Commissariat for Internal Affairs (NKVD)'s Extraordinary Commission indicated that late in December, "partisans" from Kamysh Burun and Samostroi were executed there.

One problem the Germans faced was determining who in the city counted as a Jew, the racial enemy of the Reich who controlled governments from Washington to London, but especially Moscow, which in the minds of leading Nazi ideologues was the headquarters of Judeo-Bolshevism. Nazi experts had

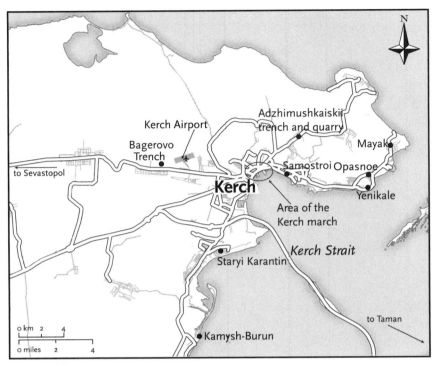

Kerch and its outskirts. Black dots represent killing sites in the vicinity.

determined that Ashkenazi Jews—those eastern European Jews who spoke Yiddish and were the primary representative of "the Jew" in Nazi ideology—were simply slated for death.

But sometimes, people's chosen intimate relationships saved them from racially marked murder. As in Germany, where marriage to a non-Jew protected a person from deportation, at least at the beginning, the same relationship also protected a Jew in some parts of the occupied Soviet Union. It was a short-lived protection, lasting all of a few weeks, but this exemption from immediate execution suggested that there were inconsistencies in how Nazi racial ideology would be put into action. In late December, another order went up on city walls ordering Jews in "mixed marriages" to report to Haymarket Square on January 3, 1942. By this point in the occupation, most residents, and certainly all of those in these marriages, knew what the order meant.

The German occupation authorities encountered two other groups of people in Soviet Kerch whose racial category confounded them. Luckily for them they could thank the Soviet Union for having spent the previous twenty years defining its population by "nationality," the Soviet, Marxist-Leninist–inspired,

nonracialized designation for a culturally, perhaps even ethnically, distinct group of people.

As a way of breaking down the idea of a global religious community and replacing it with an ethnically specific one, the 1926 Soviet census divided Jews in the Soviet Union into six categories based on each one's distinct cultures. In addition to Jews, who spoke Yiddish (at the time, the Russian word for "Yiddish" was *evreiskii*, or Jewish), there were Georgian Jews (who had resided in Georgia, according to local lore, from the time of the sixth-century BCE Babylonian exile from Jerusalem), Mountain Jews (in Dagestan), Bukharan Jews (in Central Asia), Crimean Jews (known as Krymchaks), and Karaites.[53] When the German occupation authorities developed their plans, they used these Soviet designations to shape their own policies. This included determining who was a Jew—and therefore who was racially destined to die.

In Kerch, in addition to Yiddish-speaking Jews, the worst racial offenders, there were at least two different groups that the Germans investigated for their racial background—Karaites and Krymchaks. Karaites broke away from rabbinic Jews, who would become the form of Judaism defining the Jewish tradition throughout much of the world, in the ninth century in a dispute over religious authority, not unlike the relationship between Shi'ite and Sunni Muslims. Although Karaite Jewish communities flourished in the medieval Middle East, by the twentieth century, Jewish communities and Karaite communities had grown so distant from one another that there was little sense of a common community among them. Then modern nation-states began categorizing their populations according to ethnicity and race, including the Soviet Union and Germany.

In 1939, the small Karaite community in Germany had convinced the Nazi authorities in the Reich Office for Genealogical Research that Karaites were not racially Jews. If it was easy to determine what Karaites were not, Nazi genealogists were confounded to determine what they indeed were. After their invasion of the Soviet Union in June 1941, the Nazis encountered a much larger population of Karaites in Lithuania, Ukraine, and elsewhere. There too, following the German precedent, the Karaites convinced the authorities that they were not Jews. A September 1, 1941, report stated, "The Karaites . . . both in the eyes of the [Ottoman] Turks and of the Soviets are included in the Turkish races and not in the Jewish race."[54] After a few weeks of further investigation, and after the first wave of mass killings of Jews, a December 5, 1941, Einsatzgruppe report confirmed that Karaites were not to be treated as Jews. With that stroke of the pen, their lives were spared from racially motivated murder.

The same could not be said for Krymchaks, who according to another Einsatzgruppe report were "Jews who emigrated from Italy about 400 years earlier. They arrived in Crimea and adopted the Tatar language."[55] Like those

Ashkenazi Jews in marriages to non-Jews, Krymchaks were spared the initial orders to report to Haymarket Square for deportation (and what Kerch knew by mid-December was also for execution). But in late December, Krymchaks, like Jews in mixed marriages, were ordered to report to Haymarket Square on January 3.

Back at Soviet high command in early December, winter set in. The ground froze, temperatures dropped, and the Red Army began its first major counteroffensive against its less prepared German enemies. Echoes of Napoleon's wintertime folly in 1812 echoed in the halls of the Kremlin. The Red Army's first focus was the capital and the defense of Moscow as the Red Army retook cities to the west of the capital, including Volokolamsk and Klin. Later in December, the counteroffensive also aimed to retake territory the Germans had occupied in southern Russia and Crimea. On November 29 the Red Army retook Rostov-on-Don, which the Germans had held for only one week, and it also made gains in the Crimea. The Red Army attempted to liberate the peninsula via an aerial raid over the Kerch Straits that began on December 26. Known as the Kerch-Feodosia Amphibious Operation, it was the largest such operation in the entire war. The whole counteroffensive was surprisingly successful, and the entire Kerch peninsula was cleared of German troops by January 2.

In its hasty retreat from Kerch in the face of a newly emboldened Red Army, the Wehrmacht seized partisans, Soviet prisoners of war, and others from Kerch and the nearby villages of Kamysh Burun and Samostroi, brought them to the antitank trench near Bagerovo, and executed them. They did so both as punishment and also as a preventive measure to stem the ongoing partisan warfare in the rest of Crimea. On December 29, the Soviet Fifty-First Army, referred to by surviving Soviet citizens in oral testimonies of the experience as "our side [nashi]," retook the city, ending the Wehrmacht's forty-five-day occupation of the city. (The lieutenant general commanding the Wehrmacht in Kerch, Hans Graf von Sponeck, in fact, did not have permission from the commander of the Eleventh Army to retreat. He was dismissed two days later and court-martialed in January 1942.)[56] The Fifty-First Army's reconquest of the city saved the lives of Krymchaks and Jews married to non-Jews who were due to report to Haymarket Square just four days later for deportation and execution.[57]

2 WITNESSING GRIEF: THE FIRST REPORTS OF GENOCIDE

Soviet investigators arrived in Kerch almost immediately after its liberation and began interviewing residents about what had taken place. After all, it was one of the first major cities that had been under German occupation for any length of time to be liberated.[1] Because of the location of the area's airfield near Bagerovo, the antitank trench was one of the first scenes that Soviet investigators who flew into the city came upon.

One sailor, who was part of the Red Army liberating forces then based in Kerch, reported to his commanding officer of the rumors he heard of a mass killing site on the city's outskirts. The commanding officer asked him to investigate the scene. That morning in early January, several days after the return of Soviet authorities, he and several other sailors drove out from Kerch toward Bagerovo. They approached the site and saw a mound of earth obscuring the trench. Upon going around the mound, they saw a scene stretch out before them unlike any they had ever seen. The ground had some snow on it, but it was mostly wet, a field of semifrozen mud. According to this sailor and other eyewitnesses, a trench—the antitank trench the Soviets themselves dug—that stretched between one and two kilometers in length, four and five meters in width, two meters in depth, was now filled with corpses.

That scene would have been shocking enough. But eyewitnesses did not end their descriptions with the pit full of the dead, because that was not the first image they saw. The trench was so full that the Germans murdered their last victims—a few remaining Jews, partisans, and prisoners of war as well as non-Jewish civilians executed in reprisal for partisan actions against the German occupiers—in late December out on the frozen field along the edge of the ditch. The bodies of those last to be executed lay on the open field, left in haste upon the German retreat.

The remaining scene was horrifying: "Around the trench lay frozen pools of blood," wrote Boris Volfson, who was commissioned to write the earliest official Soviet report of the mass murders of Kerch's residents.[2] One story, which also appeared in Volfson's report, was quite familiar to the city's residents. A murdered woman, perhaps thirty-five years old, was shot dead with her young children. That story had other sources, including photographs, to corroborate it, but Volfson's report also included a story about how the Germans poisoned a school full of children in Kerch, a horrible act almost too shocking to believe.[3]

The fact that the vast majority of the people murdered had certain collective characteristics was clear to anyone living in the area who had seen Order No. 5 posted in late November. By early January everyone in Kerch understood that the Germans had not simply marched the Jews from Haymarket Square to the city prison and then relocated them to forced labor on a collective farm. One man, when asked more than fifty years later if he could tell that the corpses at the trench were Jewish, replied, "They had Jewish faces, even the woman," referring to the unnamed thirty-five-year-old with her small children, who was blonde. "She [too] had a Jewish face."[4]

Despite the ubiquitous local knowledge of the victims' collective identity, every official report investigating what took place at Kerch and produced in the months after the city's liberation obscured the Jewish identities of the victims. On the one hand, this fit into a long history of the communist state universalizing particular anti-Jewish violence. After all, communists view the world through the Marxist lens of class and, in theory, do not believe in biological destiny. This was a primary difference between the Soviet Union and the rest of the Western world, which in the first half of the twentieth century was infatuated with the idea of eugenics and race science. The concept of universalizing anti-Jewish violence had held true ever since the Bolsheviks took power and responded to anti-Jewish pogroms during the civil war of 1919–21.[5]

On the other hand, the same Soviet Union that emphasized the common human experience and outlawed antisemitism also emphasized an individual Soviet citizen's membership in a Soviet ethnic group as a way to emphasize communism's postcapitalist embrace of diversity. German reports had no problem naming the enemies being targeted—communists, partisans, and—the biggest enemy of all—Jews. And yet, here too these reports often conflated the political and military enemies as just another manifestation of the true racial enemy—Jews.

Soviet reports generally referred to those murdered as "peaceful Soviet citizens," which of course the majority, those who were not fighting as partisans, were. (Among them would have been some Polish Jewish refugees, who would not have been carrying a Soviet passport.) Volfson, however, wrote that "the fascists

exterminated everyone: Russians, Jews, Ukrainians, Tatars, Karaites, Krymchaks, and Greeks." His report opens with this universal statement about the fascists' seemingly indiscriminate killing of Soviet ethnic groups. He even includes Tatars, whom the German occupation forces had explicitly recruited to be Hiwis.

But this begs the question: If the Germans really killed everyone, in the sense of indiscriminate mass murder, then why would Volfson list the ethnic groups making up the victims unless ethnicity was a category through which the Soviet Union understood its own population? His statement on its own could be true if, and only if, among the others killed in reprisal actions, one identified the dead as Russians, Ukrainians, Tatars, Greeks, Karaites, and Krymchaks.[6] Volfson himself recognized that even if the above were true, one's ethnic identity shaped one's experience under German occupation.

His very next sentence immediately dispelled any sense that he thought that all groups were exterminated equally: "Jews were exterminated with particular ferocity, as revealed in the especially humiliating and brutal torture they endured before their execution."[7] *This* formulation highlighting the particularly "ferocious" violence that Jews experienced under German occupation, along with the preceding list of other ethnic groups killed indiscriminately, became the common way the Soviet press reported on German crimes on Soviet territory in 1942, the first year after the discovery of those crimes.

Reports also strove for scientific accuracy by declaring a specific number of victims at the Bagerovo trench. Volfson's essay reported seven thousand victims, a number that he got from the Soviet research commission assigned to investigate German crimes at Kerch. German necrology reports were even more specific. A January 2, 1942, Einsatzgruppe report back to the RSHA headquarters in Berlin proudly proclaims: "Simferopol, Jewpatoria, Aluschta, Karasubazar, Kertsch, Feodosia, and other districts of the Western Crimea have been cleared of Jews. From 16 November to 15 December, 1941, 17,645 Jews, 2,504 Krimschaks, 824 gipsies, and 212 communists and partisans have been shot. Altogether 75,881 persons have been executed."[8]

Members of the Einsatzgruppe D, which produced the report, were not the only Germans involved in the mass murder of the city's Jewish population; the military administration was involved as well. A report sent on December 7 by the town's Ortskommandatur to Feldkommandatur 553 stated, "The extermination of some 2,500 Jews was carried out on December 1 to 3." The Ortskommandatur also noted with concern the huge discrepancy between the number of Jews registered and the number murdered and called for additional actions to find those in hiding.[9]

More than twenty years later, Einsatzgruppe D officers on trial in the Frankfurt Auschwitz Trials, which ran from 1963 to 1965, concurred with the

early report that among the 21,185 people murdered in the region, the sum total of Jews, Krymchaks, Gypsies, communists, and partisans, "only" 2,500 Jews were murdered at Kerch specifically, at least in that first three-day action.[10] Even the most dispassionate statistics produced by contemporary historians of the Soviet Jewish experience suggest that the Jewish population of Kerch upon the Wehrmacht's arrival, and therefore the maximum number of Jewish bodies in the antitank trench, could barely have been seven thousand.[11] Perhaps, these scholars insinuate, the Soviet researchers exaggerated their data, because Soviet sources should always have their reliability questioned.

Yet all of these reports mention only in passing that wartime population statistics were constantly in flux, with numbers rising and falling depending on the field of battle and which regime was in control of a given territory. Kerch was a primary destination for Polish and Ukrainian Jews along with hundreds of thousands of non-Jews fleeing the advancing Wehrmacht, and these individuals were likely not officially registered in the city. Despite the desperate need for humility among researchers in resisting the urge to give exact numbers, which obviously one cannot do given the exigencies of war, each one of the reports produced at the time, as well as later historical reconstructions, is more certain than the next about the numbers and accuses the others of over- or underestimating.

In addition to scientific researchers and investigators working with the People's Commissariat of Internal Affairs (NKVD), the Soviet secret police who conducted forensic work and interviewed witnesses, journalists also arrived in the city on the heels of the Red Army to report on the story. Upon arriving in Kerch on January 2, 1942, no one could have known what the story would be. Most assumed that they would be documenting another heroic liberation in the Red Army's counteroffensive, this one of a key port city after a daring amphibious landing from across the straits.

To be sure, journalists had seen their share of horrors in newly liberated cities. From Rostov, which the Germans occupied for eight days from November 21 to 29, journalists, photographers, and filmmakers reported on the German execution of one hundred Jews.[12] From smaller towns near Moscow liberated in the first days of December, like Volokolamsk, writers had written in outrage about German war crimes such as the hanging of partisans in town squares and churches and about other Russian cultural patrimony wantonly destroyed. The liberation of Kerch proved to be different: it was the first place to have anything like the trench on the city's outskirts filled with mostly Jewish corpses needing to be exhumed.

Many newspapers, including *Izvestiia*, ran anonymous reports from news sources such as Sovinformburo, the wartime Soviet news agency. But the bare facts of the story, along with the charged language the unnamed author used,

would have shocked any reader: "Doctors from the city of Kerch, who remained alive after the spectacular atrocities of the German occupiers, published a letter in which they described the heinous acts of the Hitlerite dogs, that garbage of humanity."[13] According to the surviving doctors' letter (although left unsaid in the Sovinformburo report, those doctors were Jewish), the Nazis kept them alive to take care of wounded German soldiers.

Those "heinous acts" included "Order No. 4, pasted around town, that told thousands of civilians regardless of sex or age to appear at Haymarket Square with three days' worth of food. The fascists then drove all of them to the local prison. Then several thousand people, among them pregnant and nursing women, the elderly, and the severely infirm were driven to the outskirts of the city to an antitank trench, and at that site were barbarously executed."[14] (Note that the author meant to write Order No. 5.) This Sovinformburo writer found ways of conveying their utter horror, to the point of physical revulsion, at seeing thousands of freshly murdered, mostly Jewish bodies overflowing a purpose-built Soviet antitank ditch.

The Soviet Jewish writer Vladimir Lidin's short article about the Kerch massacres appeared on page four of the January 31 edition of *Izvestiia*. The grim opening set the tone for the entire essay: "Whole groups were driven from the Kerch city prison, 7000 of them, shot in Kerch, and this, after the antitank ditch was already overflowing with the dead." Lidin then searched for psychocultural explanations for such atrocious behavior among the seemingly cultured Germans. Readers might have been surprised to read his answer: Germans were capable of this kind of sadism, he suggested, because of their history of "unbelievable sexual deviance including tolerance and support of homosexuals, who even had their own *legal* pornographic newspapers." The author's main point, aside from the violent homophobia mobilized by both National Socialists and communists to demonize the other, was to argue that only in Germany, where a perverse society of sexual deviance destroyed the classic liberal culture of Schiller and Goethe, was it possible for their troops to execute tens of thousands of peaceful Soviet civilians.[15]

What does a reader do with that kind of gruesome information about the massacre and its presumptive causes, buried as it was on page four? Assume it was an exaggeration to demonize the enemy and convince those reading the paper to continue fighting? Wonder why the Germans would round up pregnant women and murder them, if that was indeed what happened at Kerch? And then there was the description of the trench literally overflowing with the dead. Was such a thing possible?

Lidin was a well-known author who had become a special correspondent for *Izvestiia* at the outbreak of war, writing short pieces for the newspaper. (He also

collaborated with Baltermants on a book about the November 1941 defense of Moscow.)[16] Other journalist-writers such as Ilya Selvinsky turned to poetry-as-testimony. Selvinsky was on the scene reporting for *Red Star*, the Red Army's newspaper. Out of that experience he produced *I Saw It* (*Ia eto videl*), a poetic response to reflect what he had seen in his first few days in the liberated city. Unlike Lidin's analytical treatment of events, Selvinsky bore witness to the killing site and never attempted to explain how such a crime could have happened in the first place.

There was a long tradition of literary writers being commissioned to produce journalism in the aftermath of atrocities. Then, in the moment of putting pen to paper to write their documentary account, they found themselves turning to their artistic craft to convey the full extent of what they had seen. After the 1903 anti-Jewish pogroms in the Bessarabian city of Kishinev, the poet Chaim Nachman Bialik was sent to cover the story for an Odessa-based newspaper. Although the editor may have expected a journalistic account of the violence, what Bialik turned into his editor was a powerful *poema*, a long-form narrative poem, called "In the City of Slaughter," which served as a template for future Jewish responses to anti-Jewish violence.[17] Selvinsky certainly worked in the literary genre of the *poema*; perhaps he even knew of Bialik's poetic response to anti-Jewish violence in southern Russia.

Semen Rafailov, a Kerch resident at the time of the German occupation, remembered visiting the trench on the outskirts of town and being overcome with sadness at the magnitude of what lay before him. He also met a soldier who urged him to get revenge for what he was witnessing. Rafailov went home and reported what he had seen to his friends, family, and the Soviet authorities, who had been back in the city for only a short time.[18] A few days later, he went out to a local club to listen to a military concert. As he reported in his interview with the Shoah Foundation's Visual History Archive, "I was shocked that the Soviet soldier who told me to avenge the crime was there reading a poem from the stage. It turns out it was Ilya Selvinsky. The next day, his poem titled 'I Saw It' was published in [the local newspaper] *Kerchenskii rabochii*."[19] Readers of the Sovinformburo reports in Moscow might have been suspicious of them given their claims of the mass murder of thousands of "peaceful Soviet citizens," as the press reported shortly after the city's liberation. This was one reason Selvinsky turned to poetry.

Selvinsky saw the antitank trench firsthand as he accompanied the troops liberating the city. In January 1942, he recorded in his diary, "I got to Kerch with the second wave of airborne troops. The city is half-destroyed. That's that—we'll restore it. But near the village of Bagerovo in an antitank ditch—[were] 7,000 executed women, children, old men and others. And I saw them. Now I do not have the strength to write about it in prose. Nerves can no longer react. What

I could—I have expressed in verse."[20] "I Saw It" appeared again in the Moscow-based *Bolshevik* on January 23, 1942, and went on to become one of Selvinsky's most widely known poems.

The poem opens with a challenge to the reader: "It's possible to ignore gossip, / or to distrust newspaper stories, / but I saw it with my own eyes. / Get it? I myself." In this bold poem, Selvinsky suggests that not only did Western press outlets distrust Soviet newspapers given the different standards of evidence-based journalism in the "capitalist" West; so too did Soviet readers.[21] He poetically emphasizes the power of sight as a form of documentation, arguing that he alone is a reliable witness. The poet forces us to ask: When mass murder has taken place, what stories do we believe? Only those things we see with our own eyes? What about a reliable witness like Selvinsky? Why should we believe him or the magazine *Bolshevik*, in which his testimony appeared? Maybe we need a photograph of the site as evidence?

But even photographs demand context and can be manipulated to tell stories that might not reflect the reality in front of the camera. Selvinsky understood that the most powerful way of convincing a reader of the truth of one's words was by having *seen* the site for oneself and to describe in detail what he saw. He

Террор фашистских оккупантов в Польше. Поляки, заключенные в одном из концентрационных лагерей, роют под наблюдением фашистских палачей могилу для своих расстрелянных товарищей. (Американский журнал «Лайф»).

"Terror of the fascist occupiers in Poland. Poles imprisoned in one of many concentration camps dig a grave for their executed comrades under the surveillance of the fascist executioners. (American magazine 'Life')," *Izvestiia*, June 25, 1941

transformed an authoritative, third-person journalistic account into a poetic, first-person eyewitness testimony.

Starting on June 25, 1941, just three days after the German invasion, *Izvestiia* and *Ogonek*, which was founded in 1923 and served as the Soviet Union's leading illustrated magazine, along the lines of America's *Life*, both began publishing photographs depicting fascist mass violence. Unlike the panoramas of factory workers listening to Molotov or proud soldiers ready for battle, these photographs had not been taken by the Soviet press's own photographers. These were "trophy" photographs, wartime photographs captured from the enemy that served as a window onto the enemy's mindset. Trophy photographs were rare commodities during wartime, a high-value propaganda weapon that was intended to damn the enemy. These photographs were just that.

But how did Soviet press outlets have trophy photographs from an enemy with which it had been at war for a mere three days? *Izvestiia*'s single trophy photograph labeled the source—the American magazine *Life*. (The same photograph appeared in *Ogonek* on the same date without attributing it to *Life*.) The Soviet press would have received the *Life* photograph the same way Soviet photographs would have reached *Life* editors in the States—over the wires.[22] These photographs seem to have been too gory or graphic for *Life* to publish, too intense for a readership that editors generally shielded from the violence of war. The Soviet press was not so squeamish.

Even though the Soviet Union and Nazi Germany had signed a nonaggression pact, the Allies—and we can include the United States, which, although not yet formally at war, was supporting the Allies—were doing their best to bring the Soviet Union into the war on their side. One form of information Western allies supplied to skeptical Soviet officials was photographic evidence of German atrocities. With the German launch of Operation Barbarossa on June 22, 1941, bringing the Soviet Union unwillingly into the war, German trophy photographs of the mass murder of Poles suddenly took on a new urgency.

(By 1942, the Red Army began capturing its own German trophy photographs that documented the mass execution of their own Soviet citizens in even more horrible fashion than those from Poland, which had only hinted at the horrors that awaited the victims under German occupation. A March 1942 diptych, found on a German soldier named Kurt Seidler, shows off the sadism of the Hitlerites in their treatment of peaceful Soviet citizens, who "were shot in the back and, as they died, they fell into the bottom of a grave, dug out by those sentenced to die on orders of the executioners."[23] The victims' only crime: "They were Soviet citizens." The close-up of the grave, which was in fact a long trench, would have horrified any viewer.)

The Soviet press, especially *Ogonek*, published Nazi trophy photographs of German mass killings of Poles (and Jews) throughout the summer of 1941. Even if most of the photographs labeled the victims of atrocities as Poles or Serbs, articles that ran alongside these trophy photographs, occasionally translated from the foreign press, were not shy about naming Jews as victims who received particularly violent treatment. As an *Izvestiia* article that ran shortly after the German invasion informed readers, "For the Jewish population of Poland, the German fascists established a regime before which every kind of medieval horror paled in comparison."[24]

As readers were coming to grips with the violence of German occupation, Dmitri Baltermants was photographing on assignment on the frontlines. Through the summer and early fall, he followed the Red Army. The images his editor published rarely identified the specific location, so as to avoid revealing to the reading public classified information, especially the fact that the Red Army was generally moving east, in retreat. In one Baltermants photograph from September, his editors labeled the image "the town of N." Another shows him photographing from high above the battlefield in one of his rare aerial photographs. His editors often published somewhat uninspired close-ups of tanks on the battlefield.

Dmitri Baltermants, *On Their Way to the Front*, November 7, 1941

Based on his published record in *Izvestiia*, we know that Baltermants spent most of the fall and winter of 1941–42 on the front, with occasional breaks in Moscow. While he was in Moscow, *Izvestiia* sent him to photograph the Revolution Day parade on Red Square on November 7; a snow-covered landscape frames the troops, who listened to Stalin encouraging them to fight on and to the cavalry heading off to the front, mere miles from Red Square. After the late November counteroffensive, which liberated several cities to the west of Moscow, the newspaper sent him to photograph that late-breaking news. There, he discovered horrors that would shape his entire war career. None of those pictures appeared in *Izvestiia*. We do not know why. Then, in December, he was sent south from Moscow to photograph the ongoing events in the Black Sea region.

Shortly after the liberation of Kerch, after the first wave of paratroopers landed on Kerch's shores on December 29, the local Soviet newspaper *The Kerch Worker* (*Kerchenskii rabochii*), reappeared after having been closed down by the German occupation authorities in mid-November. Reports on the mass murder of Kerch's residents appeared regularly there throughout January.[25] On January 24, *Red Crimea* ran a shocking full-page spread titled "Atrocities of the Germans at Kerch."[26] The writer and the photographer responsible for the story, Mark Turovsky and Izrail Antselovich, both of whom worked for the Soviet news agency TASS (Telegraph Agency of the Soviet Union), aimed to recreate for the reader what life under German occupation was like for Kerch residents. Among the five photographs that appeared in the paper, the photo editor published two brutal close-ups of murdered women and children. Although the accompanying text does not specify whether the dead women and children were Jewish, the Einsatzgruppe generally did not murder non-Jewish children.

A few days later, on January 29, Lev Romanovitch Ish, a correspondent for *Red Star* (*Kransaia Zvezda*), published "Bloody Atrocities of Fascists in Kerch" and included much more detail about the immediate history of Nazi occupation that led to the mass murder of Jews at Kerch.[27] But this series of articles about the Kerch atrocities appeared only in the local and regional press, and therefore had limited impact on broader Soviet and international audiences. Lidin's "Ryegrass [*Plevely*]" appeared in *Izvestiia* in late January, but the newspaper's editors did not run any photographs.

Mark Redkin, a photographer working for TASS, saw his photos first appear in *Komsomol'skaia Pravda* on January 20, and then again in *Ogonek* on February 4.[28] The caption suggests how Redkin and the *Ogonek* editors placed the photograph into an evolving narrative of the war: "Hitler ordered his bandits to annihilate the peaceful Soviet population. Wherever the Germans found themselves, they murdered thousands of women and children. The bodies of the murdered were dumped in a pit (see above photograph). Among the murdered were many

women and children (see lower photograph). The Hitlerite thugs showed no one any mercy." The caption writers obscured the perpetrators of the crimes. In one sentence it is followers of Hitler; in another, Germans.[29]

Yevgeny Khaldei, a young photographer who would be made famous by his World War II photographs of victory in Berlin, also worked for TASS. The press

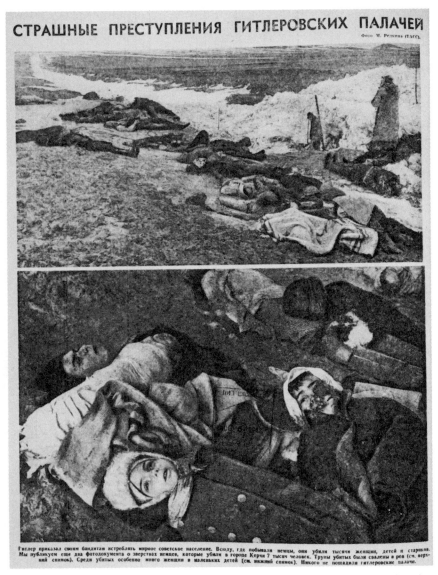

Mark Redkin, "Horrible crimes of the Hitlerite executioners," *Ogonek*, February 4, 1942

agency sent him south after his tour of duty with the Northern Fleet, where he also bore witness to Nazi mass murder in Kerch and documented the massacre with his camera. "The trench was two kilometers long," opens the section of his diary, emphasizing the vast scale of the massacre. If the size of the killing site was not enough, Khaldei then wrote in his diary the numbers killed, "the 7,000 women, children, and elderly."[30] In order to give context to his images coming from the trench, Khaldei interviewed townspeople and went to the trench to meet with witnesses about the Germans' forty-five-day occupation of the city and the mass murder of Soviet civilians.[31]

Baltermants joined Redkin and Khaldei with the second wave of Soviet paratroopers landing as part of the military operation to retake Kerch and its neighboring city Feodosia on January 1. Since he was a photographer, not a paratrooper, he opted against jumping out the plane and instead went by cruiser across the channel. Baltermants recalled that New Year's Eve channel crossing with stunning detail. Despite the stormy weather and choppy water, the mood was celebratory. Champagne flowed and sailors cavorted as one would have after liberating Kerch and Feodosia. The date also happened to be the New Year, one of the most celebrated holidays on the secular Soviet calendar.

All was quiet as the ship left the harbor at Novorossiisk. The sound of bombs and the piercing light of morning woke the sleepy and hungover sailors and journalists, letting them know that they had nearly reached their destination of Feodosia. Torpedoes from the water and bombs from the air, however, made further forward motion dangerous. The ship was forced to maneuver abruptly, forward, back, side to side, but finally, when the crew deemed the final destination of Feodosia too dangerous to reach, the ship returned to Novorossiisk.

Most soldiers were likely quite pleased that they did not have to face the heat of battle again, but Baltermants was on assignment to cover the liberation of these two Crimean cities, something he could not do from across the Kerch Straits. He made it to Crimea one day later, on January 2, on a support plane out of Krasnodar that landed at an airfield on Kerch's outskirts, the airfield located near Bagerovo. As he tells the story, the moment he stepped off the aircraft, he saw the antitank trench.[32]

Baltermants, along with other photojournalists, all immediately saw the horror that, as Selvinsky wrote, simply could not be described in prose: "I can't describe what I saw in mere words." Selvinsky chose poetry. Baltermants used his camera. Photojournalists arrived just as the Red Army opened up the site to local residents to both identify the dead and begin the long process of burying the bodies. Baltermants saw older women and families wandering around crying, searching the area around the killing field. And then, amid the wailing, Baltermants saw what people were looking at: dozens of corpses littering the

Unknown photographer, *Dmitri Baltermants*, ca. 1942

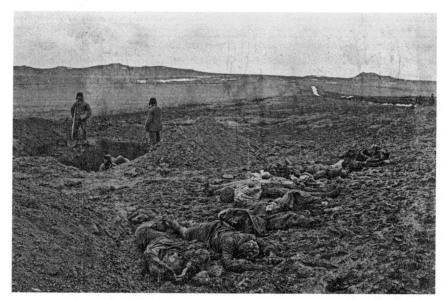

Yevgeny Khaldei, *Exhumation of the Bagerovo Antitank Trench*, January 1942. *Courtesy of Anna Khaldei and the Yevgeny Khaldei Archive*

bleak, wintertime landscape. And by early January, when Baltermants and other photographers arrived at the trench, most everyone knew the general outlines of what had taken place there—and most knew that the vast majority of those murdered were Jews.

Every photographer was confounded with how to document the scene in front of their cameras. Redkin aimed to take in the whole spectacle. He captured the overall scene with corpses littering the landscape, a few living figures conducting their investigation, and the white snow of the trench serving as the main subject of the photograph. He also took close-ups of the dead, in his particular case of dead children, which presumably shocked the Soviet newspaper readers at the time as much as it stuns historians today.

At the killing site, in addition to photographing the exhumation of bodies, Khaldei also documented the story of one man, Grigory Berman, head of a middle school in the Jewish agricultural colony of Larindorf, some two hundred kilometers away, whose family had been in Kerch during the occupation. On that day after liberation, Berman discovered his family members murdered at the trench. There are several photographs documenting Berman's anguish as he comes to grips with his losses.

Khaldei varied his own vantage point, as he took both close-ups of Berman and broad panoramas revealing the desolate landscape in which the killings took

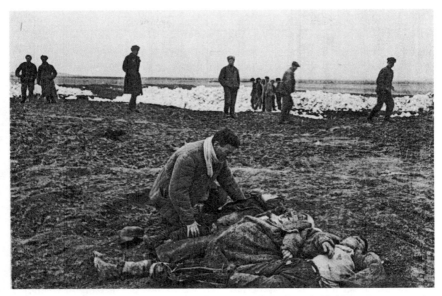

Yevgeny Khaldei, *Grigory Berman Finds His Dead Wife and Children*, January 1942. *Courtesy of Anna Khaldei and the Yevgeny Khaldei Archive*

place, to give context for this lone man's grief. We see nearly a dozen figures on the horizon, all appearing to be male. Some look at the cameraman and, because of Khaldei's position, also at Berman. Most are in shadows, rendering them faceless witnesses to Berman's pain, even though they are clearly on site conducting their own investigation of the scene.

A different version of Khaldei's photos of Berman discovering his murdered wife and child—this one with grieving women behind him—served as the image illustrating the headline "We will avenge!" that appeared in the February 1942 edition of the *Illustrated Newspaper of the Political Directorate of the Red Army*.[33] (Berman is the only man searching for his murdered family members in any liberation photographs from Kerch. The others are all women.) Red Army soldiers saw the photograph of the Jewish man mourning his dead wife and children, along with the headline, "We will get revenge." They may have been motivated to fight the enemy even harder as they saw themselves in Berman's suffering. For his spectacular photography documenting the Soviet liberation of Kerch and other feats of bravery demonstrated by a frontline photographer, the Red Army awarded Khaldei the Order of the Red Star in December 1943 for his work with the Black Sea Fleet.[34]

Baltermants took a similar approach to documenting the unimaginable scene that, Selvinsky suggested, could not be represented with mere prose. He spent the

day at the killing site hearing people tell stories as he took pictures.[35] Baltermants had already become, in the words of Olga Sviblova, one of the most important art directors and critics in twenty-first-century Moscow, a "master of the horizontal." His expertise in the panorama and the importance of the horizon gave him a unique ability to visualize the magnitude of what he saw that day and capture it with his camera. He considered the scene in front of him so important that he took two rolls of precious 35 mm film.

One photograph shows a mound of dirt covered with snow and ice. Presumably it is the rise that witnesses—either as survivors of the mass murder or as later visitors to the site—described seeing when they approached the killing site. Baltermants photographed people with shovels, and in a different image two men with pickaxes, breaking up the ice to dig down into the frozen trench and reveal the magnitude of the crime.

After his overview image of the scene, Baltermants photographed the dead bodies of murdered Jewish women and children close up. His photographs of corpses are grotesque as the dead children stare blankly at the camera with eyes open, save for a swaddled baby, eyes closed, lying horizontally across the dead mother.

Whether these photographs are too gruesome to reproduce is a difficult question. On the one hand, Baltermants pictured the horror laid out in front of him with the goal of publishing these photographs for a broad viewing audience. He wanted people to know what the Germans had done at Kerch, and he understood that his camera had the power not only to tell that story but to convince wartime skeptics of what German occupation would mean.

On the other hand, Baltermants photographed the corpses of men, women, and children, and the dead have no power to give consent to the photographer about whether to take their picture. As we know with contemporary accounts about photographers being sued by living family members of terror victims, such as after the November 2015 Paris attack on the Bataclan concert hall, there has always been a tension between protecting the privacy of the dead and the need to tell a story in the public interest.[36]

These images of the dead also fascinate, in deeply troubling ways. When viewers gain a bizarre sense of fascination, even pleasure, from images of the dead, the photographs become voyeuristic, verging on what we might call "necropornography." No image is by definition pornographic, even the most sexually suggestive. Pornography is about a representation that becomes embedded in the relationship among the image maker, the subject of the image, and its consumer. Pornography is ultimately about the social relationships created in images' consumption.[37] It is about the photographic moment. What makes necropornography a bigger ethical challenge than pornography in general is the

fact that the subject cannot give their consent for participating in the moment created among the photographer, the viewer, and the subject: the subject is dead.[38]

We also have to pose the question about gender and sex. A male photographer is taking pictures of minimally clad women's bodies, most likely Jewish women's bodies. If that were not enough, there is the additional issue of religious injunctions. These injunctions—not only those of the dead subjects in the photographs, who may or may not have seen themselves as bound up in a Jewish religious world, but also of you, the viewer of these photographs—may render this killing field a site of "impurity." In traditional Judaism, this defilement (or impurity) would happen regardless of whether the dead were women or men. But the sparely clad female body (it is important that these are not naked women's bodies but are women in a state of disrobe) also violates a traditional Jewish injunction on a Jewish woman's modesty.

And yet, neither systems of ethics nor instincts toward revulsion are universal through time and space.[39] Today, the cultural response to death and the ethics of reproducing photographs of the dead are not the same as 1940s Soviet responses to death or to Soviet wartime ethics, which demanded that the reader see, even become witness to, each and every crime the Germans were committing. Perhaps more important, Soviet readers during World War II would have become completely inured to death in living color taking place in their metaphoric, and potentially real, backyards.

In fact, photographing the corpse became an important visual trope in Soviet wartime imagery. Nearly every issue of any wartime newspaper in the period from December 1941 through the spring of 1942 had photographs of dead bodies, including publications from Leningrad during the Germans' siege of the city. In those publications, the dead were not shot with bullets but were starved to death, resembling imagery from the wartime Nazi ghettos for Jews, Roma, and others.[40] The Soviet press encouraged readers to engage with their instinct for revulsion by forcing them to look at dead bodies, including Baltermants's photographs of women's and babies' corpses. But this book will not include photographs that only include dead bodies unless they were published in the Soviet press.

As he thought about what to photograph, Baltermants decided to tell a different visual story from Redkin and Khaldei. If they focused on living men, either as grieving husbands, scientific researchers, or military personnel securing the site, Baltermants was more interested in living women.

Since there were few female military personnel or researchers on site, that meant that a majority of the women, at least those still alive, were wandering the killing field, looking for their dead relatives, and overcome with emotion for their losses. In his multiple photographs of grieving women, they wear long skirts,

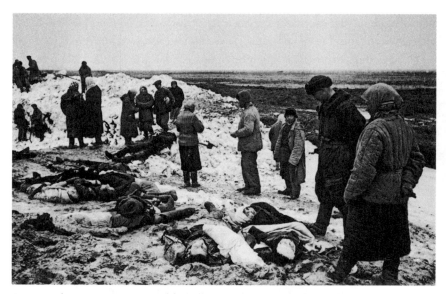

Dmitri Baltermants, *Overview of the Killing Field and Antitank Trench*, Kerch, 1942. *Hood Museum of Art, Dartmouth: Purchased through a gift from Harley and Stephen C. Osman, Class of 1956, Tuck 1957. Courtesy Dmitri Baltermants, Glaz Gallery*

heavy coats, and head coverings as they roam the landscape searching for—Who knows whom? Husbands? Sons?

Baltermants photographed a lone woman discovering a man with a large rope around him, presumably her husband, whose body is being hauled out of the trench, presumably for a proper burial. Were he alive, this picture might suggest impending horror as we imagine his soon-to-be hanging body. But he is already dead, with a bullet to the head or neck. Since he is at the bottom of an eight-foot-deep trench, we have to assume he is being lifted out by others not pictured. Baltermants points his camera at the victim's face, but it is not a close-up. He is on top of the trench shooting down at the couple's interaction taking place at the bottom. He is a short distance from them, as he is in most of his photographs. We cannot see her face, but she clutches a small book in her hands, another act of devotion. Perhaps she reads him traditional rites after a loved one has died, perhaps his favorite poem as a way of saying goodbye.

In addition to these women in a seeming state of calm resolve, Baltermants photographed other women displaying an anguish that builds to a climax of wild gesticulation as they are overcome with emotion. This woman, whom we learn from a March 1942 *Ogonek* publication, is named V. S. Tereshchenko, spent some time searching the killing site for her husband, an already unimaginable scene. At last, she finds him among a pile of bodies and is grief-stricken, and Baltermants

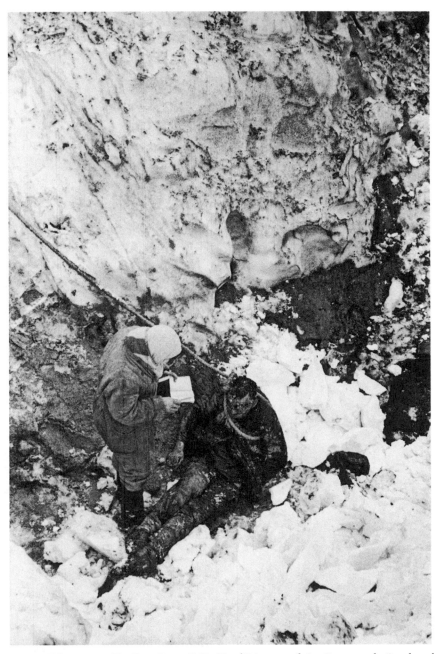

Dmitri Baltermants, *The Last Rites*, 1942. *Hood Museum of Art, Dartmouth: Purchased through a gift from Harley and Stephen C. Osman, Class of 1956, Tuck 1957*

is there to capture her expression. In this first photo, we see the moment of discovery. She glances down at the pile of corpses, hands outstretched. What adds particular drama to Baltermants's photograph is the fact that this is also not a close-up. He photographs Tereshchenko on the backdrop of a larger story taking place behind her—of many women weeping with her, quietly, in an act of empathy as they watch the subject gradually become overcome with grief.

In this second photo, she becomes overwhelmed with sadness as she leans over, almost bowing toward the corpses arrayed in front of her. All we see is the top of her head, a torn-up coat, checkered skirt, and her arms stretched out. In contrast to the women's empathetic tears, Baltermants has included bored soldiers, positioned at the center of the background, as they speak with one

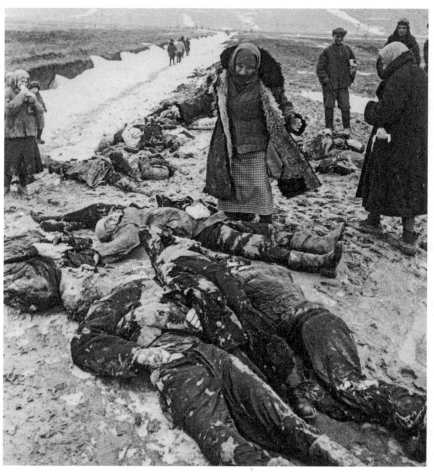

Dmitri Baltermants, *V.S. Tereshchenko Discovering Her Husband, I. Kogan,* 1942

another, seeming to ignore the horror surrounding them. Framing the left side of the image, we see the frozen trench, which at this point already represents the horror of the mass shooting of Jews and others. Other soldiers contemplate how they have spent their day.

That day, Baltermants also took photographs he knew he needed to take for purposes of documentation, perhaps even as evidence of the crime he unwittingly found himself photographing: close-ups of the dead, panoramas of the killing fields. But in none of the cases is he photographing forensically, as a means of using the camera scientifically to document a crime scene for use in future trials, as one might have expected. Yes, this is evidence of fascist, Hitlerite atrocities, but his photographs are not evidentiary. They document, in the words of Julia Kristeva, the "sacred power of horror."[41]

But those documentary photographs were not the most compelling visual stories Baltermants wanted to tell. Of the eighteen photographs from the killing site in his archive, which is not the entirety of his photographs he took that day, many of them focus on women in mourning. He photographed the compelling women several times as he tried to capture their changing emotions as manifested in their bodies in various states of gesticulation. His work at the trench echoed a

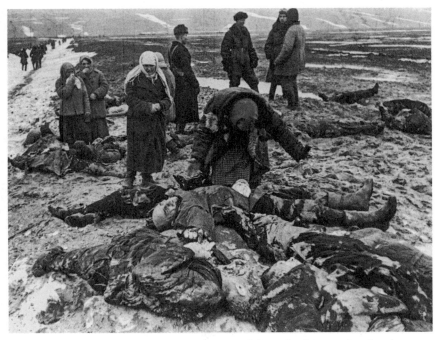

Dmitri Baltermants, *V.S. Tereshchenko Digs to Find the Body of Her Husband*, 1942

whole history of wartime images documenting the aftermath of battle. In particular, he organized his photographs of grieving women that resonate with the art historian Aby Warburg's concept of the "pathos formula [*Pathosformel*]."

Using the Aristotelian concept of pathos (meaning "emotion" or "sense") as a key tool in the art of persuasion, Warburg coined the term *pathos formula* in the 1920s to describe an ancient Greek mode of representing overwhelming emotion. It was his way of making meaning out of the "primeval vocabulary of passionate gesticulation" as pictured in images of the ancient maenads, female followers of Dionysus, whose name means "raving ones."[42] With their heads tossed back and arms raised, the maenads are emblems of frenzied, orgiastic abandon. Later artists were able to use this pathos formula without regard to its original intention.[43] It's hard to imagine a moment in modern times more ripe for emotional overload than the living encountering the aftermath of mass killing.

When it comes to war, the pathos formula has been a frequently used mode of depicting a postbattle scene, especially one involving the horror of a civilian massacre. There, the optics of death have the potential to look similar to the aftermath of battle, except for one problem: military battle does not usually include mothers with bullets to the back of their heads, with their nursing babies smothered to death, which is what took place at the antitank trench.[44] One can think of the pathos formula as the creative aesthetic tension between orgiastic abandon and a viewer in control of the violence pictured.

At the center of the pathos formula is an emotional woman. Even a cursory look at Baltermants's photographs suggests that he understood the power of the pathos formula and its ability to connect with viewers through emotional appeal. If dead babies generated anger to get revenge and panoramas of the killing fields served as evidence of war crimes, then living women in various states of anguish created an emotional connection with the viewer. Perhaps Baltermants had in mind the Pietà, the classic Christian image of a grieving woman and her son lying dead—or put more accurately, Mary grieving for Jesus, who had been executed by state power.

No matter what visual formula Baltermants had in mind when he took his two rolls of photographs at Kerch, his work fostered relationships not just between the photograph and its viewer, but also among the subject, the viewer, and the photographer.[45] Although he has photographs of murdered Jewish women and children as well, most of Baltermants's photographs from the trench show living non-Jewish women mourning dead adult men. Almost by definition, we know that any survivors cannot have been Jewish, because they would have been dead, save for the Jewish doctors whom the Nazis spared and the occasional survivor of the mass shooting, like Weingarten the fisherman.

Baltermants left Kerch a changed person, one who used his photographic skills to tell a horror story. By then an experienced military correspondent working on the front, Baltermants had learned how to set up a mobile darkroom in which he could develop his film. He then sent the developed film, along with his notes about the photo shoot, by plane back to Moscow.[46]

After that, it was anyone's guess what would happen with his images. Would they make it to Moscow given the number of Soviet planes being shot out of the sky during war? If they did, would they arrive intact? Even then, who was to say whether or not the *Izvestiia* editors would like the pictures, although Baltermants was confident that he had taken powerful photographs of what he thought was the most important news story of the day? After all, his own newspaper published Molotov's "Note on German Atrocities on Occupied Soviet Territory" on January 7. Molotov mentioned the Kerch mass murder of seven thousand peaceful Soviet citizens.[47] Baltermants likely knew this and hoped that his photographs could create emotional resonance and serve as evidence of the war crimes Molotov described.

But they never appeared in *Izvestiia*. Why remains a mystery. According to a colleague of Baltermants's, his editors told him that they were worried about "offending the Germans."[48] But although *Izvestiia*'s editors may have been worried about German sensibilities, few other press outlets were. *Ogonek* followed up its February publication of Redkin's gruesome photographs from Kerch with a March 1942 two-page photo essay, "Hitlerite Atrocities in Kerch," which included eight images taken by three photographers—Baltermants, Israel Ozerskii, and Israel Antselovitch. The five photojournalists creating these first liberation photographs of Nazi atrocities at the antitank ditch—Redkin, Khaldei, Antselovitch, Ozerskii, and Baltermants—were Jewish. It is hard to imagine the kind of impact this must have had on them, as opposed to photographers who did not identify or would not have been identified as Jewish. Unlike their non-Jewish Soviet photographic colleagues, the Jewish photographers now knew the fate awaiting their own families, who might be living under German occupation, as was the case for Khaldei.

Alongside the eight-image photo essay, the *Ogonek* editors ran Antselovitch's short essay, "Vile Murderers," in which he described the state-sponsored mass murders that defined the German occupation of the city: "The head of the Gestapo in Kerch, the executioner Feldman, developed a precise schedule, based on orders from Berlin, of the extermination of Kerch's residents. According to this plan, the first to be executed were Soviet citizens of one nationality, after that another, then a third. In all cases, whole families were to be executed together."[49] As a piece of journalism, "Vile Murderers" may be vague on its facts, but that was not the point: it was heavy on emotion, on the pathos reflected in the images.

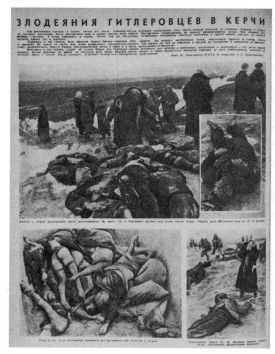
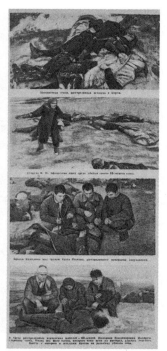

"Hitlerite Atrocities in Kerch," *Ogonek*, March 2, 1942

Antselovitch obliquely reminded readers that one ethnic group (the name did not need to be mentioned) had been singled out for immediate extermination.

The paragraph introducing the March 1942 photo essay reads as follows: "These photographs were taken at a moment after the German occupiers drove [these people] out to this place. 7,500 residents from the very elderly to breast-feeding babies were shot from just a single city. They were killed in cold blood in a pre-meditated fashion. They were killed indiscriminately—Russians and Tatars, Ukrainians and Jews. The Hitlerites have indiscriminately murdered the Soviet population in many other cities, villages, and the countryside."[50]

Unlike other written reports, which emphasize the special persecution of Jews, or even like Antselovitch's article about "one nationality," this passage emphasizes that the German occupiers murdered civilians in a horrible wartime atrocity regardless of ethnicity or nationality. Many readers, Jews among them, would have understood which nationality the writer was speaking about; others might not have picked up on the reference. But in wartime, making the photograph too much about specifically Jewish suffering as opposed to national Soviet suffering, which included Jews, ran the risk of having the general readership not see themselves in the photograph. It also risked supporting a Nazi racial vision of the world

with repeated references to Jews in the captions and potentially undermined their presumably more enlightened Soviet relationship to ethnicity.[51]

But a photo essay is not primarily about words. It is published because a story needs to be told visually, so an editor's selection of the photographs is of central importance. That also means that the power of the story about Nazi atrocities at Kerch was no longer in the hands of the photographers but was with the photo editor at *Ogonek* back in Moscow. He assembled eight photographs by three different frontline photographers to create a powerful visual story of atrocities on a scale unlike anything the world had yet seen. Such a process took time, two months in fact.

The most visually dominant photograph in the *Ogonek* photo essay is one of Baltermants's—"Residents of Kerch Search for Their Relatives. In the photo: V. S. Tereshchenko digs under bodies for her husband. On the right: the body of 67-year-old I. Kh. Kogan." Only with this caption do we know the name of the woman Baltermants found so compelling that he took her photograph several times—a Ukrainian named Tereshchenko. The photo editor overlaid a second photograph of sixty-seven-year-old I. Kogan onto Tereshchenko's. This allowed the *Ogonek* reader to assume that Tereshchenko had found her dead Jewish husband ("Kogan" means "Cohen" in Russian) among a pile of male corpses. The editor chose a Baltermants photograph of Tereshchenko that places her at the center of both the photograph and the page layout, thereby minimizing the presence of dispassionate soldiers in the background and the endless landscape of women's sadness that defined Baltermants's day at the ditch, as we know from his photo archive.

Tereshchenko is not the only woman pictured in the *Ogonek* atrocity photo essay. There are photographs of three women, each one photographed by Baltermants. In all cases, the woman has arms outstretched or raised. The editor, possibly following Baltermants's aesthetic instincts, understood the power of the pathos formula and chose gendered images of female grief that had been channeled into an image that a reader could approach. Tereshchenko's image dominates the left-hand page. The right page features O. I. Afanasyeva, "searching among the dead for her 18-year-old son." If Tereshchenko searches for her husband, Afanasyeva's maternal instincts drive her forward into the frame as she desperately wants, but also does not want, to find her murdered teenage son.

The third image, captioned with the brutally clear description, "P. I. Ivanova, a Kerch resident, found her husband tortured to death by fascist executioners," brings together the collective tragedy of the first with the individual grief of the second. Here, Baltermants photographed Ivanova, whose head is thrust backward and her body contorted. Her arms are close to her face catching her falling tears, rather than being outstretched, a gesture of intimate sadness. Ivanova is

alone with her grief and positioned in the foreground as she interacts with the lone corpse in front of her.

Even though we know that there are other women in the background, Baltermants's composition and the editor's cropping have made this photograph about one woman's discovery of her dead husband and her devastating personal loss. We relate to her, empathize with her. We do not get overwhelmed in the cacophony of death of the Tereshchenko photograph or coldly distanced in the almost desert-like, empty surroundings of Afanasyeva.[52]

The editor has placed these three images of grieving women in a larger context of civilian atrocities. Two photographs on the right page, which Antselovitch and Ozerskii took, depict entire families mourning dead men. In one, three brothers mourn their dead sibling Rakhman, a Tatar name, and in the lower one, a woman and her two sons mourn their husband/father. The older son, Ivan, had survived the mass execution that resulted in his sixty-eight-year-old father's death.

One of the final two photographs of the dead depicts an excavated pit in which we see a pile of several dozen newly murdered bodies in various states of undress. The other one, by Baltermants, depicts a Jewish mother and her three children, the photograph that visualized the stories that had circulated in the city about just such a horrible scene. The caption to this photograph is telling: "Unidentified family executed at Kerch by the Germans." Of course, the dead cannot tell their stories of how they ended up there. They also could not tell Baltermants who they were. And he did not find someone grieving for *this* family, because this family was Jewish and all of its extended family members were also dead in the pit or had fled from the city in advance of the German occupation. Nonetheless, he and the photo editor found the frightening image of an entire family shot dead by the "bestial Germans" too compelling not to capture and then publish.

The March 1942 issue of *Ogonek* was the only time Baltermants's Kerch photographs appeared in the wartime central Soviet press. But his and others' photographs of the Bagerovo trench circulated in other ways during the war. And thanks to Khaldei and his camera, we know that they appeared around the city of Kerch itself. Soviet administrators of Kerch affixed posters produced by TASS, known as *Okna TASS* (*TASS Windows*), in several places around the city, giving visually graphic evidence of what the Nazis had done, in case it was not obvious to the city's residents, who had lived through Nazi occupation.

Like the *Ogonek* photo editor, whose vision shaped how the images would be presented to its readership, the editor for *TASS Windows* (or perhaps the construction worker installing the newspaper on the wall) had ultimate authority in shaping how the photographs would be presented. Popup agitprop street art had appeared during the revolution and civil war period due to a lack of paper, type, ink, and other printing material and because of the general illiteracy of the Soviet

Yevgeny Khaldei, *Kerch Residents Look at Wall Newspaper*, 1942, US Holocaust Memorial Museum. *Courtesy of Anna Khaldei and the Yevgeny Khaldei Archive*

population before the massive literacy campaigns of the early Soviet period. With the outbreak of war against Germany and the return to scarcity, this news/art form returned to the streets of the Soviet Union.[53]

The text on this wall newspaper is chilling. At the very top, the headline reads: "Get revenge. Mercilessly take vengeance against the German murderers." At the top of each column, it reads, "Death to the German Occupiers." It would not take long for a passerby to understand why the newspaper would be calling for such violent revenge. This particular poster displayed a montage of twenty images, most of which were by Baltermants, taken at the killing fields on the outskirts of town.

Below those two headlines the editor included two more sentences: "7000 Kerch residents murdered by the German barbarians. They didn't spare old people, women, or children." After all of that fiery rhetoric bound up in those headlines, each photograph had its own caption, many of which emphasized the murder of mothers and children. In addition, there were grieving women: "Above the corpse of her husband" is the caption to a photograph of a woman bending down toward a corpse as she gestures in anguish. "Executed baby," with no name attached. "Executed worker, D. Ivanov" (or possibly Zhvanov—the text is hard to read). As we move closer to the visual center, the impact on the viewer increases. Baltermants's photograph of the executed mother and her children is included, as

are several landscapes of the trench sporadically strewn with bodies. At the center of this wall-mounted photo essay was Afanasyeva, arms outstretched in a show of unrestrained maternal grief.

There is never anything random about the placement of photographs, either on the page or on a wall. This wall newspaper straddles the boundaries between a publication and an exhibition, and the person who decided on its final appearance was both editor of a newspaper and curator of a visual display. The photographs are carefully arranged in two neat, horizontal rows with the photograph of Afanasyeva mounted vertically in the center. Although not perfectly symmetrical, the left and right flanks of the display mirror each other. Perhaps to resonate with a Russian viewer, the editor who created it may have had in mind a traditional Russian iconostasis, a large screen in a Russian Orthodox church that separates the profane from the holy and is decorated with images of saints framing Mary and Jesus. Afanasyeva hangs in a place where the iconic Jesus would hang. By arranging the photographs to echo a holy experience, the producers may have unwittingly elevated those murdered to the status of martyrs, saints-in-miniature, as they present these mostly Jewish dead in a Russian Orthodox visual context. Moreover, Baltermants may have been gesturing to the Piéta by picturing a woman in mourning over her dead husband or son.

Kerch photographs by Baltermants and others were sent around the world on the wires—to the Office of War Information, the US government's wartime propaganda division, and to news wire services. This was a two-way street, as images taken by Soviet press outlets traveled across the Atlantic, and American press outlets sent photographs to the Soviet media. It is likely that these Soviet photographers did not know that their January 1942 photographs from Kerch, the first widely circulating liberation photographs of Nazi atrocities of Jews and others, made their way not just to the United States and its state archives but into print around the world.

On May 4, 1942, *Life* magazine published one such photograph, an Antselovitch photograph from Kerch: "Russian parents lament their dead son at scene of a German execution of guerrillas." The image of the mourning Russian parents stood in for the mass murder of the city's Jews that lay buried in the earth just beyond the frame of the picture. The *Life* editors, like Baltermants, recognized that the wartime story needing to be told was about Afanasyeva's overwhelming grief and her husband's need to hold her up, as her body again echoes a crucifixion scene. This was the second time that the earliest wartime liberation photographs were presented using Christian aesthetic tropes.

On June 20, 1942, the British illustrated magazine *Picture Post* published several Soviet photographs of areas that had been liberated from German occupation and presented them in a large photoessay.[54] The headline on the magazine's

cover reads "German Crimes in Russia," and the subtitle hinted at something sinister: "What the Advancing Russians Found." The photo essay included five images from three different sites the Soviet army liberated during the late 1941 counteroffensive. The opening image was of a massacre at the cathedral in Vereya (which the *Picture Post* mislabeled "Vereyma") and the final two photographs showed eight Communist Youth members hanged in the town square of Volokolamsk, both in the Moscow region.

The visual drama of mass violence reached a crescendo in the middle of the essay. A *Picture Post* reader turned the first page to be confronted by Afanasyeva, who had dominated both the *Ogonek* photo essay and the *TASS Window* wall newspaper. The article accompanying the photographs does not mention these two photographs, so the *Picture Post* editors wrote a separate caption for Afanasyeva: "The Germans came to the village, they looted it, and took some of the men away. The Germans retreated when the Red Army attacked, but they left the bodies of the village men behind them. Now the village women come out to search for husbands and sons. One of them, S. [*sic*] Afanasyeva, cries for a youth who was only eighteen years old. She searches up and down the rows of dead—if only she could find his body."[55]

The fact that the magazine referred to the place from which the photographs came as "Russia," rather than the Soviet Union, that it labeled Kerch a village, not a city, and that it misspelled the subject's name shows how the magazine was less interested in the historical details about the photograph. This was likely not done out of a lack of fealty to the truth on the part of the editors, but rather it better fit the particular national needs at a time when the fact of Britain having a communist ally, which was also formerly in a nonaggression pact with Nazi Germany, was an uncomfortable truth for the reading public. The *Picture Post* recognized that the photographs needed to tell a British reading audience a different story than was told to a Soviet audience, given the country's radically different relationship to the war with Nazi Germany. The nation's need was more important than the history actually pictured in the photographs.

From an aesthetic point of view, the *Picture Post* editors selected the most striking image of a grieving woman for its photo essay. The editors were in good company. Whereas *Ogonek* at least provided the location of the city and historical background of what had taken place, the *Picture Post* was interested in an iconic image reflecting how England's Nazi enemy conducted war. With the *Picture Post* publication in June 1942, the image of Afanasyeva, whose first name now began with "S," was stripped of its anchors in time and place, which identify V. S. Tereshchenko and P. Ivanova as early witnesses to the Nazi mass murder at the killing site near Kerch.

Perhaps the most tragic part of the story is that aside from the most astute readers of the daily news, the British reading public flipping through the *Picture Post* in June 1942 was likely unaware that Kerch—and likely the mourning families pictured in these early Nazi atrocity liberation photographs—were once again under German occupation when the city fell to the German army for a second time on the morning of May 16, 1942.

3 THE AFTERMATH OF GRIEF

Although *Izvestiia* did not publish his Kerch photographs from January 1942, Dmitri Baltermants was one of the newspaper's rising photographic stars. His ability to highlight the human drama of war defined his published wartime work. On February 11, 1942, the paper's editors published one of his photographs on page one, from the village of Mochalki. Shot from behind a group of Red Army soldiers, the photographer documented them in a moment of triumph as they liberate another place that had been under German occupation.[1]

One week later, again on page one, a dramatic shot by Baltermants appeared showing a Red Army soldier on the western front, photographed from below, standing casually with a weapon in his hand. He is looking off into the distance as the viewer's eye is drawn toward the right of the photograph, given the diagonal of the black train cars, which had been intended to evacuate German soldiers. Not all of them were successfully evacuated. At the center of the image lie two dead German soldiers, killed because they did not leave with the rest of the German army before the Red Army arrived. The Soviet soldier stands sentinel at the right edge in front of the train. The photograph leads us to believe that the soldier is the reason for their failed attempt at evacuation.[2] The next day, another Baltermants photograph appeared on page one, this one a panorama, showing the liberation of another village that had been under German control. And there were many more, each more dramatic than the next, as Baltermants captured the human relief of liberation.

A reader might have noticed the names of the villages from which these photographs came, places like Yukhnov and Mochalki. These were towns to the southwest of Moscow but still deep in the heart of Russia. The newspaper acknowledged a fact a reader versed in the geography of the country would know: that the Germans had already taken much Soviet territory and that these liberations of towns in central Russia in the winter of 1942 were small victories in the face of an overwhelming military disaster for the Soviet Union.

But in times of war, newspapers have to put a positive spin on any situation, no matter how dire. In March, the triptych of liberated Yukhnov showed not only the joy and heroism expressed in the faces of those photographed but also a downed German airplane, an important trophy for a struggling Red Army.[3] On March 11, *Izvestiia* published a Baltermants picture of a liberated village on the "western front," this time shot from above as he turns the mundane work of soldiers rebuilding a ruined bridge into an exciting image heralding the war effort. Baltermants was on a roll with his editors, as he appeared on the cover page of *Izvestiia* almost every week.

On March 20, *Izvestiia* published one of Baltermants's most dramatic war photographs, of a cavalry troop galloping through the snow. With the stark white, winter sky blending into the white of the snow in the background, the black of the horses creates a visually powerful rupture in the image. Baltermants gave this wintertime landscape depth by including the leafless bush in the foreground. In this case, unlike much of his earlier wartime work in which the faces of soldiers are obscured, those of the cavalrymen are visible, although small, suggesting that this cavalry unit under the leadership of Kakurin is a collective of individuals in a heroic battle against the enemy. The panorama also demonstrated Baltermants's prewar training in mastering the horizontal.[4]

Dmitri Baltermants, "Western Front. Cavalry Unit under the command of Major A. Kakurin going off to perform a combat mission," *Izvestiia*, March 20, 1942

Baltermants's photographs for *Izvestiia* also appeared in a beautiful art book, published in November 1941, about the successful defense of Moscow. This was the first time his photographs appeared in a book, rather than in a periodical, suggesting that he was on his way to becoming a leading Soviet war photographer. His image of the cavalry unit, here called *Cavalry Guardsmen Pursue the Enemy*, would end up becoming one of his signature photographs well after the war.[5]

Despite the stories of liberation appearing on the pages of the central Soviet press, by May 1942, the war was looking particularly grim for the Soviet Union. The German army retook many of the regions in southern Russia that had been liberated in the first Soviet counteroffensive, the previous December. Any news that conveyed a sense of Soviet victory was desperately needed. Baltermants's valiant photograph *The Inglorious End of Fascist Tanks* documented a Soviet success against the recalcitrant fascists. It appeared on May 16, the day that Kerch fell for a second time. Shortly thereafter new rounds of mass executions took place there, including those of any remaining Jews, including those in mixed marriages, as well as Krymchaks. While the latter point did not make news that day (why would the loss of a previously reconquered city be broadcast in the Soviet papers?), the destruction of fascist tanks did. For Baltermants, who had returned to Moscow for a brief respite from a grueling first ten months serving as a frontline correspondent, May 16 was a good day.

Three days later, Baltermants's photograph traveled farther than he could have imagined, as it appeared in a London newspaper. The Moscow correspondent for London's *News Chronicle*, Paul Winterton, saw the photograph in *Izvestiia* and recognized its wartime propaganda potential. He wanted it for his British readers as a testament to the weakness of a mutual enemy, whom the British had just started bombing from the air. He also hoped to celebrate a new agreement between the Soviet Union and Great Britain that both countries would fight the fascist enemy until an unconditional surrender. Unlike in 1938 with the Munich agreement between Great Britain, France, and Germany, which gave permission to Germany for the invasion and dismemberment of Czechoslovakia; and then in 1939, when the Soviet Union signed a nonaggression pact with Germany, leaving the Wehrmacht and the Red Army to have free rein over Europe, this time there would be no separate peace among the Allies.

It was not unusual for Winterton to send photographs back to his editors in London over the wires. He was not alone in circulating the best Soviet photographs to British publications. Most foreign correspondents living in wartime Moscow showed some kind of sympathy for the Soviet experiment, even if their editors back in the home office maintained a deeper skepticism to images and news stories coming out of Moscow. The Moscow-based Western correspondents were

in a unique position to see the war from the Soviet perspective as well as their own national one. That was why they took that particular assignment. Winterton wanted to use Baltermants's photograph of destroyed German tanks to convey to his British readers this bit of good news.[6]

Not long after the photograph's publication in the *News Chronicle*, the editors knew something was not quite right when they began receiving letters from British military experts in response to the photograph. They pointed out that, while it was important to celebrate British–Soviet cooperation, this photograph did not accomplish that goal. In fact, they said, the destroyed tanks in Baltermants's photograph were not German at all. Instead, they were British Matildas that had been sent to the Soviet Union as a sign of mutual military support. Rather than presenting a British-Soviet wartime success story, it instead reminded readers of another military disaster meted out against British tanks on the distant eastern front. To say otherwise was crass propaganda. It could also undermine the very trust that the reading public in England had in its journalists and newspapers, especially those working in Moscow.

Neither the editors, nor the censors back in Moscow who first dealt with the photograph when it came in, nor those at the *News Chronicle* in London, who picked it up off the wires, recognized the tanks as Matildas. The *News Chronicle* editors demanded that something be done. Despite the many layers of vetting that had overseen the publication of the image, Baltermants, the original imagemaker himself, was blamed. He was immediately fired from *Izvestiia*, removed from his military unit, and demoted from his rank of lieutenant. The political division of his unit sent him to a penal battalion, the dreaded *shtrafbat*, which ended up fighting a few months later on the Stalingrad front. Penal battalions basically served as cannon fodder, because they were given the most dangerous assignments. Few who served in one returned alive.[7]

In the summer of 1942, when Baltermants was sent to the penal battalion, the Soviet Union was despondent and could not tolerate any mistakes. The German army was moving east through territory that had already been liberated once, like Rostov-on-Don and, of course, Kerch. The Wehrmacht continued its march through the Donbass region, part of the northern Caucasus, and headed up the Don River toward Stalingrad, which sat on the west bank of the Volga River, stretching a mile wide as it meandered through the city.

Stalin could not countenance his namesake city falling to the fascists. On July 28, 1942, after the (second) fall of Rostov-on-Don, this time with little resistance, he issued Order 227, commonly known as "Not Another Step Back (*Ni shagu nazad*)." Order 227 was draconian to say the least:

a) Unconditionally eliminate defeatist sentiments among the troops;

b) Unconditionally remove from their posts and send to the High Command for court martial those army commanders who have allowed unauthorized troop withdrawals from occupied positions, without an order from the Front command;

c) Form within each Front from one to three penal battalions (800 persons) where commanders and high commanders and appropriate commissars of all service arms who have been guilty of a breach of discipline due to cowardice or bewilderment will be sent, and put them on more difficult sectors of the front to give them an opportunity to redeem by blood their crimes against the Motherland.[8]

The list of offenses worthy of court martial piled up. Commanders were often executed; rank-and-file troops demonstrating cowardice, or the occasional military photographer who made an attribution error, were sent to penal battalions.

As a member of one of the penal battalions fighting at Stalingrad, Baltermants took magnificent photographs of Soviet tanks rolling toward Stalingrad on their way to the final battle in November 1942. He also took pictures of German prisoners of war after their capture. He would have remained in the penal battalion throughout the war, but "luckily," he was severely wounded in January 1943 and sent to a military hospital. Doctors had to amputate part of his foot, but at least he survived.[9] He then returned to Moscow and spent a long time

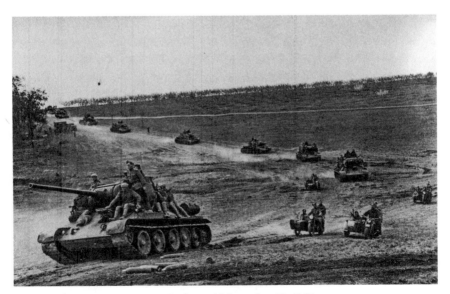

Dmitri Baltermants, *Moving on Stalingrad*, November 19, 1942

in recovery. On February 2, 1943, the Germans capitulated on the banks of the Volga River as the tide of the war turned.[10] It seems that Order 227 may have been more effective than Stalin imagined.

With the Red Army's victory over the Wehrmacht at Stalingrad, the eastern front moved almost continuously to the west. By November 1943, the Red Army had liberated Kiev, more than eight hundred miles to the west of Stalingrad. As for Kerch, the second German occupation lasted for nearly two years. The Crimean port city was liberated, for a second and final time, on April 11, 1944, and although Baltermants was not there to photograph the second liberation, Yevgeny Khaldei was.[11] More importantly, the Sovinformburo circulated newsreel footage of Kerch's second liberation with the now-famous reporter Yuri Levitan, whose radio voice had become recognizable to Soviet listening audiences during the war, narrating the heroic scenes.[12]

By this time, Baltermants had recovered from his injuries, was reinstated in the military, and was hired again as a frontline photographer, but this time not for the central press. One presumes that although Baltermants took good pictures with powerful human stories, he was still too big a political risk, after the tank photograph fiasco a year and a half earlier, for *Pravda*, *Izvestiia*, or *Red Star* to take him on. But he was released from the hospital to a radically changed world with Soviet victory on the horizon. He was hired by *The Enemy's Destruction* (*Na razgrom vraga*), a military newspaper attached to the Bryansk Front. The newspaper and its readers benefited immensely from his photographic skills.

A front newspaper (*frontovaia gazeta*) was no insignificant venture, publishing mere propaganda pamphlets informing the troops of what the state wanted them to hear. Rather, when *Na razgrom vraga* was founded in August 1941, just days after the Red Army organized the troop formation known as the Bryansk Front, it employed thirty people on its editorial staff.[13] Among those were important writers, such as the poet Iosif Utkin. Other renowned photographers, among them Arkady Shaikhet, also worked for front newspapers, not as prestigious a position as working for the central press to be sure, but an important role for the war effort nonetheless.[14] In his role as a photographer for that newspaper, Baltermants photographed troops fighting with the Bryansk Front and took some of his most arresting photographs, including one of Soviet troops crossing the Oder River.

In summer 1944, the Soviet Union crossed its old frontier into Poland, and victory seemed imminent. From that position of power, the Soviet higher command began handing out medals and awards for feats of valor that had taken place since the beginning of fighting back in 1941. Baltermants's career as a war

Dmitri Baltermants, *Crossing the Oder*, 1945

photographer was now seen in a new light, and his time in the penal battalion was more or less forgotten.

In September 1944, for his work as a photocorrespondent for *Na razgrom vraga* with the rank of lieutenant, he earned the Order of the Red Star, a modest military award, but nevertheless one that officially marked him as a rehabilitated military photographer. His nomination form—which lists his nationality as Jewish, his employer as *Na razgrom vraga*, and his battle experience starting on June 22, 1941, the day he enlisted—extols the virtues of this brave photographer, who documented the heat of battle despite being "severely wounded" in January 1943.[15] There is no mention of the penal battalion assignment resulting from the mistaken description of his tank photo. In October, he was awarded the Defense of Moscow medal for participating in the 1941 battle that saved the capital from falling to German forces.[16]

On May 16, 1945, just a week after victory over Germany, Baltermants was given another award, the Order of the Patriotic War, Second Class, for "taking initiative" and "being conscientious" as a frontline photographer. In particular, he was given this award for his photographic work at the Battle for Breslau, which included the "episodic battles, heroes of street battles," and perhaps most importantly, "because of his many valuable shots for the exhibition produced in honor of the Day of the Press."[17] At no time was he singled out for his Kerch atrocity photographs. By this point in the war, those photos were best left tucked away in his archive.

After the Soviet victory at Stalingrad in February 1943, the frequency of Nazi atrocity photographs in the Soviet press diminished. However, photographers working for the Extraordinary Commissions (EC) continued to take photographs of Nazi atrocities. Established in December 1942, a year after the first liberation of Kerch, the commissions were established by the Soviet Union to systematically document German crimes. These forensic research teams were made up of scientists, scholars, forensic medicine specialists, and photographers taking pictures of crime scenes. Many EC files have photographs that were used for that purpose upon the liberation of a village, town, or city that had been under German occupation. In town after town, the Red Army found burial pits—natural ravines, wells, and/or antitank trenches—on the outskirts of town where Jews, Sinti/Roma, partisans, and others were shot en masse, and buried; then, as the Red Army approached, the German occupation authorities exhumed and burned the bodies and buried the ashes.

The EC photographers first documented the overview of the crime scene. Then they would move in for closer detail, and the photographs became more forensic. The final images often showed a skull with a bullet hole or a hand emerging from a crematorium.[18] The atrocity photographs published in the Soviet press tended to fall into two categories—images used in Soviet war crimes trials, which began in 1943, and photographs taken at the liberation of death camps, especially Majdanek in summer 1944.[19] By May 9, 1945, the day "freedom-loving peoples," as Soviet jurists referred to the Allies, defeated "Hitlerite Germany," there was little public discussion in the Soviet press of Nazi atrocities, since the former "Hitlerite executioners" and "bestial Germans" became "occupied German people."

Stalin's Soviet Union found itself with a new global power as much of the world recognized that it was the Red Army that had liberated all of eastern Europe and first reached Berlin, the heart of the fascist beast. Communism in Europe had a renewed visibility as the Red Army now occupied half of the continent. In western Europe, Communist Party members had run underground movements in occupied countries and were generally not tainted by German collaboration. They scored electoral successes in many democratic countries, which made Western democracies associated with the anticommunist United States nervous. The Soviet Union had also suffered the gravest losses by far of any country. Nearly half of all World War II victims (approximately twenty-seven million out of about sixty million) had been Soviet. With Red Army troops in control of much of eastern and central Europe, including in the capitals of Berlin and Vienna, the Soviet Union now participated in the construction of a global postwar order.

Perhaps the most significant outcome of the Soviet, American, British, and French four-power negotiations focused on the failures of post–World War I

international political structures, including the League of Nations, and the need to establish a better form of global governance. From that discussion was born the United Nations (UN). Although all nations across the world were entitled to membership in the General Assembly, the body within the UN that had the force of authority to speak for the new global order was the fifteen-member Security Council. Although ten seats rotated among members of the General Assembly, there were five permanent members, the five victors of the war, each of whom had a veto over any decision the UN would make: the United States, the United Kingdom, France, the Soviet Union, and, from the Pacific theater, the nationalist Republic of China. At the time of the UN's establishment, the Soviet Union was the only communist country with the power to remake the global order.

In addition to crafting a civilian structure that aimed to foster global cooperation, there was still the issue of dealing with the crimes that had taken place during the war. To prosecute those crimes defined by international law that was already in place from the prewar era, the legal teams at the well-known postwar International Military Tribunal (IMT), commonly known as the Nuremberg Trials, needed evidence. What better evidence could there be than photographs?

The Soviet legal team at Nuremberg presented hundreds of still photographs as well as hours of film footage documenting Nazi violations of international law. Aron Trainin, the Soviet legal theorist whom one scholar refers to as the Soviet Raphael Lemkin for his legal theories relating to the genocide on Soviet soil, helped prepare the Soviet team at Nuremberg.[20] In his book, *Hitlerite Responsibility under Criminal Law*, he outlined the crimes against peaceful populations in great detail, including the mass murder of Soviet Jews:

> The Jewish people during the thousands of years of its existence has more than once been subjected to persecution; but the Hitlerite villainies against the Jews far exceed in their inhumanity everything that is known to history. The Hitlerite atrocities against the Jews . . . represent a blood bath organized by means of the machinery of the State, in broad daylight, under the eyes of a shocked humanity. Great will be the responsibility for these atrocities.[21]

At the end of his book, Trainin listed the body of evidence to be presented at the trial, which included many EC reports, including the one produced about Kerch.[22] The Kerch report included the following statement:

> The place of mass execution that the Nazis chose was an anti-tank trench near the village of Bagerovo, where for a full three days, motor vehicles brought whole families of people doomed to die. Upon the arrival of the

Red Army in Kerch in January 1942, during the survey of the Bagerovo ditch, it was found to be over a kilometer in length, 4 meters wide, and two meters deep. It was full of corpses of women, children, the elderly, and teenagers. Near the trench were frozen puddles of blood. Children's hats, toys, ribbons, torn buttons, gloves, bottles with nipples, boots, galoshes along with stumps of hands and feet and other body parts were also lying around. All of this was splashed with blood and brain.[23]

The report included Baltermants's photographs as well as film footage shot by Tbilisi Film Studio in January and February 1942.[24] In the end, of the twenty-four defendents on trial at the central IMT trial, twelve were found guilty and sentenced to death, seven received prison sentences, three were acquitted, and two were not charged. None of those on trial, however, were accused of the crimes documented in Baltermants's Kerch photographs. Nonetheless, the Soviet prosecutors used these forensic photographs to make the horror real in a way that mere archival documents could not.

In addition to the role that Soviet photographs of Nazi atrocities played as evidence in international justice, they also played a central role in the Soviet Union's own trials.[25] The Allied powers agreed in the Moscow Convention of November 1943 that individual countries could prosecute war criminals for crimes committed on their own national soil for violations of national law.[26] Based on this concept, the Soviet Union began conducting its own war crimes trials in December 1943. The first trial for international war crimes during World War II took place in the Soviet Union in Kharkov. Three Germans were charged with murder of Soviet citizens and one Soviet citizen was charged with treason, in what some have called the first Nazi war crimes trial. All four were found guilty and hanged the next day.[27]

From that point until the German capitulation in 1945, when armies representing "freedom-loving people" liberated a country, that newly freed country would conduct its own trials. Poland began conducting trials based on violations of its national law in November 1944 for crimes committed at Majdanek. Poland's own postwar trials of war criminals reached a fevered pitch in the trials of Amon Göth and Rudolf Höss in 1946 and 1947, respectively.[28]

France, under the leadership of Charles de Gaulle, conducted its trials almost immediately after the country was liberated by the British and the Americans in the fall of 1944. The most famous of them was the trial of Pierre Laval, one of the heads of the Vichy government, who was found guilty of plotting against state security and collaborating with the enemy.[29] The Soviet Union continued conducting war crimes trials of Germans as well as local collaborators in 1946 and 1947. The primary form of evidence the prosecution used was eyewitness

testimony, both from live witnesses for the prosecution and from transcribed interviews compiled in EC reports.[30] In addition to testimony, prosecutors introduced photographs—taken both by those committing the crimes and those mostly Soviet photographers who documented the aftermath—as evidence.

In addition to his frequent publications in *Na razgrom vraga* and having his Kerch images appear at Nuremberg, Baltermants's photographs reappeared in *Ogonek*. One April 1945 photograph, a play on the question of whose soldiers are being commemorated, demonstrates how Baltermants returned to classic socialist realism as victory was in the air. The living soldier, the one in the foreground, is I. I. Gavrish, a proud Soviet soldier, who has just liberated another city on his way to Berlin. Behind him stands a silent, stone German memorial to an unknown soldier. In this single image, Baltermants contrasted the role of the individual Soviet liberator, who has defeated the faceless stone mass of the fascist enemy.

The poet and Stalin Prize winner Aleksei Surkov, whose poetry appeared frequently in *Ogonek*'s pages, took over as editor in chief in 1945 and served in that role until 1953. After seeing the powerful work Baltermants produced near the end of the war, not to mention the many military awards he received for valor, Surkov hired him as a staff photographer in 1945. Although his photography had appeared in the magazine since the early years of the war, including the March 1942 photo essay from Kerch, because of *Ogonek*'s stature as the leading illustrated magazine in the country, Baltermants's staff position at *Ogonek* meant that he finally had privileged access to Soviet political leaders in the way that many of his mentors had in the 1930s.

In this position, Baltermants took pictures of Stalin and the rest of the Soviet leadership at news-breaking moments throughout the late 1940s. He was sent to photograph the funeral of the Soviet Union's "wise old man," head of state Mikhail Kalinin, in 1946.[31] On Red Square, Baltermants documented this grand international celebration of a life well lived, taking powerful photographs of the Soviet leadership making speeches and serving as pallbearers. In 1950, he photographed a massive rally announcing that Stalin had been reelected head of the Supreme Soviet. Here, Baltermants returned to his roots in avant-garde photography as he shot from a tower looming over the crowd. The mass of faceless people is punctuated by images of Soviet leaders, including Stalin and Lenin.

As Baltermants was becoming an important photographer, the Soviet Union was becoming increasingly xenophobic as the postwar period saw the end of the era of internationalism and the rise of Russian nationalism. The newly drawn Soviet border, one hundred miles further west than its prewar border, became less permeable until it was virtually sealed by 1948. In 1946, under the leadership of Andrei Zhdanov, the Central Committee passed a resolution directed against

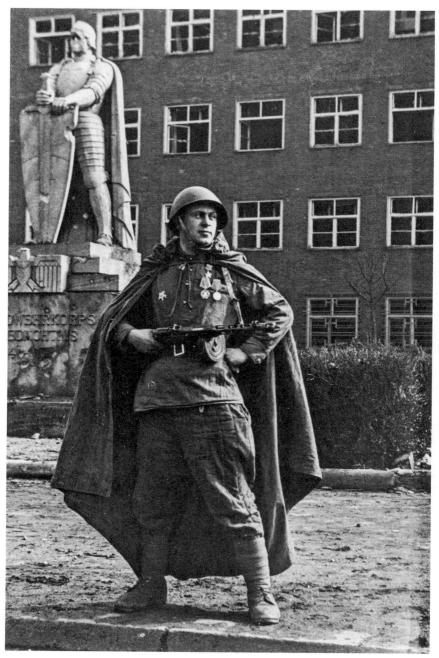

D. Baltermants, *Soviet Soldier Posing in Front of German Memorial to the Unknown Soldier, Ogonek*, April 10, 1945, cover page

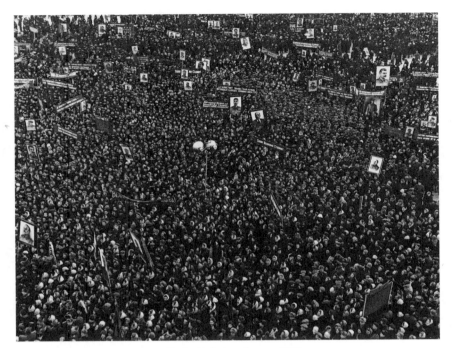

Dmitri Baltermants, *Moscow rally for Stalin's reelection*, 1950

two literary magazines, *Zvezda* and *Leningrad*, and singled out works by the satirist Mikhail Zoshchenko and the poet Anna Akhmatova. This cultural crackdown was the first salvo in the anticosmopolitan campaign, which became more overtly antisemitic as it became more nationalistic.[32] In 1948, the Central Committee issued a new decree calling for an end to "formalism" in music.[33] Photographers were keenly aware of these political changes, both because of their professions as war photographers, which placed them on foreign soil and enmeshed them in an international network of other photographers, but also because many of them, Baltermants included, were Jews.

With xenophobia and antisemitism becoming more visible in Soviet society during and immediately after the war, questions about Jews' visibility in the Soviet intelligentsia began translating into doubts about Jews' loyalty to the country and to communism. This only became more acute after the founding of the state of Israel in May 1948. The Yiddish writers who published in *Unity* (*Eynikayt*), the Soviet wartime Yiddish-language newspaper of the Jewish Anti-Fascist Committee, such as David Bergelson, Perets Markish, Itsik Fefer, and others, and all of those connected with the Jewish Anti-Fascist Committee (JAFC) were among those most harshly targeted. Solomon Mikhoels, head of the JAFC, lead actor of the State Yiddish

Theater (GOSET), and the symbolic leader of Soviet Jewry, was murdered in January 1948, marking the beginning of the persecution of Soviet Yiddish culture makers. More members of the JAFC were arrested in late 1948 and early 1949, and Soviet Yiddish cultural institutions, including GOSET, were closed down by 1949. Arrested, put on trial, and pronounced guilty, Bergelson, Markish, Fefer, and most members at the secret JAFC trial were sentenced to death. They were executed by firing squad on August 12, 1952.[34]

The anticosmopolitan campaign shook up the entire Soviet photographic community, especially those who were Jewish. For example, Khaldei was nearly fired from the Russian news agency TASS in 1943 for failing to submit his work to the proper censor. After a postwar period of increasing turmoil with his editors, on October 7, 1948, Khaldei received notice that he was terminated from TASS, after twelve years of employment, for reasons of "staff downsizing." As for Baltermants's mentor, Georgi Zelma, his work was not exhibited between 1948 and 1958. According to his son Timur, in 1952, Zelma began destroying many of his negatives after being interrogated about some of the people in his photographs. Given all of this turmoil for Soviet Jewish culture makers, it is a surprise that Baltermants did not experience a similar fate.[35]

Perhaps Baltermants's most important photo shoot during the Stalin era was documenting the moment that concluded it—Stalin's funeral in March 1953. He had begun documenting Stalin's death with its public announcement over the radio, a piece of news as big as the German invasion of the Soviet Union. News trickled out slowly, first to foreign news agencies and only later across the Soviet Union.

Early in the morning on March 7, the voice of Yuri Levitan crackled over Soviet radios. The sound of his voice signaled comfort, in its familiarity as perhaps the most widely known radio voice, but also anxiety at the content of his message. As editors got word of the big news, they assigned their best photographers to document the broadcast of Levitan's report over the radio, which was not unlike Molotov's speech announcing the German invasion on June 22, 1941:

> The Central Committee of the Communist party, the Council of Ministers and the Presidium of the Supreme Soviet of the U.S.S.R. announce with deep grief to the Party and all workers that on March 5 at 9:50 p.m., Josef Vissarionovich Stalin, Secretary of the Central Committee of the Communist Party and Chairman of the Council of Ministers, died after a serious illness. The heart of this collaborator and follower of the genius of Lenin's work, wise leader, and teacher of the Communist Party and of the Soviet people, stopped beating.[36]

Four days later, Stalin's funeral took place in Moscow. Rivaled only by the Victory Day celebrations of June 1945, the lavish ceremony traveled from the Hall of Columns in the Kremlin out to Red Square and Lenin's Mausoleum, renamed Lenin's and Stalin's Mausoleum after he was interred there. A who's who of the global communist world attended the funeral, with the most important dignitaries perched atop the dais: Gheorghe Dej from Romania, Pakh Dem Li from Vietnam, Walter Ulbricht from the German Democratic Republic, and Dolores Ibarruri, communist hero of the Spanish Civil War. The central Soviet leadership carried Stalin's coffin into the mausoleum.

Baltermants documented the entire proceedings surrounding Stalin's death, from the radio announcement to his body's interment in the mausoleum on Red Square. Perhaps his most noteworthy image from these events is one of Stalin's open casket on display in the Hall of Columns in the days preceding burial, photographed in vibrant, almost garish color.[37] But the photograph that ended up becoming his best known was one of his first, a panorama documenting Dynamo factory workers listening to Levitan's announcement of Stalin's death. Baltermants collaged three shots together to create this dramatic picture. If we look closely we can see the seams of the three separate photos.

Stalin's death was a moment of trauma for much of the population, who could not imagine the Soviet Union without him as its leader. And yet for others, such as those incarcerated in the Main Administration of Camps (known by its acronym, Gulag) or survivors of the 1953 Doctors' Plot, when (mostly Jewish) doctors were accused of poisoning Soviet leaders, his death might have meant relief. His death did not lead to a smooth transition of power. How could it have, after he had transformed the state into a cult of his own personality? A leadership battle ensued, and Nikita Khrushchev eventually became the secretary general of

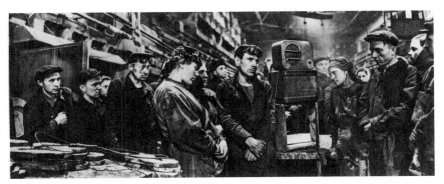

Dmitri Baltermants, *Listening to the Announcement of Stalin's Death*. This photograph was a composite of three distinct photographs, collaged together, printed, and then cropped as this montage.

the party. His chief rival, Lavrentiy Beria, the deputy premier and former head of the People's Commissariat for Internal Affairs (NKVD), the man who expanded the Gulag system during and after the war, was charged with treason and executed in December 1953.

In fact, Khrushchev did not have to wait until the power struggle was over to transform the Soviet Union. One of his first acts as leader was to release nearly five million prisoners in the Gulag system. Later in his rule, he also rehabilitated many of those persecuted and purged in the 1930s Great Terror.[38]

Khrushchev's rise to power also meant Baltermants's rise in influence, as he became arguably the nation's most influential photographer. Unlike Stalin, who preferred to stay in the Soviet Union, Khrushchev liked to travel abroad as part of his vision of reincorporating the Soviet Union into the global order. In 1955, Khrushchev met with leaders of the United States, France, and Great Britain to hammer out the Geneva Accords, which enshrined the principle of "peaceful co-existence" between capitalist and communist countries. Although Baltermants did not photograph Khrushchev in Geneva, that same year *Ogonek* sent him to document Khrushchev's friendship mission to Burma, a former British colony that gained independence in 1948, and India, also a former British colony, independent since 1947. His photographs appeared in a lavishly illustrated color version of the magazine on December 30, 1955.[39]

He took a beautiful portrait of Viet Cong leader Ho Chi Minh, cigarette casually dangling from his elegant fingers as he sits in a living room, during the Vietnamese leader's 1955 visit to Moscow, a year after the final fall of French colonialism at Dien Bien Phu. That same year, Baltermants went to Vietnam and took a series of photographs documenting daily life in newly communist Vietnam. One particularly poignant series of Baltermants images documents the trial and subsequent execution of a bourgeois landowner, just one year after French colonial authorities left Indochina.[40]

In the three years between Khrushchev's rise to power in 1953 and his secret speech to the 20th Congress of the Communist Party of the Soviet Union (CPSU) in 1956, a speech that upended Stalin's cult of personality in a single blow, Baltermants had become Khrushchev's most trusted photographer and visual documentarian. As secretary general of the CPSU, Khrushchev figured out how a post-Stalinist communist world power would act on a global stage—building political and military relationships with postcolonial nations, opening itself up to Western countries through soft diplomacy, and making the Soviet Union a global destination for both elites and the everyday person in ex-colonial nation-states throughout Africa and Asia, while also maintaining tight military and political control over eastern Europe. Baltermants learned how to project the new Soviet superpower visually.

Dmitri Baltermants, *Portrait of Ho Chi Minh*, 1955

In his inaugural 1957 photograph in *Pravda*, the Communist Party's newspaper, Baltermants documented Hungarian journalists visiting Moscow for an exchange. His photograph depicts a warm, collegial relationship between Soviet and Hungarian journalists. The problem with this photograph was that relations between the Hungarian population in general, and more specifically the journalists, and the Soviet Union were anything but warm in 1957.

This was less than one year after Soviet tanks had crushed a three-week, student-initiated rebellion against the pro-Soviet Hungarian communist government. [41] In all, 2,500 Hungarians and 700 Soviet soldiers were killed in combat and an estimated 200,000 Hungarians became refugees, most fleeing across the border to Austria, where they ended up in more than 250 refugee camps.[42] (*Life* magazine published a whole series of photographs demonstrating the brutality of the Soviet military response to the uprising.[43]) These were not exactly the kind of events to create warm relations between the journalists.

Baltermants's photograph aimed to look beyond, over, or perhaps through the challenging historical events of 1956 by celebrating the Hungarian delegation's time in Moscow. His work from across Asia in *Ogonek*, as well as photographs

of foreign delegations in Moscow like the Hungarian one published in *Pravda*, envisioned a harmonious postwar global communist world for readers back home in the Soviet Union.[44] Although his images may have succeeded in fostering a common identity among Warsaw Pact nations, they did little to mask the fact that Soviet troops were still stationed in eastern Europe ready to enforce orders from Moscow.

As Baltermants was becoming one of the most widely published magazine and newspaper photographers in the Soviet Union, photography was coming off the pages of publications and onto the walls of exhibition spaces. For the first time since the 1930s, the most august art institutions in the Soviet Union exhibited photographs.

Practitioners of "photography as art," especially prerevolutionary image makers known as pictorialists, who had clustered around the Russian Photographic Society had been denounced as bourgeois relics in the early 1930s during the Soviet Cultural Revolution. Their denunciation, however, did not mean that the Soviet Union saw photography as inimical to art. The same photographer could be labeled in one instance a "photojournalist" (in Russian, *fotoreporter*) and in another, an art photographer (*fotokhudozhnik*). The last major photography exhibition at which all the well-known Soviet photographers of the day took part and showed off their best work took place in 1937 and was quite intentionally called the All-Union Art Photography Exhibition. The magazine of the profession, *Soviet Photo* (*Sovetskoe foto*), founded in 1926 to serve the burgeoning community of Soviet photographers, ceased publication in 1941. The cultural politics of the Great Terror and then the Great Patriotic War ended any chance of repeating such large-scale photography exhibitions.

But now, under Khrushchev, times had changed. The fiery debates on the pages of Soviet magazines about what defined Soviet photography in the 1920s and 1930s—which led to photographers fearing for their lives for taking too much license with, for example, staging a scene—had seemed to pass, even under Stalin (although a misidentified picture during the war could land a photographer such as Baltermants in a penal battalion). Khrushchev had reaffirmed socialist realism's central role in representing the socialist project in his 1957 speech "On the Close Relationship of Literature and Art to the Life of the People." In it, he declared that socialist realism was the most progressive aesthetic form.[45]

Beyond that statement, and with the country now enjoying global power and photographers projecting images of that power, photography could now make a comeback as art, preferably of the socialist realist variety although some photography reflected the avant-garde of an earlier era. The pages of *Sovetskoe foto* could also reintroduce an open conversation about what it meant to take photographs under socialism. Perhaps most importantly, Soviet photographers now had the

material basis for printing photographs not just in black and white, but also in color.

Russian photographer Sergei Proskudin-Gorskii experimented with color photography before World War I, and Soviet photographers dabbled with the new technology of developing color film in the late 1930s. The Soviet conquest of Germany, and its occupation of the eastern half of the country after World War II, meant a whole new trove of booty from the vanquished.

In addition to the industrial plants, food, and the human capital of German prisoners of war, all of which helped rebuild the postwar Soviet Union, the Soviet occupation forces took advantage of Germany's leading role in photographic technology. Although they had possessed German Leica cameras and some German-made Agfa film prior to World War II, equipment that Baltermants used in much of his wartime work, Soviet photographers now also had Agfa color film as reparations from Germany. Based in Wolfen in the Soviet occupation zone, Agfa was rivaled only by Technicolor for making the best color film in the world. These photographic spoils allowed for a renaissance in Soviet photography, and Agfa film as well as Agfa's developing and print technology, not to mention high-quality paper, gave photographers in the Soviet Union the tools to use color.[46]

By the late 1940s, color film had become the new standard in magazine photography in other parts of the world, especially the United States. In fact, nearly all American magazines were using color photographs on their covers.[47] *Ogonek* also started publishing color photographs on its covers at the same time, but it stood out from other Soviet publications still working almost exclusively in black and white, if only because of the dire socioeconomic conditions of the postwar period.

Moving from black and white to color forced photographers and those viewing, displaying, and circulating photography to rethink its status. The shift also transformed the market for photography, not just in the Soviet Union but around the world. Henri Cartier-Bresson claimed to have used color in his photographs not for aesthetic reasons, but because magazine editors would only buy color photographs. If photography in the prewar period had been defined by the geometry, shadows, and angles of a black-and-white aesthetic, the introduction of color had the potential to push photography toward painting, potentially a move back in time, in the direction of the pictorialists.

In the 1950s, subscribers to *Ogonek* tore off the saturated color covers and hung them on the walls of their new one-room or, for lucky families, two-room apartments, turning what might have been a drab space into one enlivened by color on the walls. The everyday Soviet citizen-reader became curator of home-based displays using mass-produced color photographs as art. In this way, *Ogonek's*

publication of color covers and the citizen-curator-reader brought the worlds of journalism and art photography together.[48]

Hanging color photographs printed in magazines on walls did not become a mass phenomenon out of nowhere. These intrepid amateur curators learned how to hang works on paper in their apartments from the Tretyakov Gallery, which specialized in Russian art and one of the Soviet Union's most important art institutions. It was also among its most conservative. The Tretyakov had been hosting All-Union Art Exhibitions for several years in the postwar period. (During the war, it was doing its best to save its collections from enemy bombs, which hit the building on August 11, 1941. In Leningrad, a city under a nearly nine-hundred-day German siege, curators saved art and artifacts from the Hermitage shortly before the Germans cut off rail lines in and out of the city in the summer of 1941; those curators' heroic efforts became legend.[49])

In 1951 the Tretyakov took a bold step by including color photography in its art exhibits. Among those photographers participating in the inaugural art photography exhibition was none other than Baltermants.[50] Tretyakov Gallery visitors—the broad professional classes of engineers, teachers, and other white-collar workers—were also likely *Ogonek* readers, and thus they would have seen color photographs being exhibited alongside paintings, sculpture, and other forms of art in state-sponsored art exhibitions. In an era before inexpensive poster-sized reproductions of exhibition prints were available for purchase, average Soviet citizens took it on themselves to decorate their apartments like the Tretyakov—but with *Ogonek* covers. They demonstrated to themselves and their guests both their immaculate taste and their simultaneous modest decorating habits.[51]

Journalist Boris Gorbatov, one of the best-known Soviet wartime correspondents, wrote an essay about the All-Union Art Exhibit for *Literaturnaia Gazeta* in which he mentioned Baltermants, who had been known primarily as a black-and-white photojournalist. Gorbatov celebrated this major accomplishment in photography, as he wrote in a one-sentence paragraph near the opening of the article: "And thus was born a new kind of fine art."[52] Photography had moved from the printed page to the exhibition wall.

For the fortieth anniversary of "Great October," Soviet nomenclature for the Bolshevik seizure of power in October 1917, the Ministry of Culture at last hosted a second All-Union Art Photography exhibition, twenty years after the previous one.[53] The central show in Moscow featured 238 photographers and 907 works of art. To celebrate the way the revolution had transformed each Soviet republic, the ministry also took on the challenging task of hosting photography exhibitions in the capitals of each of the fifteen Soviet republics.[54]

Gorbatov's article about the anniversary photo exhibition celebrated both the accomplishments of the socialist country and photography's ability to document

that country's past, present, and bright future: "The art photographs on exhibit convincingly bear witness to the increased economic power of the socialist state, to the laboring feats of urban and rural workers, the creators of all the values of our rich, flourishing cultural life of our country."[55] In honor of the fortieth anniversary of the revolution, Soviet society reflected on its past achievements, which the revolution had made possible. It also emphasized how photography had documented every moment in the unprecedented building of socialism.

The ministry produced a lavish catalog in honor of the occasion, which listed not only the photographers and their works, but also any awards that the exhibited photographs had already won. Most photographers had just their name and the titles of the works on exhibit, but not Baltermants: his entry also included awards his work had won in international photo competitions in Yugoslavia (1956 and 1957) and Hungary (1957). As part of Khrushchev's Thaw culture and the new openness to western Europe, Baltermants made an even bigger splash in postfascist Italy in the 1958 Third International Photo Competition in Biella, the first time Soviet photographers had been invited to participate. Baltermants's color photographs won both the silver and bronze medals at the show.[56]

As Soviet art photography became further institutionalized and was exhibited in shows internationally, the professional journal *Sovetskoe foto* reappeared, as did debates about what defined Soviet photography. Its editors, as well as the photo editors of most widely circulating publications, served as the central institutional leadership, making them responsible for shaping the field, overseeing photography competitions, and curating photo exhibitions, since art museums generally did not have dedicated curatorial staff overseeing photography. Although the Tretykov occasionally included color photography in its major art exhibitions, exhibitions dedicated exclusively to photography generally took place in spaces not dedicated to the display of art, such as the Central House of Journalists (*Tsentral'nyi dom zhurnalista*) and even the Gorky Park exhibition center.

If photography was once the realm of professionals who had access to the scarce materials one needed to take pictures, by the 1950s photographic supplies, cameras, and other equipment became more widely available. The amateur photographer (*fotoliubitel'*) became a key market for the magazine as its circulation soared in the late 1950s to more than 100,000.[57] The editors invited magazine readers to write in with comments and, especially, their own photographs, for commentary. In turn, the magazine published highly detailed technical information about the process of producing photographs. It also encouraged all newspapers, including *Pravda, Izvestiia*, and many others, to hold photography competitions among its readership. This encouraged readers to learn how to use cameras, which were ever more popular as they became cheaper, but also created

a feedback loop for professionals to define what "socialist photography" was supposed to look like for the common Soviet citizen.[58]

As color photography was becoming more common, *Sovetskoe foto*'s pages were filled with discussions about the pros and cons of auramine and rhodamine, each a kind of dye used in producing color photographs; in others, authors examined the variety of light sources an amateur could use to help Mother Nature along when the sun was not cooperating. *Sovetskoe foto* bridged producers and consumers, professional and amateur photographers to create a community and a photographic public.[59]

After the Stalinist era's crude manipulation of photography to change history—in which people appeared in photographs where they had not been or, more often, disappeared when they fell out of favor—articles once again began to call out photographers who took too much license in creating their photographs.[60] But letters from readers also asked how much latitude a photographer could have to produce a photograph, at one point decrying the "falsification" of photographs as a violation of photography's yearning to document.[61] Readers and amateur photographers were also involved in clarifying the theoretical boundaries between documentation and aestheticization through letters to the editor and editorial responses to those letters.[62]

One issue that everyone could agree to about photography: a photograph was never simply a mimetic representation of external reality. As Yuri Korolev wrote in 1957,

> Photoreportage is information about events and appearances of the "now," about people, their lives, and deeds. At its basis, there always lies real facts and people who exist in the world. Photoreportage is a reliable, truthful display of life. However, "a fact is not the whole truth," as M. Gorkii once said. It is the raw materials from which one extracts the genuine truth of art.[63]

The photographer's role was to tease out a deeper truth from the facts documented in a raw photograph. In other words, a Soviet *photograph*, as opposed to reportage, was not a documentary report of the facts. It was instead, as a 1961 article in *Sovetskoe foto* stated, "the intentional, party-driven reflection of reality."[64]

In addition to wrestling with philosophical questions about the nature of photography, the magazine covered the ever-deepening relationship between Soviet and world photography through its coverage of international exhibitions and photo competitions, including shows in Washington, DC, Copenhagen, and Singapore.[65] *Sovetskoe foto* showed Soviet photographers and their work being exhibited abroad and covered shows of foreign photographers on exhibit in

Moscow.[66] If that was not enough, the Union of Journalists reestablished its division of photography and began hosting photography exhibitions at the Central House of Journalists on Nikitskii bul'var.[67]

Baltermants's work and commentary about photography appeared regularly in the magazine. In a 1957 issue, he published brilliant color photographs from China, where *Ogonek* had sent him on assignment.[68] He described in detail what it meant for a photographer in the 1950s to be photographing in China: from choosing the camera and lighting to bring with him, packing everything up, flying thirty-six hours across the world ... to discover a radically changed Beijing (Peking), where he had been just two years earlier. He had a particular interest in Mao's China, which he visited on at least three occasions. This included the tenth-anniversary celebration of the founding of the People's Republic in 1959, at which Khrushchev appeared with Mao.[69] In the fall, he exhibited his work in a major international photography exhibition in Budapest and ended up winning a silver medal. He had also served on the organizing committee for the 1957 All-Union Photography Exhibition, to celebrate the fortieth anniversary of the October revolution.[70]

Baltermants continued building his photographic career. He played a leading role at the Exhibition of Soviet Art Photography that opened in June 1958 and won second prize at the All-Union Photo Exhibition in honor of the Twenty-First Party Congress in 1959, the first Congress open to foreign news reporters and therefore part of Khruchshev's broader campaign to inform the world about the Soviet Union.[71]

As a leading photographer for *Ogonek*, he and a team including Zelma and Yakov Khalip were sent to document the ethnic diversity of Khrushchev's Soviet Union, a project not unlike that of the 1930s when the Soviet press sent photographers around the country to document how communism incorporated diverse nationalities into the Soviet Union.[72] But in the 1930s, while Zelma was traveling the country documenting its ethnic diversity, Baltermants took pictures of Pioneers and students from across the Soviet Union in Moscow, which served as the center of this ethnically diverse empire. Although most of the photographers had been to the outer reaches of the Soviet Union before World War II, as Baltermants remarked in a 1959 article on his voyage to the four corners of the country, "I was in many of these places for the first time."[73]

Baltermants achieved another photographic milestone when he published *And the Chestnut Trees Bloom ...*, which depicted daily life in Kiev, in 1960.[74] The book introduced readers to the people and city of Kiev with aerial photographs as well as a few images in color.

Although it included contemporary photographs of the ruins that still blighted the city's landscape, the emphasis was on the present and future of the

Dmitri Baltermants, *Chinese Street Scene*, 1957

city. To that end, Baltermants included many photographs of children. The final photograph is a close-up of an infant with the caption, "I am a Kievan, and all of this is mine!" Only occasionally did it hint at the city's dark wartime past of violence and destruction. (Not surprisingly, there was no mention of the city's most violent moment, which had taken place at Babi Yar in late September 1941, when German occupation forces executed 33,000 Kievan Jews.)[75] Finally, the book suggested that the city, once the capital of ancient Rus', served as the fount of three "brother peoples"—Russians, Ukrainians, and Belorussians, each of whom, the book claimed, traced its roots to the fabled city.

The establishment of Baltermants as a photographer of the Soviet state and Communist Party coincided with the Soviet Union's memorialization and simultaneous monument-building campaign dedicated to the Great Patriotic War, the specific segment of the broader world war that began with the German invasion of the Soviet Union in June 1941. During the late 1950s and through the

Dmitri Baltermants, *Mao Tse-Tung Dancing with Chinese Woman*, 1957

1960s and 1970s, heroic war memorials went up all over the country, in every town, culminating in the completion of the massive *Motherland Calls* (*Rodina zovet*) statue in 1967 in Volgograd. (The city had been Stalingrad until 1962, when all things with the name of Stalin were renamed after the Twenty-Second Party Congress made Stalin into communism's enemy, including having his body removed from the mausoleum on Red Square in August 1961.) At the time, it was the largest freestanding statue in the world.[76]

Dmitri Baltermants, *Motherland Calls*, Volgograd, 1970s

The state-sponsored creation of a collective war memory demanded the creation of a heroic narrative of Soviet victory. *Sovetskoe foto* began running essays in the late 1950s and through the 1960s of photographers' work from the wartime period documenting the heroism of the Soviet population. Stalingrad, in particular, served as the site at which the tide of the war "inevitably" turned in favor of the victors. Lavishly illustrated magazine articles about Stalingrad appeared after 1954; Georgi Zelma became the most important image maker of the past, present, and future of the "hero city." One of the earliest efforts was Zelma's 1954 book *Stalingrad: Photographs*, which celebrated the "second birth" of the city. Its saturated color images of the Volga River waterfront and happy children reminded readers of the power of photography to show a post-Stalinist Soviet Union to the average Soviet reader after the destruction of the war.[77]

There is the occasional reminder to the Soviet reader about Stalingrad during the war and how it earned the title "hero city" back in 1945 when Stalin designated Leningrad, Stalingrad, Sevastopol, and Odessa the first "hero cities."[78] In particular, Zelma included an aerial panoramic photograph from early 1943 of a ruined Stalingrad, which served as a stark contrast to the Stalingrad of Zelma's 1954 photographs. In 1957, the year marking the fortieth anniversary of the October revolution, when looking back at the Soviet past became an important collective act, history was never too far beneath the surface. Therefore, it is not

surprising that as part of the municipal celebrations, several cities that played a key role during World War II—Leningrad, Moscow, and Kiev—also put on photography exhibitions titled *The Great Patriotic War in Art Photography*.[79] And the 1958 Exhibition of Soviet Art Photography, which took place at Gorky Park, featured an entire section dedicated to the Great Patriotic War and the "unsurpassed resistance of Soviet patriots."[80]

In a 1957 essay looking back over his professional career, photojournalist Boris Polevoi reprinted several photographs of his wartime experience. Among the many images celebrating Soviet heroism was a frightening photograph he had taken at the liberation of Auschwitz (*Osventsim* in Russian), an image not unlike some of those Baltermants had taken at Kerch. Polevoi explained his decision to take it at the time as well as his subsequent decision to republish it:

> I had just arrived at the recently liberated Osventsim, this monstrous death factory where fascists murdered millions of people and burned them in ovens. The buildings that had been crematoria, which the fascists had attempted to destroy, were still warm and still had the fumes of the destroyed gas chambers, those gigantic stains. Thin, emaciated people in striped outfits—the camp committee—had already set up some kind of organization and showed us around the camp where fascists had carried out their vile deeds. No, not everything had been blown up, not all traces removed. This picture shows a pile of corpses, stacked up near one of the barracks, ready to be burned. I wanted to show this picture now to those who were once again nourishing the German Wehrmacht and financing arms through atomic bombs, to those who in such a primitive way destroyed an entire people.[81]

During the war, Polevoi suggests that he was documenting a crime scene, in this case the process of mass murder that took place in a purpose-built death factory. He captured the remaining "traces" to document evidence that would be used in war crimes trials, most notably at Nuremberg. "The Soviet procurator Roman Rudenko gave his speeches. The lens of the camera, with which I never parted, captured the moment when those accused: Göring, Hess, Ribbentrop, Redder, and Denis, listened to the Soviet indictment."

In the 1950s, Polevoi was not republishing these photographs to prove the facts of the case; that had already happened. He republished them in a specialty Soviet magazine to remind readers that German fascism was not dead, but was alive and well. He does not say where, but with the reference to the German (not fascist) Wehrmacht (*nemetskii vermakht*), he reminds readers of fascism's persistence in 1950s West Germany.[82]

Any reader of the magazine would know that there were two Germanies at the time—"democratic Germany" in the east, which the Soviet Union had officially recognized in 1955 and to which it had repatriated German prisoners of war who had remained in the Soviet Union as part of its reparations, and West Germany, the bulwark of the North Atlantic Treaty Organization (NATO) and inheritor of German fascism. Through the 1950s, the United States and West Germany had high-profile and quite public discussions about what it meant to be on the frontline of the Cold War and the role nuclear weapons would play in deterring a future war.[83] Polevoi republished his Auschwitz photographs as a 1950s Cold War warning against the American-led atomic arms race and the Soviet sense that fascism persisted in Konrad Adenauer's Germany.

In the 1960s, images like Polevoi's circulated widely, primarily domestically, but also functioned as visual diplomacy when they traveled abroad. The Soviet Union used the tragedy of its wartime experience to assert itself as the global leader in fostering world peace. *Sovetskoe foto* ran a regular column at the height of Khrushchev's global peace campaign in 1962 called "For Universal Disarmament and Peace." Page one of the July issue invited photographers, both Soviet and international, to send their most powerful visual statements calling for world peace. The Soviet photographs that appeared in the magazine showed the end of World War II, especially with Soviet soldiers raising the red flag over the Reichstag.[84] Baltermants would play a key role in this kind of photographic diplomacy.

The role of global peacemaker is one the Soviet Union had been politically and rhetorically claiming shortly after the United States dropped atomic bombs on Hiroshima and Nagasaki in 1945. Images of the bombs' detonation circulated immediately, even before Japan's unconditional surrender.[85] The horror described in *Life*—walls of fire, instant desertification of lush Honshu, humanity itself incinerated in the blast—overwhelmed those writing the captions. The aerial photograph of the Nagasaki bomb's aftermath, "new and improved," according to *Life*, looked more like a mushroom. Observers witnessed "a big mushroom of smoke and dust billow darkly up to 20,000 feet (above) and then the same detached floating head observed at Hiroshima. Twelve hours later Nagasaki was a mass of flame, palled by acrid smoke, its pyre still visible to pilots 200 miles away."[86]

Images of the soon-to-be iconic mushroom cloud served as a visual emblem of the new power of human beings, in this case the United States, to destroy the world. Stalin used it as a political tool in the early years of Cold War to damn the United States—even after the Soviet Union conducted its own successful atomic weapons test in August 1949.[87]

Images of mushroom clouds began appearing in exhibitions that were produced as a form of photographic diplomacy . . . but not in Soviet exhibitions, where one

might have expected them to appear. Edward Steichen's 1955 *The Family of Man* opened at the Museum of Modern Art to thronging crowds and an overwhelming number of reviews and other kinds of critical response. Steichen curated the show not around individual photographers, which was the way organizers traditionally put together art photography exhibitions. Rather, Steichen used a thematic approach and included photographs (and photographers) from around the world, including the Soviet Union (although not Baltermants), in each theme.

Among the more than 450 black-and-white photographs in the show, there was a single, large-scale color image to which Steichen devoted an entire section of the exhibition labeled: "Location: Marshall Islands; Photographer: Atomic Energy Commission"—a 96 × 120-inch image taken in 1953 of a mushroom cloud from a hydrogen bomb test detonation, the newest and most sophisticated weapon in the global nuclear arsenal.[88] When *The Family of Man* was on exhibit in Japan, due to the sensitivities of the viewers, the image of the hydrogen bomb's mushroom cloud was removed entirely. *The Family of Man* also made a star-studded appearance in Moscow later in the decade when Khrushchev and Richard Nixon had their famous Kitchen Debate.

Khrushchev by no means abandoned Stalin's postwar assertion of global Soviet power in the political arena, especially as he saw opportunity everywhere around the globe. Western empires were falling apart around the world, and new nations sprang up in their places. However, Khrushchev also sought to improve relations with Western countries as he traveled frequently with the goal of rebuilding relationships with capitalist countries. He also traveled to other communist and nonaligned countries, whose independence had just come as a result of decolonization, to reaffirm Soviet relationships with those countries. Khrushchev hoped to influence countries using both hard and soft diplomacy, and on occasion military power in the form of the Soviet army, which still occupied much of eastern Europe.

The Soviet Union had always been open to foreign people, experiences, and cultures, ever since the 1925 establishment of the All-Union Society for Cultural Relations with Foreign Countries (VOKS). As an example, in the 1930s, the society organized long-term stays in the Soviet Union for African American communists such as Langston Hughes and Claude McKay as well as for French communist writers like André Gide.[89] In the 1950s and 1960s, Khrushchev wanted to broaden those relationships by making them not just about elite communists and fellow travelers; he wanted to make developing foreign relationships a mass phenomenon. By the 1960s, under the auspices of a whole network on institutions, large numbers of African students came to Moscow to study only to return to their home countries with new education and European cultural experiences. (The United States underwent a similar diplomatic shift

of having "average" people meeting each other in its People to People program, which Eisenhower set up in 1957.)

Khrushchev also opened the relatively closed borders of the Soviet Union. He did this for those wishing to emigrate, such as granting permission for Polish citizens, including Jews, to leave the Soviet Union between 1955 and 1959.[90] He also invited intellectuals from abroad to help resurrect a positive global opinion of the Soviet Union after Stalin had done much to destroy those relations. When it still existed, VOKS hosted French philosopher and writer Jean-Paul Sartre and photographer Henri Cartier-Bresson in 1954 for the first visit by a major photographer to the Soviet Union since Stalin's death.[91] The organization also hosted foreign photography exhibitions, usually in the Central House of Artists in Moscow.[92] In September 1957, under Khrushchev's leadership, VOKS formally changed its name to the Union of Soviet Friendship Societies (*Soiuz sovetskikh obshchestv druzhby* [SSOD]).[93]

Like VOKS before it, the SSOD was an umbrella organization housing many bilateral friendship societies, each with the aim of developing cultural relations with a specific country and thereby mitigating negative political relations at the height of the Cold War.[94] On March 30, 1959, the society opened its new headquarters—the turn-of-the-century Morozov mansion on Vozdvizhenka Street, a stunning piece of prerevolutionary architecture in downtown Moscow. The new facility had meeting rooms and exhibition spaces for use by SSOD member societies, including its inaugural exhibition of Chinese photography.

The building's eclectic design served as a meeting ground of East and West in the heart of Moscow, only a short distance from the Kremlin. After the revolution, the building was home to an avant-garde theater, and then to Proletkult, the Soviet institution fostering proletarian culture. Following the eclipse of Proletkult in the mid-1930s, the house lost its cultural liveliness. In 1958, it became home to the SSOD and had big plans for hundreds if not thousands of ordinary Soviet citizens to crowd into the building to experience global culture in a Soviet key.[95]

In the 1920s, VOKS's goal was to show how radically different the new socialist society emerging in Soviet Russia (and Ukraine, Belorussia, and elsewhere) was from the capitalist West. It served to "showcase an experiment" to curious Westerners.[96] With its resurrection under Khrushchev as Cold War tensions defined relations between the Soviet Union and the United States, the SSOD emphasized what Soviet and Western citizens had in common, especially among ordinary people. It did so by means of exchanges with scientists, writers, university students, and others and also by exchanging culture through film festivals, literary exchanges, and, most important for our purposes, photographers and photography exhibitions.[97]

Almost immediately after its founding, the SSOD opened a photography division; Baltermants served as its deputy director. Given the photography division's primary mission of visualizing commonalities in the day-to-day lived experience in the Soviet Union and other countries, Baltermants published and exhibited his photographs of contemporary Soviet daily life. And he was not alone. The broadcasting of everyday life in the Soviet Union was, in fact, the SSOD's primary mission.

The 1957 International Photo Exhibition in Budapest that Baltermants photographed for the Soviet press had a map of the world at its entrance with a small flag marking every exhibited photographer's home country. The map had forty flags on five continents. This was photographic diplomacy come to life, especially given the fact that this event took place just several months after the Soviet crushing of the Hungarian revolt.[98] Nearly every issue of *Sovetskoe foto* included an article about the role photography played in bringing people on opposite sides of the global political spectrum together with the phrase "photography brings people closer together."[99]

At the same time, it never abandoned its second goal, a legacy of Stalin's VOKS that was explicitly political: letting those same countries with whom it built cultural ties know that the Soviet Union was the greatest vanquisher as well as the biggest victim of fascism. The Soviet Union also reminded the world that only one country had already shown the willingness to use nuclear weapons against its enemy—and it was not the Soviet Union. Moreover, the Soviet leadership was confident that "peaceful coexistence" with capitalist countries in the present, which Baltermants photographed repeatedly through the 1960s and 1970s, would only result in the eventual collapse of the capitalist system.

To make the matter official policy, in 1961, the Third Communist Party Program effectively rewrote classic Marxism by putting peaceful coexistence, rather than violent revolution, as the primary driver of history: "Destroying war and establishing eternal peace, that is the historical mission of communism."[100]

"In the Name of Friendship," a 1958 *Sovetskoe foto* article about SSOD and its network of magazines around the world, opened with the following statement: "The launch of the first Soviet artificial satellites, which have opened a new era in the development of world science, has also turned millions of people's attention to the Soviet Union, the country that leads progressive humanity."[101] In 1959, the same magazine published a long photo essay with images taken by several journalists who had traveled in the United States that summer. This was just before Khrushchev's visit to the United States to meet with President Dwight D. Eisenhower and tour the country. The images crowd the page as they celebrate the reception every ordinary American had on encountering a "Russian."[102] The journalists met with important newspaper publishers, like Arthur Sulzberger

Dmitri Baltermants, *Peace Rally on Red Square*, 1960s–1970s

of the *New York Times*, as well as central figures in American photography like Edward Steichen, head of the photography department at the Museum of Modern Art and curator of *The Family of Man*.

Their visit celebrating cultural ties between the two countries preceded Khrushchev's clearly political visit one month later, when he and Eisenhower were photographed at Camp David outside Washington, DC. Khrushchev became the first Soviet premier to visit the United States, with the goal of improving the relationship between the two governments. And yet, the magazine followed the cover photograph of a smiling Khrushchev and Eisenhower with a quote from Khrushchev proclaiming: "Soviet banners on the moon. . . . Victory of our space explorers—it is a feat of the entire Soviet people, a victory of the whole socialist camp."[103]

Around the same time that Soviet photographers and Khrushchev went to the United States, American political leaders traveled to the Soviet Union for the

1959 American Exhibition, a sumptuous, and in some Soviet eyes crass, demonstration of American capitalism, with hundreds of consumer goods on display in one part of the exhibition at Sokolniki Park interspersed with bold paintings by Jackson Pollack and Andrew Wyeth.

The exhibition also included Steichen's *The Family of Man*, whose global tour had been underwritten and organized by the United States Information Agency (USIA). Founded in 1953, as a response to seeing the success of Soviet culture permeating European society in the late 1940s, the USIA was a quasigovernmental agency, along the lines of the SSOD, devoted to promoting American ideals and values abroad. And in Sokolniki Park, *The Family of Man* was in the heart of the Cold War enemy. Muscovites thronged the exhibit.[104]

Steichen came to Moscow with his exhibit. While there, he met with the Soviet photographic establishment for a conversation about the role photography played in fostering diplomatic relations. At least as reported by the Soviet press, the conversation was warm and friendly. Soviet photographers asked about the absence of color photography in Steichen's show and how long it took him to mount the exhibition (four years and a team of dozens). Baltermants and Semyon Fridlyand, chief photo editor of *Ogonek*, were at that meeting and asked Steichen about the lack of abstract photography in the exhibition, a surprising question coming from the leading photographic realists in the country.[105] In time, administrators of Soviet photography, including Baltermants in his role as deputy director of photography for the SSOD, would put together their own exhibitions that would travel the world as a form of cultural diplomacy. These shows would depict the daily life of average Soviet citizens, with the aim of fostering peaceful coexistence.

They would also remind viewers that twenty years earlier, the fascists committed genocide against the Soviet Union.

4 PRODUCING AND DISPLAYING *GRIEF*

In the early 1960s, the Italian photographer Caio Garrubba came to Moscow looking for material for a photography show that he and its lead curators—the important theorist of photography Karl Pawek and Germany's foremost writer, Heinrich Böll—suggested would rival Edward Steichen's *The Family of Man*. Many people in Europe saw it as a Cold War and distinctly American vision of the globe.[1] Rivaling Steichen's, the show was going to be a massive international photo exhibition that would travel around Europe for two years.

As Dmitri Baltermants relates the story, Garrubba came to Moscow and, as was typical for foreign photographers visiting Moscow to learn about Soviet photography at the height of Khrushchev's Thaw, he met with Baltermants. (According to Baltermants's daughter Tatiana, Garrubba also knew Baltermants personally.[2]) Garrubba's visit was different in that he was searching for Soviet photography to include in his show. Baltermants first showed Garrubba his exhibition-sized prints, likely those that he had printed and exhibited at Soviet photography exhibitions and in other international shows from the 1950s depicting daily life of Soviet people. Some of those intrigued Garrubba, but he did not find what he was looking for. Baltermants then showed him control prints of negatives that he had not yet made into large-scale exhibition prints. Garrubba selected a few of those but was still not satisfied.

So Baltermants kept digging deeper into his archive but became "sick and tired" of hunting for pictures to fit Garrubba's vision. That is, until he came across a packet of negatives from the war. Garrubba sifted through those with special attention, since he, Pawek, and Böll had wanted their show to contrast with Steichen's rosier American, 1950s Cold War view of global humanity. Gruesome images of the war on the eastern front might demonstrate just such a darker picture of humanity.

In the packet of negatives, Garrubba likely came across the images from Kerch that Baltermants had taken in 1942. He likely

came across photographs of the better-known wartime images of Afanasyeva and Tereshchenko, but he was most compelled by those of Ivanova. Of the four Garrubba found, one shot struck him immediately. "He silently slid the selected images over to me and said, 'Excuse me, Dmitri. These are fantastic shots but let them hang in other exhibitions. I will take *this* one.' He had set aside the shot taken at Kerch in 1942," one of the four he took of Ivanova.[3]

Baltermants was deeply invested in Soviet photographic diplomacy, serving as he was as the deputy director of the photography division at the Union of Soviet Friendship Societies (SSOD). Being included in the European rival to Steichen's *The Family of Man* would be just the way to bring Soviet photography into the visual history of the globe. The first goal of this form of diplomacy was to highlight visually the commonalities among human beings across the world: going to work, enjoying leisure time, and raising families. The second goal was to show the Soviet Union's radically different experience of World War II, both in terms of the overwhelming violence meted out by Nazi Germany and the Red Army's stunning victory. To achieve this objective, Baltermants and many other Soviet photographers returned repeatedly to Nazi atrocity photos that had riled up the anger of the Soviet population during the war. Not surprisingly, he found his photographs of fascist atrocities at Kerch to be the most compelling.

Whether or not the story about Garrubba being the one to select the photograph is true, Baltermants wanted to highlight Soviet suffering, to make a polemical point, but also to use an image that would resonate with all audiences, regardless of national background. As long as there was no accusation of *who* committed the mass killings in the image (captions or other textual cues might supply that information when needed), an image of a grieving woman could play precisely the diplomatic role Baltermants intended.

He had plenty of grieving women from whom to choose as subjects. During the war, several such photographs had circulated widely in the Soviet Union. They were published in *Ogonek* and also appeared in wall newspapers in cities across the country, denouncing the evils of the fascist occupiers and calling for viewers of these photographs to get vengeance against the enemy without mercy. His Kerch atrocity photographs also appeared in illustrated magazines in England and the United States. The photograph of Afanasyeva, in particular, became a global emblem of fascist German atrocities against Soviet civilians during the war.

Back then, Soviet atrocity photographs, which appeared frequently in the Soviet wartime press, and the articles accompanying them aimed to demonize the wartime enemy. Photography during the Cold War, however, aimed to create a common visual vocabulary of human suffering with the goal of fostering universal peace. Baltermants did not end up choosing Afanasyeva. Instead he chose

images of a different woman who had appeared on the pages of *Ogonek* during the war: the heartbreaking photograph of P. Ivanova, captured in her sorrow on finding the body of her husband.

This may seem a surprising choice. During the war, when the *Ogonek* editors published a two-page photo essay on the "Hitlerite Atrocities at Kerch," they tightly cropped Ivanova's image; it was printed on the left-hand page of the two-page photo essay. She was not the visual center of the essay, as the other two women were.

During the war, far-off photo editors in Moscow had control over how his images would be presented and distributed, but by the 1950s and 1960s Baltermants had more power to shape how his work would appear. But more power did not mean he had sole authority: now he worked with editors, curators, and essay writers in negotiating the final presentation of his photographs on gallery walls and in exhibition catalogs.

Baltermants had originally taken four shots of Ivanova finding her husband's body. It is clear that although the face is clear, the first one could not be selected for exhibition for several reasons: the blurred black shape in the background and the motion of her hands presenting not as motion but again as a blur. The second image lacks the impact of the third and fourth shots; the white handkerchief is not yet playing a role in the image, the way it does in the third and fourth. Her face is turned away from the camera, and the viewer's eye is drawn simultaneously to her and to the soldier in the background, whose face we see distinctly. Since Baltermants and the editors thought that Ivanova was the story, she became the subject of the photograph; an obscured face would not work. As I. Romanov and A. Yarinovskaia suggested in *Sovetskoe foto* in 1959, a good portrait photograph

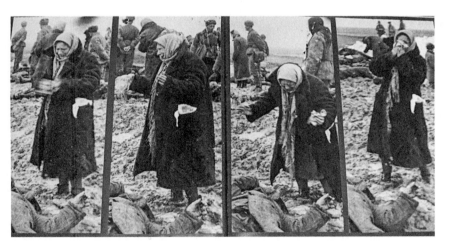

Dmitri Baltermants, control prints of the four cropped versions of P. I. Ivanova, n.d.

needs to reveal the individual, ideally through the face. Strong portraits could not have faces obscured by hair, shadows, or a kerchief.[4] Although this photograph is not a portrait of Ivanova in that sense, her story of grief takes center stage.

That leaves the third and fourth frames. Of all the images, the one the editors selected for publication in 1942, the fourth one, is striking and emotional. Unlike the first three, Ivanova's face is raised and the kerchief is now part of the scene, as she uses it to catch her tears. At the same time, the kerchief obscures her face, which takes away from the "portraitness" of the image. The overall composition also lacks the drama of the third one, in which Ivanova's arms are stretched out, her head bowed, the white of the kerchief against the black of her coat drawing our eye to her, as she expresses a moment of profound anguish and pain. Image three is the one that best expresses the pathos formula, the mode of visually representing a woman in a moment of overwhelming emotion. During the war, when Baltermants sent his film to Moscow, the *Ogonek* editors had final say and chose the best one, at least from their vantage point: number four.

It turns out, however, that the *Ogonek* editors' choice may have been limited by the fact that the third version of Ivanova had been damaged. In interviews with Baltermants, he explained what happened in the makeshift darkroom he set up in the field near Kerch to develop the film: "I remember how I sat down, removed my coat, and put my hands in my sleeves, as I rotated the light-proof tank with the contact paper. I remember it very well, because as often happens, the best frames often end up coming out a bit spoiled, either from movement or for some other reason. In this case, the film got stuck to the contact paper."[5]

When pulling the negative apart from the contact sheet, he noticed that there were two specks left on one exposure—the exposure he and Garrubba liked the best. One speck loomed behind Ivanova over the head of the soldier in the background; the other was right in the middle of the gray Kerch sky. In addition, there was more damage on the left edge of the frame, where several spots disturbed the scene.

He could have cropped the image and removed the sky to do what the *Ogonek* editors did—make it a close-up of Ivanova. But Baltermants was the master of the horizontal, and the overall photograph was too good to crop close. Now that he had the luxury of time to turn it into a dramatic art photograph, Baltermants found a way to use the damaged negative: "I filled in the sky. But I didn't do this for aesthetic effect, but simply because of specks from the adhesive."[6] He produced a new image by overlaying a second negative with an undamaged sky to replace the flaw in the exposure. Then, he retouched the composite. This was a photographic technique he used many times in his career, going back to his first panorama photographs from the 1930s.

In Baltermants's first attempt at "repairing" the image and producing his sig-
nature image of war, he chose a sky that aimed to reproduce the scene as it was in
1942—flat, gray, and lifeless. Baltermants seems to be positioned slightly above
the scene immediately before the camera and documents the horror of what is
splayed out in front of him. At the center of the frame is a corpse, whose hands
reach above his head as if he had been killed just moments before the women,
soldiers, and photographers arrived on the scene.

But following the photographic "rule of thirds," in which one imagines a
grid on a photograph dividing the horizontal and vertical into three parts each,
Baltermants draws our eye to the woman foregrounded on the right, whose name
we know from 1942 to be P. Ivanova. Her face is obscured, as are those of every
individual in the photograph. Although he wants us to connect with this woman,
we cannot engage with her face, which only peeks out from beneath her kerchief.
It is her hands that draw us in, the white of their skin against the stark black of her
coat, in motion, clutching a handkerchief. We know she is crying, even though
we cannot see her tears.

Although the *Ogonek* editor had cropped the Ivanova photograph to give the
reader a close-up of her, Baltermants very intentionally did not take a close-up.
Perhaps he wanted to respect her privacy. Or he understood that a photographer,
as Cartier-Bresson suggested to his Moscow-based colleagues in 1958, should

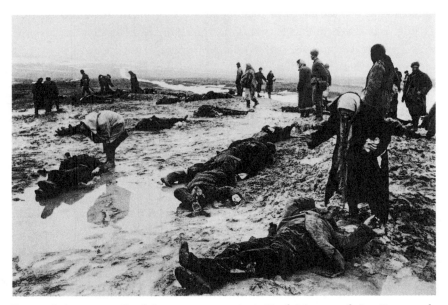

Dmitri Baltermants, *Grief*, documentary version. *Hood Museum of Art, Dartmouth:
Purchased through a gift from Harley and Stephen C. Osman, Class of 1956, Tuck 1957.
Courtesy Dmitri Baltermants, Glaz Gallery*

always imagine the widest frame of the photograph and crop only later, when figuring out the final story.[7] In other words, the click of the camera was only the beginning of the process of creating a great photograph.[8]

Baltermants knew that he did his best work in panorama. He used his skills with the horizontal to show the scale of devastation at the trench, although we do not actually see an overflowing trench in his photographs. His photograph of the "ditch of Kerch," as the killing site is sometimes called, shows a vast field, rather than a ditch, of the dead. We know from other Baltermants photographs that just beyond the frame, and in this photograph marked by the long white line ripping through its center, lay the deep trench filled with dead, mostly Jewish, bodies.

After the viewer takes in Ivanova, the eye next moves to the left third of the frame, where another woman, in light jacket and dark skirt, is hunched over and clutching her face. One assumes she has just found her murdered husband and is now in a state of overwhelming sadness. What makes her image particularly dramatic is the shadow Baltermants has captured on the ground in front of her, as if there are two people in mourning for the dead man between them.

From those two visual markers, Baltermants draws the eye out to infinity as we see more women in grief, more soldiers patrolling the scene. The top third of the image is dominated by the flat sky, white with a touch of gray on the left, which was what the sky looked like that day in January 1942. Baltermants should have been proud of his work, since there is no residual evidence of the damage. And yet, as he stared at the image, he found himself disappointed. So he tried again.

The second version has heavy contrast, making the blacks blacker and the whites whiter. We now see aspects of the photograph not apparent in his first version. Whether alive or dead, the people clothed in dark clothing now appear as ghostly shadows on the landscape—the soldiers in the distance patrolling the site; the women looking on in the back left, curious about the photographers at the site; the facial profiles of those looking grimly to the side. Even the face of the soldier behind her to the right, whom we know is looking at the camera, is obscured as he too becomes a faceless, shadowy figure inhabiting the border between life and death.

The new version also gives us more information about the second woman, the one off to the left and hunched over in so much grief as to cause her physical pain. If the original photograph with less contrast implies that we see her shadow on the ground in front of her, the newer version with heightened contrast reveals something quite different. Rather than a shadow on the frozen, solid earth, we now see that it is her reflection, suggesting that the snow had melted, leaving a small pool of water—the ideal mirror for her grief.

But was it really water? From eyewitness descriptions of the site, we know that in some places, the number of people executed by bullet had been so large

that their blood created small pools in and near the trench. This fact leads us to a horrifying possibility—perhaps the pool in which we see her reflection is not melted snow after all. Perhaps it is the life force of humanity, the blood that had poured out of the dead surrounding her, leaving a pool in which Baltermants could capture her reflection.

Baltermants's desire to emphasize her reflection, rather than her shadow, evokes the work of the poet Ilya Selvinsky, who would have been by Baltermants's side at the trench. The same year that Selvsinky, born in Simferopol, first published *I Saw It*, he also published a long narrative poem (*poema*) titled "Kerch." The work is a historical narrative about a city that he loved dearly but had now become a metonym for mass death and the grief that lingered among the living. This ode to the city closes with a line that could have served as a description of Baltermants's photograph: "Kerch! You are the mirror where the abyss has been reflected."

Despite the increased contrast and the second woman's image looking like a reflection, Baltermants was still unsatisfied. Regardless of the heightened contrast, which reveals so much new about the photograph, in this version, the one he landed on, the most dramatic aspect is clearly the black, billowing clouds. Baltermants had seen how the inclusion of clouds in a photograph made the ordinary extraordinary.

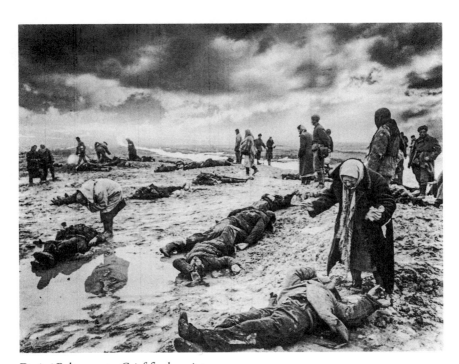

Dmitri Baltermants, *Grief*, final version

In the 1957 Budapest exhibition at which Baltermants won the silver medal for his color photograph of a Chinese woman catching fish, the gold medal went to the Brazilian photographer João dos Santos's *Storm*, an abstract black-and-white image of swirling clouds, almost like the aurora borealis, over a blurred image, possibly a train traveling at high speed. But in dos Santos's photograph, the storm clouds take up the top half of the image. Baltermants may have been influenced by dos Santos's photograph as he decided to have storm clouds occupy a larger percentage of the frame than the original, damaged negative of Ivanova.

As Baltermants hunted for a second negative to pair with the original one as a way of dealing with the specks, this choice clearly moved away from the documentary. If there is one thing we do know about that day in Kerch, it is that there were no dark, billowing clouds. Why add them? Are they there because nature is bringing a storm? Because human beings have made "storm clouds" of smoke by burning down villages? In Kerch, either could be possible. Although it matters whether they are clouds or smoke, in a black-and-white, two-dimensional image that lacked the smells and sounds of the world, the differences disappear. Given their location coming down from above, rather than curling up like smoke, we have to assume that Baltermants intended them to be clouds in the sky, perhaps a divine statement about the scene of horror that he was capturing from the ground.

João dos Santos, *Storm. Sovetskoe foto*, no. 1 (1958)

But one other issue may have encouraged him to insert clouds, which are not just another feature in an image. When comparing the flat gray sky with the dark, clouded one, it becomes immediately clear that the one with clouds has a deeper sense of perspective than the first one. The one with clouds makes the viewer feel enveloped in the scene as two dimensions become three.[9]

Clouds have played a central role in the making of an image at least since the Renaissance. No artist did more for thinking about the role of the cloud in making two dimensions (either the flat surface of a canvas or, in this case, a photograph) into three than Leonardo da Vinci. Da Vinci is likely not the first artist one would turn to when thinking about Baltermants's process as he figured out what to do with the image Garrubba wanted for his exhibition; to be sure, Baltermants was likely not thinking about da Vinci either. But he *was* thinking about perspective, and no one theorized the idea of perspective better than da Vinci.

Da Vinci was both a scientist and an image maker and saw little contradiction between the two. Given the dramatic scientific revolutions taking place around him, he felt compelled to figure out how new understandings of cosmology could be represented in images, none more so than Christian iconography. Da Vinci applied the principles of geometry, especially perspective, to the human construction of the visual as he attempted to better represent an external reality, one that existed in three dimensions, on the two-dimensional surface of his canvas. For him, the cloud played a central role.

Scientifically speaking, a cloud is a meteorological feature, a "body without a surface but not without substance for, like mist, it is the product of a *thickening of the atmosphere*, a contraction of the humidity dispersed in the air."[10] In representation, especially in Christian iconography, clouds also have served as a boundary-like space separating the divine from the mundane, heaven and earth, here and there. The fact that da Vinci was both a scientist and artist is central to understanding how he created a revolution in artistic representation. It took geometry to create perspective, which was necessary to represent the world as it was. And it took a change in cosmology to *want* to represent the world as it was.[11]

Baltermants was trained in applied mathematics and had taught math at a military academy in the late 1930s. He thus would have been intimately familiar with geometry and the science of perspective. It also was no coincidence that Baltermants thought carefully about perspective as he was producing the most important photograph of his career. While he was contemplating what to do with the photograph, there were public conversations taking place in the pages of *Sovetskoe foto* about how to create better perspective in photography.

One article in particular, S. Lerman's "Representing perspective in photography," talked at length about how the eye sees in three dimensions, and stressed that the photographer's challenge is to recreate the experience of depth in two

dimensions, paying particular attention to an image's vanishing point. Lerman makes the obvious point that the basic rules of perspectives are not new: "[They] were established by the artists Piero della Francesca and Leonardo da Vinci and others."[12] In that moment, Baltermants may have done what da Vinci did five hundred years earlier: he brought his knowledge of mathematics and science to bear on producing the photograph that best captured that moment of horror at the trench by focusing on the image's vanishing point.

Therefore, it is hard to take seriously Baltermants's modest claim that all he did was repair a negative. He did so much more than that. When he printed the Kerch image for exhibition and publication, he made sure to put out the best version he could, one that better reflected the photograph's new function as an art photograph. Baltermants transformed his wartime journalistic image of Ivanova into the photograph that would come to define his career. He recognized that the photograph did not simply document an external reality, as he referred to himself as an "author" of the photograph.[13]

Baltermants's final version echoes classic battlefield photography in a long line stretching back to Mathew Brady's images of the American Civil War from the 1860s, which stunned and shocked American audiences.[14] Those photographs focused on an endless battlefield of dead soldiers or on a military fort and breastwork as Brady encourages the viewer to see an endless space of grief rising off into infinity. For Baltermants, the depiction of a woman grieving over her husband on that endless field of corpses, one of many such women, heightened the drama of the living engaging with their dead. Not only did his final version resemble other iconic postbattle scenes, it also echoed other icons of atrocities in which a living, nameless woman grieves over a dead man, either a husband or a son. Recalling the Pietà, Baltermants produced a woman in sorrow observing the horror on earth as the clouds imply a relationship between human violence in an Augustinian "City of Man" and the heavens in his "City of God."

Solo shows had become more common among Soviet photographers during Khrushchev's Thaw period, usually focusing on "photo masters," photographers who had been taking pictures in the Soviet Union at least since the Stalin era. In 1959, Pyotr Otsup, the prerevolutionary photographer, who had documented Lenin's rise to power, was honored with a solo photography show at the SSOD's House of Friendship.[15]

In 1962, the Central House of Journalists hosted several solo shows for the country's most important photographers, including Maks Alpert, Nikolai Kozlovskii, and Baltermants. Hung salon style, some walls included three exhibition-sized prints that nearly stretched to the ceiling, as the editors-cum-curators aimed to display as many photographs on the walls of the modest exhibition space as they could. Viewers would have strained their necks to see

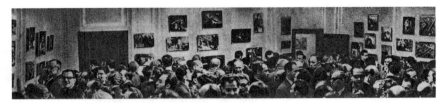

"Maks Alperts' Jubilee Exhibition." *Sovetskoe foto*, no. 5 (1962)

those hung at the top. Nonetheless, the goals of these shows, usually in honor of a birthday or an anniversary of one's professional career, were about celebrating a photographer. The specificity of any single image became less important than the totality of a career.

Baltermants's retrospective went up in that space in July 1962 to honor his fiftieth birthday. *Sovetskoe foto* covered the opening of the show, at which Pavel Satiukov, the editor of *Pravda* and chairman of the Union of Soviet Journalists, spoke.[16] He extolled Baltermants's gift at capturing the "joyous life and labor" of the people as well as the difficult times during the Great Patriotic War. Visitors received a glossy pamphlet celebrating the show that included a checklist of the 120 prints on exhibit, along with four reproductions, three contemporary and one from the war. He had planned to produce a proper catalog, but its production got only as far as a mockup, which nonetheless shows the photographer's vision for the work.[17] In his handwritten checklist of the show, Baltermants did something that photojournalists rarely do but that is a common convention for photographs hanging on walls in an exhibition: he titled his photographs.

Baltermants led with his best material, most of which he had taken during the war. The lone wartime photograph he reproduced in the pamphlet was called *Tchaikovsky . . . Germany, 1945*. The name was that of the most familiar Russian composer in history, Peter Tchaikovsky. The image shows a group of Soviet soldiers near Breslau, today's Wrocław, sitting around a piano. One of them plays a piece, presumably by Tchaikovsky, in a formerly grand German home that now lay in ruins, save for the upright piano pushed against the lone standing wall. The photograph resembled other Baltermants photographs from late in the war, when Soviet soldiers had finally reached German soil, documenting the stone-cold death of Germany and the life force of culture that the Red Army brought with it.

Although the photograph had little newsworthy information, the title highlighted the persistence of Russian culture during the most barbarous war in history. Baltermants titled it in the early 1960s, at a time when the Soviet Union had opened itself up to the West, and the United States in particular. This post-Stalinist opening of the Soviet borders was both about fostering mutual

Dmitri Baltermants, *Tchaikovsky*, Breslau, 1945

understanding and about engaging in competition between the two economic and social systems—communism versus capitalism. Khrushchev knew which system he thought would triumph.

Perhaps it was the 1959 Kitchen Debate, between Khrushchev and US vice president Richard Nixon at the American Exhibition in Moscow that launched the public competition that eventually infiltrated all aspects of life.

Who got to space first? The Soviet Union did in 1957, and then Soviet cosmonaut Yuri Gagarin was the first person in space in April 1961; the American astronaut Alan Shepherd followed one month later.[18]

Who had the best pianists? In 1958, Van Cliburn from Texas won the International Tchaikovsky Competition for piano at Moscow's conservatory. Cliburn's victory may have warmed the hearts of Muscovites and the world at large, but it also challenged the Soviet claim to superiority in classical music over the decadent, Elvis Presley–listening, lascivious hip-gyrating rock music that Americans loved.[19] By naming his photograph *Tchaikovsky*, Baltermants reminded its viewer that the Soviet Union was the country that, even in the darkest of times, conquered fascism through the might of the Red Army and that those soldiers brought with them the beauty of Russian culture.

But it was not *Tchaikovsky* and its redemptive theme of music overcoming evil that captured audiences at his first photo exhibition. It was a second photograph from World War II, titled *Gor'e*, usually translated as *Grief*, that garnered the most attention. The title referred to an emotion, one connected with a living person's relationship to the death of a loved one.[20] *Sovetskoe foto* was the first press outlet to publish Baltermants's new version of Ivanova with his chosen title, *Gor'e*.

The *Sovetskoe foto* critic who wrote about the show, A. Aleksandrov, called Baltermants the "barometer" of Soviet photography, one whose most distinguishing characteristic is the fact that "he has reflected the mainstream of all postwar Soviet photography. His work could easily be titled the 'History of Soviet photography from 1941 to the present'" because "more than anything Baltermants is a journalist first, and only then an artist." By this he meant that a journalist was "more flexible and open" on formal questions than an artist. Baltermants's photographs are defined by their "direct and sharp reflections of events and the pathos of contemporary reality." More than any kind of aesthetic movement, at the center of his work are the historical events themselves. Put another way, Baltermants serves as the "photo-chronicler of our time, whose point of departure was the year 1941 and the outbreak of war with fascist Germany."[21]

As Aleksandrov concluded his overview of the Baltermants retrospective, he emphasized that not only were the photographs important for their "historical meaning and understanding of humanity" but, given the conditions of war,

"there was no place for embellishment or rhetoric, so the photographs reflect truthfulness as it is."[22]

What does it mean to be "truthful" when those representing the most violent war in history are at a loss for words and perhaps even images? Baltermants, in repairing the damage to the negative, responded to the failure of photographic technology to represent the horrors of reality by adding clouds. Aleksandrov too addressed the messiness of truth. He describes *Gor'e* as one of the most important photographs of Baltermants's more-than-twenty-year career:

> Many [visitors] were struck by the picture *Gor'e*. The image is of corpses, those executed on an icy landscape not unlike one would encounter in springtime or autumn. The work is exceptionally dramatic. But there is also some kind of intentionality going on. The sky, low and gloomy, feels purposeful as if nature had produced it especially for this particular drama. However nature did nothing of the kind. The photographer printed the sky into the image, making it more impactful, but also less truthful.[23]

Although he asserted that the addition of the cloud, which he called "theatric," made the image less truthful, Aleksandrov also suggested that "truth" in photography, especially photography of war, does not mean a mimetic representation of external reality. This goes not only for *Gor'e* but also for *Tchaikovsky* and many of Baltermants's signature war photographs, which were "obviously staged images." But after all, in life, "one sees things that cannot be real, that seem theatrical." The critic closed with a fundamental point about Baltermants's photographs: "What's important is not what really happened in life, but what the artist saw in that reality, and how the artist chose to represent it." So a "chronicle" of Soviet photography of the Great Patriotic War by definition had to include photographs that went beyond what the camera documents.

Only experienced photographers knew how much artistic license to take when producing a print, and Baltermants, as one of the most senior photographers in the country, took plenty of license. More important than a photographer taking that license is having critics publish reviews in support of the photographer's right to assert that kind of creative vision. While it may have been true that, according to Aleksandrov, "staging and falsifying historical events had been the scourge of our photography," by 1962 that was no longer the case.[24]

Aleksandrov used his review of Baltermants's retrospective to make a broader statement to up-and-coming Soviet photographers, who were demanding "reportage," a seeming fealty to documenting external reality. One "despotic dogma" should not replace another: "In contrast with an official report, [a photograph] carries with it aesthetics that are simply taken for granted." This seems

obvious: What photographer does not have some notion of aesthetics? But he goes further: "Can't an art photographer tell a person's story by basing it on long term observation and producing creative work with nature?" Aleksandrov argues that the creative process defining photography is true for *any* photograph, especially for portraits, which are always staged. All photographs are the product of a photographer's creative engagement with the natural surroundings to visually tell the story of a subject. No one worked with nature to produce more compelling visual stories than Baltermants.

Although *Gor'e* made its debut in summer 1962 on the walls of the House of Journalists and in September on the pages of *Sovetskoe foto*, Baltermants's contemporary photography was already well known around the world. The Photo Section of the SSOD had been participating in international photography exhibitions since the 1950s. In the early 1960s, the scale and scope of these exhibitions increased as cities around the world, large and small, saw the hosting of such an exhibition as a marker of status in the art world. Through its partner organizations in capitalist countries, the SSOD saw the opportunity to send Soviet photographs, and through them its ideology, to anywhere hosting an exhibition.

In 1962, just as the House of Journalists was showing his retrospective, Baltermants's photographs could also be seen in an international photography exhibition in Santos, Brazil. The SSOD sent seventy-nine works by more than two dozen photographers, including three by Baltermants. All of his were contemporary photographs, two of them in color.[25] That same year, the organization participated in a major international photography exhibition in Adelaide, Australia, again including three of Baltermants's works.[26]

While Baltermants and other Soviet photographers were being exhibited in the Southern Hemisphere, that same year, the USSR–Great Britain Society, a bilateral subgroup of the SSOD, hosted a solo photography show in Moscow, at the House of Friendship, for the Russian-born English photographer Ida Kar. Soviet–British relations occupied a particularly important place in Moscow's new openness to Western countries, since it was the first capitalist country Khrushchev visited after the 1955 Geneva summit that put cultural relations with such countries on the Soviet Union's agenda in the first place.[27] As part of these exchanges, Kar had visited the Soviet Union several times in the late 1950s as she took photographs that would end up in her exhibit, which opened on April 2.[28] The event was a grand affair, receiving mention in *Pravda*, with speeches by Kar and the British ambassador, Frank Roberts. Although *Pravda* did not mention it, representatives from the society likely made speeches as well, and perhaps even Baltermants.[29] The society also produced a bilingual catalog of her work, *Ida Kar: Artist with a Camera*, a lasting artifact of an ephemeral exhibition.[30]

In 1963, the Czech illustrated publication *Praha-Moskva* published Baltermants's new version of Ivanova in an essay accompanying an exhibition of Soviet war photography in Prague. Here, the Kerch photograph appeared with the simple, haunting Czech-translated cognate title, *Hore*.[31] His work was starting to be exhibited as part of the Soviet Union's broader project of friendship among communist nations, in this case between the Soviet Union and Czechoslovakia.[32]

Also in 1963, the Great Britain–USSR Association, the society's partner organization in London, began organizing a reciprocal solo show for Baltermants to take place in England's capital in 1964. The archival records of the Baltermants show highlight the challenges of cultural exchange.[33] From the basic fact that communication by post was slow to the clash of competing political goals of London and Moscow, the society and the association agreed on little except that they both wanted to hold the show; that the host site, in this case London, would pay its costs; and that there would be a catalog, as there had been for Kar's show.

Where and how the catalog would be published led to a major rift between London and Moscow. The key source of conflict was in the SSOD's desire to list as cosponsors as many British organizations as possible, including those associated with the British Communist Party (BCP). This benefited Moscow's vision of fostering cultural cooperation as a means of overcoming the political divisions between the nations. Therefore, the BCP could not be excluded from the list of cosponsors. The British association, on the other hand, needed to appear as apolitical as possible and therefore insisted on having no visible BCP participation.[34]

On the Moscow end, the process of producing the catalog and show moved forward smoothly. Prints were produced, catalogs were published, and flights were booked. There was one issue into which the SSOD intervened—a request that the censorship agency Glavlit not stamp the photographic prints being approved for export. Glavlit presumably complied, because censorship stamps on prints being exhibited abroad would not send the right message about the open flow of culture.[35] Baltermants selected ninety-five exhibition prints to include in the show, an average number for an SSOD traveling show.[36]

Back in London, the association and its associate director Michael Green were responsible for its installation. Green had managed to secure the Ceylon Tea Centre, a space the association had used in the past, at the last minute, but was disappointed with its "grubby appearance." But Green had bigger concerns: he was skeptical that photographs could even be considered art and therefore was not convinced of a photograph's ability to stand alone on the wall. He thought that photographs, unlike paintings, could become repetitive, possibly even boring. To get beyond the individual photograph, Green clustered Baltermants's carefully numbered works of art into groups rather than hanging each photograph on its own. To achieve the desired effect, he used a single spotlight to highlight

a cluster of photographs. This solved two problems at once—both to assuage his fear of boredom on the part of the visitor having to slog through ninety-five photographs and also a means of masking the substandard state of the gallery.

Green was not the only person concerned about exhibiting photography as one would exhibit a painting. These questions faced anyone exhibiting photographs, Soviet or otherwise, ever since they were first put on display. How large should a photographer make an exhibition print? On what kind of paper? Some photographers favored large prints (such as at popular exhibitions, when photographs were blown up to 2–3 meters square); others preferred more intimate-sized photographs, as one might see on the page of a magazine, so that viewers had to get close to the image. Should the photographs be matted? If yes, how big a mat and what color? And then the biggest question facing anyone exhibiting works on paper: To frame or not to frame? Framing elevated photography to the status of art, but it also increased the cost of the exhibition. Most 1950s photography exhibitions did not frame the work on display.

The final question for any curator thinking about the viewer's experience in the gallery was the tombstone, the information accompanying the photograph that included title, date, and materials used in the production of the photograph. Should these be in a large or small font? What kind of type? What color? And how to affix the label to the wall? Pins into cardboard? Adhesive labels on the wall? There were so many questions for a photography curator and few authoritative sources to consult, let alone training programs in the art of photography curation.[37]

After a photographer printed, matted, and on rare occasions framed a photograph, how should it then be displayed? With the exponential increase in cameras and photographers in the 1950s, new forms of public photographic display emerged to respond to the ever-increasing abundance of photographs. In some cases, the "wall newspaper" morphed into the photo newspaper or the photo display case. The Soviet camera manufacturer Zorkin produced its own photo newspaper called *Don't Leave Behind the Zorkin*. Found in combine plants, a store's glass display case, a youth dormitory, or a workers' club, the Zorkin newspaper was both a form of advertising for the Soviet camera as well as a means of spreading news and information.[38]

Installation shots from the 1950s and 1960s suggest that Green's display of photographs was not that different from Soviet exhibitions, although the motives may have been different. Whether it was an international exhibition in Amsterdam or a solo show in the Moscow House of Journalists, photographs were rarely hung solo. In her comments about the 1955 Second International Photo Exhibition in Amsterdam, reviewer Irena Pavelek from Poland commented that the exhibition "lacked any kind of decoration. The photos were hung on white

walls without easels, frames, or glass. And the titles and last names of the photographer were placed on small cards."[39]

This may have been because of the overabundance of photographic images. On one occasion, Baltermants asked the curator of the 1957 Budapest exhibition what his biggest challenge was in putting on the show. The curator's response: "selecting from the more than 3000 submitted photographs the ones that you now see." In general, an exhibit organizer—or a person today we might call a curator, a word rarely used in the early 1960s to describe someone whose primary job was acquiring and displaying photography—hung at least two photographs, if not three or even four, vertically stacked on the wall.

The show that Green curated finally came together in June 1964 with the title *People and Events of the USSR: An Exhibition of Dmitri Baltermants.* The large-scale photographs had been printed in Moscow, likely on East German photographic paper, crated, and then shipped to London. The SSOD failed to notify Green about the shipment, so the crates sat on the doorstep of the Grosvenor Place offices of the association for some time before someone noticed them. When Green opened the crates, he saw large glossy photographs of children playing, men fishing, costumed women folk dancing, and factories producing, in both black and white and bold color. The subjects of the photographs, not to mention the title of the show, supported the core goal of the association in London and the society in Moscow: to create mutual understanding among everyday people in England and the Soviet Union.

For this, his first solo show abroad, Baltermants relied on the organization of his 1962 solo show from Moscow, but he rearranged the order of photographs. In London, he led with the photographs he had taken two decades before, during the war, each one with an evocative title: *Chaikovsky . . . Germany, 1945; Tank Attack; Sorrow (Ditch of Kerch),* which was a different title for *Grief; Across the Oder,* depicting soldiers pushing an antitank gun across the Oder River; and finally *Parade in Moscow, 1941,* a wintertime scene of troops on Red Square preparing for battle. Only *Chaikovsky* and *Parade in Moscow* had dates included in the title.[40] Baltermants selected these five wartime images as signature photographs that defined his emerging global reputation.

The SSOD had commissioned several essays for the accompanying catalog. Journalist Konstantin Simonov was invited to contribute the lead article in the catalog. This was an unusual choice for an essay introducing a catalog of contemporary photography. Simonov was one of the most important newspaper correspondents and leading writers during World War II and wrote some of the most arresting reports from Nazi extermination sites across the Soviet Union and Poland. In addition to his firsthand accounts of Nazi atrocities, he shaped the Soviet response to those atrocities. His 1942 poem "Kill Him" fostered a culture

Dmitri Baltermants, *Tank Attack*, 1940s, print made 1960s

of vengeance in a people brutalized by the German occupation. At the time, Simonov called on his *Pravda* readers to "kill a German every time you see one."[41] If words were not enough, the artists' group Kukriniktsy visualized Simonov's poem in a widely circulating wartime poster by the same name.[42]

Therefore, it should not have been a surprise that Simonov's essay, titled "On Dmitri Baltermants," did not comment at all on the show's contemporary photographs of Soviet daily life. Instead, he wrote about the war photographs: "Among the work which Baltermants is taking to London are a few photographs from the war . . . During the war with fascism he was one of the most courageous of our war correspondents. . . . If I was asked which of the photographs I like the best I would answer 'Kerchenskii Trench.'"[43] It is important that Simonov did not use Baltermants's chosen name for the photo; he used a name more specific to the history behind the photo rather than the emotion it expressed.

Simonov knew what Nazi atrocities looked like, having seen them firsthand. He said as much in his catalog essay: "In my notebook from the time, I have dozens of pages about this very subject." Many of Simonov's impressions about Nazi genocide ended up in his published articles from the war about Majdanek and other extermination sites. But Simonov admitted that "the photograph shows me something I did not know, something I had not noticed or hit upon. The photograph has the distinction of being a work of art rather than just simply

Cover of the catalog for the exhibition *Dmitri Baltermants: People and Events*, Ceylon Tea Centre, London, 1964

ON DMITRI BALTERMANTS

I AM very glad that the exhibition of Dmitri Baltermants' work is to go to Great Britain. A piece of my country's history, its past and present is coming to Great Britain together with these one hundred photographs.

Baltermants has the sharp eye of a talented and honest artist. He knows not only what people of this country look like, he also knows what they think and what they feel, because he himself is one of them, he studied with them, worked, fought, lay in military hospitals and then worked again.

Some of the photographs which he brings to Great Britain are not taken here in this country but abroad. But these photographs are also a piece of our history to a certain extent, a piece of the history of our attitude towards people of other countries and other continents. These shots of London and Moscow were seen through the same eyes—these were the eyes of a man, who is sensitive to both the beauty of things and of the human personality.

There are some shots of the war among the photos Baltermants is bringing to London. During the years of the war against fascism he was among our bravest war correspondents. I can state this because for some time we worked in the same army newspaper and I well remember what each of us was worth then.

Should I be asked which one of Baltermants' photographs I love best of all I should answer: the "Ditch of Kerch" ("Sorrow"). I was in Kerch at that time and remember all this quite well. Several dozens of pages in my diaries are covered with notes describing this very event, and, after all, this picture reveals to me something which I did not know, which I had not noticed, which I had not thought of. But it is in just this way that art of photography differs from common photography. If it is art it should reveal something new to you even in things which you have seen, even in what you seem to know as well as anybody else. And in this case the striking photograph of Baltermants reveals to me something new in what I felt I already knew perfectly well. And this is great art.

I have said about this picture that I love it. This is so. But to say only this will not suffice. Looking at this picture I hate war. I hate fascism which unleashed this war, I hate people who killed these people lying dead on this wet muddy horrible earth.

I have told you about one photograph. I could have told you about others as well, told something different for they themselves are different. But in appreciation of his skill I should have said basically the same about them. So I limit myself to what I have said.

I should like to add only one thing. Dmitri Baltermants is now one of our greatest and most famous masters in photography and his biography is not quite usual for people of his profession. Before he became a professional photographer he had been a mathematician and had graduated from the physical and mathematical faculty of the Moscow University. May be, I should not have said what I am going to say if I had not known that. But sometimes it seems to me that knowing his former profession, the mathematical foundation on which he started building his life has produced the amazing finest precision and scrupulously calculated design of Baltermants' shots.

Konstantin SIMONOV

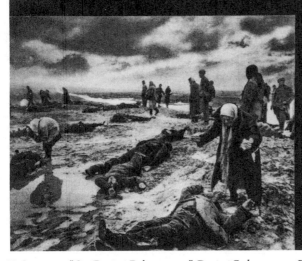

K. Simonov, "On Dmitri Baltermants," *Dmitri Baltermants: People and Events*, 1964

a photograph. Art must reveal something new even for the person who has seen the event and would think that he knew as much about it as anyone else."[44]

Simonov highlighted the transformative potential of a work of art, even for a viewer who was at the scene being photographed. (In the show, the photograph was undated, only adding to its timeless quality.) He continued, "I have said that I love this photograph. That is true. But to say only that is not enough. When I look at this photograph I also hate. I hate the war, fascism, anything connected with this war. I hate the people who have killed those lying dead in the damp, dirty, terrible earth." For Simonov and, he was hoping, for the British viewers of the exhibition, the photograph of Ivanova moved him, not just out of appreciation for a work of art, but for the politics behind this particular work of art.[45]

How would a reader of his catalog essay respond to his "politics of hate"? His words could encourage readers to become pacifists, although Simonov himself was anything but a pacifist. (From its earliest days in the 1940s, the Soviet peace movement was far from pacifist.) More likely, he hoped the photograph might inspire a new set of questions about *who* killed those lying dead at Kerch.

From one vantage point, Simonov was calling out the perpetrators of the "Holocaust," a word that had recently been applied to describe the racially motivated Nazi genocide of European Jews and others. This included the vast majority of those lying dead inside the trench near Kerch, the seven thousand peaceful Soviet citizens beneath the surface of Baltermants's Kerch photographs. The essay and the photograph appeared as the country was resurrecting the wartime image of the ravine and trench, in this case the one at Bagerovo, as a symbol of fascist atrocities across the entire Soviet Union. For Simonov, and more broadly from a 1960s communist perspective, the central issue was not the ethnic identity of the victims; it was the motivation of the perpetrators and the suffering and heroism of its chief victims—the Soviet people.

Simonov first called the photograph *Kerchenskii Trench* in the English translation of his article. By the last version of his essay, which was accompanied by a reproduction of the image of Ivanova, it was titled *Ditch of Kerch (Grief)*.[46] In the end, though, the wall label (*Ditch of Kerch [Grief]*), the catalog listing (*Sorrow [Ditch of Kerch]*), and Simonov's *Kerchenskii Trench* all missed Baltermants's preferred English title describing a deep human emotion—the single haunting word *Grief*.

The show had a brief ten-day run, from June 23 through July 4, 1964. It opened with a formal reception, whose guest list included a who's who of British photography. The event itself included speeches from Kar, since she had received a similar reception from her Soviet photographic hosts in Moscow two years earlier, a representative of the Soviet embassy in London, and the guest of honor, Baltermants himself, who had come to England for a three-week tour.

More than two thousand people visited the show over its ten days. Although Green had been worried about a photograph's ability to capture the attention of gallery-goers, viewers loved Baltermants's "art photographs," a phrase used repeatedly in the guest book. Visitors used adjectives like "magnificent," "powerful," and "profound" to describe both Baltermants's technical skill as a photographer and his aesthetic vision. Referring to him as Russian, rather than Soviet, gallery-goers came from all over Great Britain as well as from India, the United States, and Australia. It was a rare treat for visitors to see any exhibition in London dedicated to photography, let alone work by a photographer from behind the "Iron Curtain."

Many of the most celebratory comments were from the other photographers who came to see images by the Soviet master. Among them, one name stood out in the guest book. Anya Teixeira, a British photographer who had cofounded the Creative Photographers Group in London that year, was born to the Gershonowitz family in Odessa before the Bolshevik Revolution. In the wake of the revolution the family fled to Berlin, where they remained until 1939, when they left for England. Daughter Anya took the family name of her Brazilian partner, Teixeira (they would have married were it not for the Nazi antimiscegenation laws). She took up photography in wartime England and quickly became well known across the country.[47] She referred to him as a "great photographer" and made particular note of *Gor'e*, which she thought "should have been in the 'Family of Man' exhibition."[48]

Indeed, perhaps it should have been included. Steichen's 1955 *The Family of Man* exhibition aimed to transcend political differences through photographs of everyday experiences taken not long after a cessation of hostilities in the Korean War. The US Information Agency had underwritten that show's global tour, but nonetheless Teixeira implied that like Steichen's exhibition, Baltermants's photographs had a universal quality that seemed to transcend politics. One anonymous comment suggested that Baltermants is "a great artist, not purely of Russia, but of humanity," and another celebrated his ability to "capture [the] spirit of humanity."

There was apparently only a single published review of the show in a photography magazine. Roger Hill's August 21, 1964, review in the *British Journal of Photography* first describes Baltermants the photojournalist and his work for *Ogonek*. The review said very little about the photographs on exhibit, although he criticized Baltermants for the fact that "there is no exaggeration of camera angle, no bombastic grain, no high contrast, technique, in short, [none of that] concerns him. Question is, whether by European or American standards, his pictures don't lose some drama by his ignoring the full range of his medium." The review closed with a mention of a single photograph that he considered his favorite, "A very

powerful idea of the Soviet Union does come through his pictures, and so they are, for the purposes of this exhibition, entirely successful. And one of them—'The Ditch of Kerch'—is one of my very favourite photographs." He ended with a quote from Simonov about *Grief*.[49]

The show was taken down in mid-July, and the three large crates carrying the ninety-five photographs were shipped back by boat to Moscow via Leningrad in mid-August.

During his three-week stay that summer, Baltermants took many photographs of England. In fact, he took one of his best-known photographs of the early 1960s, *Reminiscences* (*Vospominaniia*), an image of an older woman looking at a wedding dress, on the streets of London. He published a photo essay in *Ogonek* later in 1964 depicting everyday English life, this time for a Soviet reading audience, precisely the intention of photographic diplomacy.[50]

In the same year, Baltermants's Kerch photograph appeared in the show for which Garrubba had originally come to Moscow in search of material—Karl Pawek and Heinrich Böll's massive exhibition, *Was ist der Mensch?* (*What Is a Human Being?*). Pawek decided to break up the exhibition into forty-two "photographic sentences" that would attempt to answer the question posed in the title. Baltermants's lone photograph appeared in the third sentence, "Man against man," a collection of war photographs. There were no titles in the catalog, only notes at the back. The description for Baltermants's photograph reads: "Immediately after the retreat of German troops (1942) residents of Kerch (Crimea) search for their fellow citizens from among the dead."[51] There was no reference to the Soviet Union or even to Russia, just to a place called Crimea.

The show opened in Hamburg and then traveled across Europe for several years. What Baltermants did not know was that his photograph won the Viewers' Prize for best photograph in the show from among 555 photographs, earning him 6,000 West German marks.[52] Being presented in this photography show embedded Baltermants and *Grief* in a European-wide conversation about the legacies of war, and specifically World War II. It also responded to Teixeira's frustration that *Grief* had not appeared in *The Family of Man*. Ten years after that groundbreaking show, it *did* appear, albeit in a different but equally massive photography show. For Baltermants, who saw himself as a photographer, artist, and diplomat, the show's wide distribution meant that his photograph, in the words of Soviet photo historian Vladimir Nikitin, "would tell the entire world about what our people lived through during the war."[53] And thus *Grief* and its central role in Soviet diplomacy was born.

In October 1964 members of Khrushchev's inner circle ousted him from power, an event that Baltermants also documented, making Khrushchev the first general secretary of the Communist Party not to die in office. Leonid

Dmitri Baltermants, *Reminiscences*, London, 1964

Brezhnev followed him as general secretary and died in office in 1982, as did subsequent general secretaries until the collapse of the Soviet Union. Baltermants photographed Brezhnev's funeral.

Khrushchev's ouster could have meant trouble for Baltermants, as it did for other leading figures in photography such as Pavel Satiukov, who lost his job as *Pravda* editor when Brezhnev came to power. Instead, Baltermants's career continued to soar. *Ogonek*'s director of photography, Semyon Fridlyand, one of the founders of Soviet photography, passed away in 1964, leaving the position of photo director open. As a result of Baltermants's success in London and Hamburg, Anatolii Sofronov, editor in chief of *Ogonek*, named Baltermants its

Dmitri Baltermants, *Khrushchev's Last Time on the Mausoleum*, 1964

director of photography in 1965.[54] That same year, he also was elevated to the position of president of SSOD's photography division.[55] This made him the most powerful creator of the Soviet Union's public image around the world during the Cold War.

Baltermants became well known not only among other photographers but also across the Soviet Union. Two popular Soviet films, released in 1966 and 1968, each referenced Baltermants as a leading photographer and as someone worth emulating.[56]

In January 1965, *Ogonek* published "We Will Never Forget!," a two-page layout of *Grief*, although the photograph itself was left untitled.[57] This was the first time any of his Kerch photographs had appeared in a central Soviet publication since the war. After more than twenty years, it now served different purposes. More important, "it" was not the same image as the photograph from 1942. When Ivanova's grief upon finding her dead husband was news during the war, the photograph visualized fascist atrocities against Soviet citizens, most of whom were Jews, and the grief overcoming Soviet women left alive in the aftermath. The wartime publication and wide distribution of it and other Kerch photographs by Baltermants forced readers to bear witness to war crimes perpetrated by the national enemy against the Soviet people.

In the 1965 pages of *Ogonek*, *Grief* was given additional context. First, in small print, the editors included a comment from Böll, who had included the

prize-winning photograph in the *Was ist der Mensch?* exhibition: "Women on the field of battle searching among the dead for their loved ones. Their cry stops being their own. It becomes the cry of humanity." He could not have expressed a pathos formula of battle any better. Moreover, unlike Simonov's politics of hate, which inspires the reader to action, Böll's emphasis on the women's crying transcends politics and silences any call to action on the part of the viewer. One is left contemplating the women and their sadness rather than being angered by the horrific violence. But Böll's meditative comment is small and placed on the lower left; it is not the headline over the photograph.

The phrase "We will never forget!" played that role and complicated, potentially even undermined, Böll's universal, postfascist appeal. Using the first-person plural immediately begs the question as to who is included in this "we." "We," in such a context, refers to all Soviet citizens, since *Ogonek* came out in Russian and as the lingua franca of the Soviet Union reached a broad, middle-class, pan-ethnic audience. The issue of "what" will not be forgotten emerges from the question of who constitutes the "we." During the war, the phrase "We will never forget" was used frequently, especially after the discovery of a Nazi atrocity site, to rile up anger and foment vengeance against the Germans. It read something like: "We will never forget the war crimes you German, Nazi, Hitlerite fascists have committed against us peaceful Soviet people, and we will avenge those crimes." The phrase "we will never forget" was often followed by "we will never forgive."[58]

By the 1960s, that wartime tone of angry vengeance had waned. "We will never forget" became widely used in many contexts beyond the Soviet Union having to do with contemplating and memorializing a history of violence, in particular the developing memory around the Nazi genocide of Jews and others, which by this point was becoming known in the West as the Holocaust. The assumption was that contemplation of past violence might prevent future violence, but the mechanism for translating meditation into action was left vague. In fact, most uses of the phrase "we will not forget" encouraged memory of the past rather than action in the present. The haunting photograph, then, seems to have fostered quiet, mournful contemplation.

Why, then, the exclamation point in the magazine? It expresses anger, not reflection; it encourages an active response for the reader, not passive contemplation. It might remind readers of their feelings from the war and, in the 1960s, might encourage them to follow Simonov's charge about hating those who committed the crime. The two-page layout and the exclamation point seem to charge the reader to *do* something with the memory of the event reflected in the photograph.

And then there is the question of why are we not forgetting. This relates to the question about Simonov's politics of hatred that he addressed to a foreign

audience. Is a reader of *Ogonek* meant to remember war in order to end it, as the workers' petition in Baltermants's 1960 photograph might suggest? Or is it a call to maintain vigilance against the return of fascism, to look for fascism where it might still lurk and respond to it?

At the level of a collective response, would a Soviet Jewish reader of *Ogonek* respond differently to the three questions posed above? Which Soviet Jewish reader? On the question of "we," such a reader may have also read Jews into the collective first person, although it is not clear if the photograph would still have maintained any connection to the original news story—about the racially motivated murders—except perhaps for a Soviet Jewish reader living in Kerch in the 1960s.

It is highly unlikely that any reader would have read only Jews, and not Soviets, into the title. For a Soviet Jewish collective "we," one would have to turn to *Sovetish Heymland*, the Soviet Yiddish journal that began appearing in 1961 and regularly published articles about the specific Jewish wartime experience in general, and the Nazi genocide of Jews in particular. The editors of *Ogonek* and perhaps Baltermants himself—a Soviet Jewish photographer invested by the state with the power to create its visual record of how the Cold War shaped memory of the Great Patriotic War—invited *all* of these questions without providing definitive answers.

VALUING *GRIEF*

On that damp gray day in Kerch when he turned his camera toward a field of mourners searching for their dead, Dmitri Baltermants created an image that had value. His Kerch images were considered something of importance and use for which his employers and other news agencies during World War II paid good money. In 1942, his images had value to his newspaper editors, who employed him to take those photographs. The images of mourning women were of value to the Soviet state, which saw compelling visual material that would gird the population for a potentially long war.

The Kerch photographs were of value to the foreign press that saw glimpses of Hitler's war on the eastern front. Yet they were so gruesome that some editors were not sure they could believe them, and they frequently remained in the archives unpublished. In the 1940s, the value of Baltermants's photographs lay primarily in their documentary, informational, and motivational message, charging viewers to take revenge for the atrocities the Germans were committing against the Soviet people. In the immediate postwar period, his Kerch photographs, and others like them that documented the dead, were valued for their evidentiary potential in war crimes trials. Although the photographs of the Bagerovo trench do not document who committed the crime pictured (in fact, aside from photographs taken by the murderers themselves or forensic photographs in which one is able to identify the source of a bullet, very few photographs have evidentiary value useful in trial without a human narrative), it nonetheless reminded viewers in trials, whether the prosecutors or the defendants, that *someone* committed this mass crime.

Out of his Kerch series, sometime in the middle to late 1950s, Baltermants selected one image, *Gor'e/Grief*, that defined him as a photographer of international renown. He made this selection at a time when he and the Soviet state saw new ways of assessing the image's value. The Soviet Union valued the photograph for its role in fostering post-Stalinist Cold War diplomacy. If the wartime captions

emphasized fascist atrocities against the Soviet Union that took place at Kerch, Baltermants's title *Gor'e* expressed an emotion, one that only a living, suffering person can share. Domestically, *Gor'e* reminded Soviet readers of the horrors of a war that killed upward of twenty-seven million of their fellow citizens. The image had a particular resonance for Soviet Jewish readers as it evoked the specific mass murder of Soviet Jews. Its value shifted from the realm of news to one of memory.

When *Gor'e* became *Grief, Sorrow, Hore, Leid,* or any other name or phrase that non-Russian-speaking curators attached to the photograph, its value was in the image itself, as a panoramic scene of the tragic aftermath of war. In some foreign Cold War contexts, the photograph was valued for its specific Soviet provenance. In these cases, *Grief* was a reflection of the communist world, which was seen as either a place that would transform the world for the better or a totalitarian state that built and defended the Iron Curtain. More often, however, the fact that it was a Soviet photograph surprised viewers in exhibition spaces around the world. Viewers and critics abroad valued the image for its ability to communicate the tragedy of war and the depths of human cruelty. The ominous clouds, the corpse, and especially the anonymous grieving woman stood in for every viewer suffering the pain of loss.

Although photographs have always had personal, political, and aesthetic value, the photographic print, that piece of paper with an image on it, did not have financial value as a commodity from which photographers could make money. In fact, in the 1950s, nowhere in the world, neither in the communist Soviet Union nor in the capitalist United States, did a photographer make a living solely on the sale of prints. Photographers earned their living through their photographic work for magazines, newspapers, government and relief agencies, and during and after World War II, at least in capitalist countries, corporations, which saw the value of beautiful images in selling products.[1]

With the advent of new means of reproducing images, museums produced posters of objects in their permanent collections, including the occasional photographs they exhibited. Since a photograph was by definition reproducible, was a poster of the photograph, enlarged to exhibitable proportions, not good enough for a viewer to bring the aesthetics of an image into one's private home? Certainly, Soviet readers of *Ogonek*, who decorated their apartments with them, thought so.

In the twenty-first century, individual photographs sell for more than $1 million, and photographers, like other visual artists, support themselves on the basis of sales and commissions. There is in fact an entire institutional network dedicated to the collecting, buying, and selling of photography. When did a photograph gain financial value in the market, and how did *Grief*, a photograph

produced in a country that did not operate on market principles, gain financial value in that global photography marketplace?

In 1965, the same year that Baltermants published "We Will Never Forget!" for the Soviet readers of *Ogonek*, he continued to cultivate his international reputation, now from Leonid Brezhnev's Soviet Union. On the heels of his London solo exhibition, he was included in a landmark photography show in New York City, a place Baltermants had visited in 1960 when he reported on Khrushchev's visit to the United States, and in particular the United Nations, for *Ogonek*.

The organizer and curator of the 1965 New York show, Morris Gordon, was quite well known to the American and global photographic communities. Gordon served as chief photographer of Western Electric. Like most photographers of the 1950s who earned their living publishing commercial photographs, he also played important roles in building an infrastructure for magazine photography as a field of art. Gordon headed the American Society of Magazine Photographers, served as the US juror for the World Press Photo competition in 1963, and chaired the jury in 1965.

He took an additional job as coordinator, what we would now call a curator, of photographic exhibitions at the new Huntington Hartford Museum Gallery of Modern Art (GMA). His first act as the gallery's coordinator was to put together, or curate, a group show called *11 Photographers: An International Exhibition of Contemporary Photography.*[2] He planned *11 Photographers* (which ended up becoming twelve photographers, with the last-minute addition of Lord Snowdon, best known as a photographer of the British royal family) to run at the same time that New York hosted the International Photographic Exposition, May 1 through 9, in order to have a global audience for his show.

Gordon was on a mission to transform how the world saw documentary photography, which he claimed was rarely exhibited in American art museums. (We know this is not quite true given the Museum of Modern Art [MoMA]'s frequent photography exhibitions during World War II and in the postwar period, including a solo show by the French magazine photographer Henri Cartier-Bresson.) Nonetheless, Gordon, a man who had made his name in commercial and magazine photography, thought it was time to elevate the medium's status as an art form.

So, in addition to the exhibition, he published a beautifully illustrated programmatic statement in the May 1965 edition of *Camera*, the publication of the International Federation of Art Photography, based in Lucerne, Switzerland. If the international audience missed his exhibition in New York, it would not miss his manifesto in the field's flagship publication.[3] In it, he explained his rationale for mounting an art exhibition of "magazine photographers," including Philippe Halsman, Robert Doisneau, and Irving Penn: "My philosophy concerning

photographic exhibitions is really quite simple. It is to hang photographs in recognized museums where they are given the same consideration as other art media such as painting, sculpture, etchings and drawings."[4]

Gordon spent six years preparing the exhibition, and in the process visited ten countries, including the Soviet Union in 1961, a visit facilitated under the US-USSR Cultural Exchange Agreement. President Eisenhower had responded to Khrushchev's invitation to open up the Soviet Union by proposing a cultural exchange agreement between the two countries, which was signed in 1958.[5] During his visit to Moscow, Gordon met with the leaders of Soviet photography. He also visited the Manezh exhibition hall to see the recently opened photography show, *The Seven Year Plan in Action*. There, at least according to Soviet archival records of the encounter, Gordon "learned more about the Soviet Union than if he had read 1,000 books."[6] He also had specially facilitated meetings with Soviet photographers, including Baltermants, with whom every visiting photographic delegation met given his role as the then deputy director of photography for the Union of Soviet Friendship Societies (SSOD). Gordon decided to include a Soviet photographer in his show and invited Baltermants to participate.

After he selected the photographers, all men, it was up to the artist to choose the work to be exhibited. Among the thirty-five photographs Baltermants sent to the GMA, he included three of his most important war photographs along with several more recent photographs.[7] Although Baltermants printed his own photographs, he had many of them professionally retouched before sending them to his first big exhibition in New York.[8] This echoed his selections for the London exhibit, in which an exhibit on contemporary photography also included several twenty-year-old war photographs documenting Soviet suffering and heroism.

Gordon's *Camera* manifesto included one photograph from each of the eleven photographers. The image selected to represent Baltermants, the only photographer from a communist country, was none other than his already iconic image from Kerch, here titled *Seeking Out the Dead. Kerch Front, 1943*. Once again, this was an unusual choice to serve as a photographer's key image for a contemporary photography exhibition. Gordon's title, which incorrectly identified the date, context, and even the photographer's chosen title, shows how Baltermants's art photograph had become firmly embedded in the visual formula of a postbattle photograph. Moreover, Baltermants's photograph was the only noncontemporary one printed in Gordon's manifesto. It was also the only one with a very clear political message: in light of the tragedy of war, we must call for peace.

Gordon's goal of having the viewing public see magazine photographers as artists was successful. Photographer Alfred Gescheidt, who reviewed the exhibit for *Infinity*, a specialty magazine for the profession, was "knocked out by the show."[9] Gescheidt appreciated Gordon's decision to dedicate individual rooms

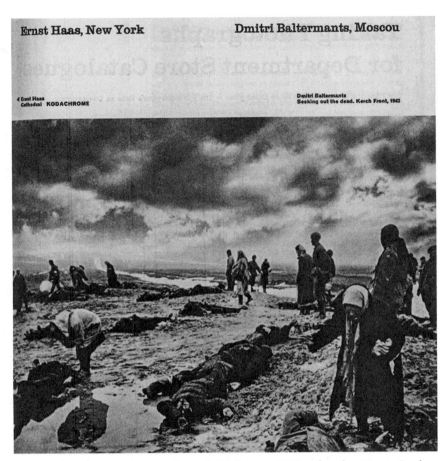

Ernst Haas, New York **Dmitri Baltermants, Moscou**

◄ Ernst Haas
Cathedral KODACHROME

Dmitri Baltermants
Seeking out the dead. Kerch Front, 1943

Dmitri Baltermants, *Seeking out the dead. Kerch Front, 1943*, as found in Morris Gordon, IPEX International Photographic Exposition, *Camera* 44, no. 5: 7–25

of the dramatic exhibition space to Penn and Halsman. This was a radical shift from Steichen's 1955 *The Family of Man* exhibition, which he organized thematically rather than by artist. Among all of Baltermants's photographs, Gescheidt mentioned only one, the same one Gordon included in his essay: "Dimitri Baltermans [*sic*] of Russia gave me the shock of seeing a great photograph. It was entitled 'Seeking Out the Dead. Kerch Front. 1943.'"

Although he thought the photograph was "great," he also implied that it might be aesthetically derivative: "We see that the best Russian photographers are now doing what the *Life* boys did twenty years ago." It is not entirely clear whether Gescheidt thought the aesthetics of *Seeking Out the Dead* with its dark clouds and focus on women were derivative or whether the process Baltermants used to produce the photograph was derivative. Either way, he explained why

Baltermants's photograph might actually bode well for Cold War politics, which was probably another reason Gordon included a Soviet photographer in the first photo show at the GMA: "That Russia is tagging along after American patterns of development in many ways may mean that we are not as nations forever doomed to misunderstand one another. For this reason, Baltermans' [sic] pictures and the values implied therein should be very welcome to the American eye."[10]

The dean of the New York photographic world at the time, New York Times camera editor Jacob Deschin, wrote even more glowingly about Baltermants's Kerch photograph, saying: "One picture in particular—a post-battle scene with mourners searching the field for their dead—may possibly go down as one of the great wartime landscapes of all time."[11] It is hard to overestimate the importance of Deschin's review of photography shows in the 1960s. Helen Gee, who in 1954 had opened Limelight, a coffeehouse in Greenwich Village that was one of the first places to exhibit photographs for sale, describes Deschin as the only camera editor on a newspaper whose opinion mattered.[12] (The Limelight closed in 1961, owing to insufficient sales.) With Deschin's glowing assessment, Baltermants and the SSOD could not have asked for a more successful response to Soviet photography. The who's who of the global photography world saw Baltermants's photographs alongside other great masters of documentary photography.

If the GMA show were not enough to launch Baltermants into the ranks of important global photographers, the Metropolitan Museum of Art included him in a series of exhibitions called Photography in the Fine Arts (PFA) that began in 1959. After Baltermants's critical success at the GMA in 1965, the Met curators took notice of his work. In PFA V, which ran at the Met from March to June 1967, the illustrious curatorial team, representing art museum leadership from across the United States, included Grief.[13] His was the only Soviet photograph among dozens of images in this major show.

After his 1964 London and 1965 and 1967 New York shows, Baltermants's international visibility continued to grow. In 1965, in his new role as president of the photo section of the SSOD, Baltermants corresponded with Frank Christopher, vice president of the Photographic Society of America and a central figure on the American side to develop photographic exchanges between the USSR and the United States, to have one-man photography shows tour their respective countries. The Soviet photographer Vladimir Shakhovskoi's exhibition toured the United States at the same time that Baltimore-based photographer Aubrey Bodine's exhibition toured the USSR.[14]

As for Baltermants the photographer, Caio Garrubba and the Italian Communist Party made arrangements for Baltermants to have a solo show in Rome in 1969 called "Baltermants's Rome." His images appeared in the party's magazine Vie Nuove in 1969 under the title, "A War Photographer and His

Vision of a City: Some Photographs of the Anti-Nazi War." The magazine included Baltermants's own photographic vision of Rome and published them just after his World War II photographs. The five "anti-Nazi" photographs spiral in toward the visual center, where we find *Grief.* In an interview for *Vie Nuove* in which he described the scene, Baltermants sets the number of dead in the trench at forty-two thousand. By exaggerating the numbers, he embedded the story of Kerch in the universal horror of massacres and atrocities and distancing it from the specific racially and politically motivated murder of Jews, communists, partisans, and others.[15] In April, *Fotografare* published a series of Baltermants's wartime and postwar photographs. The three war photos—*Attack, Grief,* and *On the Road to War*—were printed on a full page.[16] According to Soviet photographer and photo historian Vladimir Nikitin, who interviewed Baltermants in the 1980s, he told Nikitin that even the pope saw value in this photograph when it was used in an encyclopedia about religion as an "illustration of human grief."[17]

SSOD photography exhibitions showcasing a wide variety of Soviet photographers became a centerpiece of the country's cultural diplomacy, which reached its peak in 1970 with the *USSR Photo,* a massive exhibition of hundreds of photographers, including Baltermants, showing more than a thousand images in a show that traveled across the United States.[18] This meant that Soviet photography in general, and Baltermants's photographs in particular, were increasingly familiar to the American photo-viewing audience.

In the 1970s, Baltermants also held solo exhibitions in a variety of locations, including Prague; Nicosia, Cyprus; West Berlin; Budapest; Tampere, Finland; Brussels; Sarajevo; and Paris.[19] Nearly all of the catalogs have the Kerch photograph on the cover. In 1974, he served on the jury of World Press Photo in Amsterdam, one of nine photographers from around the world, including John Morris, chief photo editor for the *New York Times.*[20] In 1979, the German magazine *Die Zeit* reviewed a book of Soviet war photographs and described *Leid* (the German translation of *Grief*) as "recognized worldwide."[21]

Back in the Soviet Union, Baltermants's fame continued to grow. People wondered if the *Grief* photograph was the only one he took at Kerch. It obviously was not. When people encouraged him to publish the entire series for an exhibition dedicated to the thirtieth anniversary of the Allied victory, in 1975, he claims, "I did not agree." He explained at the time:

Publishing the details [of the surroundings to the photograph] would destroy the sanctity of the primary photograph; the details would lessen its power. But in the end, they convinced me I was wrong, and so I printed nearly all of the shots I took at Kerch in January 1942. Only then did I realize that I had been wrong. This reportage or more precisely this series of

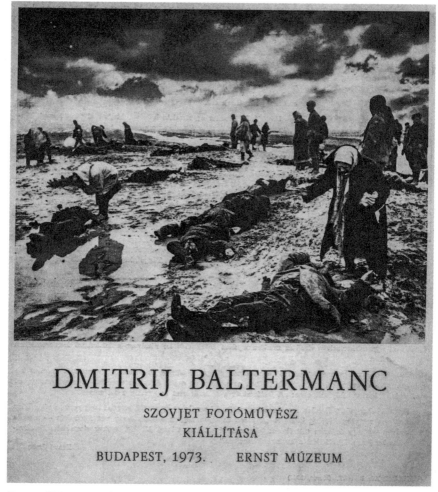

DMITRIJ BALTERMANC

SZOVJET FOTÓMŰVÉSZ
KIÁLLÍTÁSA

BUDAPEST, 1973. ERNST MÚZEUM

Cover of "Dmitrij Baltermanc," *Szovjet Fotómüvész*, Budapest, 1973

shots contained with them a special persuasiveness. They were amazing documents. And that's when I began exhibiting them at exhibitions.

The additional historical context provided by the other Kerch photos, some of which appeared in the March 1942 *Ogonek* photoessay, added value, or a "special persuasiveness," to *Grief*.

Before exhibiting the photographs in 1975, Baltermants returned to the outskirts of Kerch, to the precise location of his 1942 photographs. "Now there stands an obelisk with the following inscription, 'We will not forget, nor

will we forgive! In November 1941, here at the Bagerovo Anti-Tank Ditch, the fascist occupiers shot 7000 peaceful residents of Kerch.' "[22] Baltermants reflected on why he took Ivanova's picture several times in his later years: "At that moment I realized that I revealed this one woman's pain," never actually naming her. "I photographed her several times in various states. She sobbed, screamed, bowed towards the murdered, and those were the bodies of children. And now there are documents that will identify those people. How could I photograph that!"[23] But how he could he not have photographed that? It was his job. The ethics of a war photographer, and one who captured some of the earliest images of Nazi genocide, caused Baltermants much anguish for the remainder of his life.

To echo an emerging slogan describing the Soviet memory of its wartime past, Baltermants named his Kerch series *That's How It Was*, which was the same name given to a 1975 television broadcast about the war and to the 1971 memoir of a military journalist.[24] Baltermants also put together a book maquette of the series. It opens with *Grief*, which is then reproduced three more times in increasing size as the words *THAT'S HOW, IT, WAS* appear, one word per page, each in increasing size as well. The very next photograph is a series of control prints of the subject of the icon, P. Ivanova, in various states of emotion.

That four-shot sequence of a single image is then followed by more than ten photographs that Baltermants took at the Bagerovo antitank trench in 1942, several of which I described in the second chapter, including the close-up of the murdered Jewish children and the two photographs of Tereshchenko. He also included photographs of the transport of the dead, first as they come across bodies and then as they were transported by horse-drawn wagon.

Baltermants also included a close crop of *Grief*, this one focused not on Ivanova but on the other nameless woman and her reflection in the frozen pool of water.

The final three pages repeat the opening theme, *THAT'S HOW*, then another page with the word *IT*, and a final page, *WAS*, printed small. The accompanying photographs on those three final pages depict local residents transporting corpses in a wagon from the killing site, presumably for proper burial. A careful viewer would have noticed that *Grief*'s dark, haunting sky was nowhere to be seen in the archival photographs he reproduced.

But *That's How It Was* was not just about the wartime past. Baltermants went one step further and bookended the wartime images with contemporary photographs of the war's memorialization in the Soviet Union. On the cover, we see Baltermants's name and *That's How It Was* with a single photograph intended

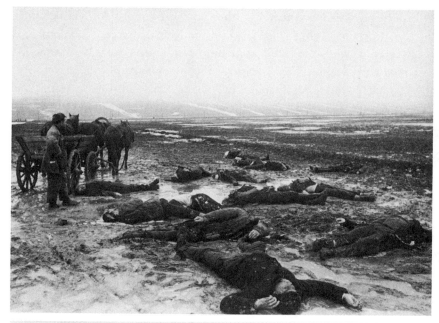

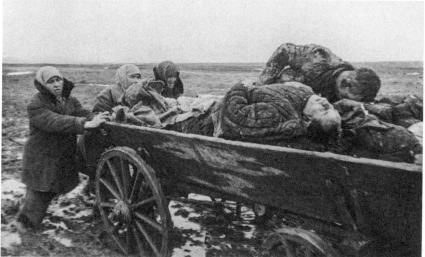

Dmitri Baltermants, *That's How It Was*, photos taken in 1942; *That's How It Was* exhibition, 1970s

to signal to the reader what one might find inside. It depicts a war memorial from Novosibirsk known as *The Grieving Mother*, which became a ubiquitous symbol on the Soviet memorial landscape in the late 1960s and 1970s. One of the earliest *Grieving Mother* memorials was designed by Lev Kerbel, a Soviet Jewish sculptor,

who was commissioned to design the figure as a memorial for a Soviet Jewish cemetery. In November 1965, it was unveiled with Kerbel and regional and local authorities in attendance. [25]

In Baltermants's cover image for the maquette, *The Grieving Mother* is an abstract, stone person, and although named "mother," the statue's gender is ambiguous. The actual figure looms over Novosibirsk's Glory Memorial Park, the city's war memorial complex, complete with an expansive stone square, eternal flame, changing of the guards, and a giant statue of tanks.[26] Its head is draped in a hood, eyes severe and on the verge of tears; the hands are almost skeletal and the right one clutches the mouth in sorrow.[27]

Cover of Dmitri Baltermants's maquette for *That's How It Was* (*Tak eto bylo*), 1970s

Under Brezhnev, when war memory became a central aspect of Soviet collec-
tive identity, memorial complexes to commemorate the Great Patriotic War went
up around the country. To represent heroism, there was usually a statue of mus-
cular soldiers, socialist realist in aesthetic, highly representational, and intended
to convey power and dominance.

At Volgograd, the former Stalingrad, the memorial complex sits atop Mamayev
Hill, the site of the city's fiercest battle. Looming over the city is *Rodina-mat'*, the
Mother Russia statue, a giant, muscular woman wielding a sword through the sky.
Begun in 1959 and unveiled in 1967, she is arguably the most iconic memorial to
the Great Patriotic War in the entire country. She stands guard over Grief Square,
a massive granite space that includes an eternal flame, a grave for an unknown
soldier, and a massive stone *The Grieving Mother*, holding an abstract child. (In
the post-Soviet period, local city authorities commissioned the construction of
an Orthodox church with gleaming gold domes to join *The Grieving Mother* on
Grief Square.)

If Mother Russia and the muscular soldier represent stoic heroism for the
local population, to represent grief and suffering most Soviet cities installed their
own "grieving mother" statue. She was often more abstract than her muscular
memorial counterpart, but she was generally in the same geographic proximity
to the memorial complex. These complexes, especially the eternal flame for the
unknown soldier, also became a site of contemplation and, in many cities, a pil-
grimage site for newlyweds.

Kerch had installed several socialist realist statues commemorating its heroic
wartime past, especially after it was named a "hero city" in 1973. These included a
massive granite statue near the harbor of three soldiers and an unusual memorial
of a motorboat, which celebrates the Red Army conducting a successful amphib-
ious landing.[28] But Kerch had no "grieving mother" save Baltermants's own pho-
tograph of Ivanova—who was mourning her husband, not her son. (Kerch finally
got its "grieving mother" statue, dedicated to the city's children killed during
World War II, in 2003.[29])

Why Baltermants chose the statue from Novosibirsk for this book we do
not know. Perhaps he chose the figure because it had already become a widely
recognized national symbol of wartime loss. Installed in 1967, the same year
that the Volgograd's memorial complex opened, this statue was one of the
earliest "grieving mother" statues to appear in the country. In 1974, the Soviet
state declared it an "object of cultural patrimony," and it appeared on postcards,
making the statue well known beyond Novosibirsk.[30] The final photograph in
That's How It Was is a serene photograph of a field of flowers in the same site
where the mass killings took place in 1941.

Through the 1970s, Baltermants's work appeared many times both in publications and as prints in exhibitions around the world.[31] In 1977, the Moscow publishing house Planeta produced *Dmitrii Baltermants: Selected Photographs*, a bilingual collection of Baltermants photographs with an introduction by Vasilii Peskov, who worked with him at *Ogonek*.[32] He had name recognition among those in the photography world. Yet although he had been widely exhibited, he was not yet well known enough for his prints to have financial value beyond the cost of production. In fact, according to Tatiana Baltermants, her father frequently gave his prints away as tokens of gratitude to his hosts when traveling to foreign lands and to other photographers, not recognizing the fact that these prints would one day have financial value on the art photography market.[33]

The origins of the photography art market go back to the 1950s and 1960s, when several events coincided to create a marketplace for an object that was infinitely reproducible. In 1952 Swann Auction Galleries, which specializes in rare books and prints, held the first auction in New York City dedicated exclusively to photography. The auction's highest-selling item was a set of a thousand collotype plates by the nineteenth-century photographer Edward Muybridge, which brought in a total of $200, or five cents per collotype.[34]

Through the 1960s, a new institution emerged that would transform the marketplace for art photography. University art museums and art departments built photography programs, and there was a sense among those working in those departments that they needed to have permanent photography collections for their museums to bolster their national reputation.[35] The University of New Mexico Art Museum opened in 1962 and put photography, at the time a rarely acquired art object, at the center of its permanent collection.[36]

Photographic prints were relatively inexpensive and could be used to enhance an institution's reputation in the increasingly competitive market for higher education. But curators of university art museums ran into a problem in terms of acquiring photographs. First, there was little money to acquire works of art, so those curators had to find creative ways to stretch a dollar. But more important than the issue of finances was the fact that unless curators reached out directly to photographers, there were no dealers or gallery owners for acquiring photographs. Perhaps an individual photographer had a personal relationship with a particular university, an alma mater for example, although most midcentury American photographers had not attended American universities. (If they went to university at all, it would have been in Europe, where most midcentury American photographers came from.) Otherwise, curators had to make the purchase directly from the photographer, a highly inefficient system for connecting supply and an ever-increasing institutional demand.

In 1969, three events took place that gave birth to a system, the fine art photography market, that would connect supply with demand. First, MoMA purchased the Eugène Atget collection from Berenice Abbott and Julien Levy. The photography powerhouse couple had offered the Atget collection to the institution back in the 1940s when MoMA first started exhibited solo photographers as artists, but at the time MoMA was generally not interested in using its scarce resources to buy photography. The Atget collection contained more than fourteen hundred glass negatives and nearly eight thousand vintage prints. Those prints were made from more than four thousand distinct negatives, making it one of the largest single acquisitions of photography by an art museum in history.[37] The museum exhibited a sampling of its new acquisition in December 1969.[38]

Second, the US tax code changed radically in 1969. The revision, which altered the way noncash charitable contributions were valued, made it increasingly difficult for artists, in this case photographers, to donate their works to art museums directly for their own financial benefit. In fact, it became impossible for artists to benefit more from donating their compositions than from selling them. So photographers needed to find new outlets to sell, rather than donate, their work.[39] And along came Lee Witkin, fomenting the third event of 1969 that helped foster a fine art photography market.

The thirty-three-year-old Witkin opened a commercial gallery space. Like Helen Gee and her Limelight café and commercial photo gallery before him, Witkin recognized that a gallery dedicated to "fine photographic prints" might not be financially sustainable on its own, so he maintained work as a freelancer for construction trade publications. As he wrote to Mrs. Cornell Capa in November 1968, after having met her husband, the brother of Robert Capa, at a photography exhibition opening, "I realize the chances of a photo gallery paying for itself are slight. But I'm willing to take the chance. Perhaps the time is ripe."[40] Witkin's first show, in March 1969, featured six contemporary photographers, whose prints he put on offer for between $15 and $35, again not much more than the cost of the production itself and hardly more expensive than Gee's prices in the 1950s. He sold a disappointing three prints. Six months later, he put on a show of the deceased photographer Edward Weston's prints made by his son, Cole. When the show came down five weeks later, Witkin had sold 150 Weston prints.

The commercial photography gallery served as the link between the photographer and the individual and institutional buyer. Through the 1970s, Witkin became well known nationally as the go-to address for photographs. In 1979, Witkin and his business partner Barbara London published *The Photograph Collector's Guide*, which they hoped would become a kind of primer to photography collecting.[41] Witkin's collector's guide included a list of photographers to keep an eye on. (And it included a pitch for himself: "a wisely selected dealer

will help you by supplying tips about quality, authenticity, good buys, bad buys, and so forth.")[42] The only Soviet photographer to have a full entry among photographers was Alexander Rodchenko, who was listed not as Soviet, but as Russian.[43] The index at the end of the guide included a longer list of more than a thousand photographers. Baltermants appeared on that longer list, along with more than a dozen other Russian or Soviet photographers.[44]

Baltermants and *Grief* may have been "world famous," according to a German magazine, but the image was relatively inaccessible to the marketplace given the fact that markets work in hard currency and the Soviet Union's currency, the ruble, was not convertible. Even if Baltermants's photographic prints were not collectible, he himself was a valuable commodity in the ongoing development of people-to-people cultural exchanges. The organization that facilitated Baltermants's visits to the United States in the 1980s was a small but influential nonprofit organization based in New York called the Citizens Exchange Council. Founded in March 1962, the council developed out of the Peace Hostage Exchange Foundation, an initiative conjured up by a young Bronx man named Stephen James.

"Peace hostages," a long-term exchange of family members of the US and Soviet leadership, were meant to develop trust between peoples in as visceral a form as possible. As a "Talk of the Town" piece in the *New Yorker* from March 1962 reported, "I feel that the exchange of hostages should start at the top. For example, let one of President Kennedy's brothers or sisters go with his or her family to Russia in exchange for the family of one of Premier Khrushchev's children."[45] Although his peace hostage idea never took off, James's focus on people-to-people exchanges made him a regular visitor to the Soviet Union and Washington, DC.

Renamed the Citizens Exchange Corps, the organization sent five hundred American students to the Soviet Union in the summer of 1965 to "acquire a systematic and factual knowledge of one another's social systems and civilizations."[46] James hosted visiting delegations from behind the Iron Curtain and organized visits of US citizens to the Soviet Union through the 1960s.

Perhaps the person most responsible for bringing Baltermants to the US photography community was Michael Brainerd, who took over the Citizens Exchange Corps in 1981 and led it until 2006. He reintroduced Baltermants himself in the 1980s by arranging exchanges, photography shows, and teaching engagements and by representing Baltermants in the art photography market.[47] Baltermants's first solo show in the United States happened through just such an exchange.

The New School for Social Research had hired Benedict (Ben) Hernandez to direct its photography program in 1971. Hernandez turned around the New School's flagging program; he organized courses, held festivals, and made it a

destination for budding photographers. Brainerd approached Hernandez in 1981 about doing an exchange of photographers from the United States and the USSR. Hernandez agreed but was unable to travel to the Soviet Union himself. He invited David Chalk, then head of the Soho Photo Gallery (SPG), a photographers' cooperative, not a commercial gallery, founded in 1971. (Unlike all of the early commercial galleries, in 2020, SPG is still in existence.)[48]

Chalk and several other photographers traveled with Brainerd to the Soviet Union in 1982, at the nadir of the diplomatic relationship between the United States and the USSR following the Soviet invasion of Afghanistan and the US boycott of the 1980 Summer Olympic Games in Moscow. He later recalled that he and the other photographers had an amazing time photographing everything from Red Square in Moscow to a lone woman walking a street in Leningrad.[49] He also noted that first-rate Soviet photographers were using "second rate cameras and older technology." The SPG photographers brought exhibition-sized prints with them to display in the Soviet Union. While there, Brainerd introduced Chalk to Baltermants, and they spoke about organizing a solo exhibition of Baltermants's work at the SPG. Hernandez would also arrange for Baltermants to teach at the New School's annual photography workshop called Focus.

In 1983, Brainerd brought Baltermants to the United States for a bicoastal photographic tour. His three-week visit began with a week in California, where he was hosted in Carmel by none other than Ansel Adams. Evidence of his time in Northern California is spotty, but Baltermants did take a portrait of Adams himself, less than one year before the American photographer's death in 1984.

Brainerd had arranged for Norman Cousins and the Southern California chapter of US-USSR Dialogue, Inc., in Los Angeles to serve as the California hosts. At the time, Cousins, who had been the legendary editor of the *Saturday Review*, served on the psychiatry and biobehavioral sciences faculty at the University of California at Los Angeles. But why would a health sciences researcher be interested in organizing Baltermants's first visit to California?

Cousins also had a second life as a peace advocate and a founding member of the World Federalist Movement (WFM), which advocated for a world government in the wake of the horrors of World War II.[50] He wrote essays in the *Saturday Review* decrying nuclear weapons, and he personally supported victims of the Hiroshima bombing. In 1961, he founded the American-Soviet Dartmouth Conference, a high-level gathering of Soviet and American representatives meant to tackle the tough issues of the day. Cousins also facilitated communication between the Vatican, the Kremlin, and the White House that helped lead to the first Soviet–American–British nuclear test ban treaty.[51] Given Cousins's role in Cold War efforts for peace, he likely had met Baltermants on one of his visits to Moscow back in the 1960s.

Cousins hosted Baltermants at a lavish dinner party at his Beverly Hills mansion tucked into the hills of Coldwater Canyon on June 2.[52] Cousins and Brainerd carefully selected the guest list to include people with important connections in Los Angeles and its burgeoning art market.[53] Two nights later, he gave a presentation about his work in Pasadena hosted by US-USSR Dialogue.[54]

From California, Baltermants, Brainerd, and his interpreter returned to New York City, where he was a featured lecturer at Focus '83, a series of photography workshops taught by prominent American photographers. These included Cornell Capa, a photographer in his own right as well as the founder of the International Center of Photography (ICP); the New School's Ben Hernandez; and Arthur Rothstein, a photojournalist on the faculty of the Columbia University Graduate School of Journalism. Baltermants also attended several public gatherings, including the opening of his show, jointly produced by the Citizens Exchange Council (formerly Citizens Exchange Corps), Focus '83, and the SPG.[55]

The press release for his first solo show emphasized Baltermants's recognition as a war photographer: "The powerful images reflect the enormity of the events at Kerch—where over 176,000 men died. The Kerch series dramatically depicts the inhumanity of the confrontation. One of the photographs, Grief, was lent to the 1965 world exhibition, 'What is a Man?' and brought the photographer international fame."[56] (The problem with this explanation of the photograph is that Baltermants took it in the months *before* the major battle leading to the deaths of 176,000 Soviet soldiers over the course of twelve days.) On this trip, the New York press, like the *Los Angeles Times*, began using a phrase that Baltermants himself adopted, "the Soviet Robert Capa." What better way to bring a lesser-known Soviet photographer to the American photography world than by equating him with one of the most important war photographers in the world?

Baltermants brought more than fifty prints with him from Moscow to New York, but it was up to the SPG to install the show. Given the unusually large size of Baltermants's photographs, the SPG had to cut extra glass to cover the photographs for exhibition, a significant expense. Andy Grundberg reviewed the show for the *New York Times* and wrote warmly about Baltermants's "classics of war photography including one of a woman grieving over the dead." But he did not like Baltermants's postwar photography:

Here, we see the sweaty but smiling Soviet oilfield worker, the obligatory group "Paying Tribute to Lenin," the celebrations of ethnic quaintness and chauvinistic sentimentality that are part and parcel of the Socialist Realist style. These postwar pictures are sharp, shiny and polished, but they are

unbelievably mannered. This may make them good propaganda, but not good photojournalism as it is conceived in the West.[57]

Although he appreciated the attempt to showcase a foreign photographer, Grundberg saw the postwar Baltermants as nothing more than a Cold War image maker or, put differently, the leading propagandist for the Soviet superpower. *Grief* and his other World War II photographs, however, were not branded as propaganda: "Had the photographer limited himself to [wartime] pictures, we might think of him with the same respect we accord Robert Capa."[58]

It was not a coincidence that on this same trip, Baltermants met with Cornell Capa. They already knew each other, because in the fall of 1977 ICP had hosted *The Russian War, 1941–1945*.[59] The show featured dozens of Soviet war photographs that Cornell Capa selected, which included several Baltermants photographs.[60]

This came two years after the initial installation in Prague of *They Photographed War: Soviet War Reportage*. Daniela Mrázková, the editor in chief of a new Czech photography magazine, *Revue fotografie*, and her collaborator Vladimir Remeš curated the show and published Soviet war photographs in the magazine's inaugural edition.[61] The exhibition included a catalog by the same name, published in English as *The Russian War: 1941–1945*. For the English translation, to make sure the book reached an international audience, she commissioned an introduction from Harrison Salisbury, the Pulitzer Prize–winning journalist and former *New York Times* Moscow bureau chief. In addition, they invited the military historian A. J. P. Taylor to write a preface. This was at the height of détente between the communist and capitalist worlds. Therefore, it is not surprising that Mrázková was able to commission such high-profile authors as Salisbury and Taylor.

A review appeared in the August issue of the *Czech Historical Magazine*, which reminded readers that the goal of these war photographs was not to mimetically reflect an external reality. Rather, the reviewer identifies the higher goals of war photography: "Especially sensitive environments . . . raise the original authentic engagements to the level of an important artistic performance that does not lose any of its documentary function and witness testimony."[62] The exhibition and book included Baltermants's photographs at Kerch, among them *Grief*. But in this case, it had a broader context.

In the last years of Brezhnev's rule, Baltermants traveled from Moscow less frequently, but he did not stop taking pictures or having his photographs exhibited. In 1982, the Central House of Journalists hosted a solo exhibition in honor of Baltermants's seventieth birthday. The faded color photographs in his private archive show that Soviet photo exhibitions had not evolved much in the twenty years since his first solo exhibition in 1962. Mostly color photographs

crowd the walls as they stretch up to the ceiling. Photographs of the opening depict him being mobbed by friends and colleagues, celebrating one of the most senior Soviet photographers.

His arresting photographs of Brezhnev's funeral in November 1982 brought to life the drama of Brezhnev's death, rumors of which had circulated in the Soviet Union since the mid-1970s. Brezhnev's "death" had been a longstanding joke in the Soviet Union; thus, when his time finally came, Baltermants photographed Brezhnev lying in state in the Column Hall of the House of the Unions, as mourners gathered around him. In the center of the frame, Galina Brezhneva, Leonid's daughter, leans over the casket as her husband, Yuri Churbanov, holds his hand in front of her face, presumably catching her tears. Brezhnev's wife, Viktoria, is off to the side, with a veil covering her face. The photograph looks like a still from a movie as Brezhnev's long-anticipated death is frozen in time and space.

In 1984, in anticipation of the fortieth anniversary of the end of World War II, *Life* magazine decided to do a story on Soviet World War II photographers. John Loengard, the *Life* photo editor, was invited by the Soviet embassy in Washington to look through its archives for dramatic photographs from the war. He complained that he was uninspired by the institutional photo archival records at the embassy and asked his photographer colleague Felix Rosenthal for ideas. Rosenthal, a Russian, connected him with the photographers themselves

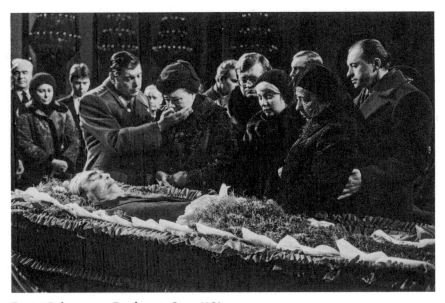

Dmitri Baltermants, *Brezhnev in State*, 1982

in Moscow. Loengard flew to Moscow, where he visited Baltermants's apartment. Loengard pulled out his camera and took several pictures of Baltermants and his dog on the couch next to him. In this rare glimpse into Baltermants's domestic space, we see him rummaging through his prints with *Grief* on display, the only print fully in Loengard's photograph.

1985 saw the inauguration of Mikhail Gorbachev as the general secretary of the Communist Party. The 1980 invasion of Afghanistan, the subsequent US boycott of the 1980 Summer Olympic Games in Moscow, and Ronald Reagan's 1982 election as US president and his vow to fight the "evil empire" ended the era of détente and launched the second Cold War.

In 1985 the ICP hosted two shows of Soviet photography organized by Baltermants in Moscow and brought to the United States through Brainerd and the Citizens Exchange Council. (Both shows traveled from the ICP to the Williams College Museum of Art.) The show that included Baltermants's own work, *Soviet Photography of World War II: 1941–1945*, was a collection of 175 contemporary black-and-white prints, blown up so that viewers could see the grain in the large prints made from the 35mm negatives. Given the timing of the show at the height of the second Cold War, it is not surprising that the reviews were not flattering. Gene Thornton reviewed both shows for the *New York Times* and, like Grundberg before him, panned them both. According to Thornton,

John Loengard, *Baltermants at Home*, 1984. © John Loengard

neither show lived up to the standards of what American photojournalism was meant to be—truthful:

> What are we to think of the strong suspicion of airbrushing and combination printing in the battlefield classics of Zelma and Baltermants? We may excuse suggestions of stage-managed make-believe in some of the intimate scene of farewell and home-front anxiety. But how are we to take the straightforward improbabilities of a picture like Tyomin's "First Day of Peace in Berlin, May 1945," which shows a group of Soviet soldiers smiling shyly at a group of German civilians, mostly pretty young women, who are smiling shyly back at them? Are we to believe that this represents a typical response of the defeated German people to the victorious Red Army? Are we to believe that it depicts the usual behavior of an army of occupation? . . . The result is an overall lack of plausibility at the center of both exhibitions that casts doubt on the truthfulness of even the most moving images to come out of the Soviet Union since the Revolution and, indeed, on the fundamental ideas of Soviet photography.[63]

A review could not have been more damning. Thornton understood perfectly well that the notion of truth in Soviet photography was different from American photojournalism, yet he wrote a scathing review. The American understanding of photojournalism saw a camera as a tool in the hands of a potentially, perhaps even ideally, anonymous photographer. The Soviets understood a camera as similar to a painter's brush and palette, and used it to aestheticize the world to get at a deeper, existential truth.[64]

In general, exhibitions of exclusively Soviet photographs elicited at best mixed reviews from American photo critics. At worst, the reviews panned the entire Soviet photographic project, as Thornton did. Once a whole exhibition carried the label "Soviet," its content suddenly became propaganda and was summarily dismissed. In order to achieve Western recognition as a photographer of artistic talent, Baltermants—the Soviet Robert Capa— would have to downplay the adjective "Soviet" and highlight his relationship to Capa.

Individual Soviet photographs, however, made it into the panoply of iconic photography, including *Grief*, which appeared in several shows in the United States. In a 1986 exhibition at the Corcoran Gallery of Art in Washington, DC, *Grief*—along with World War II photographs by Soviet photographers Yevgeny Khaldei, Max Alpert, and Emmanuel Evzerikhin—was on exhibit as part of *The Indelible Image: Photographs of War, 1846 to the Present*.[65] The prints by the other three Soviet photographers were courtesy of the Union of Journalists of the USSR, which by the 1980s served as the representative of most Soviet photographers

lending to international institutions. But Baltermants was alone in having *Grief* on loan to the exhibition by Brainerd's Citizens Exchange Council. By the mid-1980s, although Soviet war photographers were becoming known to the wider world, Baltermants had a higher stature in the global art photography market than the others, with Brainerd and the Citizens Exchange Council functioning as Baltermants's representative.

Through the 1980s, none of these institutional efforts to build name recognition for Baltermants generated a commercial market for his photographic prints, nor were any other Soviet photographers popular on the booming photography market.

Although the photography market formed in New York City in the late 1960s, it had always been international. Paris was the launching point for the modernist art market. It was where New York–based photography dealer Julien Levy met Eugène Atget in the 1920s and where the Magnum photographers, who had taken postwar America by storm, set up their European headquarters. The New York–based marketplace for fine art photography developed during the Cold War when communism was a bogeyman for Americans and the Soviet Union was an unknown, exotic place behind the Iron Curtain.

From shortly after Stalin's death in 1953, Soviet photographers participated in international photo exhibitions, hosted major shows that drew photographic material from around the world, and served on the boards of international photography associations. Cold War exchanges of culture makers were as important as the exchange of the objects they created. Cartier-Bresson, Morris Gordon, and the American photographer Arthur Rothstein each visited the Soviet Union in the late 1950s and early 1960s in conjunction with international photo exhibitions. Such visits were intended to build a global photographic community that transcended politics. But politics always lurked in the background of these relationships that were meant to bridge the capitalist/communist divide.

Baltermants had been showing his work in international shows and playing a leading role in photographic diplomacy since the mid-1950s as both a photographer and head of the photography division of the SSOD. Usually, when photographers exhibited their work as part of international exhibitions, the prints were sent back to the photographer. Display was the goal for these exhibition spaces, not collecting and storing. But in the 1960s, art institutions around the world increasingly wanted to enlarge their own permanent collections of photography. Consequently, in the 1960s Soviet photographers began receiving requests to leave their photographs behind after an international show. For example, the executive director of the Adelaide Photo Club in Australia, the oldest camera club in south Australia, wrote to several Soviet photographers, including

Baltermants, after a 1962 exhibition, letting the photographers know that the club wanted a copy of their photographs for its collection.[66]

The Soviet photography world devoted increasing resources to circulating Soviet photography around the world and having it shown in a more diverse array of locations. In 1965, under Baltermants's direction, the SSOD planned a major exhibition of Soviet photography to travel to the United States. Perhaps surprisingly, in addition to the expected goals of building relationships between Soviet and American people, the SSOD explicitly stated that the *sale* of photographs was a goal of the exhibition.[67] In other words, the SSOD saw an opportunity to generate hard currency through sales of a developing cultural commodity— photographs of its wartime experience and of postwar daily life.

Eight years before Baltermants arrived in Los Angeles on his 1983 tour, G. Ray Hawkins opened a commercial photography gallery there on Melrose Avenue, the first of its kind in Los Angeles. Hawkins had been a navy photographer in the 1960s and returned to school to study film and photography at the University of California at Los Angeles. Ever the entrepreneur, he supported himself by trolling the best used book stores in Los Angeles, looking for rare, unloved books, which he would purchase and then sell to collectors. "I was learning about fine art photography in the classroom and was learning about the market for art out on the streets," he recalled.[68]

One store in particular, Zeitlin & Ver Brugge, a Los Angeles antiquarian institution since its opening in a red barnlike building on La Cienega Boulevard in 1948, served as Hawkins's proving ground. Zeitlin himself mentored Hawkins in how to differentiate worthless junk from what might prove to be valuable. In those antiquarian bookstores, Hawkins occasionally found photographs, either tucked away inside books or standing alone. Susan Martin, a salesperson at Zeitlin & Ver Brugge with whom Hawkins struck up a friendship, suggested that Hawkins might want to buy the photographic prints from the bookstore, or even at flea markets, and sell them. She ended up serving as his mentor in the market for photographs.[69]

As Hawkins recalled, Zeitlin & Ver Brugge was selling six photographs by Paul Outerbridge—a well-known photographer from New York who had retired to southern California and passed away in 1958—for several hundred dollars each. Hawkins could not afford all six and did not know how to choose among the photographs. This is where Martin's mentorship came in handy. She explained, "You need to buy the [Outerbridge] photograph that was published in John Szarkowski's book, *Looking at Photographs*." Szarkowski, MoMA's photography curator after Steichen, produced the 1973 publication of one hundred photographs held in the museum's permanent collection as a bible to photography collectors in the emerging market, a precursor to Witkin and London's

guide. As he boasted, he bought and sold the only Outerbridge that appeared in the book, *Untitled, 1922*, three separate times, each time turning a tidy profit.

From this modest beginning, Hawkins eventually opened his own gallery. To make a go of a commercial gallery, dealers often needed to work with one or two well-known photographers and serve as their dealers. Witkin had understood this and attempted to make his relationships exclusive; not even the photographers themselves could sell a print. On the one hand, such an arrangement helped standardize the market for a photographer's prints by providing a single access point. This also had the potential to make both the photographer and the dealer wealthy. On the other hand, it limited photographers' ability to set their own prices; that task was left in the hands of the dealer.

In the early 1970s, most photographers refused to be represented by only one dealer. Exclusive representation for photographers took hold only in the mid-1970s, just as Hawkins was opening his gallery, whose primary relationship was with the photographer Max Yavno, with whom he had a longstanding business relationship.[70]

Hawkins claimed that his gallery was the first institution in Los Angeles to exhibit photography at all, noting that the Los Angeles County Museum of Art did not begin exhibiting photography until 1980.[71] Starting in 1983, he began hosting his own photography auctions, because the only auction house in the 1970s with a branch in Los Angeles was Sotheby's.[72] This put the G. Ray Hawkins Gallery in a radically different position than the Witkin Gallery, which was operating in New York City, a place with many art institutions already showing photographs. Because of the absence of a West Coast photography market, Hawkins's gallery became a key player in the photography world, not just in Los Angeles, but around the world, as he represented Yavno, Outerbridge, and other well-known photographers.[73]

Only in 1984 did the Los Angeles–based Getty Museum do a major acquisition of photographs, nearly ten years after Hawkins first opened his gallery.[74] The *Washington Post* article announcing the Getty's acquisition closed with a quote from Hawkins himself, "Just to have everyone's belief confirmed by an institution as conservative as the Getty says that photographs are art. The market place will become extremely excited." Although Baltermants visited Los Angeles in 1983, Hawkins did not recall hearing the name Baltermants until a Colorado-based photography collector named Paul Harbaugh approached him in 1989.

Harbaugh was a high school teacher of biology and photography in Denver. He had been taking pictures since his days on the staff of his college yearbook in the late 1960s. He was fascinated with the American Southwest and Native Americans and took pictures of adobe homes and prairie landscapes. He and his

wife Teresa became partners in the San Juan Mercantile, an old trading post on the San Juan Pueblo in New Mexico, and they began their career as collectors.

His first break in the world of collecting photographs happened when he met Laura Gilpin, a well-known photographer of the American Southwest famous for her platinum prints. He represented Gilpin from 1973 until 1976, when Witkin offered her an exclusive relationship with his gallery, which she could not turn down. Harbaugh knew that Gilpin was the only one back in the 1930s photographing the Navajo nation, and that in the 1970s, images of Native Americans were valued both for their documentation of Native American life and for their aesthetic beauty. Harbaugh recognized Gilpin's talents in platinum printing. It had been a long time since Gilpin printed using platinum, but as Harbaugh recalled, he encouraged her to take it up again, especially since the market for a platinum print was much stronger than a contemporary silver gelatin print.[75]

In 1978, given his knowledge of biology and chemistry, he began teaching science in the Denver public schools, and on the side, continued buying vintage photographs of Native Americans. Teresa Harbaugh opened Azusa Publishing in the early 1980s to produce high-quality postcards based on their collection of Native American photographs. Neither Harbaugh nor Hawkins, both of whom were involved in the photography world of the West since the 1970s, had yet heard of Baltermants. That changed in 1987, when Harbaugh ended up in Riga, the capital of the Latvian Soviet Socialist Republic.

His arrival in the perestroika-era Soviet Union was due to his budding collection of the work of Philippe Halsman. Born in 1906 in Riga, Latvia, Halsman, who had made his name in Europe as an avant-garde photographer, became a cutting-edge magazine photographer in the United States after arriving in the United States in 1940. Halsman had more photographs published on the cover of *Life* than anyone else, and in 1945, after only five years in the United States, he became the first president of the American Society of Magazine Photographers. Halsman died on June 25, 1979, as he and Cornell Capa were planning a major retrospective of his work that would travel for the next eight years. His death caused the Halsman family to worry about estate taxes. Therefore, according to Harbaugh, family members began selling his photographs to collectors and dealers, and through a partner, Paul Harbaugh bought many of them. He eventually became good friends with Halsman's widow, Yvonne.

As Harbaugh recalled, Yvonne got a call about mounting an exhibition of her husband's work from a childhood friend of Philippe's who lived in Soviet Riga. In the mid-1980s, bringing an exhibition to the Soviet Union through private channels was virtually unheard of. But now, as a result of perestroika, it could happen, the more so because Latvia was on the periphery of the Soviet Union

and had its own robust photography scene. Yvonne turned to Harbaugh, who had a large collection of Halsman prints, to accompany her and take his Halsman photographs to Riga for the exhibition. Harbaugh readily agreed, sensing new opportunities to bring lesser-known photographers to the American marketplace.

This 1987 trip was the first attempt to move from people-to-people exchanges of photographers to object-to-object exchanges of photographs meant for the marketplace. This opening meant a newfound freedom to take pictures of subjects previously forbidden in the Soviet Union. It also allowed Soviet citizens to interact with people from the capitalist world more openly and even to engage in limited economic transactions with them in ways that were once forbidden.[76] Whether or not Harbaugh knew all of this, Soviet citizens, including Baltermants, certainly did. According to Harbaugh, he met Baltermants for the first time at his home in Moscow during a trip in 1989.

As a photographer in his own right, Harbaugh took a photograph of Baltermants signing a print of *Grief*. It emphasized how central the artist's signature was to ensuring the photograph had value in the photography market. It was "proof" of its origin story with the photographer himself.

By the 1980s, as Baltermants reached his mid-seventies, his daughter, Tatiana, a smart, savvy translator, started working, and on occasion traveling, with him. In 1989, she accompanied him to Helsinki where he had a show. She understood better than other daughters of Soviet photographers how to help her father's work gain value on the global photography marketplace that was just beginning to incorporate Soviet photographers, given her exposure to foreign diplomacy and the art world since she was a teenager.

Harbaugh was not the only Westerner who was aiming to develop relationships with lesser-known Soviet photographers and who saw opportunities to bring them to the fine art photography market. One of the earliest Westerners to discover the potential financial value of Soviet photography was Howard Schickler. Having collected photography since 1975, Schickler was doing research on Czech modernist photography in Prague in the 1989 when he saw an exhibition of Soviet photography and realized that he needed to meet these photographers and develop his collection.[77]

Another gallerist was Alex Lachmann, who had started collecting photography in the Soviet Union and then opened a gallery in Cologne, Germany, after his emigration from the Soviet Union. He specialized in material from the Soviet avant-garde as he collected photographs from Alexander Rodchenko, El Lissitzky, Georgi Zelma, and Arkady Shaikhet, whose photographs appeared on the covers of 1920s *Ogonek* magazines and in the large-format illustrated magazine *USSR in Construction*, which was published in four languages.[78]

Paul Harbaugh, *Dmitri Baltermants signing* Grief, July 1989.
© Paul Harbaugh

Western European photography gallerists and collectors also started to come to *glasnost'*-era Soviet Union, in particular to Moscow and Leningrad, with an eye toward discovering more photographic diamonds in the rough. In this way Baltermants, now with his daughter Tatiana by his side, entertained a stream of visitors in 1988 and 1989. And in some cases, these collectors presumed that they could buy up large amounts of material on the cheap and sell it abroad on the fine art photography market. The Baltermantses would have none of that. But they felt differently about Harbaugh. Perhaps it was because he was a photographer himself; perhaps it was because he was a public school teacher training the next generation of youth. This was not the profile of most of the other westerners coming to Moscow to buy Soviet photographs. No matter the reason, Baltermants agreed to let Harbaugh bring him to the wider photography market.

Harbaugh was a collector, not a commercial gallery owner. He served as a kind of impresario, working behind the scenes to connect sellers and buyers. He needed to find an interested third party to publicize and exhibit Baltermants and his photographs. Those two aspects of raising a photographer's profile had

Jorma Komulainen, *Dmitri and Tatiana Baltermants in Helsinki*, August 9, 1989. © Jorma Komulainen.

already happened with the SPG show in 1983. But the final step—bringing Baltermants's photographs to market—demanded someone with expertise in *selling* photographs for a profit, in other words a commercial gallery owner. As someone committed to developing photography collections and markets in the western United States, Harbaugh went to one of the leading photography dealers on the west coast, Hawkins.

In 1989, Harbaugh called Hawkins to let him know that he had discovered an undervalued visual artist, a Soviet photographer whose works were already known but still very affordable. When Hawkins saw the prints that Harbaugh brought back with him, Hawkins said that he wanted "all in" and knew immediately that he wanted to do a solo show of Baltermants's work.

Hawkins wanted to be the one to launch Baltermants's career as a fine art photographer in the marketplace. He ordered twenty sixteen- by twenty-inch prints for his own collection (ten copies of *Attack*, five of *Grief*, one of *Outskirts of Moscow*, and two each of *Tchaikovsky* and *Tank Fire*) and then would sell some of those to his customers. He also asked Harbaugh to work with the Baltermants family to help organize a show at Hawkins's Santa Monica gallery for the following year.[79]

Based on Hawkins's expectations of Baltermants in the market, Harbaugh and Baltermants decided to produce a portfolio, a beautifully produced boxed set of twenty prints that would be his way of entering the marketplace. Hawkins asked that they be printed in the United States, where they could be produced by experts and, more importantly, at museum-quality standards. Then they would be sent back to Moscow for Baltermants's signature.

Hawkins sent a lengthy note to Brainerd, who facilitated these transactions, about why the signature was so important: "It would be best if he were to use a semi-soft lead and sign in pencil on the front border of each print and then sign again on the reverse of the image with the same pencil in the region where he has placed his stamp and titled the print." This correspondence was in response to a problem with the signature getting smudged on a previous set of prints, which Baltermants had signed with water-soluble ink. The letter went on to explain that his clients "require their modern images to be archivally washed, which means placing the print in a selenium bath for three to five minutes then rewash in water . . . a long and poisonous process." After Baltermants signed the prints in this precise manner, they would then be shipped back to Santa Monica for the show at his gallery.

This obsession with quality printing and the need for a proper signature was likely foreign to Baltermants, who understood the importance of printing but had little awareness of the power the marketplace gave to issues of provenance and print quality. For that expertise, he relied on Hawkins and Harbaugh. The

inaugural show at a commercial gallery was scheduled to open in August 1990, just one year after Harbaugh had been introduced to the Baltermants. Plans were proceeding as planned when Baltermants got a kidney infection in the spring of 1990. He was hospitalized in June. One week later, he died from a usually treatable infection, at the age of seventy-seven, just two months before the exhibition's opening.

Brainerd was in Moscow when he learned of Baltermants's sudden passing. It was a shock to everyone, not least his daughter, who cared for him in his final days. She lost her father tragically, owing to a lack of quality medical care. More than that, she had hoped her father would live to see the day when he might become famous, and perhaps even well off, as a result of his decades of work in photography.[80]

Tatiana Baltermants stepped into the void left by her father's passing and became his surrogate. She flew to Los Angeles in August, stayed at a luxury hotel on the beach in Santa Monica, which Hawkins paid for, and gave a talk at the gallery opening in September. She, along with Harbaugh, who was also at the opening, gave interviews to the local press. Both of them repeatedly referred to Baltermants as the "Soviet Robert Capa." By doing this, they emphasized his heroic wartime photographs, and perhaps, now that he had passed, with a touch of the tragic lone photographer dying prematurely.

Baltermants never lived to see how his post-Soviet legacy would take shape. As Tatiana Baltermants remarked in an interview, it is probably best that he did not live to see the collapse of the Soviet Union in 1991. He was a Soviet photographer who made a good living documenting the communist state as it projected its power. She remarked that it would have devastated him to see what took place in the 1990s in his homeland, the only country he knew, as the Russian people (as they were now called) faced hyperinflation, rampant crime, and a collapsing society. At least she had his photographs as a way to remain solvent during those economically trying times.

HOW *GRIEF* BECAME A COMMODITY

Dmitrii Baltermants died on June 11, 1990, as he was in the final stages of planning his first commercial show, at the G. Ray Hawkins Gallery in Santa Monica, California. The Associated Press obituary for Baltermants appeared in several local American newspapers, while Andy Grundberg, the *New York Times* critic who had written a negative review of his first American solo show at the Soho Photo Gallery, in 1983, was well positioned to write Baltermants's obituary for the *Times*. Grundberg opened with the basic details of his life, including the fact that he "became a staff photographer for the Soviet Government newspaper *Izvestia* in 1937." Then he followed with what had already become the standard comparison: "His pictures, like those of the American photographer Robert Capa, focused as much on the pain and suffering caused by war as on the valiant struggle of combat.... Among his most memorable images is a 1942 photograph of Soviet women grieving over the frozen bodies of Soviet soldiers. Titled 'Searching for the Loved Ones at Kerch,' it is a frieze-like arrangement of human figures, evocative gestures and a dark, looming sky."[1] By reminding *Times* readers of his similarity to Capa, he focused on his wartime photographs and the tragedy of his premature death, rather than his role in documenting the Soviet Union at the height of its power during the Cold War. The only photograph he spent time discussing was "Searching for Loved Ones at Kerch," which he (erroneously) described as a postbattle photograph, rather than the aftermath of an atrocity committed against civilians, most of whom were noncombatant Jews.

The *Times* of London also ran an obituary for Baltermants, but it opened quite differently: "If cultural détente between the West and the Soviet Union had arrived earlier than it did, Dmitri Baltermans [*sic*] would have been prominent among the beneficiaries." It then discussed one, and only one, photograph: "Unfortunately, his work is known in Britain only by repute, knowledge being more or less limited to one much-reproduced though undoubtedly remarkable

picture." That picture was *Grief*, or as the writer referred to it, "Looking for Loved Ones, Kerch, 1942." This obituary notes that because of the scarcity of information about Baltermants, "Western photographic literature has tended to ignore all but modernists such as Alexander Rodchenko. If the facts and the pictures had been forthcoming Baltermans [*sic*] would certainly have achieved much more fame outside his own country."[2] Contrasting Baltermants with the modernist Rodchenko, the writer observes that *Grief* was all that *Times* readers had of Baltermants.

Shortly before his death, Dmitri and Tatiana Baltermants had written to Michael Brainerd in advance of the exhibition, expressing apprehension about the arrangements: How would they fly from Moscow to Los Angeles? They preferred a hotel to an apartment, and his daughter had to come; Dmitri Baltermants wanted financial guarantees on sales of his work, rather than an arrangement just based on sales in a given year.[3] Then Dmitri Baltermants died, casting a pall over his inaugural commercial show in one of the most reputable photography galleries on the West Coast. Instead of the anxious photographer arriving in sunny Los Angeles, his daughter-in-mourning came alone.

In order to attract publicity for a little-known Soviet photographer, Hawkins wanted to exhibit Baltermants with a more recognized name in the world of photography. As he explained, "Give them something they know and then something they will learn!" So he paired Baltermants with a show of O. Winston Link's more recognizable photographs of the American railroad.[4] Ideally, this juxtaposition would pique interest in Baltermants and ideally make money for the gallery owner, the collector, and the photographer—or now Tatiana Baltermants, who inherited the rights to her father's photographs. As she recalled, Hawkins sent a limousine to pick her up at the Los Angeles International Airport, put her up in a hotel with an ocean view, and gave her a tour of Los Angeles and Hollywood to impress her. The warm skies and luxury accommodations were merely a reminder to her that the inaugural commercial gallery show was primarily about how Baltermants had been given a new life in the Western photography market. This was the beginning of the process of transforming a powerful communist war photograph produced for aesthetic and political purposes into a capitalist art commodity for aesthetic and financial purposes.

The *Los Angeles Times* sent Cathy Curtis to review the show. In "Dimitri Baltermants, the Soviet Robert Capa," Curtis wrote glowingly about his "keen eye for chance composition," or for decisive photographic moments, in the language of Henri Cartier-Bresson, which "show[s] him to be a member of the pantheon of great documentary photographers." She then turned to individual works and honed in on one: "'Grief' from 1942 captures the extraordinary strength and stoicism of a populace who were to lose between 15 and 20 million of their fathers

and sons during the war. Under a lowering sky, on a bed of crevassed earth, men lie scattered. Here and there, among knots of observers, grieving women stand with bowed heads."[5] Once again, Curtis implied that *Grief* captured the aftermath of war, albeit a particularly brutal war in which an estimated twenty-seven million Soviet citizens were killed, but not the aftermath of genocide.

The *Times* editor recognized that this was more than just another commercial show at Hawkins's gallery, which it covered regularly. The paper assigned Steve Appleford to produce a feature story about Baltermants. He wrote, "Like Robert Capa, Dmitri Baltermants chronicled war. But, unlike Capa, the horror he photographed was in his own town [*sic*]. The late artist's work finally comes to Los Angeles." (Although he did not photograph it, Capa's hometown of Budapest also had its Jewish population destroyed late in the war.) Appleford interviewed both Tatiana Baltermants and Paul Harbaugh. They both suggested that Baltermants's wartime photographs, like Capa's, were among his most important because they demonstrated the horrors of war. Harbaugh then reflected on the photograph and its contemporary relevance: "Right now, war is imminent in the Persian Gulf. If they could see some of these photographs, nobody would want to fight."[6] The press coverage of Baltermants's inaugural, sadly posthumous, commercial show could not have been better, and this just five years after the harsh review denouncing him as a propagandist stooge for the Soviet Union. Perhaps all it took was the death of the artist and the death of the Soviet Union for reviewers to appreciate its aesthetic qualities.

Times had also changed radically. In 1989, the Berlin Wall had come down; the Baltic republics were gaining their independence and it was clear that the Soviet Union was nearing its expiration date. The time when the Citizens Exchange Council was the primary means of moving people and culture between the United States and the USSR was over. Individual citizens were now organizing their own travel to the Soviet Union, sometimes for tourism, other times for business.

To that end, in 1989, *Aperture*, the leading American magazine dedicated to photography, ran a cover story called "Photostroika: New Soviet Photography." The essay celebrated the new openness that perestroika, Mikhail Gorbachev's initiative to restructure Soviet society, and glasnost—an openness to new ideas about the past, present, and future—gave to Soviet photographers. Perestroika and glasnost also gave Soviet citizens, photographers included, opportunities to tell a history that did not shine a positive light on the Soviet Union. People now had the freedom to criticize the Soviet past in independent ways, and now they could do it publicly. The introduction to the issue decried the "lack of information" about the Soviet Union, not unlike the London *Times* obituary of Baltermants. This only seemed to add to the communist country's mystery. The

introduction then gave a very brief history of Soviet photography, mentioning such modernists as Rodchenko and Sergei Eisenstein, whose radical photographic and filmic experiments were "cut short" by Stalin. "Despite severe governmental constraints," the essay continues, "some photographers were still able to produce significant work in the ensuing years, notably the brilliant photojournalists of the war years—Dmitri Baltermants, Eugene Khaldev [*sic*], and others."[7]

The only official Soviet photographer invited to participate in this special edition was Baltermants. (Although Khaldei was also alive, his entrance into the American photography market would not come for several more years.[8]) In the *Aperture* interview, Baltermants spoke to the magazine's readership yearning for stories about Soviet oppression of the arts. He discussed the wartime "petty officials of art," who suppressed the best of Soviet war photography: "I suffered from these same restrictions. Today, though, these magnificent photographs have begun to appear in exhibitions and journals, telling of the courage, grief, and suffering that war brings." He thus positioned himself as a beneficiary of perestroika and glasnost. He did not mention that these images circulated widely both during World War II and throughout the Cold War.

Not surprisingly, Baltermants selected *Grief* to be printed with his interview. With this kind of late perestroika-era recognition of Baltermants, he was now well positioned for the art photography market. The Baltermantses, both father and daughter, knew that. Harbaugh knew that. Hawkins suspected as much, and he was the key figure to bring Baltermants to market. But the question remained: Would he be able to sell a Baltermants photograph as a marketable commodity?

Sales of Soviet photography on the art market did not happen during the Cold War. But then, no one was selling photographs for more than their production costs until the early 1970s, when a mass market of institutional and individual buyers sought out affordable art commodities. With the advent of Gorbachev's perestroika and glasnost, there was an opportunity to bring Soviet photographers to the market. Would those collectors, gallerists, and dealers bringing these photographers and their photographs to the West use the word "Soviet," an adjective used to describe the historical enemy of the West, to describe these newly discovered photographers from behind the Iron Curtain? Or would they would avoid the politics of the photographs, focus on the images themselves, and describe the photographers as "Russian," using a national designation that was more common in art historical nomenclature?

The first Soviet photographer to succeed in the global photography market was Alexander Rodchenko, to whose images several of Baltermants's photographs have been compared.[9] In 1979, Rodchenko had already garnered a full-page spread in Lee Witkin's *The Photograph Collector's Guide*. At that time, when Soviet–US

détente was about to come to an end, Witkin labeled him a Russian, rather than a Soviet, photographer. In scholarship the totalitarian school of Soviet studies, which compared the Soviet Union with Nazi Germany and Stalin with Hitler, was having its heyday. Therefore, anything dealing with cultural production from the "totalitarian" Soviet Union was presumably propaganda on behalf of the state and could not be worth collecting. Why, then, did Witkin include Rodchenko in his list of important global photographers?

First, a good photography dealer pitches a story. Rodchenko's biography as a young upstart painter-turned-photographer read as follows: this radical painter became a photographer, adopting a new method of revealing a world that the naked eye cannot see, and more or less founded the aesthetic school known as constructivism. He was ultimately hounded out of the photography profession by photographic acolytes of Stalin in the early 1930s who labeled him a "formalist." Perhaps most important, in an era when art collectors were driving up the prices of works by Pablo Picasso and Salvador Dalí, the term "constructivist," which emphasized the shapes of images, or "modernist"—a nebulous term referring to culture that was not realistic—always appeared somewhere in the description of Rodchenko's work. The life story of a radical, visionary modernist painter/photographer of the 1920s who was subsequently repressed, if not oppressed, and yearning for artistic freedom played well with late Cold War global audiences. (The Museum of Modern Art's online Rodchenko biography spends most of its narrative in the 1920s, then contrasts his 1920s work with the socialist realism of the 1930s, suggesting that he stopped making art, or at least art worthy of discussion. It more or less omits the 1940s and leaps straight to his death in 1956.[10])

Collectors were interested in Rodchenko's images as well as his personal story. Little did the photography world know at the time that Rodchenko had been an avid documenter of 1930s Stalinist slave labor camps and that some of his most famous work was not from the "revolutionary" modernist 1920s but from the "oppressive" Stalinist 1930s, when socialist realism shaped Soviet aesthetics.[11] One of the first sales of a Rodchenko photograph at auction, a somber 1924 portrait of the poet Vladimir Mayakovsky, took place in 1987. It sold for $4,400. However, from the date of his first sale in 1987, Rodchenko's photographs—at least his "vintage prints" (a photograph that the photographer printed himself at about the time he took them plus five years)—skyrocketed in value. In 1992, his 1927 *Fire Escape* sold for $77,000 at Christie's, and the value of a Rodchenko reached its peak in 2007 when *Sokolniki Park*, taken in 1929, sold for $312,000 at Phillips in New York, nearly one hundred times what his Mayakovsky portrait sold for twenty years earlier.[12] And this does not take into account the private market, where most fine art photography was being traded.

In contrast to Rodchenko, Baltermants was the photo editor of *Ogonek* and the leading image maker on behalf of the Soviet Union during the Cold War. The American press branded him a Soviet propagandist as late as 1985. Therefore, it would be a bigger challenge for dealers and collectors to avoid the label "propagandist" from Baltermants's prints that appeared in the art photography market in the 1990s.

In fall 1990, just as the reviews of his first solo show at a commercial gallery appeared in the *Los Angeles Times*, a few of Baltermants's prints, which he had made himself for his earlier exhibitions, appeared at Christie's New York, in its fall photo auction, for the very first time. Likely to the surprise of many of his supporters, one of his images from World War II, *Attack, 1941*, sold for three times the estimated price. As it turned out, there was indeed a market for his wartime work, and a much stronger one than initially anticipated. *Grief* first sold at Christie's New York in its spring 1991 nineteenth- and twentieth-century photography auction. When the hammer fell, it had gone to an anonymous buyer for $6,600, more than four times the estimated sale price.[13]

In the early 1990s, there was an initial flurry of interest in Baltermants's photographs, driving up the prices two, three, and sometimes four times over estimates. By 1992, his work more or less generally sold at estimated prices, which had caught up with market demand. By 1995, as more collectors started to hold Baltermants wartime photographs, lesser-known Baltermants photographic prints started appearing at auction. Those photographs increasingly did not reach the minimum bid, and they remained with the seller.

Baltermants's most popular photographs have always been those from World War II. They include the original five that Baltermants himself had set as his key wartime images back in the early 1960s when he began touring his work on behalf of the Union of Soviet Friendship Societies (SSOD): *Attack*, *Grief*, *Tchaikovsky*, and *Crossing the Oder*. The only one of them that was not up for sale was *Parade in Moscow, 1941*, the wintertime scene of troops on Red Square preparing to go to the front. Another wartime photograph, *Behind Enemy Lines*, previously published in *Izvestiia* in March 1942, depicting cavalrymen charging through the white snow on the western front, is currently the most valuable of Baltermants's images.

When he produced those prints in the 1950s and early 1960s, their value lay in the aesthetic, political, and diplomatic power of the images. As they traveled the world, Baltermants's wartime photographs, especially *Grief*, showed the suffering and heroism of the Soviet Union. Because of this unique Soviet wartime experience, and the images depicting that experience, the Soviet Union—rather than the United States, which was the only country in history to use nuclear weapons against an enemy—was better positioned to advocate for peace.

What he might not have realized at the time of the initial production of those prints was that they would turn out to be *financially* valuable. In addition, although Baltermants did his own printing, the more he oversaw every detail of the printing process, the more valuable it would turn out to be. Although he had another five or six postwar photographs that also sold at auction, his war photographs were the most important, and *Grief* the most frequently seen at auction.

In the 1960s, 1970s, and 1980s, Baltermants had produced many large-scale "period prints"—a term used to describe those made by a photographer anytime during his lifetime—of his wartime photographs. These were not technically vintage prints, because the print was not produced within five years of the negative. Baltermants had been a magazine photographer, so if he had any vintage prints of his wartime photos, they would be control prints, to determine which images would end up in publications, and then small prints that his editors produced at the time to print in the magazine. He began producing large-scale prints himself only in the late 1940s and 1950s, for exhibit in traveling shows abroad and group shows back home. These 1950s and occasionally 1960s prints tend to be referred to as "vintage."

In his many visits to foreign countries, he frequently left behind his prints as tokens of appreciation, and they eventually had value in the fine art photography marketplace.[14] In 1989, when Harbaugh showed up at Baltermants's apartment, the two of them agreed to make prints of his classic war photographs as well as a select few of his postwar images as a limited-edition portfolio.

The number of distinct images ranges wildly, as does the "limit" on the number of copies of each image. A limited edition generally ranges from five to fifty copies of each print. In the case of Baltermants's inaugural limited-edition portfolio, each print used specially selected photographic paper that Baltermants and Harbaugh chose. Then those prints were slipped into sleeves, made from museum-quality acid-free paper. Those sleeves holding the prints were then placed in a beautiful hand-letterpressed box. The protocol of its production is almost as important as the prints themselves. Although the negative of the photographs is generally preserved, rarely do further prints get produced. Often, legal contracts are signed making it illegal to make any additional ones. Each copy is numbered out of the total number of prints, which is generally stamped or written on the verso of the print.

The producers leave no detail to chance—from the box's material, font of the lettering, and color of the letters and the box itself; to the precise order in which the images appear; down to the size of the print, the paper on which it is printed, and the location of the artist's signature on the print itself. In the case of Russian photographers, there was the additional question of the alphabet: Should the

Cyrillic alphabet be used for photographs aiming to reach an American, British, French, or German audience? Would the strangeness, or perhaps the exoticism, of Cyrillic letters alienate buyers potentially put off by its association with the Cold War and lack of intelligibility? Or might it in fact attract buyers for precisely the same reasons?

Harbaugh brought the selected negatives to the United States for printing in Denver. He then sent the sixteen-by-twenty-inch prints to Moscow for Tatiana Baltermants to sign and number them. Then the portfolios were shipped back to the United States for sale through Hawkins's gallery.[15] After a three-year process of travel between Moscow, Denver, and Santa Monica, the Baltermants portfolio appeared in 1992. Harbaugh and Hawkins are listed as the producers, but Harbaugh and Tatiana Baltermants are listed as the holder of its rights. The Agfa Portriga paper they selected was considered top of the line, and professional photographers laud its "beautiful, old-school" quality and believe it is "one of the finest warm tone papers" ever made.[16] The printer, Ray Tomasso, is a master letterpress printer and artist in his own right, who earned his master of fine arts degree in printmaking at the University of Colorado, Boulder, just ten years earlier. Teresa Harbaugh had been running Azusa Publishing for more than ten years and was herself a specialist in printmaking and image presentation. Even the case maker is identified in the introduction, and thanks are given to all of those involved, including Brainerd, who had been Baltermants's primary American liaison through the 1980s and facilitated much of its production. Another was Dmitry Gershengorin, a recent Soviet Jewish émigré to Denver, whom Paul Harbaugh had met back in 1987 in Riga. They reconnected in Denver, where Gershengorin served as the translator for Harbaugh, who could not read Cyrillic, and provided historical context for the images. Since Baltermants had died by the time the final prints were ready, "each image . . . has been marked with the photographer's original stamp and signed by Tatiana Baltermants on her father's behalf." *Grief* was number five of twenty images.

The portfolio was produced with an eye toward beauty and marketability. The text is almost entirely in English, except for the Cyrillic script of the photographer's name, Бальтерманц, printed just below the English "Baltermants" on both the cover and the title page. On the page preceding the contents list, they reproduced the emblem of the USSR, a country that in 1992 no longer existed. It interspersed wartime images with postwar photographs, many of them taken on Red Square, perhaps the foremost icon of Russia, communism, and the Soviet Union. The images move from a scene of soldiers assembling on Red Square, *Cavalry, Red Square, November 7, 1941*; to a postwar photograph, *Queue for Lenin's Tomb, 1959* (even though in 1959, Stalin would also have been buried there); Red Square's clock tower, *The Nation's Chief Time Piece, 1967*; and a physically

disabled veteran at a Victory Day Parade, *Without Looking Back, 1970* (dated 1965 in other prints). In total, they produced thirty prints of each image, five artist's proofs and twenty-five for the limited edition.

If Western art institutions and professionals generally downplayed Rodchenko's Soviet identity and highlighted his persecution under Stalin, the portfolio producers chose a different approach and emphasized Baltermants's Soviet identity. Whereas Rodchenko's biography, as well as those of other Soviet modernist artists like El Lissitzky, could easily focus on his constructivist ideas from the 1920s and repression under Stalin's totalitarian dictatorship, Baltermants, as a novice photographer who made his name during the Great Patriotic War, did not have that luxury. He was the "semi-official" photographer of the Soviet state, as one American newspaper noted. More to the point, many of the photographs were taken in the postwar period to glorify the Soviet Union during the Cold War. His photographs had to play to collectors' desires, the producers thought, to get an exotic and beautiful glimpse behind the Iron Curtain. His name was spelled in Western style, "Dmitri Baltermants," as it had been with his first solo show in London. These differences matter when one is new to the art market.

In April 1992, Harbaugh and his Denver-based photographer colleague Rich Clarkson were instrumental in getting Capa's International Center for Photography (ICP) in New York to host a major retrospective for Baltermants that ran for six weeks.[17] Clarkson was a sports photographer who taught at the New York photography training program Focus '81 (Baltermants had taught at Focus '83). At Focus '81, Clarkson met Capa, who administered the show and invited Clarkson to serve as guest curator for *Dmitri Baltermants: A Soviet Photojournalist's Retrospective, 1939–1989*.

Harbaugh, Clarkson, and Tatiana Baltermants all came to New York for the show, and because Harbaugh knew the most about the work on exhibit, he gave a tour at the opening. Having met Baltermants personally in Moscow, Budapest, and New York, Cornell Capa wrote a statement for the exhibition in which he described the photographer as a creator of "a mirror-image history of the life and death of the Soviet Union from Stalin through Gorbachev." Capa also noted that Baltermants "recognized 'the decisive moments' in Soviet history" and not only "captured their reality" but also "improved upon it." Capa then focused on *Grief*, suggesting that as a collage of two distinct prints Baltermants increased its value as an art photograph.

Charles Hagen reviewed the exhibition for the *New York Times*, noting Baltermants's stature as "one of the few Soviet photojournalists whose work was known in the West." The review was damning, however: "After the war, Baltermants appears to have devoted himself to recording the familiar rituals of

Paul Harbaugh and Tatiana Baltermants in front of a vitrine at the opening of the International Center of Photography exhibition of Dmitri Baltermants, 1992

the Soviet state, photographing leaders on reviewing stands, troops marching through Red Square on May Day, heroic factory workers and the like. . . . Some of the photographs have a certain historical and human interest, but for the most part they are unrevealing." Then Hagen threw into question Baltermants's status as a photojournalist by noting his use of collage and montage: "A number of composite photographs, made of several negatives printed seamlessly together into a single print, demonstrate Baltermants's willingness to resort to this device to create more convincing pictures. Even 'Grief' turns out to be a composite, with the dramatic lowering clouds coming from a different negative."[18] Hagen's review assumed protocols of photojournalism, in which the choice of when and where to click the shutter is as much latitude as a photojournalist can take and still call it photojournalism; otherwise, it becomes falsifying reality. In some ways, Hagen is right that Baltermants was falsifying reality. Recall that after the first exhibition of *Grief* in 1962, Aleksandrov argued that Baltermants's use of montage made the image less truthful. However, Aleksandrov reminded his readers that we should be approaching Baltermants's photographs as art photographs and not as photojournalism.

Cornell Capa thought the composite better reflected what Baltermants experienced on that day than what the camera actually captured. Moreover, the photographer had wanted to make viewers sympathize with the woman in the picture by drawing them into the photograph through the addition of clouds. Baltermants made no pretense to hiding this technique, not in the 1960s and at no point in his life. In the 1960s, Soviet reviewers who approached his work as art appreciated the new impact his composite image had on the viewer. Western reviewers, who believed that magazine photographers should simply use the camera as a tool to mimetically represent reality, saw Baltermants's photographic alteration as a problem. And as a *Soviet* photographer, they read his work not just as a problem, but as an intentionally manipulative piece of Soviet propaganda. American reviewers in particular considered his photographs "fakes" meant to deceive the viewer and exaggerate the suffering of the lone woman and, through her, the Soviet people.

The ICP is not a commercial gallery, but having a show there only increased his name recognition as a photographer. Given the Baltermants family's relationship with Harbaugh, the *Denver Post* also covered the ICP show, with *Grief* serving as the lead illustration for the article. The piece highlighted Harbaugh's role in bringing it and Baltermants to the United States, and described the process Harbaugh went through to make Baltermants and *Grief* attractive to photo collectors in the United States. It also reminded readers with a touch of postcommunist irony that "capitalism may be very, very good for the most prolific photographer of the former communist state."[19]

From the time he appeared on the American market in 1990, many American reviews of Baltermants emphasized the role capitalism, in particular American capitalism, played in giving value to images taken by the "most prolific photographer of the former communist state." These reviewers often juxtapose the death of the Soviet Union and of state communism (not to mention the death of the photographer) with the newfound life Baltermants's photographs found under the conditions of capitalism.

Ever since Baltermants's work arrived in the marketplace, the connections between Denver and New York in building up his reputation were bidirectional. Harbaugh emphasized the importance of Clarkson, the Denver-based sports photographer, as did Loengard, the *Time* magazine photographer who went to Moscow in 1984 to take pictures of Soviet photographers for a *Time* story in honor of the fortieth anniversary of the end of World War II. This was several years before Harbaugh was even a part of exposing the Western photographic community to Soviet photographers.[20] When Loengard later produced a book about the photographic negative and its value, he wanted to use one he had seen back in Moscow in 1984, the one of *Grief.* Loengard credited Clarkson with connecting him with Harbaugh, who had the damaged negative.[21] It was in Harbaugh's possession at the time because he was overseeing the production of the limited-edition portfolio in which *Grief* was featured. Loengard's photograph of Harbaugh holding the damaged negative appeared in his 1994 book *Celebrating the Negative.*[22]

Two years after the ICP exhibition in 1994, Mario Cutajar, a multimedia artist on faculty at the Otis College of Art and Design in Los Angeles, wrote a review about a second Baltermants show that was held at the Hawkins gallery. Cutajar focuses on two images in the show, *Attack* and *Grief.* "*Attack*," he writes, "is such a wonderfully conceived picture that even after one has discounted its propaganda purpose it remains stuck in the mind as one of photography's truly iconic images." He then describes the image in loving detail and suggests that "the camera angle recalls Rodchenko." He concludes his discussion of *Attack* by claiming that "the overall effect is at once cinematic and epic."[23]

Had this been the entirety of Cutajar's review of the show, it would have made Hawkins quite happy. But Cutajar had opened the review with a discussion of the image that had graced magazine covers, newspaper articles, and, by this point, auction house catalogs: "[*Grief*] is so patently manipulative that even without knowing that the cloud-darkened sky is a darkroom addition, I've always been unwilling to lend it my sympathy, a reluctance hardened by the knowledge that the regime that put this image to use was itself guilty of atrocities against its own people at least as dreadful as those perpetrated by the Nazi invaders."[24] Although Cutajar's critique reflects those of other American critics, he goes one step further

in criticizing Baltermants, *Grief*, and the entire Soviet project by wading into an uncomfortable historical evaluation when he says that the Soviet regime used Baltermants's "fake" photograph to mask Soviet crimes against its own population that were as horrific as the Nazi genocide.

Despite Cutajar's harsh review, the 1990s was a good decade for Baltermants's photographs on the market. The biggest boost to his reputation was the publication of an illustrated narrative history called *Faces of a Nation: The Rise and Fall of the Soviet Union, 1917–1991*, published by Fulcrum Publishing in Golden, Colorado. Tatiana Baltermants wrote the introduction, and the prominent historians Theodore and Angela Von Laue wrote the accompanying text, all in service of Baltermants's beautifully printed photographs. The book brought to life what Soviet reviewers had been saying about the photographer back in the 1960s—that he chronicled the life of the nation.[25]

As one of the most prominent photography dealers on the West Coast, Hawkins had collector-clients in whom he could generate interest in Baltermants. Several of his clients purchased individual prints and, after 1992, possibly even whole portfolios. Since the 1970s, he had also been trying to persuade established Los Angeles art institutions to invest in photography holdings. Both the Getty and the Los Angeles County Museum of Art (LACMA) opened their respective photography departments in 1984, the same year that the Getty made its first multimillion-dollar purchase of photographs with the acquisition of several major American and European collections.[26]

LACMA holds ten Baltermants photographs in its permanent collection, but those acquisitions were begun a decade later, in 1995. However, this made LACMA one of the earliest US museums to have multiple Baltermants photographs in its permanent collection. This is not a surprise, since Hawkins was based in Los Angeles. Seven of LACMA's Baltermants photographs were gifted by clients of Hawkins, many of whom were involved in "the industry," as the entertainment business in Los Angeles is called.[27] The name on the appraisal of the photographs was G. Ray Hawkins.[28]

In 1995, Hawkins and his wife Susan also donated a single, untitled Baltermants print to LACMA, described as a "boat crossing with horses." At nine by nine inches, the print was not one of those produced in the limited-edition portfolio. Moreover, it came already mounted; clearly it had been produced for one of Baltermants's exhibitions. This photograph's acquisition file lists the date of the vintage print as 1940s. (The couple also donated a period print of a scene from Yevgeny Khaldei's day on the Reichstag's roof, in which he took his *Raising the Red Flag over the Reichstag*.) In 1997, Eric Orr, an installation artist and also a client of Hawkins, gifted two Baltermants prints to the museum. Hawkins did an excellent job selling the portfolios. Some ended up in the hands of private

collectors in Los Angeles; others ended up in commercial galleries, which hoped that they could then sell either the entire portfolio or the individual prints for a profit.[29]

By the mid-1990s major art institutions held Baltermants photographs in their permanent collections, and in 1996 Christie's New York held another photography auction. What made this auction stand out was the fact that it included nearly three hundred Soviet war photographs, which had been produced for the 1975 exhibition *The Russian War*. Robert Koch, a San Francisco–based photography dealer, one of the few entrepreneurs who has run a successful commercial gallery for more than thirty years, bought the entire lot of 297 prints.[30]

Grief appeared at auction quite frequently. Swann Gallery, the firm that held the first-ever auction devoted to photography, in 1952, and director of photography Daile Kaplan, at Swann since 1990, has sold the photograph no fewer than six times over twenty-two years, albeit different prints of the image. In 1995, Swann held its first auction of *Grief* and sold it for $11,500, close to its estimated value. Kaplan sold *Grief* several times through the late 1990s and 2000s, again generally reaching the estimated amount.[31] But Swann was not alone in auctioning Baltermants's iconic photograph. In 2000, it sold at Sotheby's New York; in 2001, prints of *Grief* sold at Sotheby's New York and at Sotheby's Los Angeles. In 2002, a signed *Grief* sold in Amsterdam, and Christie's New York sold one in 2008.

Tatiana Baltermants continued her business dealings with Hawkins into the early 2000s, after agreeing to let him produce a second portfolio of different material. She arrived in Los Angeles in the summer of 2001 to stamp, sign, and number the new limited-edition portfolio as well as to appear at a public event at the studio of Thomas Lavin. The event, titled "Dmitri Baltermants and Aesthetic Allies," included Russian art and music.[32] But Tatiana Baltermants faced a more pressing issue about managing her father's archive, and therefore his legacy. She did not consider her house the best place to store her father's negatives: it was damp, the materials were getting moldy, and she had difficulty in general maintaining the archive. She could have donated them to a local Moscow-based museum or archive, but in the 1990s, she did not think any of them would be able to do any better at storing the material than she could.

Russia in the 1990s was an era of deep economic transformation in the form of hyperinflation and crash privatization. Hyperinflation gutted the savings and pensions of most former Soviet citizens, leaving those most vulnerable to inflation—those surviving on fixed incomes, especially the elderly—living in penury. Crash privatization involved turning over most state-owned production, which included selling off the "heights of industry," oil, gas, and steel, on the cheap. It also meant turning over real estate, in the form of apartments, that had been owned by the state to the individual occupants. Then, the logic

of capitalism defined post-Soviet society. This led to massive layoffs, a decline in gross domestic product, and, most challenging for a society trying to assert itself in a postcommunist world, a steady decline in life expectancy, especially of Russian men, whose life expectancy had dropped precipitously down to fifty-eight years in 1998.[33]

Because of hyperinflation, the ruble was not stable and most people dealt only in hard currency, which at the time meant US dollars. Tatiana Baltermants presumably did not feel that her father's archive would best be served in a Russian institution, so, given her long-established relationship with Harbaugh, she asked him for help in finding a buyer who would do right by the archive. Harbaugh found just the man.

Michael Mattis, a physicist at Los Alamos, and his wife Judith Hochberg began collecting photography in the early 1980s when the market for fine art photography was barely a decade old. They met as doctoral students at Stanford, and, according to Robert Koch, the Koch gallery's photo exhibitions in 1980s San Francisco inspired the couple to take up photography collecting themselves.[34] Mattis's biography echoes Harbaugh's: both have scientific backgrounds, both were based in New Mexico for their formative years, and both have a passion for collecting. Harbaugh identified Mattis as a collector with enough ambition to bring Baltermants's entire archive to the United States and perhaps make him better known to a Western audience.

According to Tatiana Baltermants, Mattis traveled to Moscow and stayed at the Hotel Cosmos, an unlovely concrete block built for the 1980 Moscow Summer Olympic Games. Staying at the Cosmos, rather than a place near Red Square, was a sign not only of Mattis's frugality but also of his seriousness. The two met, and after much negotiation, Mattis acquired the archive. They signed a nondisclosure agreement regarding the terms of the sale. If one person could bring Dmitri Baltermants to the world, it would be Mattis, who was now motivated to make good on that investment.

The transaction took place in 1999, not too long after the 1998 collapse in the Russian economy. Tatiana Baltermants was wise to deal in US dollars. This was the late Yeltsin period, when export laws were less strictly enforced than they had been. Under Vladimir Putin, who became president later in 1999, most cultural treasures of the fatherland, especially those connected to World War II, the cataclysmic event in twentieth-century Russian history, would have been considered national patrimony and more challenging to export. But before Putin's ascension, Tatiana Baltermants and Mattis successfully shipped the materials from Moscow to New York.

Mattis made the second floor of his mock Tudor home in Scarsdale, New York, the global headquarters of the Baltermants archive. He hired several

Russian-speaking research assistants to process the archive and make it accessible to researchers and, more importantly, the photography market. This meant that the team sorted through the negatives and prints, conducted research, and wrote descriptions of them, and then Mattis decided how best to bring Baltermants to the wider market. Mattis chose a multipronged approach to increasing Baltermants's name recognition. These included organizing major photo exhibitions, selling or donating his work to art institutions, and producing new limited-edition portfolios of mostly unprinted work that could garner attention in the photography world.

When Mattis purchased the Baltermants archive, he and Tatiana Baltermants had agreed to work together to produce additional portfolios. In 2003, he produced three separate limited-edition portfolios but, for legal reasons, could not use any of the images that appeared in the 1992 portfolio. Two of the new portfolios were limited editions of Baltermants's World War II photography. Mattis produced thirty-five sets titled "The Great Patriotic War, Portfolios I and II." Each portfolio included twenty sixteen-by-twenty-inch silver gelatin photographs that were printed on Ilford multigrade fiber paper. Seven were printed as artist's proofs; twenty-eight of them were for the limited edition. Tatiana Baltermants came to the United States to stamp and number each of those fourteen hundred prints made "under the supervision of the estate." In order to recoup his investment, Mattis had to find a way to distribute the prints, which meant setting a price and finding buyers, whether individual or institutional. He encouraged potential purchasers to acquire both for their own collections and to donate them to art institutions. Mattis, with help from Hawkins, who was effectively the gatekeeper for photography exhibitions in southern California, organized a summer 2003 exhibition at the Stephen Cohen Gallery in Los Angeles called *Dmitri Baltermants: The Great Patriotic War 1941–1945* in order to publicize the new portfolios.[35]

Collectors often seek discretion and do not want to announce to the public details about their private financial transactions unless legally required to do so. Yet in 2004, Mattis agreed to a story about his photo collecting for *Forbes* magazine. The fact that the article appeared in *Forbes*, a business magazine with the slogan "Devoted to Doers and Doing," highlights the central role the media, in particular the financial media, has played in the commodification of art in general, and Baltermants's photography in particular. Susan Adams's article about Mattis and the acquisition of the Baltermants archive was titled "Red Eye: Collector Michael Mattis Aims to Make an Obscure Dead Russian Photographer Famous. If He Can, He'll Make Himself Richer."

Adams focused on the collector even more than the photographer as she described Mattis's purchase of the entire archive from Russia. Although she

referred to Baltermants's photographs as "mannered," as was the style of all Soviet photographers, she also stated, incorrectly, that "the most revealing photos are those Baltermants didn't dare print until long after he'd taken them. 'Grief,' a searing 1942 picture of a Crimean battlefield, shows an anguished peasant discovering the body of her husband. It wasn't printed until the 1960s." Her use of the word "dare" reminded her *Forbes* readers of Soviet censorship. Her statement echoed similar ones that Baltermants himself had been making in the Soviet Union since the 1960s as he distanced himself from Stalinism. As Adams and Baltermants suggested, only once the more liberal Khrushchev was in power and Soviet politics of war memory had changed could he "dare" to print his famous wartime photographs. She also implied incorrectly that the photograph was a postbattle image that had been repressed by Stalin.

Since this article was for a *Forbes* readership interested in the business aspects of collecting photography, the writer asked Mattis how he intended to increase the value of Baltermants's work. Adams reported that Mattis was making fifty-six large-format limited-edition portfolios, in two separate parts, containing twenty World War II prints. As it turns out, Mattis also produced five massive portfolios that included eight hundred smaller eleven-by-fourteen-inch prints. (This single portfolio resulted in four thousand eleven-by-fourteen-inch Baltermants prints, a large number of prints that needed to be sold.) There was one problem with the eight hundred prints: they were missing the twenty photographs that Baltermants himself had used throughout his career. Instead, Mattis printed photographs that either had never before been printed but looked like they had aesthetic potential, images that had appeared in publications relating to Baltermants, or those that had something in common with his well-known images—including several never-before-printed variants of *Grief*. These "variants" included different versions of the iconic photograph as well as other photographs Baltermants took that day in Kerch. The final portfolio included nineteen eleven-by-fourteen-inch prints from that day in January 1942 when Baltermants photographed the killing site near Kerch. By 2004 Mattis, according to Adams, had sold a third of the Great Patriotic War portfolios.

Adams closed her article by reminding readers that "a gradual buildup in Baltermants' fame may pay off some day in Russia, where the newly rich are buying back their country's art treasures. Mattis would be pleased if someday the archive returned home to Russia—at the right price."[36] Capitalism defined the American economic system during the Cold War. Adams was suggesting that post-Soviet Russia and its nouveau riche class of billionaires made wealthy through crash privatization of the 1990s was trying to catch up to the United States. Little did Adams know how prescient she was.

In the first decade of the 2000s, several art museums began receiving end-of-year donations of Baltermants photographs, nearly all of them with a print date of 2003, the year Mattis made his 5,400 prints. As Adams noted in her article, Dartmouth College's Hood Museum purchased one portfolio of eight hundred prints. That was a massive expense for a university art museum, so Mattis brought together two of his clients who were alumni of Dartmouth, and the Hood, with whom these particular clients had a long relationship. They purchased two of the five portfolios from Mattis and donated one to their alma mater. This makes the Hood arguably the largest institutional holder of Baltermants prints in the world.

Starting in the mid-2000s, museums beyond the northeast United States began receiving donations of Mattis's Baltermants photographs. The Akron Art Museum (AAM) received its first gift of twenty-seven Baltermants prints in 2006 from one of Mattis's clients in the San Francisco Bay area. By 2012, the AAM's Baltermants collection reached forty-seven, one of the largest collection of Baltermants in the country.[37] His photographs from the 2003 printing ended up in the collections of the Chrysler Museum of Art in Norfolk, Virginia, and the Utah Museum of Fine Arts (UMFA).[38] Another of Mattis's clients donated Baltermants photographs to several art museums, including the UMFA, the Cleveland Museum of Art, and the AAM.

If the post-Soviet period saw remarkable developments in the United States, it was in Europe where Baltermants had his primary viewing audience ever since his first London exhibition in 1964.[39] After her father's death, Tatiana Baltermants built relationships with European institutions even though she sold his archive to a collector in the United States. While they were developing his reputation in the US market, she and Harbaugh also worked with French galleries and publishing houses as interest in the photographer in France increased after his death. In October 1990, at the Comptoir de la Photographie gallery in Paris, she attended the opening of a show of her father's work organized by the Paris-based Marie-Françoise George.[40] His work, especially *Grief*, was sold at auction in London, Paris, and Germany through the 1990s and 2000s. In 1997 Robert Delpire and his Photo Poche series put out a book dedicated to Baltermants, part of an influential and successful series of photography monographs. Delpire was the distinguished publisher of many notable photography books, including Robert Frank's *Les Américains*, and Paris was a key venue for magazine photography.[41]

In post-Soviet Russia, perhaps Baltermants's most important champion (after his daughter) was Olga Sviblova, the contemporary impresario of the art world. Born in 1953, Sviblova attended her first photography exhibition at age six. The show was dedicated to Khrushchev. In an interview with the *New York Times* in 2010, she recalled that the show included Baltermants's shots of Khrushchev doing such mundane activities as playing the accordion and eating popcorn.[42]

This, according to Sviblova, was what inspired her lifelong love of Baltermants's work. In 1996, Sviblova founded the Moscow House of Photography (MDF), and in 2012, she opened a second institution on the same site on Ostozhenka Street, not far from the Kremlin, called the Multimedia Art Museum (MAMM).

Sviblova hoped that the MDF/MAMM would serve as a beacon of Russian photography and arts to the rest of Europe and that their shared space could educate post-Soviet Russians about world photography. To that end, in 1996, she hosted Moscow's first photo biennale. (She later served as curator of the Russia pavilion at the 2007 and 2009 Venice Biennales.) In 2007 Sviblova was awarded the Order of Friendship by Putin for her contributions to the development of Russia's cultural ties, and in 2008 she received the French Legion of Honor. She sees her task as educating the Russian public about its great artistic, and in particular photographic, traditions. In addition, she wants to expose these same audiences to the best in international and contemporary art.

In 2011, Sviblova brought together 150 photographers from across Russia to Moscow for a project called Foto Fest, in which these photographers showed their work to influential people in the global photography market. The goal was to give little-known Russian photographers more exposure to the international photography market. She did this with financial support from the Garage: Center for Contemporary Culture, an institution dedicated to contemporary art that was launched in 2008 by Daria Zhukova. The Garage also hosted the event. To emphasize how the photograph-as-commodity had come to post-Soviet Russia, the *Wall Street Journal* article "Free Market Exposure," about Sviblova and Foto Fest, began: "Fine-art photography is a business. Artists need markets to sell their photographs in order to continue to make art."[43] If anyone was going to help Tatiana Baltermants convince Russian billionaires to be interested in her father's war photography, it was Sviblova.

The goal of getting wealthy Russians to buy Baltermants's photographs coincided with the Putin government's reestablishing World War II and the Soviet victory over Nazi Germany as a world-changing moment for Russia and all of its citizens. This conscious effort to return World War II to an event of Russian glory took place after perestroika, glasnost, and the Yeltsin years of the 1990s revealed that the Great Patriotic War was, perhaps, not so great after all.

With the archives finally accessible in the late 1980s and 1990s, scholars and amateur historians shed new light on dark issues during the "glorious victory": rampant rape by Soviet soldiers during their occupation of Germany; the violence Soviet officers meted out on enlisted personnel; deportations of whole populations of Soviet ethnic groups; and Stalin's refusal to acknowledge the devastation and pain that the German occupation had left in its wake in the immediate postwar years. With Putin returning surviving veterans to a place of

honor and affirming memories of World War II as a source of pride for Russians of all ethnicities, including Jews, it was not hard to convince successful Russian businesspeople, including many billionaires, most of whom had war veterans in their families, why they would want to acquire classic Soviet war photography.

In 2005, an exhibition called simply *Dmitri Baltermants/Дмитрий Бальтерманц* was curated and produced in Moscow but exhibited at Paris's European House of Photography. This was not unlike his 1964 London exhibition, which was also produced and curated in Moscow and then exhibited at the Ceylon Tea House by the local Great Britain–USSR Association, albeit with very different goals. The MDF, with Sviblova as curator, exhibited 150 Baltermants photographs and produced a bilingual (Russian and French) catalog. It then traveled to Paris. In the 2005 retrospective, *Grief* was called *Горе/Douleur*. The mayors of Moscow and Paris, Yuri Luzhkov and Bertrand Delanoë, each contributed funds to produce the exhibition.

The show was widely covered in the press. Marina Raikina reviewed the show for the *Moskovskii Komsomolets*. Not only did she celebrate Baltermants's wartime photographs, as many other critics had done before, but she also engaged deeply with his photographs of the Soviet leadership, suggesting that the images had deeper meanings. Raikina read his photographs psychologically, even psychoanalytically, as she referred to his photographs of Stalin, Lavrenti Beria, Andrei Zhdanov, and others as a "political horror story" and of Khrushchev himself as "bald, happy, and sexy." Raikina describes Khrushchev's photograph with a corncob not as an agricultural product to consume but as a "phallic symbol of the CPSU [the Communist Party of the Soviet Union]." Her review also complimented the lighting designers for the exhibition.[44]

Writing for *La Croix*, the Catholic newspaper in Paris, Armelle Canitrot wrote that *Douleur*, which was one of a series of images included as part of Baltermants's 1975 series, *That's How It Was*, "shows the 'pain' of women discovering the frozen corpses of civilians who littered the fields in January 1942 . . . not hesitating to insert a leaden sky above their heads to better convey the tragedy of the situation."[45] This French reviewer for a Catholic newspaper did not lambaste Baltermants for having produced a composite print. Instead, Canitrot understood that Baltermants's addition of the clouds was not simply to repair the negative but rather to help the photograph better impact the viewer with its pathos.

In England, Barbara Oudiz, reviewing the Paris retrospective for the *Financial Times*, whose readership was interested in the market aspects of photo exhibitions, returned to more traditional themes of Soviet state control and censorship. She used phrases like "Kremlin-approved" and "unwavering patriotic militancy with an elegant artistic vision." She spent two paragraphs discussing *Grief*. In this retrospective, it was on exhibit as part of Baltermants's 1975 series, *That's How It*

Was. The goal of the curators was to return the iconic *Grief/Gore/Douleur* to its historical context. But Oudiz insisted that *Grief* was special. Following reviewers of the Soviet past, Oudiz emphasized that the photograph "is one of the most emblematic of his style, which often uses strong, horizontal compositions."

She also reminded readers that the "practices and morals of the times" meant that Baltermants "admitted to having altered the photo, replacing the mist enveloping the scene by a dark, cloud-filled sky to heighten the drama." She followed this statement by suggesting that such photomontages were openly used by Baltermants and his peers "for patriotic purposes."[46] British reviewers echoed their American colleagues in seeing Soviet photographs through the lens of propaganda.

Sviblova and Tatiana Baltermants worked not only with galleries in France but also in England, where there was a large, wealthy Russian expatriate community. There, the more skeptical British audience had a more mixed response to Sviblova's exhibitions. In 2013, she curated a show at the MDF/MAMM called *Primrose: Early Colour Photography in Russia* that then traveled to London's Photographers' Gallery. Sue Steward reviewed the show for the *Evening Standard* and, not surprisingly, wrote about color—one color in particular, red—and one photographer who was well represented, Baltermants. (Although *Grief* is in black and white, Baltermants was widely known as a master of color photography.) The conclusion of this laudatory review praised Sviblova for conducting a huge amount of research for this "magnificent collection."[47]

This positive review was followed by a highly negative review titled "From Russia with Lies." Writing for the *Independent,* Zoe Pilger called out Baltermants for propagandistic manipulation: "A new exhibition . . . has just opened at the Photographers' Gallery, London. It is timely: last week, a new law came into effect that further restricts Russia's internet, a space that has enabled relative freedom of speech while the mainstream media is heavily censured by Putin's regime. Those who wish to understand the events of the past few months in light of the long history of ideological control in Russia will enjoy this exhibition. It explores the attempts of successive regimes to dictate reality through images."[48]

In fact, by the second decade of the twenty-first century, Putin's regime had in fact ushered in what some people refer to as a post-Soviet Cold War given his ever-tightening control over the public sphere and his consolidation of power through his political party, United Russia. In 2013, when the *Primrose* exhibition opened in London, Pilger's condemnation of Baltermants's supposed propagandistic manipulation raises questions about whether cultural exchange could overcome this new Cold War. This had been Baltermants's explicit goal in the 1960s when he was in charge of photographic diplomacy at the SSOD and specifically the Great Britain–USSR Association. But Pilger casts these motives in

doubt, suggesting that these exhibitions were simply a masquerade for the nefarious politics of Putin's regime. No matter whether Pilger was right that the show was a mask for Putin's politics or whether Steward correctly understood the brilliance of the exhibition as a means of cultural exchange, *Primrose* only increased awareness of Russian photography in general, and Baltermants specifically, in the British photographic community.

In honor of Dmitri Baltermants's 100th birthday, in 2012, Sviblova and the MDF/MAMM hosted another retrospective, the third since the MDF opened in 1996. She was clearly a fan of Baltermants, and this latest exhibition, following in the tradition of jubilee shows, received rave reviews from the Russian-language press. Rosfoto, a portal for contemporary Russian photography, and many other press outlets in Russia, published Sviblova's press release, which lauded Baltermants as a "strong, intelligent, wise, courageous and handsome man, who masterfully both created and maintained the basic myths of the Soviet system about the happy life of the strongest and happiest people." To be sure, Sviblova reminded readers that Baltermants participated in the myth making or, better put, propagandistic activities, of the Soviet state as its leading photographer. On the other hand, she reminded the reader that Baltermants "demythologized reality in the most merciless manner, accentuating in his photographs universal pain and joy that ignore geographical boundaries and social order."[49]

Back in 2008, as the world economy went through significant challenges in nearly all spheres of investing, any diversification was seen as positive, a hedge against further losses. Although it was affected by the 2008 recession, the art market had been relatively stable. Therefore, in 2010 the Russian legislature made it legal for art to be used as a security. This seemed a practical move given what William MacDougall, owner of London's auction house specializing in Russian art, suggested: "Russian photographs are a sensible investment."[50] That same year, a Russian investment fund called Agana entered the art investment business. For its first venture in the field of art, Agana launched the world's largest closed-end mutual investment fund for photography called *Sobranie: Fotoeffekt* (Collection: PhotoEffect).

Russian investment firms are not known for their timidity about putting money into areas that they believe will produce high rates of return. Russian billionaires, whose collections made up Sobranie: Photoeffekt, hoped that art would serve as a hedge against changes in the political climate both in Russia and around the world. Using third-party middlemen and relying on the largesse of some of Russia's wealthiest men, whether they were living in Russia or abroad, *Sobranie: Fotoeffekt* acquired dozens of Russian and global photographers' vintage prints and in some cases whole archives. These included works from Joseph-Philibert Girault de Prangey, who in the 1840s took some of the earliest

photographs of Greece, Palestine, Egypt, and Syria. To give some sense of the value of this particular photographer's prints, in May 2003, a Qatari sheikh purchased a single Prangey daguerreotype for nearly $1 million. The collection also included vintage photographs from Cartier-Bresson and Alexander Rodchenko.[51] In its entirety, the mutual fund owned 295,000 original photographic prints and had a valuation of $467 million. *Sobranie: Fotoeffekt* sold shares in this closed-end investment fund on the Moscow Stock Exchange to investors who, it was hoped, would turn a profit.[52] Art as commodity had come to post-Soviet Russia, and in a big way.

In an interview with *RIA Novosti*, Dmitrii Retunskikh, the chief executive officer of Agana, claimed that art investments, in particular photography, were more stable during the tumultuous times after the global financial collapse of 2008.[53] According to Oleg Sukharev, deputy director of Agana, three independent appraisers set the $467 million value: SARL Ceros/Librairie Serge Plantureux, the latter a French appraiser who had long been involved in dealing in Soviet photography; the American firm Master Piece Fine Arts Appraisals; and the Russian firm Art Consulting, directed by Anatoly Zlobovsky and, according to Russian law, the only one of the three officially able to certify the final appraisal.[54]

Zlobovsky had been a photography collector during the Soviet period and had been active in the 1990s trying to encourage the development of a photography marketplace in Russia.[55] As of 2007, he was serving on the Ministry of Culture's Commission to Secure the Photographic Heritage of Russia, established by Putin to make sure that what took place in the 1990s—when Western collectors by the dozens came in and bought up Russian photographs for export—would not happen again. In 2012, Zlobovsky continued to encourage people to collect photographs.

If *Sobranie: Fotoeffekt* performed well on the Moscow Exchange, there would be additional listings on international markets, among them London and Luxembourg. The fund, formally launched in the spring of 2011, included daguerreotypes, numerous large archival collections, and a "portfolio of Soviet second world war photographs."[56] *Sobranie: Fotoeffekt's* inaugural exhibition in April–May 2011, *The First Paparazzi*, took place at the MDF/MAMM, which showed work by Tazio Secchiaroli, whom the exhibition claimed was the first paparazzo in history.[57]

In 2010, a few years before the creation of this Russian art investment venture, Michael Mattis realized that he was not getting the kind of traction in the United States that he had anticipated for his Baltermants acquisition. His series of planned American shows never happened, so he decided it was time to sell the archive. A French dealer served as the broker between him and the purchaser

and, after these arrangements were made, he claims to have lost contact with the archive.

According to Dmitry Gershengorin, the colleague of Harbaugh's who continued facilitating relationships between American photography collectors and Russian art buyers through the 1990s and 2000s, Russian art and photography was becoming a particular commodity that Russian billionaires could buy in order to distinguish themselves from other billionaires. "Who needs another Lamborghini?" he said in a 2018 interview. "Why not start buying art?" Gradually these wealthy art collectors came to see art as not just another investment for their portfolio, but as something they could enjoy and appreciate. These Russian billionaires were now starting to emulate, and potentially outdo, their American counterparts. In this case, it became a matter of national pride for the billionaires who initially built up the holdings of *Sobranie: Fotoeffekt* bringing back to post-Soviet Russia the works, if not the entire archives, of many key Russian and Soviet photographers.

Gershengorin said that Zlobovsky represented a group of investors looking to repatriate Russian World War II photography archives, in particular Baltermants's. Gershengorin described the process of negotiating a deal and then working with American customs agents to ship the archive from New York City to Moscow in November 2010.[58] Back in Moscow it became one small part of *Sobranie: Fotoeffekt*.

In October 2012, just eighteen months after the largest photo investment fund in the world was formed, due to its lackluster performance, the directors of Agana decided to liquidate it. *Sobranie: Fotoeffekt*'s assets were sold off in four lots. Baltermants's archive was now being auctioned off as part of lot 2.[59] The lots were listed on an online auction platform for one month, and every day that they did not sell, the price was dropped. Lot 2 had an opening price of approximately $130 million. One month later, it finally sold to a mysterious closed joint stock company, PTNKh, for approximately $1.3 million.[60]

Tatiana Baltermants said that it did not matter that it had been sold to a conglomerate (she suggested that the actual buyer was Gazprom, the state gas company) and the archive was in an unknown location. She still has many vintage and period prints left in her private collection and continues to work with Sviblova and MDF/MAMM as well as with Glaz Gallery in Moscow. Founded in 2002, and under the direction of Maria Burasovskaya since 2006, Glaz Gallery was one of the earliest commercial photo galleries in Russia.[61] Alongside Sviblova but a generation her junior, Burasovskaya is fostering up-and-coming photographers as well as the photo collectors who sustain them, and she is bringing Dmitri Baltermants along with them. As in the 1989 *Aperture* article that featured contemporary Soviet photographers, with a piece about Baltermants, Burasovskaya

is positioning him to serve in a similar role to a post-Soviet generation. In 2020, the Glaz Gallery's website had *Grief* as one of its rotating full-page images along with the grim portrait of Mayakovsky by Rodchenko, whom Glaz Gallery also represents. It seems that the market for Soviet photography, whether by Baltermants or Rodchenko, has moved from New York City back to post-Soviet Moscow.

The word "Holocaust" has appeared only in the endnotes and in a discussion of the emergence in the 1960s of the word to describe a series of wartime events in which Nazi Germany targeted specific civilian populations for mass murder, especially—but not only—Jews, for ideological and political reasons. Today, the word has become ubiquitous. For many Israeli Jews, Shoah (the Hebrew equivalent of Holocaust) is a cornerstone of national identity, proof of the need for Jewish sovereignty. For many Western Jews, the Holocaust is one of the most important markers of their Jewish identity, one that the baby boomer generation is attempting to pass on to its Jewish children. For non-Jews in the Western world, the Holocaust has become an emblem of Western civilization's darkest hour, when Germany, the most civilized society in the world, used its power to destroy humanity. How, then, is *Grief* a "Holocaust photograph" especially if there are potentially no Jews in it?

After Dmitri Baltermants's archive was sold back to Russia, his work, and *Grief* in particular, continued to be bought and sold in the United States. In 2010, at her gallery in New York City, Nailya Alexander presented an exhibition of Baltermants's work, all period prints, and she reported that his work sold very well.[1] In fact, *Grief* appeared more often in exhibitions on both sides of the Atlantic after his archive was repatriated to Russia. What is new is that increasingly *Grief* has been hung in exhibitions implying its relationship to the Holocaust.

In 2011, the Museum of Modern Art (MoMA) in New York exhibited the photo in its Edward Steichen Photography Galleries. MoMA had acquired a 1960s print in 2010. The curators hung it with other World War II photographs. Weegee's 1942 *Thomas E. Dewey and Photographers*, just a bit smaller but hung in a similar fashion, was to *Grief*'s right. The image depicts a scrum of photographers with their large cameras and flashbulbs besieging Thomas E. Dewey, district attorney of New York and future governor of New York and Republic

presidential candidate.[2] The four smaller prints on *Grief*'s left were hung as a single visual statement. All of them were works by the US Army Signal Corps. The top left, *Surrender Ceremonies Onboard the USS Missouri, Tokyo Bay, Japan*, dated September 2, 1945, shows the Japanese foreign affairs minister Mamoru Shigemitsu signing the official surrender document. The top right shows a pile of rubble on the streets of a European city. But the bottom two were both taken at Buchenwald in April 1945.

The lower-left Signal Corps image shows a person in striped prison garb pointing at a Nazi guard, seeming to accuse him of some crime. In the background are two other people, one of whom stares directly at the camera and more importantly at the drama unfolding. The image immediately to *Grief*'s left, on the lower right and therefore closest in proximity, is one of the most famous concentration camp liberation photographs. It shows emaciated prisoners lying in their bunks crammed in together with a lone man without a shirt, rib cage protruding. This was taken at Buchenwald on April 16, 1945, and includes the iconic Holocaust survivor Elie Wiesel on one of the bunks.[3] It cannot be an accident, therefore, that the MoMA curators hung *Grief* where they did.

In the same year as the MoMA exhibition, the University of Colorado Art Museum (CUAM) put on a show titled *Through Soviet Jewish Eyes*. The show included *Grief*, and it tried to do what Paris's European House of Photography did in 2005 but MoMA did not—maintain the photograph's status as an art object while simultaneously embedding it in its historical and photojournalistic context. The curators hung the large-scale photograph on the same wall as a few other photographs from the series Baltermants took at Kerch, but also made sure that *Grief* took pride of place on the wall as they exhibited a larger version in comparison with the others referred to as *Grief, Variant*.

A glass case was placed near the large print with a few tiny vintage prints of the Kerch series from the war and the 1965 *Ogonek* edition, showing the image's own history. The interpretive text described Baltermants as a magazine photographer, who during the war, could not have intended for them to be hung on museum walls. It also emphasized that in its original incarnation, the woman standing in for humanity's cry was a very specific woman, P. Ivanova, who had found her husband shot dead by the Einsatzkommando 10b at the Bagerovo antitank trench.

In the massive 2012 exhibition *War/Photography*, curated by Anne Wilkes Tucker at the Museum of Fine Arts Houston, which traveled to major photographic exhibition spaces across the United States, *Grief* also plays a starring role.[4] The catalog's cover features Baltermants's *Attack*, but *Grief* anchored the section on civilian massacres. The label noted that the image of dead non-Jewish civilians stood in for the massacre of seven thousand peaceful Soviet citizens, most of whom were Jews.[5]

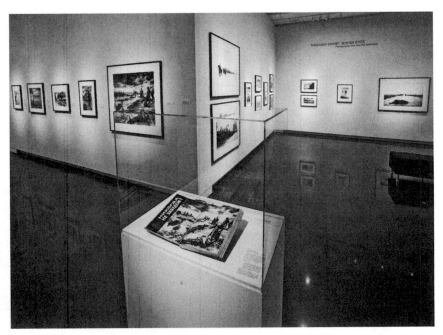

Jeff Wells, "Installation view of 'Through Soviet Jewish Eyes' exhibition at the CU Art Museum, September 8–October 22, 2011." © *CU Art Museum*

Further exhibitions of Baltermants's work continue to this day. From its initial 2012 acquisition of five contemporary Baltermants prints, the Bowdoin College Museum of Art (BCMA) has continued receiving gifts of more Baltermants prints from New York–based collectors, some of whom donated anonymously. The BCMA has sixty-five Baltermants prints—all of them produced in 2003 by Mattis. In 2017, the museum invited an undergraduate student, Johna Cook, to curate a show called *Dmitri Baltermants: Documenting and Staging Soviet Reality*. The show contained two dozen contemporary prints emphasizing Baltermants's photographs as "stages" of Soviet reality. Although Cook took a more nuanced approach to seeing his works as "stages," she concurred with American reviewers that his work obscured more than it revealed. A century after the Russian Revolution, American reviewers of the Bowdoin show still read Baltermants's photographs through the lens of politically motivated propaganda.[6]

The show included *Grief*. Its description—longer than any other print in the show—read as follows:

In January 1942 the Red Army liberated Kerch, Crimea from the German occupation and discovered the remains of 7,500 Jewish men, women,

and children who had just been massacred. Baltermants focused his lens on this woman mourning the death of her husband, excluding obvious references to the deaths of women and children as well as to the identity of the victims as Jews. This decision ensured that the image would evade Stalinist censure and, as a representation of universal suffering, would serve to enrage and rally fighters.[7]

The mourners and the dead pictured in *Grief* are most likely not Jewish. Instead, the women mourning these victims of Nazi reprisals during the Wehrmacht's retreat stand in for the thousands of peaceful *Soviet citizens*, most of whom were Jewish. This exhibition reads the Holocaust into *Grief* to emphasize Stalinist discomfort with a specifically Jewish wartime narrative, at least in Russian-language publications. (The story was quite different in Soviet wartime Yiddish-language publications, which were intended to highlight specific Jewish subject material for its readers.)

By the end of the twentieth century, Baltermants's *Grief* and his fine art photographic prints had become part of the permanent collections of art museums across the world, sometimes alongside other Baltermants prints from Kerch, many of which came from Mattis's 2003 portfolio. But his Kerch photographs also appear in the permanent photo collections of museums dealing specifically with the Nazi genocide of Jews and other targeted populations.

The US Holocaust Memorial Museum (USHMM) opened its photo archives department when the museum opened in 1993, just three years after Baltermants had his first commercial gallery exhibition. Its photo collections have been increasing to the point where it now holds eighty thousand photographs. Of these, an estimated 40 to 50 percent are copy prints from other archives, which the USHMM maintains for the convenience of researchers and for digital dissemination. Until the early twenty-first century the museum did not have large holdings of Soviet Holocaust photography, a gap that has since been filled by various means, including a diplomatic pouch of copy prints from private Russian holdings. The archivists have also undertaken mass microfilming projects of Soviet archives involving whole record group numbers from the State Archive of the Russian Federation (GARF), including the records of the Soviet Extraordinary Commission reports, which includes photographic material.

Both the USHMM and Yad Vashem, Israel's national Holocaust memorial and museum, have several Baltermants photographs from Kerch in their photo archives, some of which are photographs of the city's murdered Jews, others of the broader civilian massacre there. Yad Vashem has his close-up of the dead children and a few other landscapes. Three of the seven Baltermants photos at the USHMM originally appeared in the March 1942 *Ogonek* photo

essay. Not surprisingly, they are the ones of the three women—P. Ivanova, V. S. Tereshchenko, and S. Afanasyeva—in various states of sorrow.

Art museums tend to be interested in the photograph as an art object and therefore focus on questions of its production and provenance as well as of the artist's technique. Holocaust archives, however, keep photographs because of what they document in the image and have little interest in the object itself. Therefore, questions of "authenticity," which rarely came up in my conversations with curators at art museums, came up quite frequently in my conversations with photo archivists at Holocaust archives. In the early days of the USHMM photo archives, there was an unspoken rule that photographs that had been altered, doctored, or retouched in any way were not to be accepted. The fear of Holocaust deniers pointing a finger at a "faked photograph" would potentially cast suspicion over everything in the archives. They had to remain true to the mission of the museum, which was documenting the Holocaust.

Since the 2010s, the USHMM's acquisitions policies have liberalized significantly. Rather than removing a photograph that they learn was manipulated, they now keep it but provide the story about its manipulation.[8] Photoarchivist Nancy Hartmann explained that the USHMM archivists must think about researchers who do not believe the Holocaust happened and prevent them from thinking that "a photograph was created to deceive." But as an art historian herself, Hartmann believes that just because something is considered art and is found in art museums does not mean it cannot be used to document the Holocaust.[9]

Curators, especially those working in Holocaust photoarchives, are increasingly concerned about digital manipulation. Generally, if someone wants to donate a photograph to the USHMM and proposes to send a scan, the museum generally insists on having a print, because "we worry about authenticity." (Never mind that it is just as easy to make a print of a doctored image.) In the case of *Grief*, curators feel bound to provide information about the multiple versions of the photograph along with the specific print that the USHMM holds in its collection.

Judy Cohen, USHMM photo curator, who oversees the photography department, described icons of the Holocaust like the Warsaw Ghetto boy with his hands raised and the Einsatzgruppen photo of Jews arrayed in front of a ravine, which symbolizes the thousands of Jews shot on the eastern front. In our conversation when asked about *Grief*, she also cited it as an iconic photograph of the Holocaust: "When you think of the German invasion, you think of *Grief* . . . it is emblematic of thousands of other people who underwent that experience," which is why, she said, it has to be in the USHMM photo archive. She brushes off the insertion of clouds into the photograph as a minor technicality. "Adding clouds is one thing; adding people who weren't there is another."[10]

A search on the Yad Vashem website in December 2019 revealed 411,090 images in their database. That does not include the hundreds of thousands of prints lying in boxes uncatalogued, let alone unscanned, in the institution's storage facilities. Given the way the Holocaust functions as a founding myth of the country's formation, an Israeli institution dedicated to documenting and commemorating the Holocaust should have been more interested in emphasizing the documentary nature of Holocaust photography and less interested in theoretical questions about what photography is, means, or communicates than the USHMM.[11]

Instead, Maaty Frenkelzon, a photo archivist at Yad Vashem, talked about its exhibition, *Flashes of Memory: Photography During the Holocaust*, which opened in January 2018 to coincide with International Holocaust Remembrance Day. The massive show, which focuses on German photography, includes close to fifteen hundred photographs and eighteen films. It questions the very nature of photography as documentation and encourages the museumgoer to pay as much attention to the image maker as the image. It encourages the viewer to bring as critical an approach to photography as one brings to anything else. "This is an exhibition for the brain, not the heart," writes Daniel Uziel, historical consultant on the exhibition and head of Yad Vashem's photo archives, in the press release for the exhibition. Frenkelzon said that the exhibition had been a long time in the making and that Uziel had been one of its chief instigators, although it was curated by Vivian Uria, who directs Yad Vashem's museums division.

Writing for the *Times of Israel*, Renee Ghert-Zand lauded the show for provoking questions about the who, what, where, when, and, perhaps most important, the "why" of Holocaust photography. Ghert-Zand pointed out that virtually none of the photographs on display was being shown for the first time. What made the exhibition important was that the photographs "are exhibited here in a different light, and in a way that casts a more critical lens on Holocaust-era photography. The exhibition goes beyond the usual emotional response that Holocaust museums aim for when exhibiting photographs and takes a more cerebral and analytical approach."[12] The exhibition was designed as if one were physically entering a camera obscura through the lens to look at Holocaust images from the standpoint of the camera as well as the photographers.

This approach to exhibiting Holocaust photographs emphasized that a photograph communicates what the photographer, and the institution on whose behalf it is taken, wanted it to communicate. In a *Jerusalem Post* article about the show, Uria stated, "Although photography pretends to reflect reality as it is, it is in fact an interpretation of it, for elements such as worldview, values and moral perception influence the choice of the photographed object and the manner in which it is presented."[13]

And yet, reviews of the show remind us that, no matter the intentions of the photographer, whether a Nazi propagandist, a Soviet (potentially Jewish) liberator, or a Jewish ghetto photographer, the images leave unintended traces of people that can be used to document lives. The exhibition included a passage from the diary of Rokhl Auerbach, who went on to be one of the founding directors of Yad Vashem and during the war was part of the Warsaw ghetto's Oyneg Shabes documentation project. Oyneg Shabes, organized by Emmanuel Ringelblum, asked amateur and professional historians to write down anything and everything that was happening around them, because they sensed that they were experiencing world-historical events.[14] In 1942, as she watched a Nazi filmmaker shooting a propaganda film of Jews in the Warsaw ghetto, Auerbach wrote:

They should leave a sneak view of the Jewish passersby on the crowded streets in the movie. The faces, the eyes that in future years will shout out in silence. They should all be commemorated; the droves of beggars, the people of yesterday slowly dying from the hardships and starvation in the closed ghetto. And another thing, the main one—they should add the German participants in this drama. They were the lead actors in this play.[15]

In a lavishly illustrated and lengthy review of the show in *Haaretz*, perhaps the most deeply engaged one in any language, Ofer Aderet emphasized the show's success in emphasizing photography's instability and malleability. "The first of its kind," he wrote in the opening paragraph, no exaggeration for a photo exhibition curated by a Holocaust museum. Aderet included photographs of quotes by photo theoreticians such as Roland Barthes, who said, "The photograph: it cannot say what it lets us see." Also interspersed among installation shots were photos that appeared in the exhibition, including many by Jewish ghetto photographer Zvi Kadushin from the Vilna ghetto. And then, near the end of his review, Aderet quoted the curator Uria saying "the photographs provide sufficient evidence that a particular event indeed happened . . . Photography does not conjure an event, but rather is evidence of its very existence."[16]

After all of the sophisticated theoretical analysis of a photograph in the exhibition, Uria insists on photography's evidentiary nature. She also suggests that despite the sophistication of the exhibition exploring the very nature of photography, the museum's leadership still wants to remind its audience that photographs, especially of the Holocaust, should be seen primarily as a form of documentation.

When the CU Art Museum's *Through Soviet Jewish Eyes* traveled to Skokie's Illinois Holocaust Museum in 2015, the museum administrators organized a docent training so the volunteers would know how to lead visitors through

the exhibit. The volunteer docents were impressed by the images themselves, and as they stood in front of *Grief*, they learned that it was collaged from two prints. Some of them expressed concern that some of the images in the show were manipulated. Emphasizing that these were art photographs, their guide responded with a quotation from Baltermants about the limits of a camera's ability to document horror: "The camera did not capture what Baltermants experienced that cold January day in Kerch."

The tension between documentation and aestheticization demonstrates why *Grief* is the ideal image to serve as an iconic Holocaust photograph. It reminds viewers that the Holocaust involved the genocide of Europe's Jews (the seven thousand unseen Jews buried in the ditch running through the middle of the photograph) but also so many more people, including Sinti/Roma, Soviet prisoners of war, and other "peaceful citizens" who were caught up in the Nazi genocide, just like those actually pictured in *Grief*. Its inclusion in the icons of Holocaust photography broadens what we mean by the Holocaust and chips away at the term's parochialism and nationalism. The fact that *Grief* is stored in Holocaust photo archives and on the walls of Holocaust museums also encourages viewers to question photography's fealty to documenting external reality. For as the Yad Vashem show suggested, photographs must be questioned as much as any other document related to genocide; "truth" in images might be revealed only through the postproduction work of the photographer.

Ever since the wartime massacres at the Bagerovo trench that Baltermants photographed, Kerch residents—especially its Jewish community—have been commemorating them.[17] In the period just after the war, Soviet authorities generally did not allow public, state-sponsored commemorations for fascist atrocities specifically against Jews. In 1947, Stalin restricted remembrances even further by reducing the importance of Victory Day from its previous status as a national holiday, and that status would not return until 1965, on the twentieth anniversary of victory.

Nonetheless, memorial ceremonies for those killed during the war have been taking place from the immediate postwar period up until today. Official Soviet Jewish commemorations could take place inside synagogues run by local Jewish religious communities, although by the 1960s and 1970s, the Soviet synagogue was no longer seen as a primary space for Jewish gatherings. Jewish cemeteries also were permitted to conduct explicitly Jewish religious memorials to the dead should the local Jewish community want them. The cemetery, even in the Soviet Union, was sacred Jewish ground, as in the design and installation of the first *Grieving Woman* statue, commissioned for a Jewish cemetery, that would become ubiquitous across the Soviet Union. These were the only officially recognized

Jewish spaces in the Soviet Union after 1949, when Soviet Yiddish-language institutions from newspapers to theaters were closed down.[18]

Soviet Jews commemorated their dead through fundraising efforts to establish local memorials in the places where the Germans and their local collaborators had killed the town's Jews and other local residents. They also made annual pilgrimages to the local sites on the date either of the roundup in the town square or of the mass killing.[19] These memorials happened organically, one might say "vernacularly," by average Soviet Jews with a desire to mourn individually but also collectively. They came together to *build* something—an obelisk, a stone monument, even a wood stump with names carved into it—to identify the location of the killing site along with a memorial text to inspire contemplation. The Yad Vashem archives have hundreds of photographs of vernacular Soviet Jewish memorials documenting the extent of this process.[20]

Sometime around 1975, probably shortly after it was designated a hero city in 1973, Kerch city planners erected a memorial obelisk—rising nearly twenty feet high, surrounded by brick pavement and a black iron fence—at the far south end of the former antitank trench between the main highway, Vokzalnoe Highway, and the electric train line running between Bagerovo and Kerch, to serve as the public place at which to remember the wartime massacre at Bagerovo.[21] The late Soviet-era Kerch authorities along with the local Krymchak community established a memorial to fascist atrocities at Adzhimushkaiskii trench and quarry where, according to the memorial plaque at the foot of that obelisk installed by the Krymchak community as the Soviet Union was collapsing, "2269 peaceful citizens, among them the Krymchak population of Kerch and Soviet prisoners of war were executed."[22] Today, the memorial to the victims at Bagerovo, including those pictured in *Grief*, is located in the village of Oktyabrskoye, which did not exist during the war. At the time, everything beyond the Kerch city limits was called Bagerovo.

Since the erection of the obelisk in the mid-1970s, Jews who resettled in the city after the war and other local Kerch residents have been coming annually to the site to remember. They do so not on *Yom ha-shoah*, a memorial day set in the Hebrew month of Nissan (usually in April) that originated in Israel to coincide with the date of the start of the Warsaw Ghetto Uprising. Following the Israeli example, much of the organized global Jewish community commemorates the Holocaust on this day. Nor do the residents of Kerch do it on International Holocaust Remembrance Day in January, which marks the Red Army's liberation of Auschwitz, and, since its official adoption by the United Nations, is now observed by much of the world. Kerch residents do not even do it on June 22, the Day of Memory and Sorrow (*Den' pamiati i skorbi*), marking the date of the German invasion of the Soviet Union, which Russia, Ukraine, and Belarus made

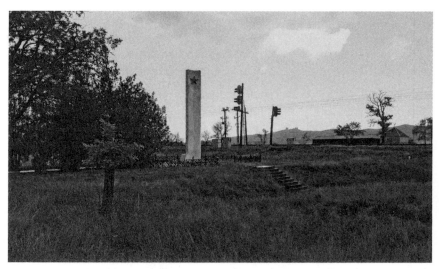

Sergei Nevzhalin and the Project Team Crimean Front, *Soviet Obelisk Commemorating the Massacre at Bagerovo Anti-Tank Trench*, July 2018. © *Project Team Crimean Front*

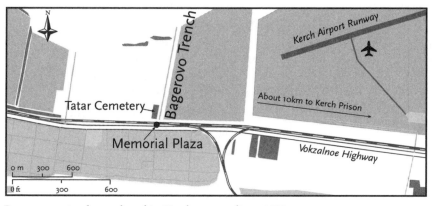

Bagerovo antitank trench and its Kerch surroundings, 2019.

a national holiday in 1996. They do so on the date of the *actual killings* at the trench, December 1, or as close to that date as possible.

Although collective memory is often shaped by and incorporated into a nation's or even the globe's foundational stories of how the past fits into the present, most memorial practices, especially for loved ones, are intimate and local.[23] They are shrines in people's homes or annual visits to local cemeteries. In this case, Kerch Jews and others who lost their loved ones at the December 1941 massacre visit the local memorial on the day of that massacre, a kind of communal

yahrzeit, the Yiddish term for the anniversary of someone's death, at least for the Jews and possibly for other local Kerch residents out of a sense of comradery, doing the commemorating.

"Here at the Bagerov antitank trench, in November–December 1941, fascist barbarians executed more than 7,000 peaceful Soviet citizens: women, the elderly, and children. Long live the memory of the victims of fascism." This classic Soviet memorial text on the obelisk names the location and date and presents a pared-down narrative of what took place here. Typical for a Soviet memorial, there is no explicit mention of Jews. "Fascists" killed "peaceful Soviet citizens," which included Jews. It also closes with a universal secular prayer for the victims of fascism. How, then, does the local Jewish community use this universal language for its particular memory?

They do it through rituals marking them as Jews coming together to commemorate a *yahrzeit*. Because Jewish cultural practices take on the shape of the local communities in which they live, Soviet and post-Soviet Jews have taken on practices common in communist countries. When Jews and other locals gather every late autumn, they bring flowers and wreaths to lay at the obelisk, along with photographs of their relatives, who were killed at the trench. Flowers, wreaths, and photographs are Soviet communist memorial practices, not Jewish ones. So how do these practices get transformed into Jewish ones?

They perform one additional ritual that renders their collective memorial practice Jewish—they recite out loud the traditional Jewish memorial liturgy. Throughout the Soviet period, if Kerch's Jews were anything like their compatriots across the country, they likely said the mourner's *kaddish* and the memorial prayer *el mole rachomim* either publicly or privately.[24] At the 2007 Kerch commemoration, as the community gathered at the memorial obelisk, the annual rituals took place with speeches by local Jewish communal leaders and the Kerch city administration as well as a representative from the local Office of Interethnic Relations. In addition, they held a Jewish memorial service.

At that same memorial gathering, a local writer, Naum Slavin, reminded the assembled crowd that Kerch was unique in terms of Holocaust massacre sites: "It was liberated early in the war; therefore, fascist atrocities against Jews were widely known."[25] This idea of being early witnesses to what German occupation meant for Jews gave Kerch an added distinction, at least to the gathered residents. The chairman of the community, Semyon Podolsky, then informed the crowd that the city was trying to sell the airport right next to the killing site to a company that would extend the runway to make it more compatible to commercial aircraft. This would mean disturbing the graves of loved ones. Podolsky called on the audience to fight the sale. (That fight never took place, because in 2008 the

airport went bankrupt; it officially reopened only in April 2018, and then only for helicopters and small aircraft landing during daylight.[26])

Coverage of the 2009 gathering included a display of mockups of a soon-to-be-assembled Jewish memorial that would be installed next to the Soviet obelisk. The new memorial, unveiled in April 2010, was a result of a fundraising campaign that involved many local Jewish residents of Kerch as well as their former Kerch compatriots, who now lived scattered around Russia, in Israel, and across the globe. According to the designers, it was intended to resemble an open book. It looks something like a Jewish tombstone, given its verticality and the plaque on the ground symbolizing the space where the body (in this case bodies) would be buried. Since it consists of two pieces of black stone, it also echoes the two tablets Moses was given on Mount Sinai to receive the Ten Commandments, but the memorial is split down the middle.[27] It has several visible Jewish signifiers on it, in addition to its shape. It features a star of David, it has two menorahs embossed on the lower right and left, and the text includes the contemporary language of global Jewry—Hebrew.

The main memorial text—"ETERNAL GRIEF/ETERNAL MEMORY/ TO VICTIMS/OF THE HOLOCAUST/SHOT HERE/IN NOVEMBER-DECEMBER 1941"—is in four languages, Russian and Hebrew on top, Ukrainian and English on bottom. Notably absent is Yiddish, a language that many of the victims would have spoken as their native language. Many memorials to fascist atrocities in the Soviet Union established in the immediate aftermath of the war by local surviving Jewish communities used Yiddish and Russian as the primary languages. The Yiddish text varied widely from community to community, sometimes explicitly referencing those killed as *kedoyshim*, martyrs in Yiddish (and Hebrew), and at other times framed the atrocities in the universal language of "Soviet citizens," understood as including Jews.[28]

In the twenty-first century, few people coming to these sites speak Yiddish. The absence of Yiddish and the presence of Hebrew (the ancient holy language of Judaism and also the contemporary national language of Israel) and Ukrainian (the national language of Ukraine, of which Kerch was a part when the new memorial was erected) reminds us that the postcommunist period saw a return to ethnonationalism as Ukrainian replaced Russian in most official public signage across Ukraine.

More than ethnonationalist ideology, Russian and Hebrew are on top presumably out of practical concerns about reaching the anticipated audience of Russian-speaking Jews, both those who are living in the Kerch region or those who emigrated to Israel in the 1990s and return from time to time with children and grandchildren, whose native language is now Hebrew. English is a gesture to

ВЕЧНАЯ СКОРБЬ
ВЕЧНАЯ ПАМЯТЬ
ЖЕРТВАМ ХОЛОКОСТА
РАССТРЕЛЯННЫМ
ЗДЕСЬ
В НОЯБРЕ-ДЕКАБРЕ 1941 Г.

ВІЧНА СКОРБОТА
ВІЧНА ПАМ'ЯТЬ
ЖЕРТВАМ ГОЛОКОСТУ
РОЗСТРІЛЯНИМ
ТУТ
У ЛИСТОПАДІ - ГРУДНІ 1941 Р.

הנצחת צער
זכרונות הנצחית
קורבנות השואה
מורה
כאן
1941 בחודש נובמבר דצמבר

ETERNAL GRIEF
ETERNAL MEMORY
TO VICTIMS
OF THE HOLOCAUST
SHOT HERE
IN NOVEMBER-DECEMBER 1941

Sergei Nevzhalin and the Project Team Crimean Front, *Close-Up of the Jewish Memorial*, July 2018. © *Project Team Crimean Front*

the broader linguistic universe in which tourists and other non-Russian speakers might operate.

The main text on the flat piece of black granite is only in Russian, the lingua franca of Kerch and its diaspora, and it reads:

Here on this site in December 1941 at the Bagerovo antitank trench German executioners and their collaborators, murderers from other ethnicities, destroyed thousands of Jews, who lived in Kerch and its surroundings: men, women, girls, and boys, young men and women, old people, and infants. They were destroyed in order to wipe out the Jewish people, erase the memory of Jews, and finish off every last person who is called Israel. May their memory be bright, and may they stand in their fate for all remaining days.

This memorial text opens as a matter-of-fact description about the when and where of the killings—"December 1941, Bagerovo antitank trench." Then it suddenly becomes a post-Soviet, nationalist denunciation of *all* of the killers, not just "German executioners" but also "their collaborators, murderers from other ethnicities." The word "collaborator" in Russian usually references *local* collaboration, in this case, Tatars and Ukrainians. Although it is not written on the plaque, "murderers of other ethnicities" likely referred to Romanians and Hungarians. Note that no ethnic group is mentioned explicitly except Germans. One suspects that this is because the Jewish memorial had the support of the local Ukrainian Kerch municipality in the late 2000s. Although during the war calls for revenge against "German executioners" could be heard frequently, rarely did language like this appear on a postwar Soviet-era memorial. These Soviet memorials named "fascists" as the killers, and attempted to redeem "collaborator" nations through an often violent imposition of communism. Moreover, the victims are very clearly identified as Jews, and referenced as "Israel," now not only a name for the collective Jewish people but also a contemporary nation-state, rather than peaceful Soviet citizens.

The final two sentences turn abruptly from a historical narrative on a memorial plaque to a biblical curse potentially meant to be recited out loud. The language of "wiping out" and "erasing" Jews draws from the Torah passages about Jews being commanded to "wipe out" (*steret'* in Russian) the "name of Amalek," the biblical enemy who killed Jews on their desperate flight from slavery in Egypt.[29] This plaque embeds the memory of the Jews murdered at Kerch in a long line of failed genocides against the Jews stretching back to the Bible. It closes with a prayer about their memory and a messianic vision of the world to come.

With the establishment of the second memorial, the Bagerovo killing fields have been reclaimed as a public Jewish space. At the same time, they remain embedded in their broader pan-ethnic Soviet context with the looming obelisk and its text as originally written in the Soviet era just steps away. Anyone who comes to remember the dead engages with both memorials and therefore with the complexity of memory and identity—as post-Soviet Jews living in Kerch

or abroad and non-Jewish locals who lost family members in the massacres during the war. This complex memorial landscape is also an accurate description of that iconic image of the Kerch massacre, *Grief*. For although Baltermants photographed dead Jews at the trench, it is likely that none of the dead depicted in his classic photograph was Jewish.

On November 27, 2016, the Kerch progressive Jewish community held a memorial ceremony in its synagogue that included many musical performances and speeches from Kerch and Jewish communal leaders. Streamers of Russian flags fluttered over the room, reminding the assembled crowd that their city was, as of the referendum that took place in 2014, now part of the Russian Federation. The multipurpose room had a stage from which people sang and on which there was a display of art projects from local Jewish Sunday school children.

These children's images included some pictures directly referencing the massacres that took place at the trench. Although no student produced art about the six-year-old Jewish memorial, one student painted the dramatic Soviet obelisk, including a wreath laid at its foot. Others produced art that reflected more universal Holocaust symbols like six candles with stars of David on them, a gesture to six million murdered Jews; a barbed-wire fence surrounding a concentration camp; shattered windows; and a Jew with his hands raised, like the iconic boy in the Warsaw ghetto photograph.

Next to the obelisk painting was a statement written in a child's handwriting that sums up how today's Kerch Jewish children understand what took place at the trench where Baltermants took his famous photograph, and more generally throughout the region: "During the years of the fascist occupation of Crimea more than 90,000 peaceful citizens—among whom more than 40,000 Jews and, along with Jews, more than 6,000 Krymchaks—were brutally executed."[30] These were the words of Jewish Sunday school children in Kerch in late 2016. Who could disagree with this phrasing? It brilliantly captures the way post-Soviet memory of wartime atrocities works. Jews finally reemerge as a distinct category in the list of victims, but they are always embedded in the broader Soviet and ultimately human wartime tragedy.

After the speeches, the communal *yahrzeit* (the "religious service" mentioned above) began with a Jewish memorial candle lighting ceremony that took place on a large table near the stage, on which sat a big wooden star of David. The star of David was wrapped in a Jewish prayer shawl, with black-and-white photographs blown up in the middle of the star. One of them is Yevgeny Khaldei's 1942 photograph of Grigory Berman finding his dead wife and daughter at Bagerovo.[31] At the conclusion, everyone was invited to gather at the synagogue two days later, at 12:30 p.m. sharp, to be transported to Oktyabrskoye's in-situ memorial

for the annual commemoration. This had clearly become a familiar ritual to the assembled audience of approximately one hundred people.

Two days later, on November 29, 2016, the seventy-fifth anniversary of the day of Kerch Jews' roundup, the city held its annual municipal commemoration at the memorial. Residents of Oktyabrskoye showed up, including Yuri Korotov, an official representative of the village, along with Zoya Kamskaya, chair of the Kerch Jewish community. In her speech, she noted that for decades, "conscious and engaged residents had been coming on foot and by transport to the site to pay homage" to the dead. After the speeches, there was a minute of silence and then people laid flowers and wreaths at both memorials.[32] Although not mentioned, there was likely a public reading of the *kaddish* and *el mole rachomim*.

In 2017, on the seventy-sixth anniversary of the killings, Maria Antishina covered the story for the local Kerch news channel. The images of that day show a typical gray late autumn sky and a multigenerational group of people bundled up to keep warm. Students from a local school participated in the event and posed sophisticated questions about the historical past: "Why was it called Bagerovo when the killing site was in Oktyabrskoye?" (answer: at the time at the city limits of Kerch, the village of Bagerovo began). "Were there survivors?" (answer, yes, and then they proceeded to describe how some Jews survived the mass killings).

One image shows a woman holding a photograph of relatives killed during the war with two red carnations to be laid at the foot of the memorial. Another photograph in the 2017 news story shows a female rabbinic figure from the Kerch liberal Jewish community reading from a progressive *siddur* and leading the crowd in a Hebrew prayer, again likely the Jewish memorial prayers. Then a final photograph depicts the mourners laying flowers at both memorials. Included among the photographs of the event itself, there is one additional photo of the opposite end of the antitank trench, across the highway and train tracks.

In the post-Soviet period, no one has done more to unearth the history of the killing sites in Kerch and more broadly in the Crimea than scholar Mikhail Tyaglyi, who spent years conducting research in archives and interviewing Kerch residents, both survivors of and witnesses to the killings. He did this on behalf of both the Shoah Foundation's Visual History Institute and Yad Vashem's International Institute for Holocaust Research and its newly launched portal, Untold Stories: The Murder Sites of the Jews in the Occupied Territories of the Former Soviet Union.[33]

Tyaglyi, a researcher at the Kiev-based Ukrainian Center for Studying the History of the Holocaust, gives speeches about the uniqueness of the killings in the Crimea, especially as it relates to the Krymchaks, who were a unique population murdered in this part of the Soviet Union and ultimately marked as Jewish victims of the Nazi occupation. He notes that they were initially spared being

killed at Bagerovo only to be rounded up in the second occupation by the German army in June 1942 and executed at Adzhimushkaiskii trench. In 2011, Tyaglyi visited Kerch and took pictures of the Bagerovo trench, the memorial plaza, and the various sites around town where memorials had been established (Haymarket Square, *Adzhimushkaiskii*, and the Kerch jail where Jews were incarcerated) on behalf of Yad Vashem.

Tyaglyi was not the only person conducting research on the killing fields in Kerch. Father Patrick Desbois, a French Catholic priest whose own father was held in a German prisoner of war camp in Rava-Ruska in western Ukraine, not far from Bełżec, was doing so too. Desbois was curious about his father's silence on the subject, so he went to Rava-Ruska himself to investigate what people knew during the war and, if possible, what his father might have seen. Starting in Rava-Ruska, he traveled through western Ukraine asking elderly locals who would have been living in the town during the occupation what they saw and what they remembered. Most importantly, because he knew that every town under German occupation had its ravine or trench, he asked them to show him where the occupation forces brought the town's Jews to be executed.[34]

His first research expedition in western Ukraine ended up becoming a multimillion-dollar, not-for-profit organization called Yahad in Unum (YiU, meaning "together/in one" in Hebrew and Latin). Founded in 2004, YiU investigates crime scenes in war zones where mass killings took place. YiU has primarily focused on the former Soviet Union and postcommunist countries where local killings took place like Poland, although in recent years its methods of research and eliciting stories from witnesses to crimes have been brought to other locations such as Guatemala, eastern Syria, and Iraq.

Like Tyaglyi and Yad Vashem's researchers, after conducting preliminary research in archives from around the world, the YiU team arrives in a town in the former Soviet Union to seek out any local residents old enough to have been in the city under German occupation during the war. Those elderly people then serve as witnesses to crime scenes that took place more than seventy years ago. The YiU team invites these witnesses to take them to the actual killing fields and describe the places, sights, sounds, and even smells from the past. Then, if the witness offers, the team returns to their home to continue the interview.

To be clear, these are not "survivors" in the classical sense of the word whom the Shoah Foundation Visual History Institute or Yad Vashem would be interested in interviewing. These are local witnesses to horrible crimes, and because they were witnesses to the mass murder of Jews, they are rarely Jewish themselves. They recount details about their seeing—or even involvement in—the digging of trenches, the sounds of screaming Jews, and their descriptions of the scenes

after the executions as locals, perhaps even themselves, were ordered to bury the bodies.

Some of them potentially participated in the killings, although the witnesses rarely if ever reveal their own role in the killings themselves. Using the written information and the eyewitness testimony, YiU then identifies the location of a killing site as definitively as possible and estimates the number of people killed there. They produce online records about their research in the form of a map located at YiU's website (https://yahadmap.org/), which might generate interest from the local municipality about making the space sacred (as if local residents or those who have been mourning their murdered loved ones for years do not know already!)

It is likely that elderly, primarily Christian eyewitnesses to crime scenes seventy years in the past see Father Desbois not just as another researcher but as a priest, and are therefore more willing to talk to him. They might do so as a form of psychological catharsis and even possible expiation for their sins. This line of thinking goes something like, "Finally, decades after the crimes took place, I have in front of me a priest, someone who will not judge me for the stories I am about to share." For the witnesses, Desbois might serve as confessor.

These witnesses had reason to maintain silence during the Soviet period. In the immediate aftermath of liberation, the People's Commissariat for Internal Affairs (NKVD) came to a liberated town to interview witnesses of the crimes in the form of the Extraordinary Commissions. If one was alive to serve as a witness to the fascist atrocities, NKVD officers demanded to know *how* you managed to stay alive. They collected dozens of notarized witness testimonies, but few would have been willing to name names unless those truths would get a local enemy in trouble with the NKVD. This happened on occasion, as when nine Soviet collaborators were put on trial at Kharkov in 1943. They were found guilty and executed.[35] Of course, people in the city of Kerch knew and saw everything up until the point at which the Jews were sent to "forced labor," and even then people living near the execution site would have heard and seen horrible things through December 29, 1941. During the Soviet period, these eyewitnesses to mass murder might have been brought up on charges of collaboration, so most of them remained silent.

In the decade after the collapse of the Soviet Union, Jews from around the world came by the thousands to the former Soviet Union as a form of postcommunist memorial pilgrimage. They came to see where family and friends were killed, to visualize what their lives might have been like had their family members not left the region, and to encounter ghosts of their Ashkenazi Jewish past. For these Jews, the local residents with whom they speak are often seen as mediums to the past, potentially even able to share stories about their parents,

grandparents, and others, whom these contemporary Jews never got to meet. Unless they are Jewish themselves, the personal stories of current residents are rarely of interest to Jewish memorial pilgrims beyond the connections to their family members' lives and deaths. Moreover, these Jews are often suspicious of local Christians or the occasional Muslim with whom they interact because of the reality of Ukrainian and Tatar collaboration with the German occupation forces. But these tourists' suspicions run deeper after years of Cold War rhetoric encouraging Jews to think that any non-Jew behind the so-called Iron Curtain was an antisemite unless proven otherwise.[36]

Despite the money that this type of heritage tourist brings to the economy, non-Jewish residents might have trepidation about tourists' motives, fearing that they might be upset at seeing how residents have incorporated sites of wartime mass atrocities into their day-to-day lives as playgrounds, shopping malls, or even airport runways. More than that, had these eyewitnesses shared their stories honestly and openly about the German occupation, they would likely have said things that Jewish memorial pilgrims did not want to hear. Yet with the arrival of Father Desbois, a priest asking questions about what happened in the past, suddenly they were willing, even eager, to speak, many of them for the first time and on camera.

In addition to the interviewer and interpreters, YiU brings along a professional photographer and a videographer to visually record what exists today, to document any memorials, and to capture in still photographs, both film and digital, and on video the witnesses telling their stories.

YiU made three different expeditions to Kerch, in 2003, 2004, and 2014, each with a different photographer: the Paris-based Israeli 2018 Prix Bettencourt laureate Mona Oren (2003), French photographer Guillaume Ribot (2004), and Russian photographer Aleksey Kasyanov (2014). As all of them described, the itinerary of the visit is driven by the eyewitnesses, because that is the point of the YiU visits—to figure out what they saw, heard, smelled, and felt, and then to return to that precise location. In 2003 and 2004, there are photographs of the killing site at Bagerovo, because there were still surviving witnesses to the killings that took place there. But by 2014, there was only one person left alive who could bear witness to any atrocities in Kerch, and this witness was not able to testify about the massacre at Bagerovo. So there are no 2014 YiU photographs of the Bagerovo trench.[37]

On the 2003 and 2004 YiU trips to Kerch, there were several witnesses who brought the team out to the trench. The YiU team visited Kerch on December 27 and 28, 2003, and Oren shot on film, using both 35mm and square format cameras, as well as digital. Over the course of two days in Kerch, the YiU team and Oren were brought to the site on two different occasions, both led by elderly

Mona Oren, *Father Patrick Desbois Interviewing Witnesses at Home, 2003.* © *Mona Oren and Yahad in Unum*

witnesses. One of the witnesses had someone accompanying her and the other had Jewish community members present for the visit.

Oren described the two days she was out at the trench with the witnesses—being interviewed by Desbois—showing the team where the killings took place. The team included Father Desbois, a translator, a videographer, and in this case a second still photographer.[38] In the photographs that Oren took with a film camera, which YiU did not have available (Oren scanned them for the purposes of this book), we see an elderly witness donning a pink kerchief, plum coat, and black skirt standing in the foreground as the trench stretches out into the distance. In this photograph, the sky occupies a third of the frame. Then Oren has captured an in-situ interview that Desbois is conducting with the witness. She is accompanied by two other women, one of whom is the translator; the videographer; and a second still photographer. Desbois is dressed in a long black trench coat holding a microphone. From this angle we see the farmhouse that had been built after the war, which appears in photographs of the area. Now the sky makes up closer to half of the frame. The final photograph shows the group after they descended deeper into the ravine as Oren positions herself to capture the entire scene. The sky now makes up more than half of the frame.

Oren's first digital photograph could literally be anywhere—a soft blue sky taking up a tiny fraction at the top of the image with rolling hills in the distance.

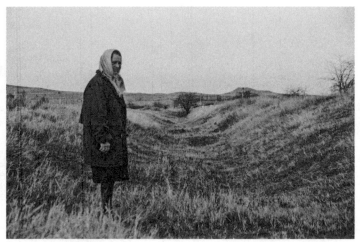

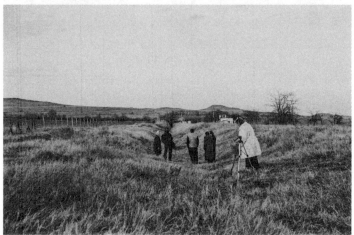

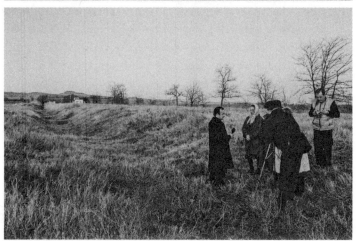

Mona Oren, *Witness at the Bagerovo Trench*, 2003. © *Mona Oren and Yahad in Unum*

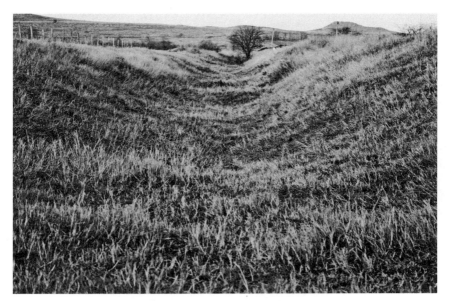

Mona Oren, Yahad in Unum, *Bagerov Trench*, labeled as "Execution on Anti-Tank Ditch,"
2003. © *Mona Oren and Yahad in Unum*

But the site is immediately recognizable. The photographer has shot the scene
from inside the trench, which is now flatter than in Baltermants's photographs
from 1942 when it had just been dug.

The photograph shows that the trench has become overgrown with wild
grasses. Browns, greens, and yellows are the dominant colors. There is a leaf-
less tree in the top center of the photograph reflecting the photograph's late
December winter color palette. In the distance, the roof of a house peeks through
and a fence frames the left side of the image. The original purpose of the antitank
trench was, as its name implies, to prevent tanks from moving forward. As it is
clear in her picture, a tank could easily drive over the now gentler terrain of the
groove the photographer has captured.[39] There are no memorials or other visible
markers in the photograph that a mass killing took place here. So how is one to
know what one is looking at?

A second empty photograph of the trench, taken one year later by Guillaume
Ribot, was shot further along and deeper into the trench. Ribot seems to have
laid down on the ground, and it has more sky, but neither the fence nor house is
visible at all. The tree remains, but at a further distance. It now looks like it might
retain its purpose as an antitank trench.

The final photograph is the most telling. Oren has climbed out of the trench,
which runs down the right third of the image, and has taken a photograph that

Mona Oren, *Execution Site of Jews, Prisoners of War, Krymchaks, and Civilians*, 2003. ©
Mona Oren and Yahad in Unum

eerily resembles Baltermants's *Grief*. First, the sky is now dark, with clouds in
various shades of gray covering the top half of the image. From this vantage
point, she allows the viewer to have a much clearer sense of the killing fields.
The roof of the house is now a full house with barn and other outbuildings. The
grasses are the brownish tan of the previous images, but then we see a shock
of green on the left, an irrigated field just beyond the brown desolation of the
killing site itself.

And then, we see on the left, barely noticeable: a white fence with six
headstones visible in the photograph, although it seems that this is just a por-
tion of the total headstones. Is it a memorial to the wartime executions or an
active cemetery for a contemporary Kerch community? This photograph does
not answer that question. But a second image of Ribot's identifies it as a Muslim
Tatar cemetery, with a metal crescent adorning the cemetery's building. Such a
site could only have been built after the return of the Tatars from their wartime
exile in the 1980s, since there is no suggestion in Baltermants's original photo-
graph of a cemetery.[40]

Today at the antitank trench, a Muslim Tatar cemetery sits just on the edge of
the killing site at which the German Einsatzkommando carried out a genocide.
Across the train tracks and highway connecting Kerch with Bagerovo stands a
genocide memorial plaza, at which residents have been gathering ever since it

was established, as well as a 2010 Jewish memorial remembering the murder of thousands of Jews. This Holocaust memorial site symbolizes the ways death echoes individually and communally among Kerch residents of diverse religious traditions and for those around the world who return to commemorate their losses.

EPILOGUE

Initially, I was touched by the face of human sadness—the face of *Grief*—and I made it my goal to learn more about the subject of the photograph. Even though there are almost twenty living people in the photograph, I had only one name to follow, P. Ivanova, and the photograph is describing *her* grief. That information came from the original caption in the March 1942 *Ogonek* photo essay, which was the first appearance of Baltermants's Kerch photographs in print. After that, her name disappeared, and with her name, so too her voice.

"Her cry" (Ivanova's cry, that is) "becomes the cry of humanity," wrote Heinrich Böll when he saw her photograph in Hamburg in 1964. It is a quotation that Baltermants himself republished when she made her star appearance as an anonymous grieving woman in the glossy pages of *Ogonek*, more than twenty years after the war, with the headline "We will never forget." For the American collector Paul Harbaugh and the Soviet writer Konstantin Simonov, anyone who bears witness to the photograph should be more convinced than ever about the horrors of war.

All of this we owe to Ivanova. People have done research on the subjects of other iconic war photographs, like the photograph of the raising of Old Glory above Mt. Suribachi at Iwo Jima that has been used as a model for memorials across the United States; the boy in the Warsaw ghetto whose image circulates in many books on the Holocaust; or the flag raiser in Yevgeny Khaldei's May 2, 1945, victory photograph of the Soviet flag being raised over the Reichstag, which has been reproduced on Soviet stamps, in books, and on covers of volumes dedicated to World War II. I have been unable to conduct in-depth research about Ivanova, the subject of this iconic image of wartime atrocities. When I decided to delve deeper into *Grief* in 2014, contemporary politics intervened. That year, Kerch became part of the frontline in the ongoing war between Russia and Ukraine, and Russia annexed the whole peninsula. I was therefore unable (and frankly unwilling) to travel there to do research.

Moreover, I confess that I have not been to Russia since 2008 when I was completing research for my previous book. In my time in Moscow visiting photographers' families and working in private and state archives, I had been stopped by the police on the streets several times to have my documents checked to make sure they were "in order." Why they stopped me, I have no idea. I assume it is because although I identify as a cisgender white male, I'm Jewish, and my skin color is a shade more olive than an average Muscovite's, making me look like a Caucasian from Chechnya.

I firmly believe in historians' need to conduct research in situ, to go to the places that they study and write about, but not at the cost of their safety. As I was flying home, I realized that given my own encounters on the streets of Moscow, I needed to rethink my strategy for encouraging students to study or conduct research in ever more xenophobic Russia. As early as 2008, I did not think it was a safe place for students of color and gender nonconforming students, and now even for me. I now counsel students who want to study in Russia to be very aware about whether it will be a physically safe place for them and then let them make their own choice. (For those students who want to study Russia, I encourage them to use archives elsewhere—Ukraine, Europe, Israel, or the United States—and only then to go to Russia.)

I assumed that I would have to return to Russia, if only to connect with people and do archival research to understand the life history of the photograph that became an icon in the Soviet Union and beyond. And then Putin began making social homophobia, which I had experienced in my many visits to Russia, into state policy. The 2013 gay propaganda law, and then the 2014 amendment to the family code stripping same-sex couples of parental rights, led to a wave of LGBTQ Russians, at least those who could afford to, leaving Russia. I now questioned whether I, as a gay Jewish husband and father, would have problems because of those aspects of my identity.

Though I visited archives and libraries and interviewed people in the United States, the United Kingdom, Israel, and Germany, I never went to Russia. Thanks to modern technology, especially video calls, I was able to conduct interviews with people all over Russia and explore digitally personal archives in the home of Tatiana Baltermants, who lives in Korolev outside of Moscow, and to whom I owe a great debt. I used Google Earth to explore the landscape of the killing site, and corresponded with local researchers in Crimea to help me understand what the local landscape looked like in 2018. I hired research assistants to hunt through archives for the Soviet side of the story. So I was able to conduct research in Russia and Ukraine even though I never set foot in either country. Yet, despite all of the new technical tools available to me, I was not able to gather any information about "P. Ivanova" from databases, archival records, memorial

books, or other traces of individual human lives. And given my reluctance to go to Russia, telling the story of Ivanova proved impossible.

I return to where we started—to consider whether Baltermants's photograph of Ivanova, a (non-Jewish) woman, mourning her dead (likely non-Jewish) husband should be considered one of the first widely circulating Holocaust liberation photographs. This image stands in for the approximately seven thousand Jews lying executed in the trench in the background of the photograph. The value of atrocity photographs, ideally from the perpetrators' cameras, as documents of the Holocaust was already made clear in the Nuremberg Trials, even though the word "Holocaust" was never uttered in the context of this photograph.

I see in *Grief* a way to bring together the specificity of the Nazi genocide against Jews along with the genocide against other Soviet people. *Grief* does this while also encouraging every viewer to see the image as a human story of wartime atrocities and the tragedy of war. Judy Cohen, the photo archivist at the US Holocaust Memorial Museum, put it best when she suggested that she considers *Grief* an icon of war that the museum must have in its collection. It is an icon of the German invasion of the Soviet Union that launched the Nazi genocide of Soviet Jews, prisoners of war, and other populations in the Soviet Union. The genocide subsequently became a war of annihilation against global Jewry—in the form of the extermination camps, which opened in 1942 after the launch of the "Holocaust by bullets" in occupied Soviet territory—as well as Jews' political cabal known as Judeo-Bolshevism.

Baltermants would likely recoil at the idea that there is any specific Jewish content or context to his photograph. He insisted that *Grief* is a photograph of peaceful Soviet citizens taken in order to document the horrors of war. Photographs are constantly telling new stories. We do not know how *Grief* will be understood or where it will be exhibited in the future. Widely reprinted as one of the most influential photographs of the last century, considered one of *Time* magazine's Top 100 photographs, it is likely to continue shaping our understanding of World War II and war in general. Perhaps it will shed its historical specificity and will be returned to the context that Baltermants expressly intended in the 1950s and 1960s—to serve as an icon against war. Perhaps it will be included in exhibitions about war and human barbarity.

But maybe, just maybe, the Kerch Jewish community, which has used Khaldei's 1942 photograph of Grigory Berman mourning his wife and child in its annual memorial ceremony, will include *Grief* as part of its ritual, allowing for a broader understanding of the Holocaust and of which victims of Nazi genocide are to be remembered.

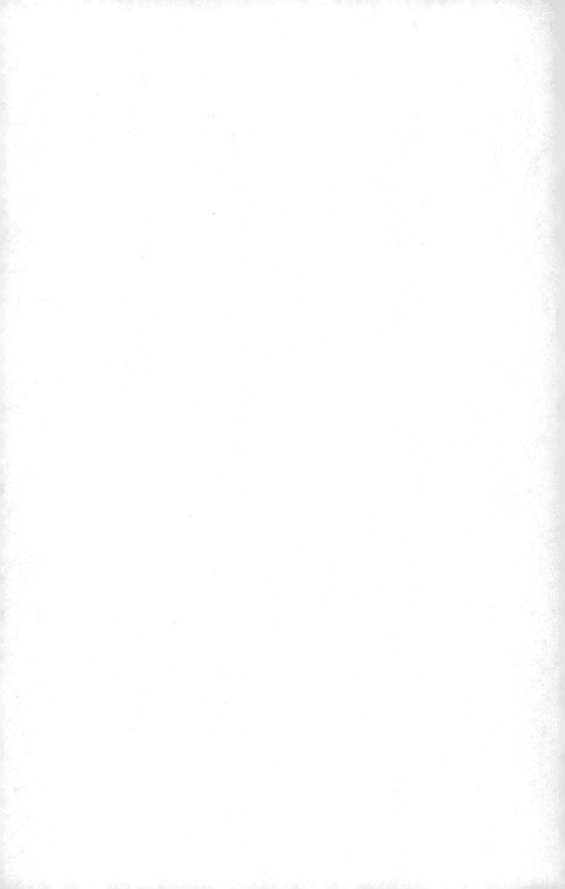

GRATITUDE

I call this my statement of "gratitude," rather than "acknowledgments," for all of the many ways I am grateful to those who have helped me along the path that led to this book. I am grateful to Joan Neuberger, Valerie Kivelson, Vanessa Schwartz, and Jason Hill for giving me the opportunity to write short articles focused on a single photograph. Thanks also to Susanne Frank at Humboldt University in Berlin, who invited me to give a talk for a lecture series about the "pathos formula"—Aby Warburg's concept of a visual formula for representing pathos—I only had a vague notion of what it was. After presenting another version of that talk at the annual conference of the Association for Jewish Studies in 2013, Phyllis Lassner, an editor at a publishing house, approached me about turning my twenty-minute talk into a book. Eight years later, those short articles and talks became the book you hold in front of you. I thank all of them profusely for giving me the confidence to write an entire book about a single photograph.

Along the way, I have benefited from the help of numerous people, starting with folks at the University of Colorado, Boulder, which has been an incredibly happy home since I arrived in 2008. Thank you to my colleagues and comrades in the History Department, the Religious Studies Department, the Jewish Studies program, and the CU Art Museum, especially Aun Ali, Lisa Tamiris Becker (z'l), Samuel Boyd, David Ciarlo, Elizabeth Fenn, Sarah Gavison, Liora Halperin, Martha Hanna, Susan Kent, Mark Leiderman, Michelle Penn, Jamie Polliard, Elias Sacks, Brittney Scholnick, Sasha Senderovich, Deborah Whitehead, Peter Wood, and Nick Underwood for generously engaging with me in conversations as I developed the book's arguments. Thanks especially to Gavison for doing on-the-ground research in Russia on my behalf.

I presented this work at a CU Boulder workshop on photography and memory, and I want to thank the organizer, Patrick Greaney, and the keynote speaker, Sarah James, for helping me think more deeply about the relationship between photography, politics, and memory.

Thank you to the staff of the University of Colorado's Norlin Library, especially Beth Arellano and Amber Thompson, who tracked down sources I would never have been able to find on my own.

The University of Colorado supported me financially through the College of Arts and Sciences College Scholar Award, which allowed me to take a full-year sabbatical to work on the book. I am most profoundly grateful to Midge Korczak and Leslie Singer Lomas, who endowed the Louis P. Singer Chair in Jewish History, which has given me the luxury of not having to spend countless hours on grant proposals, and instead to focus on research and writing.

I presented this work at a conference at Manchester Metropolitan University, and in particular I want to thank the conference organizer, Sam Johnson (z'l), and the two other keynote speakers, Carol Zemel and Michael Berkowitz, who inspired me to think deeply about the visual. Each of them has proven immensely helpful in encouraging me to think about how the visual can be used in writing history. In 2015, I presented at an international Slavic Studies conference in Japan, where Maxim Shrayer gave me smart advice. That same year, I spoke on this project at the University of Vermont (where the dean of Holocaust Studies, Raul Hilberg, taught for many years), and I offer thanks to Jonathan Huener and Alan Steinweis for hosting me.

During my sabbatical year, I served as a scholar-in-residence at the University of Southern California's Visual Studies Research Institute. Thanks to Vanessa Schwartz, Daniella Bleichmar, Megan Luke, Sharon Gillerman, and Sarah Bunin Benor for helping me think through many of the ideas that made their way into the book.

New York University's Remarque Institute, especially Katherine Fleming and Jair Kessler, provided me with access to New York's wonderful research collections, and thanks to Gennady Estraikh, to whom I have frequently turned with specific questions about Soviet Jewish history.

Thanks to a Kenneth J. Botto Research Fellowship from the University of Arizona's Center for Creative Photography, and the help of the center's staff, especially Emily Weirich and Leslie Squyres, I was able to piece together the birth and gestational period of the photography market.

I then presented the early stages of this book manuscript in 2016 at the University of Chicago and to my intellectual interlocutors there, specifically Tara Zahra, Faith Hillis, Leora Auslander, and Eleonor Gilburd, who helped me think about how communist culture circulated during the Cold War. At Temple University, I want to thank Laura Levitt, Lila Corwin Berman, David Watt, and their fantastic graduate students for encouraging me to include my own voice in the narrative.

I also presented at the Revolutionary Lives Symposium at the University of California, Irvine, and special thanks to the organizers and to Aglaya Glebova and Yuri Slezkine; and to Brandeis University's New Directions in Russian Jewish Studies workshop, especially ChaeRan Freeze, Mikhail Krutikov, Jeffrey Veidlinger, and Elissa Bemporad. Thanks to the participants in both of those workshops.

I received great feedback at the 2017 Association for Jewish Studies conference and from all of the participants in the "Jewishness in Soviet Contexts" seminar, especially Marat Grinberg and Harriet Murav.

In 2018, I presented the nearly finished manuscript at Vanderbilt University, and I offer special thanks to Allison Schachter, Emily Greble, Julia Phillips Cohen, and Ari Joskowicz. Also in 2018, I presented this work at the University of Otago, New Zealand, and benefited there from the insights of Erika Wolf, the person who perhaps more than anyone else got me interested in visual culture when we met back in the early 2000s in Moscow and with whom I have been collaborating for nearly twenty years.

I also want to thank the staff at many institutions where I conducted research: the Los Angeles County Museum of Art, especially Sarah Newby and Ryan Linkof; the Museum of Modern Art; the Getty Research Institute; the United States Holocaust Memorial Museum, especially Judy Cohen, Nancy Hartman, Vincent Slatt, and Elliott Wrenn; Yahad In Unum, Paris, especially Patrice Bensimon, Kateryna Duzenko, and Michał Chojak; and Yad Vashem, Jerusalem, especially Arkadi Zeltser, Maaty Frenkelzon, and Daniel Uziel.

I interviewed photographers, gallery owners, curators, and collectors for this book, and I want to thank each and every one of them for being generous not just with their time but with sharing their passion for their work: Michael Mattis, who graciously opened his home to me and whose collection blew me away when I first saw it; Daile Kaplan; Nailya Alexander; the freelance photographers who worked for Yahad In Unum, Aleksey Kasyanov, Guillaume Ribot, and especially Mona Oren; Alice and Alexander Nakhimovsky; John Loengard; Dmitry Gershengorin; Howard Schickler; G. Ray Hawkins; and Robert Koch.

Much gratitude to those people who engaged most deeply with the manuscript and who worked with me to improve it throughout the research and writing process: Anna Shternshis, Mark von Hagen (z'l), Nadya Bair, Maya Benton, and Adam Rovner, and to those who read the entire manuscript, James Shneer and Diane Shneer, who in addition to bringing me into this world are the smartest people I know and are always among my first readers, and Rob Adler Peckerar, whose brilliance is only matched by his attention to detail in the crafting of a narrative.

To the two most important people I had working with me on this project, Paul Harbaugh and Tatiana Baltermants, I owe a huge amount of gratitude. To Paul, in whose basement I first encountered Soviet photography, and to Tatiana, at whose dining room table in Korolyov, Moscow region, I was regaled with stories about her father, thanks to both of you. And much gratitude to Nancy Toff, my fearless editor at Oxford, and her assistants, Lena Rubin and Hannah Campeanu, who improved this book in ways both big and small; to Julia Turner and Wendy Walker, the production team that turned words into the beautiful book you hold in your hands.

I could not have written this book without being healthy enough to write it. Some readers may know that I have been dealing with brain cancer. During the writing of this book my treatments included two surgeries, six weeks of intensive radiation, and two years of chemotherapy. To my medical support teams at the University of California, San Francisco, especially Mitchel Berger and Nicholas Butowski, and the University of Colorado, especially Denise Damek, thank you for keeping me alive to see this book come to fruition. To my many yoga instructors, thank you for helping me maintain equanimity through it all.

And last, to my family, who have supported me in ways both obvious and not. Thank you to Caryn and Dawn for being fantastic co-parents; to Michelle, Wayne, Ben, Margaret, and Dennis for being my Colorado family; to Kathy and Yannai for being my San Francisco Bay Area family; and to Rob, Lani, Emi, and Kyle for being my Los Angeles support team. My parents, Jim and Diane Shneer, have already been thanked, but why not thank them again. To Sasha (Alexandra) Meirav, I love you to the moon and back; and to Gregg, my best friend, husband, and soon-to-be doctor, who has been my rock, emotionally and physically: thank you.

NOTES

INTRODUCTION

1. I use the spelling of the Russian photographers as they appear on artnet.com to remind readers that these Soviet photographers are now traded on the fine art photography marketplace.

CHAPTER 1

1. "15 sentiabria proezdom na rodinu v Moskvu pribyli pionery, otdykhavshie v Arteke, NA SNIMKE (sleva napravo): pionery-ordenonostsy: Nishan Kadyrov, Vaniia Chulkov, Mamlakat Nakhangova, Barasbi Khamgokov, Misha Kuleshov, i Buzia Shamzhanova," photograph by Dmitri Baltermants, *Izvestiia*, September 17, 1936, 4.
2. For more on the Artek camp and the network of Soviet children's sanatoria, see Monica Rüthers, "Picturing Soviet Childhood: Photo Albums of Pioneer Camps," *Jahrbücher für Geschichte Osteuropas* 67 (2019): 65-95. Established by Zinovy Soloviev in 1925, Artek was the first pioneer camp and was initially founded for children with tuberculosis. In its early years Artek was intended for elite children, such as those in the picture, but it eventually spawned a whole movement for Soviet children's health and education.
3. Baltermants photographed this group of teenage communist Pioneers and award-winning Stakhanovites, young overachievers, often representing various Soviet ethnic groups, who emerged in the Stalinist 1930s. It referred to those who had overfulfilled their agricultural production quotas and were heralded in the Soviet press for their achievements, like the title's namesake Aleksei Stakhanov, who overfulfilled his coal quota in 1935. See M. V. Fokin, I. G. Gordin, B. M. Zumakulov, *Stranitsy istorii iunykh lenintsev* (Moscow: Pedagogika, 1976), 64. On Stakhanovism, see Lewis Siegelbaum, *Stakhanovism and the Politics of Productivity in the USSR* (New York: Cambridge University Press, 1990).

4. The circular spatial structure of portraiture is significant for understanding socialist realist aesthetics and the way power was depicted. See Jan Plamper, *The Stalin Cult: A Study in the Alchemy of Power* (New Haven: Yale University Press, 2012), esp. chap. 3.

5. For more on family photographs, see Marianne Hirsch, *Family Frames: Photography, Narrative, and Postmemory* (Cambridge, MA: Harvard University Press, 1997).

6. In 1912, the Duma passed a law (106 in favor, 101 against) putting into law most of the anti-Jewish circulars from the War Ministry promulgated through the 1880s to the end of the 1900s. See Yohanan Petrovsky-Shtern, *Jews in the Russian Army, 1827–1917: Banished from Modernity?* (New York: Cambridge University Press, 2009), 246. Jewish soldiers were not ousted from the army, as the Russian far right wanted.

7. For a basic biography of Baltermants, see http://www.mamm-mdf.ru/en/exhibitions/baltermants-retrospective/?sphrase_id=76200. I conducted several interviews with his daughter, Tatiana Baltermants, to gain more detailed information about his upbringing but was unable to find any corroborating archival or published materials related to his birth or early years. Moreover, it is unclear when his parents got divorced.

8. Low estimates put the number at 250,000, high estimates at one million. See Petrovsky-Shtern, *Jews in the Russian Army*, 248; Mordechai Altshuler, "Russian and Her Jews: The Impact of the 1914 War," *Wiener Library Bulletin* 27, no. 30/31 (1973): 14. For more on Russian Jews during World War I, see Eric Lohr, "The Russian Army and the Jews: Mass Deportation, Hostages, and Violence during World War I," *Russian Review* 60 (July 2001): 404–19; Eric Lohr, *Nationalizing the Russian Empire: The Campaign against Enemy Aliens during World War I* (Cambridge, MA: Harvard University Press, 2003); Peter Gatrell, *A Whole Empire Walking: Refugees in Russia during World War I* (Bloomington: Indiana University Press, 2005). The deportation of suspected "fifth columns" became a common practice during World War I. See for example Michael Reynolds, *Shattering Empires: The Clash and Collapse of the Ottoman and Russian Empires, 1908–1918* (New York: Cambridge University Press, 2012).

9. Kenneth Moss, *Jewish Renaissance in the Russian Revolution* (Cambridge, MA: Harvard University Press, 2009).

10. For more on how Jewish Sarahs became Soviet Sofias and Sonias, see Anna Shternshis, *When Boris Met Sonia: Jewish Life under Stalin* (New York: Oxford University Press, 2017).

11. "Klassiki fotoiskusstva: Dmitrii Baltermants—zhizn' i tvorchestvo," accessed June 3, 2019, https://club.foto.ru/classics/life/36/. On the *Izvestiia* building where he worked, see "Grigorii Barkhin, *Izvestiia* Newspaper Building in Moscow (1926–1928)," accessed June 3, 2019, https://thecharnelhouse.org/2014/05/13/grigorii-barkhin-izvestiia-newspaper-building-in-moscow-1926-1928/ and Natalia Melikova, "Constructive Renewal: *Izvestiia* Building, Moscow by Ginzburg

Architects," *Architecture Review*, September 27, 2017, accessed June 3, 2019, https://www.architectural-review.com/buildings/izvestia-building-moscow-by-ginzburg-architects/10023827.article.

12. David Shneer, *Through Soviet Jewish Eyes: Photography, War, and the Holocaust* (New Brunswick: Rutgers University Press, 2011).

13. Samarii Gurarii and Dmitrii Baltermants, "Miting na L'vovskom paravozo-vagonoremontnom zavode," *Izvestiia*, November 26, 1939, 4; Dm. Baltermants, "Na ulitsakh L'vova," *Izvestiia*, December 18, 1939, 4.

14. See for example Irina Osipova, "Zhizn' s ogon'kom," *Ekspert Online 29*, March 29, 2012, http://expert.ru/expert/2012/29/zhizn-s-ogonkom/. After Ukrainian independence in 1991, the city changed its name once again to the Ukrainian Lviv.

15. "Segodniia v Moskvu pribyvaiut uchastnitsy bol'shogo zhenskogo avtoprobega," photograph by Dmitri Baltermants, *Izvestiia*, September 30, 1936, 4.

16. Interview with Tatiana Baltermants, September 25, 2016.

17. Erika Wolf, "When Photographs Speak, to Whom Do They Talk? The Origins and Audience of *SSSR na stroike* (USSR in Construction)," *Left History* 6, no. 2 (1999): 53–82.

18. Ibid.

19. "Tovarishch' Stalin delaet doklad chrezvychainomu vsesoiuznomu s'ezdu sovetov o proekte konstitutsii soiuza SSSR," photograph by Mikhail Prekhner and Georgii Zel'ma, *Izvestiia*, November 27, 1936, 5.

20. For more on how aesthetics elevated Joseph Stalin, see Jan Plamper, *The Stalin Cult: A Study in the Alchemy of Power* (New Haven: Yale University Press, 2012).

21. Correspondence with Tatiana Baltermants, March 23, 2016.

22. "24 noiabria v Sokol'nikakh . . .," photograph by Dmitri Baltermants, *Izvestiia*, November 26, 1940, 4.

23. "V bol'shom zale Moskovskoi konservatorii . . .," photograph by Dmitrii Baltermants, *Izvestiia*, December 13, 1940, 4. On the Jangar, see Smithsonian Folklife Festival, accessed June 4, 2019, http://www.festival.si.edu/blog/2013/performing-the-kalmyk-epic-tale-jangar/.

24. "Miting na L'vovskom parovozo-vagonoremontnom zavode," photograph by S. Gurarii and Dm. Baltermants, *Izvestiia*, November 26, 1939, 4.

25. The original Russian-language source can be found at ru.wikisource.org. The translation is my own.

26. This data comes from "Podvig naroda [The People's Feat]," a massive digital database of materials from the Central Archive of the Ministry of Defense (TsAMO). See specifically "Prikaz voiskam 6 armii," October 16, 1944, TsAMO, f. 33, op. 690155, d. 2642, l. 2. The award document lists his enlistment date as June 22, 1941.

27. "Otlichniki N-skoi chasti Moskovskogo voennogo okruga. Sleva napravo: krasnoarmeitsy A.S. Sukharev, A.D. Markov, serzhant N.M. Semenov,

krasnoarmeitsy N.S. Kuzmin i E.D. Shiriaev," photograph by Dmitri Baltermants, *Izvestiia*, June 26, 1941, 1.

28. World Future Fund, "Adolf Hitler Speech before the Greater German Reich: December 11, 1941; Declaration of War on America," accessed December 20, 2019, http://www.worldfuturefund.org/wffmaster/Reading/Hitler%20Speeches/ Hitler%20Rede%201941.12.11.htm.

29. "Direktiva stavki verkhovnogo glavnokomandovaniia, November 7, 1941, 2am," TsAMO, f. 48A, op. 3408cc, d. 65, l. 94 as found in S. Mel'chin et al., *Iz istorii velikoi otechestvennoi voiny. Oborona kerchi i rostova-na-donu, noiabr'-dekabr' 1941 g* (Moscow: Izvestiia, 1991), 193–94.

30. Yad Vashem Archives (YVA) TR4/12, Trial of Erich von Mannstein, September 7, 1949, 12.

31. TsAMO, f. 406, op. 9852, d. 1, l. 31 as found in Mel'chin et al., *Iz istorii*, 197. On the rate of desertion, see "Zapis' peregovorov po priamomu provodu upolnomochennogo Stavki VGK G.I. Kulika s general-maiorom P.P. Vechnym," November 15, 1941, as found in Mel'chin, *Iz istorii*, 200.

32. " 'Zapis' peregovorov," November 17, 1941, as found in Mel'chin, *Iz istorii*, 201.

33. Rebecca Manley, *To the Tashkent Station: Evacuation and Survival in the Soviet Union at War* (Ithaca: Cornell University Press, 2012).

34. See among others "Testimony of Eva Penedzhi," testimony number 41663, USC Shoah Foundation Institute for Visual History Archive, Los Angeles.

35. Erik Grimmer-Solem, "Selbständiges verantworliches Handeln: Generalleutenant Hans Graf von Sponeck (1888–1944) und das Schicksal der Juden in der Ukraine, Juni-Dezember 1941," *Militärgeschichtliche Zeitschrift* 72 (2013): 23–50. For this quote, see p. 41.

36. Ibid., 42.

37. "Report of the city Ortskommandantur 287/1, November 22, 1941," YVA, M-53/ 106, as cited in Yitzhak Arad, *The Holocaust in the Soviet Union* (Lincoln: University of Nebraska), 206.

38. State Archive of the Russian Federation (GARF), f. 1465, op. 1, d. 1, ll. 30–40, as found in US Holocaust Memorial Museum (USHMM) RG31-019.

39. "Conversation with Sofia Nikolaevna Lifshits," GARF, f. 224, op. 78, d. 42, ll. 138– 43, as found in USHMM RG-22.016, box 1.

40. Ibid. See also GARF, f. 1457, op. 1, d. 8, German City Records of Kerch, as found in USHMM RG31.030M, reel 2. The indictment can be found at GARF, f. 7021, op. 9, d. 38, ll. 68–69, as found in USHMM 22.002M.

41. "Akt no. 6, Kommissii po ustanovleniiu i rassledovaniiu razrushenii i zlodeianii, proizvedennykh nemetsko-fashistskimi zakhvatchikami v kirovskom raione g. Kerchi," August 4, 1944, GARF, f. 7021, op. 9, d. 38, ll. 107–111, as found in USHMM 22.002M.

42. Boris Vol'fson, "Krovavye prestupleniia nemtsev v Kerchi," *Istoricheskii zhurnal* 8 (1942): 34.

43. Although the USHMM's extensive *Encyclopedia of Camps and Ghettos* uses a much more expansive definition of a ghetto than previous works, it does not include the Kerch prison, in which the city's Jews were incarcerated for a period of days.

44. YVA, TR4/10, "Activity report by the town major of Kerch (Kerch Peninsula) (27/11/1941)," 58. See also the transcripts of trials against German war criminals that took place in Munich in 1972, as found in "Tatkomplex: Massenvernichtungsverbrechen durch Einsatzgruppen," *Justiz und NS Verbrechen: Sammlung Deutscher Strafurteile wegen Nationalsozialistischer Tötungsverbrechen 1945-1999*, Band 39 (Amsterdam: Amsterdam University Press, 2007), 73–81. This particular section focuses on the actions of Einsatzkommando 10b and in particular on their killings in Kerch.

45. Ilya Ehrenburg and Vasily Grossman, *The Complete Black Book of Russian Jewry*, trans. and ed. David Patterson (Piscataway, NJ: Transaction Publishers, 2003), 274–75. See also the trial transcripts that describe what the Jews would have seen and heard upon approach to the killing site as found in Christian Rüter and Karl Bracher, "Tatkomplex: Massenvernichtungsverbrechen durch Einsatzgruppen," *Justiz und NS-Verbrechen: Sammlung deutscher Strafurteile wegen nationalsozialistischer Tötungsverbrechen 1945-1999, Band XXXVII* (Amsterdam: Amsterdam University Press, 2007), 75. The exonerating testimony is on p. 80.

46. For testimony on the Simferopol and Eupatoria killings, see YVA, TR.4/12, "Trial of Erich von Mannheim, Testimony of Karl Rudolf Braune, September 7, 1949," file number 12, p. 35, Yad Vashem Digital Archives, Jerusalem, Israel. See also Ehrenburg and Grossman, *Complete Black Book of Russian Jewry*, 274–75. The transcripts of the 1972 Munich trials describe what the Jews would have seen and heard upon approach to the killing site, as found in Rüter and Bracher, "Tatkomplex," 80–81.

47. Yahad in Unum interview U114, U115, Yahad in Unum archive, Paris, France.

48. "Eyewitness Reports Nazi Massacre of 5,000 Jews in Kerch, in the Crimea," *Jewish Telegraph Agency*, July 3, 1942, 3, https://www.jta.org/1942/07/03/archive/eye-witness-reports-nazi-massacre-of-5000-jews-in-kerch-in-the-crimea. For the German report, see Bundesarchiv, RH23/72, Bl. 122–25, Tätigkeitsbericht vom 28.11 bis 7.12.1941, Ortskommandatur I/287, Kertsch, den 7.12.1941, gez. Neumann as found in Marcel Stein, ed., *Die 11. Armee und die Endlösung: Dokumentensammlung mit Kommentaren 1941/2* (Bissendorf: Biblio Verlag, 2006), 110–13.

49. As cited in Shrayer, *I Saw It*, 48–49.

50. Erik Grimmer-Solem, "Selbständiges verantworliches Handeln: Generalleutenant Hans Graf von Sponeck (1888–1944) und das Schicksal der Juden in der Ukraine, Juni-Dezember 1941," *Militärgeschichtliche Zeitschrift* 72 (2013): 43.

51. "Krovavye zverstva nemtsev v Kerchi," *Pravda*, January 5, 1942, 2.

52. "Protokol doprosa, no. 115," June 9, 1944, Anna Nikolaevna Naumova, GARF, f. 7021, op. 9, d. 38, l. 51, as found at USHMM RG22.002M. This Extraordinary Commission report contains hundreds of testimonies by residents testifying to what took place under German occupation. By 1944 when they testified to the investigators, the events that took place during the second occupation of Kerch (May 1942–April 1944) loomed larger than the first six-week occupation. Nonetheless, there is the occasional report about that initial occupation and the genocide of the city's Jewish population.

53. See the official records of the All-Union Population Census of 1926 at http://www.demoscope.ru/weekly/ssp/ussr_nac_26.php. For an analysis of this data, see David Shneer, *Yiddish and the Creation of Soviet Jewish Culture* (New York: Cambridge University Press, 2005), chap. 2. For more on Soviet ethnography, see Francine Hirsch, *Empire of Nations: Ethnographic Knowledge and the Making of the Soviet Union* (Ithaca: Cornell University Press, 2005).

54. Arad, *The Holocaust in the Soviet Union*, 203.

55. Ibid., 204. See also Arad et al., *Einsatzgruppen Reports*, 142, 250.

56. Erik Grimmer-Solem, "Selbständiges verantworliches Handeln: Generalleutnant Hans Graf von Sponeck (1888–1944) und das Schicksal der Juden in der Ukraine, Juni-Dezember 1941, *Militärgeschichtliche Zeitschrift* 72 (2013): 23.

57. On German policy toward Krymchaks and Karaites, see Kiril Feferman, *The Holocaust in the Crimea and Northern Caucasus* (Jerusalem: Yad Vashem Press, 2016).

CHAPTER 2

1. Rostov-on-Don was bigger than Kerch in terms of population but was occupied for only one week, and therefore the full effects of Nazi occupation had not yet been revealed to Soviet investigators.

2. Boris Vol'fson, "Krovavye prestupleniia nemtsev v Kerchi," *Istoricheskii Zhurnal* 8 (1942): 33.

3. Volf'son, "Krovavye prestupleniia," 34. I have found no other evidence corroborating Volfson's poisoning story, although such stories were told in other cities.

4. "Testimony from Efim Smoliansky," testimony number 32558, USC Shoah Foundation Institute for Visual History Archive, Los Angeles.

5. Elissa Bemporad, *Legacy of Blood: Jews, Pogroms, and Ritual Murder in the Lands of the Soviets* (New York: Oxford University Press, 2019).

6. In fact, a formal list of all of those killed in Kerch prepared by the Extraordinary Commissions in 1944 identified not only the list of ethnic groups that Volfson listed but also included several Bulgarians as well as a lone Estonian, fifty-six-year-old Hans Reiman. See Yad Vashem Archives (YVA), RG M33/ JM/19683.

7. Volf'son, "Krovavye prestupleniia," 35. The Russian original: "Evreev istrebliali s osobym ozhestocheniem, podvergaia osobo unizitel'nym i zverskim pytkam pered kazn'iu."

8. YVA, TR-4/12, Trial of Erich von Mannstein, September 7, 1949, 65. RSHA is an acronym for *Reichssicherheitshauptamt* or Reich Main Security Office.

9. YVA, M-53/106, report of Ortskommandatur 287/1, December 7, 1941 as cited in Yitzhak Arad, *The Holocaust in the Soviet Union* (Lincoln: University of Nebraska), 207.

10. Andrej Angrick, *Besatzungspolitik und Massenmord: Die Einsatzgruppe D in der südlichen Sowjetunion 1941–1943* (Hamburg: Hamburger Edition, 2003), 355–57.

11. See for example Mordechai Altshuler, *Soviet Jewry on the Eve of the Holocaust: A Social and Demographic Profile* (Jerusalem: Yad Vashem, 1998).

12. Jeremy Hicks, *First Films of the Holocaust* (Pittsburgh: University of Pittsburgh, 2011), chap. 2. See also Il'ia Al'tman, *Zhertvy nenavisti: Holocaust v SSSR. 1941-1945* (Moscow: Kovcheg, 2002), 274. On the occupation of the city, see Central Archive of the Ministry of Defense (TsAMO), f. 48A, op. 3412cc, d. 760, ll. 38–39, as found in S. Mel'chin et al., *Iz istorii velikoi otechestvennoi voiny. Oborona kerchi i rostova-na-donu, noiabr'-dekabr' 1941 g* (Moscow: Izvestiia, 1991), 207. Stalin excoriated the head of Rostov's administration for his terrible defense of the city. "Telegramma tov. Stalina sekretariu Rostkovskogo obkoma VKP B.A. Dvinskomu," December 1, 1941, as found in Mel'chin et al., *Iz istorii*, 207.

13. "Chto bylo v Kerchi pri nemtsakh," *Izvestiia*, January 9, 1942, 2.

14. Ibid.

15. Vl. Lidin, "Plevely," *Izvestiia*, January 31, 1942, 4.

16. Dmitri Baltermants, and Vladimir Lidin, *Moskva: no'iabr' 1941* (Moscow, Leningrad: *Gosudarstvennoe izdatel'stvo "Iskusstvo,"* 1942.

17. Bialik's original title in Hebrew is *Be'ir ha-haregah*. See Steven Zipperstein, *Pogrom: Kishinev and the Tilt of History* (New York: Liveright, 2018), especially chap. 4. For more on Jewish responses to catastrophe, see David Roskies, *Against the Apocalypse: Responses to Catastrophe in Modern Jewish Culture* (Syracuse: Syracuse University Press, 1999). The definitive study on Ilia Selvinsky is Maxim Shrayer's *I Saw It: Ilya Selvinsky and the Legacy of Bearing Witness* (Boston: Academic Studies Press, 2012).

18. "Interview with Semen Rafailov," testimony number 40910, USC Shoah Foundation Institute for Visual History Archive, Los Angeles.

19. Ibid.

20. Ilya Selvinsky, *Wartime Diaries*, January 1942, as cited in Shrayer, *I Saw It*, 36.

21. David Shneer, "Is Seeing Believing?: Photographs, Eyewitness Testimony, and Evidence of the Holocaust," *East European Jewish Affairs* 45, no. 1 (2015): 65–78.

22. "Terror fashistskikh okkupantov v Pol'she, (Amerikanskii zhurnal '*Laif*')," *Izvestiia*, June 25, 1941, 4.

23. "V bumagakh odnogo iz gitlerovtsev," *Izvestiia*, March 21, 1942.

24. "V tsarstve terror i bespraviia," *Izvestiia*, June 25, 1941, 4.

25. Shrayer, *I Saw It*, 65–66.

26. Mark Turovskii and Izrail Antselovich, "Zverstva nemtsev v Kerchi," *Krasnyi Krym*, January 24, 1942, 3, as cited in Shrayer, *I Saw It*, 59–61.

27. Lev Ish, "Krovavye zverstva fashistov v Kerchi," *Krasnyi Krym*, January 29, 1942. Ish was killed defending Sevastopol in July 1942 (TsAMO, f. 58, op. 818883, d. 649, http://tombs.sebastopol.ua/missing.php?id=16793). I am grateful to Maxim Shrayer, who has extensively researched the media coverage of Kerch and found these articles in *Red Crimea* as well as articles in *Komsomol'skaia Pravda*.

28. "Fashisty poplatiatsia za eto golovami! Otomstim za krov' bezvinnykh zhertv. Fotodokumenty o zverstvakh nemtsev v Kerchi," *Komsomol'skaia Pravda*, January 20, 1942, as cited in Shrayer, *I Saw It*, 69. *Ogonek*, February 4, 1942, 4. The original photograph can be found in Yad Vashem Archives, photograph 4331_16.

29. *Ogonek*, February 4, 1942, p. 4. For biographical information about Mark Redkin, see David Shneer, *Through Soviet Jewish Eyes: Photography, War, and the Holocaust* (New Brunswick, NJ: Rutgers University Press, 2011).

30. Jewgeni Chaldej, *Kriegstagebuch*, ed. Ernst Volland and Heinz Krimmer (Berlin: Das Neue Berlin, 2011), 77.

31. Evgenii Khaldei, "Yanvar' 1942g.," *Dnevnik Evgeniia Khaldeiia* in the Yevgeny Khaldei Archives, Moscow.

32. V. A. Nikitin, "Rasskaz ob odnoi fotografii," in *Rasskazy o fotografakh i fotografiiakh* (Leningrad: Lenizdat, 1991), 151.

33. "Otomstim!," *Fotogazeta glavnogo politicheskogo upravleniia armii* 19 (February 1942), in Shrayer, *I Saw It*, 71–72.

34. TsAMO, f. 920, op. 2, d. 275, l. 7955332, 298–99, accessed June 3, 2019, http://podvignaroda.mil.ru/?#id=7955332&tab=navDetailDocument. In January 1945, he was also given awards for his work during the defense of Sevastopol and the defense of the Caucasus.

35. Baltermants's photographs from the trench can be found at the Hood Museum at Dartmouth, which has a collection of about eighteen photographs from Bagerovo.

36. For information on the lawsuit, which was ultimately dismissed by a judge, see Dan Bilefsky, "Photo of Paris Massacre Victim Sets Off Press Freedom Case," *New York Times*, May 1, 2016, accessed June 3, 2019, https://www.nytimes.com/2016/05/01/world/europe/photo-of-paris-attacks-victim-sets-off-press-freedom-case.html.

37. Susanne Kappeler, *The Pornography of Representation* (New York: Wiley and Sons, 2013). See also Geoffrey Gorer, "The Pornography of Death," *Encounter* 5, no. 4 (1955): 49–52.

38. On the concept of the photographic moment, see Ariella Azoulay, *The Civil Contract of Photography* (New York: Zone Books, 2008).

39. In addition to thinking about the potential misuse of photographs of the dead as a form of necropornography, I read Julia Kristeva's ideas about the abject as she helped me understand why I had a hard time looking at Baltermants's photographs of the dead. She writes that corpses "show me what I permanently thrust aside in order to live. These body fluids, this defilement, this shit are what life withstands, hardly and with difficulty, on the part of death. There, I am at the border of my condition as a living being. . . . [T]he corpse, the most sickening of wastes, is a border that has encroached upon everything. It is no longer I who expel, 'I' is expelled." See Julia Kristeva, *Powers of Horror: An Essay on Abjection*, trans. Leon Roudiez (New York: Columbia University Press, 1982), 3–4.

40. Polina Barskova, "The Corpse, the Corpulent, and the Other: A Study in the Tropology of Siege Body Representation," *Ab Imperio* 1 (2009): 361–86. Barskova describes the struggle writers living through the Siege had in portraying bodies, both the living and the dead, in a city where a corpse on the street stopped eliciting revulsion and became a normal everyday occurrence. It was a place where the starved and the well-fed both elicited a revulsion, each for radically different reasons. One imagines a scene like the Warsaw Ghetto where the horror of death from starvation and the corpse on the street shifted from one conjuring horror to one becoming so banal as to barely elicit a reaction.

41. Kristeva, *Powers of Horror*, 208.

42. On how Ernst Gombrich helped create the notion of the pathos formula, see Nigel Spivey, *Enduring Creation: Art, Pain, and Fortitude* (Berkeley: University of California, 2001), 118.

43. Sarah Boxer, "The Formula for Portraying Pain in Art," *New York Times*, September 15, 2001. In explaining Warburg's pathos formula, art historian Nigel Spivey points out, "On early 5th c. BC vases, painters fashioned a certain mode of the female form to indicate a woman gone wild with the cult of Dionysus: head thrown back, hair loose, lips parted, arms akimbo, and garments swirling and slipping from the shoulders. He later analyzes another piece of classical Greek sculpture, the Laocoön, which influenced a whole range of Renaissance artists, to identify the visual markers of the pathos formula, 'the head; tilting sideways or thrown back, or both of those. Then the arms: as the statue was first reconstructed after its discovery, the right arm reached higher than it is now considered to have been; but in any case, one arm is raised, creating a dynamic axis of the thorax which is maintained by the other arm reaching downwards. Then comes the torso itself, twisting and convulsing and mapped with many lateral and abdominal muscles. Finally the legs; outstretched, the other with raised knee.'" Spivey, *Enduring Creation*, 118–22.

44. The massive exhibition *War/Photography*, which was curated by Anne Wilkes Tucker at the Museum of Fine Arts, Houston, and which traveled to several major art institutions, includes Holocaust photography under broader war-related rubrics like "camps" and, in our case, "civilian massacres." See Anne Wilkes Tucker

and Will Michels, *War/Photography: Images of Armed Conflict and Its Aftermath* (Houston: Museum of Fine Arts, Houston, 2012).

45. Azoulay, *Civil Contract of Photography*.

46. Nikitin, "Rasskaz ob odnoi fotografii," 153.

47. The Extraordinary Commission report on Kerch reported the death toll at the Bagerov antitank trench to number seven thousand. See "Spisok—prilozhenie k obobshchenym dannym, kolichestvo zhertv nemetsko-fashistskoi okkupatsii v g. Kerchi, mesta massovykh rasstrelov, Kirovskii Raion, Bagerovskii rov," RG 22.002.1.1878, US Holocaust Memorial Museum, Washington, DC.

48. Nikitin, "Rasskaz ob odnoi fotografii," 153.

49. I. Antselovitch, "Gnusnye ubiitsy," *Ogonek*, March 8, 1942, 7.

50. "Zlodeiianiia gitlerovtsev v Kerchi," *Ogonek*, March 8, 1942, 6–7.

51. Zvi Gitelman, "Internationalism, Patriotism, and Disillusion: Soviet Jewish Veterans Remember World War II and the Holocaust," *Holocaust in the Soviet Union*, An Occasional Paper published by the U.S. Holocaust Memorial Museum, November 2005, 116–17.

52. Susan Sontag suggests that viewers exposed to too much violence get overwhelmed and become callous, inured to the "pain of others." See Susan Sontag, *Regarding the Pain of Others* (New York: Picador, 2004).

53. Stephen White, *The Bolshevik Poster* (New Haven: Yale University Press, 1988); Victoria Bonnell, *Iconography of Power: Soviet Political Posters under Lenin and Stalin* (Berkeley: University of California Press, 1999).

54. "What the Advancing Russians Found," *Picture Post*, June 20, 1942, 7–9. Thanks to Michael Berkowitz for scanning the *Picture Post* images.

55. Ibid.

CHAPTER 3

1. "Zapadnyi front," *Izvestiia*, February 11, 1942, 1.

2. "Zapadnyi front," *Izvestiia*, February 19, 1942, 1.

3. "Gorod iukhnov snova sovetskii," *Izvestiia*, March 6, 1942, 1.

4. "Zapadnyi front," *Izvestiia*, March 20, 1942, 1.

5. Vladimir Lidin and Dmitrii Baltermants, *Moskva: no'iabr' 1941* (Moscow, Leningrad, *Iskusstvo*, 1942). The photograph in question is on p. 80.

6. See for example *'Tank Busters' in Action at Kharkov, News Chronicle*, May 20, 1942, a photograph that ran with a Winteron report from Moscow.

7. This magnificent story was pieced together by investigators working for *Izvestiia*, which published these findings, along with references to the many archival materials involved in this process, in a series of articles appearing in the newspaper. See Stanislav Sergeev, "Istoricheskii klub," *Izvestiia*, April 29, 2009, and Ruslan Armeev, "Istoricheskii klub Stanislavu Sergeevu," *Izvestiia*, May 5, 2009.

8. "Prikaz narodnogo komissara oborony soiuza SSSR: O merakh po ukrepleniiu distsipliny i poriadka v krasnoi armii i zapreshchenii samovol'nogo otkhoda s boevykh pozitsii," July 28, 1942, no. 227, Russian State Military Archive (RGVA), f. 4, op. 12, d. 105, ll. 122–28, accessed June 9, 2019, https://ru.wikisource.org/wiki/Приказ_НКО_СССР_от_28.07.1942_№_227.

9. Central Archive of the Ministry of Defense (TsAMO), no. zapisi 32419810, accessed April 12, 2016, http://podvignaroda.mil.ru/?#id=32419810&tab=navDetailManAward.

10. Jochen Hellbeck, *Stalingrad: The City That Defeated the Third Reich* (New York: Public Affairs, 2015). See also his website, www.facingstalingrad.org.

11. For some of Khaldei's images of the second liberation of Kerch, see http://rosphoto.org/authors/evgenij-haldej/?page=3.

12. Sovinformburo video clip, April 11, 1944 with the voice of Yuri Levitan, accessed January 14, 2019, https://www.youtube.com/watch?v=oQXYoPAzK4I.

13. http://history.milportal.ru/2013/02/gazeta-bryanskogo-fronta/ (accessed December 7, 2019).

14. On Shaikhet's career, see David Shneer, *Through Soviet Jewish Eyes: Photography, War, and the Holocaust* (New Brunswick: Rutgers University Press, 2011).

15. TsAMO, f. 33, op. 690155, ed. kh. 2642, no. zapisi 32419791, accessed April 12, 2016, http://podvignaroda.mil.ru/?#id=32419791&tab=navDetailDocument. Archival documents refer to *Na razgrom vraga* in 1944 as an "army newspaper" (*armeiskaia gazeta*), not a "front newspaper," due to the changing organization structure of the Red Army during the war. The newspaper, initially serving troops fighting with the Bryansk Front, ended up as the publication for the Sixth Army.

16. TsAMO, f. 462, op. 5263, ed. khr. 82, no. zapisi 1530185865, accessed April 13, 2016, http://podvignaroda.mil.ru/?#id=1530185865&tab=navDetailDocument. For more on Soviet military awards during World War II, see Brandon Schechter, *The Stuff of Soldiers: A History of the Red Army through Objects* (Ithaca, NY: Cornell University Press, 2019).

17. TsAMO, f. 33, op. 690306, ed. khr. 28, no. zapisi 41436188, accessed April 13, 2016, http://podvignaroda.mil.ru/?#id=41436188&tab=navDetailDocument.

18. On the aesthetics of EC photographs, see David Shneer, "Ghostly Landscapes: Soviet Liberators Photograph the Holocaust," *Humanity: An International Journal of Human Rights, Humanitarianism, and Development* 5, no. 2 (Summer 2015): 235–46.

19. *The People's Verdict: A Full Report of the Proceedings at the Krasnodar and Kharkov German Atrocity Trials* (London: Hutchinson, 1943). See also Michael J. Bazyler and Frank M. Tuerkheimer, *Forgotten Trials of the Holocaust* (New York: NYU Press, 2014). For a discussion of Majdanek photography, see Shneer, *Through Soviet Jewish Eyes*, chap. 5.

20. Michelle Penn, "'Genocide Is Fascism in Action': Aron Trainin and Soviet Portrayals of Genocide," *Journal of Genocide Research*, no. 3 (2019): 1–18. See also Francine Hirsch, "The Soviets at Nuremberg: International Law, Propaganda, and the Making of the Postwar Order," *American Historical Review* 113, no. 3 (June 2008): 701–30.

21. A. N. Trainin, *Hitlerite Responsibility under Criminal Law* (London: Hutchinson, 1945), 58–59. On Trainin and his role in developing the international legal concept of genocide, see Michelle Penn, "The Extermination of Peaceful Soviet Citizens: Aron Trainin and International Law" (PhD diss., University of Colorado, 2017).

22. See for example the EC report from the small eastern Ukrainian town of Artemovsk, which includes eyewitness testimony, scientific research about the killings, and forensic photography, including close-ups of bullet holes in skulls and wide panoramas of the killing sites. For an analysis of these photographs as forensic, see Shneer, "Ghostly Landscapes."

23. "Akt chrezvychainoi gosudarstvennoi komissii o zlodeianiiakh nemtsev v gorode Kerchi, (Dokument USSR 63)," as found in *Niurenbergskii protsess: prestupleniia protiv chelovechnosti, tom 5* (Moscow: Yuridicheskaia literatura, 1991).

24. I. I. Seregina, "Kinodokumenty RGAKFD po istorii pervogo osvobozhdeniia Kerchenskogo polostrova v 1942 godu," accessed July 1, 2019, www.rgakfd. ru/sci-practical-activity/seregina-kinodokumenty-rgakfd-po-istorii-pervogo-osvobodozhdeniya-kerchenskogo-polostrova-v-1942-gody.

25. Trainin, *Hitlerite Responsibility*.

26. The Allied powers agreed in November 1943 that Germans could be prosecuted for violations of both national and international law. Known as the Moscow Convention, this gave additional legal grounding for trials like the Kharkov Trial in December 1943. Bazyler and Tuerkheimer, *Forgotten Trials*, 22–23.

27. *The People's Verdict.* For a newsreel of the trial, see "Kharkovskii sudebnyi protsess nad nemetskimi prestupnikami, Tsentral'naia studiia kinokhroniki," accessed June 12, 2019, https://www.youtube.com/watch?v=gbpKmMpOgp8; Greg Dawson, *Judgment before Nuremberg: The Holocaust in the Ukraine and the First Nazi War Crimes Trial* (New York: Pegasus Books, 2012). See also Bazyler and Tuerkheimer, *Forgotten Trials*, chap. 1. The first trial for crimes related to the German occupation of the Soviet Union took place in Krasnodar in July 1943, but most of those put on trial were Soviet citizens found guilty of committing treason, not non-Soviet citizens found guilty of war crimes.

28. Vanessa Voisin, "War Crimes Footage and War Crimes Trials: The Soviet Policy, 1941–1946," in Pierre-Olivier de Broux, Pieter Lagrou, and Ornella Rovetta, eds., *Defeating Impunity, Promoting International Justice: The Archival Trail, 1914–2016* (La Haye, France: Springer, 2018). See also Alexander Prusin, "Poland's Nuremberg: The Seven Court Cases of the Supreme National Tribunal, 1946–1948," *Holocaust and Genocide Studies* 24, no. 1 (Spring 2010): 1–25.

29. Michael Marrus and Robert Paxton, *Vichy France and the Jews* (Stanford: Stanford University Press, 1995); Bazyler and Turkheimer, *Forgotten Trials*, chap. 2.

30. Trainin, *Hitlerite Responsibility*, 104–8.

31. Film clips of Kalinin's funeral, which drew important dignitaries from around the world, are available at "Funeral of Kalinin, 1946," accessed April 13, 2016, https://www.youtube.com/watch?v=Z-89a-ASaZo.

32. David Brandenburger, *National Bolshevism: Stalinist Mass Culture and the Formation of Russian National Identity, 1931-1956* (Cambridge, MA: Harvard University Press, 2002); see also his "Stalin's Last Crime? Recent Scholarship on Postwar Soviet Antisemitism and the Doctor's Plot," *Kritika*, no. 1 (Winter 2005): 187–204; Yehoshua Gilboa, *The Black Years of Soviet Jewry* (New York: Little Brown & Co., 1971); G. V. Kostyrchenko, *Tainaia politika Stalina: vlast' i antisemitizm* (Moscow: Mezhdunarodnoe otnoshenie, 2001).

33. For more on the musical politics of Zhdanovism, see Kiril Tomoff, *Creative Union: The Professional Organization of Soviet Composers, 1939–1953* (Ithaca: Cornell University Press, 2018).

34. See Gennady Estraikh and Anna Schur, eds., "The 1952 Trial of the Jewish Anti-Fascist Committee in the Soviet Union," special section of *East European Jewish Affairs* 48, no. 2 (2018): 139–252.

35. Shneer, *Through Soviet Jewish Eyes*, chap. 7.

36. http://www.svoboda.org/audio/25778928.html (accessed April 13, 2016). See also Joshua Rubenstein, *The Last Days of Stalin* (New Haven: Yale University Press, 2016).

37. Dmitri Baltermants, *Kalinin's Funeral*, item 2320, Mattis Archive, Scarsdale, New York. Photographs of the announcement of Stalin's death are item 2329; funeral photographs are item 2330. Exhibition-scale prints of these archival photographs can be found at the Hood Museum, Dartmouth University.

38. Miriam Dobson, *Khrushchev's Cold Summer: Gulag Returnees, Crime, and the Fate of Reform after Stalin* (Ithaca: Cornell University Press, 2009).

39. "Missiia druzhby," *Ogonek*, December 30, 1955.

40. Dmitrii Baltermants, "Trial and Execution of Bourgeois Landowner," items 1586–1610. Prints available at the Hood Museum, Dartmouth University. See also "Missiia druzhby," *Ogonek*, December 1955, 2–4, on Khrushchev's official visit to Burma and India.

41. Paul Lendvai, *One Day That Shook the Communist World: The 1956 Hungarian Uprising and Its Legacy*, trans. Ann Major (Princeton: Princeton University Press, 2008).

42. Peter Gatrell, *Free World?: The Campaign to Save the World's Refugees, 1956–1963* (New York: Cambridge University Press, 2011): 49–52. The United States allowed in 38,000 Hungarian refugees despite protests from many people that they would take away jobs and were "just like Russians."

43. "Patriots Strike Ferocious Blows at a Tyranny," *Life*, November 12, 1956.

44. By the late 1950s, his photographs of similar trips appeared in color. See for example "Prebyvanie N. A. Bulganina i N.S. Khrushcheva v Indii," *Ogonek*, no. 8, February 1958. One of the most famous visits Baltermants photographed was the 1963 visit of Fidel Castro to Moscow. His photograph of Castro on the dais of Lenin's tomb graces photo books, including those published back in Cuba celebrating the visit. See for example *Fidel en la URSS* (Havana: Comision de Orientacion Revolucionaria de la Direccion Nacional del PURSC, 1963).

45. Nikita Khrushchev, "Za tesnuiu sviaz' literatury i iskusstva s zhizniu naroda," speech given May 13, 1957, at the Central Committee of the Writers' Union. For an abbreviated version, see http://www.rl-critic.ru/texts/xrush.html (accessed May 17, 2016). On how photographers interpreted Khrushchev's speech, see A. Ziv, "O sotsialisticheskom realizme," *Sovetskoe foto*, no. 12 (1957): 5–12.

46. Andrew Dudley, "The Postwar Struggle for Color," *Cinema Journal* 18, no. 2 (Spring 1979): 41–52. See also "Fotokhimicheskaia promyshlennost' GDR," *Sovetskoe foto* 1957, no. 5: 69–70, which talks about the development of the industry for photographic film in East Germany.

47. Nadya Bair, *The Decisive Network: Magnum Photos and the Postwar Image Market* (Berkeley: University of California Press, 2020), 164.

48. "Istoriia rossii v oblozhkakh zhurnala 'Ogonek,'" *RIA Novostii,* December 21, 2009, accessed June 12, 2019, https://ria.ru/20091221/200505232.html.

49. On the Tretyakov Gallery's wartime history, see "Otechestvennaia voina. Trei'akovskaia galleria v Moskve i v Sibiri, 1941–1945," accessed June 13, 2019, https://www.tretyakovgallery.ru/about/history/otechestvennaya-voyna/. On the Hermitage, see L. Y. Livshits, ed., *Ermitazh v gody voiny* (Leningrad: Publishing Council of the State Hermitage, 1987).

50. *Vsesoiuznaia khudozhestvennaia vystavka, 1951* goda (Moscow: Gos. izdat izobrazitel'nogo iskusstva, 1953). The catalog took two years to produce and has no introduction or any other interpretive text accompanying the plates. Moreover, its editors chose not to reproduce any of the color photographs that were exhibited back in 1951. See also Sergei Morozov, *Sovetskaia khudozhestvennaia fotografiia* (Moscow: Iskusstvo, 1958).

51. Elena Zubkova, *Russia after the War: Hopes, Illusions, Disappointments, 1945–1957* (New York: M. E. Sharpe, 1999). For more on decorating the interior of private apartments, see Christine Varga-Harris, *Stories of House and Home: Soviet Apartment Life during the Khrushchev Years* (Ithaca: Cornell University Press, 2015).

52. Bor. Gorbatov, "Nepriznannoe iskusstvo," *Literaturnaia gazeta*, February 23, 1952, 3.

53. "Vtoraia vsesoiuznaia," *Sovetskoe foto*, no. 12 (1957): 1. For a theoretical rationale for the importance of photo exhibitions, as opposed to publications, see S. Fridlyand, "Ser'eznye sdvigi," *Sovetskoe foto*, no. 4 (1959): 7–11.

54. Coverage of the exhibition began as early as summer 1957. "Iubileinaia vystavka," *Sovetskoe foto*, no. 6 (1957): 1.

55. "Vtoraia vsesoiuznaia," 1.

56. *Vystavka fotoiskusstva SSSR* (Moscow: Ministerstvo kul'tury SSSR, 1958). See also V. Shakovskoi, "Pis'mo iz Italii," *Sovetskoe foto*, no. 3 (1958): 62–63.

57. Nonsubscribers complained that they had trouble getting single editions of the magazine, which was certainly a way that the magazine drove increased subscriptions. "Gde priobresti zhurnal *Sovetskoe foto*," *Sovetskoe foto*, no. 11 (1957).

58. D. Baltermants, "Obeshchaiushchee nachalo," *Sovetskoe foto*, no. 3 (1959): 15–19.

59. Nearly every edition of *Sovetskoe foto* had theoretical articles about photography. See for example the first edition after its reappearance, K. Chibisov, "Fotografiia kak metod issledovaniia v nauke i tekhnike," *Sovetskoe foto*, no. 1 (1957): 3–5, or P. Nogin, "Fotoreportazh—ne zhanr, a metod," *Sovetskoe foto*, no. 9 (1957): 4–7.

60. David King, *The Commissar Vanishes: The Falsification of Photographs and Art in Stalin's Russia* (London: Tate, 2014).

61. There were articles reflecting on this question in nearly every issue. See for example A. Vol'gemut, "Ne otstupat' ot pravdy zhizni," *Sovetskoe foto*, no. 7 (1957): 14, or V. Martynov, "Instsenirovka pod vidom reportazha," *Sovetskoe foto*, no. 3 (1958): 16–17.

62. "Pravda i krivda: po pis'mam chitatelei," *Sovetskoe foto*, no. 5 (1958): 4–9.

63. Yu. Korolev, "Za fotoocherk bez instsenirovki," *Sovetskoe foto*, no. 2 (1957): 19–24.

64. M. Bugaeva, "O printsipakh partiinosti v fotoiskusstve," *Sovetskoe foto*, no. 2 (1961): 1–3.

65. For more on Soviet Thaw culture and its relationship with Western culture, see Eleonory Gilburd, *To See Paris and Die: The Soviet Lives of Western Culture* (Cambridge, MA: Harvard University Press, 2018).

66. On the 1957 Yugoslavian exhibition, see V. Petrov, "Sovetskie mastera na zarubezhnnykh fotovystavkakh," *Sovetskoe foto*, no. 1 (1957): 12–13. On a biennale in Pescara, Italy, see "Fotografiia sblizhaet narody," *Sovetskoe foto*, no. 1 (1959): 79.

67. Jessica Marie Werneke, "The Boundaries of Art: Soviet Photography from 1956 to 1970" (PhD diss., University of Texas, Austin, 2015), 14–16.

68. D. Baltermants, "Dva goda spustiia," *Sovetskoe foto*, no. 3 (1957): 63–67.

69. D. Baltermants, "U kitaiskikh druzei," *Sovetskoe foto*, no. 10 (1959): 20–24.

70. D. Baltermants, "Na piati kontinentakh—sorok flazhkov," *Sovetskoe foto*, no. 1 (1958): 58. See also "Vtoraia vsesoiuznaia," *Sovetskoe foto*, no. 12 (1957): 4; "Iubileinaia vystavka," *Sovetskoe foto*, no. 6 (1957): 1–2.

71. "Diplomy za luchshie fotografy," *Sovetskoe foto*, no. 5 (1959): 4–6. For a short clip of Khrushchev's speech, see "U.S.S.R. 21st Congress of the Soviet Communist Party 1959 Newsreel," accessed May 23, 2016, https://www.youtube.com/watch?v=F5Cr6okf19o.

72. David Shneer, "Documenting the Ambivalent Empire: Soviet Jewish Photographers and the Far East," in Franziska Davies, Martin Schulze Wessel, and Michael

Brenner, eds., *Jews and Muslims in the Russian Empire and the Soviet Union* (Göttingen: Vandenhoeck & Ruprecht, 2015), 141–64.

73. Dm. Baltermants, "Tema rabochego klassa," *Sovetskoe foto*, no. 1 (1959): 1.

74. Photo books became popular in the 1950s not just in the Soviet Union but worldwide. French book publisher Robert Delpire began publishing a photo book series called *Photo Poche*, which produced the first photo books of many magazine-turned-art-photographers, including the 1958 publication of Robert Frank's *Les Américains*. Frank's book came out in English as *The Americans* one year later.

75. D. Baltermants and N. Kozlovskii, *Znovu tsvitut' kashtany/Snova tsvetut kashtany/* (Kiev: Gosudarstvennoe izdatel'stvo izobrazitel'nogo iskusstva i muzykal'noi literatury, 1960).

76. Peter Antill, *Stalingrad 1942* (Oxford: Osprey, 2007). For more on de-Stalinization, see Polly Jones, ed., *The Dilemmas of De-Stalinization: Negotiating Cultural and Social Change in the Khrushchev Era* (London: Routledge, 2006), especially her chapter, "From the Secret Speech to the Burial of Stalin: Real and Ideal Responses to De-Stalinization," 41–63.

77. See for example G. Zel'ma and A. K. Taradankin, *Stalingrad* (Moscow: Izogiz, 1954); see also *Stalingrad* (full-page color photograph) in *Sovetskoe foto*, no. 6 (1957); and a reprint of the 1954 book that appeared in 1957.

78. Vladimir Ivanov, "Gorod-geroi: chto eto takoe?" *Istoriia RF*, February 15, 2018, accessed June 12, 2019, https://histrf.ru/biblioteka/b/goroda-ghieroi-chto-eto-takoie. For a critical engagement with Soviet war memory and the concept of the hero-city, see Nina Tumarkin, "The Great Patriotic War as Myth and Memory," *European Review* 11, no. 4 (2003): 595–611.

79. "Vtoraia vsesoiuznaia," *Sovetskoe foto*, no. 12 (1957): 1–4.

80. "Fotoiskusstvo SSSR," *Sovetskoe foto*, no. 7 (1958): 1–3.

81. Boris Polevoi, "Vtoroi sputnik," *Sovetskoe foto*, no. 2 (1957): 36–41. The Auschwitz photograph and his quote is on p. 39. I have chosen not to reproduce the photograph.

82. Other articles in *Sovetskoe foto* also emphasized how West Germany was becoming a potential frontline of an atomic war, with the United States positioning its atomic weapons at the Soviet Union on West Germany territory. See for example L. Bezymenskii, "Germaniia glazami nemtsev," *Sovetskoe foto*, no. 5 (1957): 59–63.

83. Among the vast literature on the US role in West German Cold War defense strategy, one book approaches the question from the Americans on the ground. See John Lemza, *American Military Communities in West Germany: Life on the Cold War Badlands* (New York: McFarland, 2016).

84. "Za vseobshchee razoruzheniie i mir," *Sovetskoe foto*, no. 7 (1962): 1. See in particular Viktor Tyomin, "Znamia pobedy nad reikhstagom," in the same issue.

85. "Hiroshima: Atom Bomb No. 1 Obliterated It," *Life*, August 20, 1945, 26.

86. "Nagasaki: Atom Bomb No. 2 Disemboweled It," *Life*, August 20, 1945, 27.

87. Craig Campbell, *The Atomic Bomb and the Origins of the Cold War* (New Haven: Yale University Press, 2008). See also Robert Hariman and John Louis Lucaites, "The Iconic Image of the Mushroom Cloud and the Cold War Nuclear Optic," in Geoffrey Batchen, Mick Gidley, Nancy K. Miller, and Jay Prosser, eds., *Picturing Atrocity: Photography in Crisis* (Chicago: University of Chicago Press, 2012), chap. 11.

88. "Checklist: *Family of Man* Exhibition," Museum of Modern Art archive.

89. See for example Langston Hughes, *Negroes in Moscow: In a Land Where There Is No Jim Crow* (Moscow: State Publishing House, 1933); André Gide, *Retour de l'URSS* (Paris: Librarie Gallimard, 1936); Fred Kupferman, *Au pays des Soviets. Le voyage français en Union soviétique, 1917–1939* (Paris: Gallimard/ Julliard, collection "Archives," 1979). On African Americans in the Soviet Union, see Woodford McClellan, "Africans and Black Americans in Comintern Schools, 1925–1934," *International Journal of African Historical Studies* 26, no. 2 (1993): 371–90. Soviet writer/photographers also journeyed abroad to create visual travelogues like Ilya Ehrenberg's *Mon Paris* and Ilf and Petrov's *Single-Story America*.

90. Gennady Estraikh, "Escape through Poland: Soviet Jewish Emigration in the 1950s," *Jewish History* 31 (2018): 291–317.

91. Henri Cartier-Bresson, *The People of Moscow: 163 Pictures in Photogravure* (London: Thames and Hudson, 1955). See also Jean Pierre Montier, "Henri-Cartier Bresson, 'Public Intellectual'? *Études photographiques* 25 (May 2010), accessed April 27, 2016, https://etudesphotographiques.revues.org/3449?lang=en#bodyftn36.

92. "Vystavka shvetsarskikh fotomasterov," *Sovetskoe foto*, no. 5 (1957): 78.

93. Rachel Appelbaum, "The Friendship Project: Socialist Internationalism in the Soviet Union and Czechoslovakia in the 1950s and 1960s," *Slavic Review* 74, no. 3 (Fall 2015): 484–507.

94. By 1959, the SSOD had brought together twenty-seven bilateral Soviet friendship societies. V. Shakovskii, "Dom druzhby," *Sovetskoe foto*, no. 6 (1959): 68.

95. Gilburd, *To See Paris and Die*, 19–20.

96. On VOKS's history, see Michael David Fox, *Showcasing the Great Experiment: Cultural Diplomacy and Western Visitors to the Soviet Union, 1921–1941* (New York: Oxford University Press, 2014).

97. State Archive of the Russian Federation (GARF), f. 9576r. op. 16, d. 46, ll. 2–59, as found in Werneke, "The Boundaries of Art," 25–26, 126–27. See also Faye Bartram, "35mm Bridges: Cultural Relations and Film Exchange between France and the Soviet Union, 1945–1972" (PhD diss., University of Iowa, 2017).

98. D. Baltermants, "Na piati kontinentakh—sorok flazhkov," *Sovetskoe foto*, no. 1 (1958): 58.

99. K. Orlov, "Fotografiia sblizhaet narody," *Sovetskoe foto*, no. 8 (1957): 4–5. The SSOD archival records document the extensive involvement of Soviet photographers in

international shows, almost always traveling as a group exhibition. See for example GARF, f. 9576, op. 16, d. 184.

100. "Programma kommunisticheskoi partii Sovetskogo Soiuza, 1961 g," accessed July 30, 2018, www.museumreforms.ru/node/13891. For more on how "peaceful coexistence" was the underpinning of Thaw culture, see Gilburd, *To See Paris and Die.*

101. "V. Menshikov, Vo imia druzhby: po stranitsam zhurnalov zarubezhnykh obshchevtv druzhby i kul'turnoi sviazi s sssr," *Sovetskoe foto* no. 6 (1958): 57–59.

102. "S fotoapparatom po amerike," *Sovetskoe foto*, no. 10 (1959).

103. "Bymleny sovetskogo soiuza na lune," *Sovetskoe foto*, no. 10 (1959).

104. Eric J. Sandeen, *Picturing an Exhibition: The Family of Man and 1950s America* (Albuquerque: University of New Mexico Press, 1955), especially chap. 4, "The Family of Man in Moscow." See also Eric J. Sandeen, "*The Family of Man* on the Road to Moscow," in *American Photographs in Europe*, ed. David Nye and M. Gidley, 255–70 (Amsterdam: VU University Press, 1994); reprinted in Lori Bogle, *The Cold War: Cold War Culture and Society*, vol. 5 (London: Routledge, 2001), 57–72.

105. G. Chudakov, "'Vse, chto ia uvidel i slyshal v sovetskom soiuze, vyzyvaet liubov' i uvazhenie,' Eduard Steiken," *Sovetskoe foto*, no. 10 (1959): 62–64.

CHAPTER 4

1. Art historian Sarah James calls Caio Garrubba, Karl Pawek, and Heinrich Böll's *World Exhibition of Photography on the Theme: What is a Human Being? [Weltausstellung der Photografie zu dem Thema: Was ist der Mensch?]*, a "post-fascist *Family of Man*." See Sarah James, *Common Ground: German Photographic Cultures across the Iron Curtain* (New Haven: Yale University Press, 2013), 40–100. See also her essay "A Post-Fascist *Family of Man*? Cold War Humanism, Democracy, and Photography in Germany," *Oxford Art Journal* 35, no. 3 (2012): 315–36. See Heinrich Böll and Karl Pawek, eds., *Weltausstellung der Photographie. 555 Photos von 264 Photographen aus 30 Ländern zu dem Thema: Was ist der Mensch?* (Hamburg: Nanen, 1964). For a critique of the show, see Hans Meyer-Veden, "Photographie ist keine Philosophie: Paweks falsche Wirklichkeit Wenn das der Mensch ist . . .", *Die Zeit*, November 13, 1964, accessed July 26, 2013, http://www.zeit.de/1964/46/photographie-ist-keine-philosophie. See also Kazimierz Seko, "Dymitr Baltermanc," *Fotografiia*, no. 1 (1986): 9–13.

2. Interview with Tatiana Baltermants, September 25, 2016.

3. Many sources relate the mysterious meeting between Garrubba and Baltermants, including Baltermants's own recollections, from which the quoted material comes. Vladimir Anatolevitch Nikitin, *Rasskazy o fotografakh i fotografiiakh* (Leningrad: Lenizdat, 1991), 154. In addition, see Valerii Burt, "Ia khochu byt' Baltermantsem: K 100-letiiu izvestnogo sovetskogo

fotokhudoznika," *Stoletiie: Informatsionno-analiticheskoe izdaniie fonda istoricheskoi perspektivy*, May 14, 2012, accessed June 26, 2013, http://www.stoletie. ru/kultura/khochu_byt_baltermancem__717.htm.

4. See among others R. Il'in, "Osveshcheniie pri s'emke portreta," *Sovetskoe foto*, no. 8 (1958): 33–41.

5. "Rasskaz ob odnoi fotografii," in Nikitin, *Rasskazy*, 153.

6. Ibid.

7. V. Gende-Rote, "Kadrirovanie i kompozitsiia," *Sovetskoe foto*, no. 1 (1959): 33–35. The article opens with a Henri Cartier-Bresson quote from his visit to Moscow with Soviet photographers. He explained that one always wants to capture as much information in the frame and only later crop it to tell the story visually.

8. I. Seleznev, "Kadrirovanie—protess tvorcheskii," *Sovetskoe foto*, no. 10 (1961).

9. My interpretation of clouds as an aesthetic feature of Baltermants's photograph comes from Hubert Damisch, *A Theory of /Cloud/: Towards a History of Painting*, trans. Janet Lloyd (Stanford: Stanford University Press, 2002).

10. Damisch, *A Theory of /Cloud/*, 157. Emphasis in the original.

11. Leonardo da Vinci, *The Notebooks of Leonardo da Vinci*, downloaded April 18, 2016, www.gutenburg.org/ebooks/5000).

12. S. Lerman, "Perspektivnoe izobrazheniie fotografii," *Sovetskoe foto*, no. 5 (1959): 52–55.

13. Nikitin, *Rasskazy*, 151.

14. Anne Wilkes Tucker and Will Michels, *War/Photography: Images of Armed Conflict and Its Aftermath* (Houston: Museum of Fine Arts, Houston, 2012).

15. State Archive of the Russian Federation (GARF), f. 9576r, op. 16, d. 47, l. 35, as cited in Jessica Marie Werneke, "The Boundaries of Art: Soviet Photography from 1956 to 1970" (PhD diss., University of Texas, Austin, 2015), 127.

16. "Tvorcheskii otchet Dm. Baltermantsa," *Sovetskoe foto*, no. 7 (1962).

17. "Fotovystavka rasskazyvaet . . .," *Ogonek*, April 22, 1962, 29. See also Seko, "Dymitr Baltermanc." The catalog maquette is found in the Teresa and Paul Harbaugh Archive, Denver, Colorado. I found no evidence, however, of the maquette becoming a published catalog.

18. The "space race" had shaped Cold War diplomacy since the 1950s. A *Sovetskoe foto* article about SSOD from 1958 opens: "The release of the first Soviet artificial satellites, which opened a new era in the development of world science, has turned millions of people's attention to the Soviet Union, to the country that leads progressive humanity."

19. For a clip of Van Cliburn performing Tchaikovsky's First Concerto in 1958 at the Great Hall of the Moscow Conservatory, see https://www.youtube.com/watch?v=f7MAriotZyE.

20. Maquette for "Fotovystavka Dmitriia Baltermantsa," in the Teresa and Paul Harbaugh Archive, Denver, Colorado.

21. A. Aleksandrov, "Dmitrii Bal'termants," *Sovetskoe foto*, no. 9 (1962): 17. The phrase could also be translated as "point of departure," but the word *iskhod* is also the name of the biblical book of Exodus. Leon Uris's book *Exodus* was published in 1958 and became a totemic book in the Soviet underground of self-publishing (*samizdat*). Although the Russian translation *Iskhod* was not published until 1969 in Jerusalem, the original English and Russian typeset translations were circulating in the 1960s, perhaps adding a semantic layer to the word in this particular moment.

22. Aleksandrov, "Dmitrii Bal'termants," 17.

23. Ibid., 17

24. Ibid., 19.

25. GARF, f. 9576, op. 16, d. 152, ll. 63–65.

26. GARF, f. 9576, op. 16, d. 152, l. 66.

27. Gilburd, "The Revival of Soviet Internationalism in the 1950s," in *The Thaw: Soviet Soviety and Culture During the 1950s and 1960s*, ed. Denis Kozlov and Eleonory Gilburd (Toronto: University of Toronto Press, 2013), 364.

28. "'Nas vezde okruzhalo proiavleniie druzhby,' Ida Kar," *Sovetskoe foto*, no. 10 (1959): 59. See also the report "Fotosektsiia SSOD, 1963," GARF, f. 9576, op. 16, d. 184, ll. 43–44.

29. "Novosti kul'turnoi zhizni," *Pravda*, April 3, 1962.

30. *Ida Kar: Khudozhnitsa s fotoapparatom* (Moscow, 1962). The exhibition catalog for Ida Kar's Moscow show does not appear in libraries and seems to be available only in the collection of photographer John Massey Stewart in the Leeds University archive, "Massey Stewart Collection," accessed August 24, 2015, http://library.leeds. ac.uk/special-collections-explore/20416/massey_stewart_collection. Additional information was pieced together in the correspondence related to Baltermants's exhibition in London. See "Dmitrii Baltermants Exhibition," Great Britain–USSR Association Collection, GB206 MS1399, Leeds University Library. There is a brief biography in Clare Freestone and Karen Wright, *Ida Kar: Bohemian Photographer* (London: National Portrait Gallery, 2011).

31. Dmitrij Baltermanc, "Hore," *Praha-Moskva*, no. 1 (1963): 45.

32. Rachel Appelbaum, "The Friendship Project: The Socialist Internationalism in the Soviet Union and Czechoslovakia in the 1950s and 1960s," *Slavic Review* 74, no. 3 (Fall 2015): 484–507.

33. "Dmitrii Baltermants Exhibition," Great Britain–USSR Association Collection, Leeds University Archives, MS 1499/23/6 and 7. GARF, f. 9576, op. 16, d. 184.

34. SSOD archival records show that production of the catalog began in March 1963 when it transmitted the original Russian-language catalog, along with an English translation, to the *Pravda* publishing house for production. Letter from E. Ivanov to F. F. Olenin, director of the *Pravda* publishing house, March 30, 1963. GARF, f. 9576, op. 16, d. 184, l. 115.

35. GARF, f. 9576, op. 16, d. 219, l. 1.

36. GARF, f. 9576, op. 16, d. 219, ll. 2–4.

37. See for example Yuri Yeremin, "Kak gotovitsiia k vystavkam," *Sovetskoe foto*, no. 5 (1957): 37–39or A. Komovskii, "Kak my oformliaiem fotovystavki," *Sovetskoe foto*, no. 5 (1958): 29–32, which goes into great detail about the entire process of conceiving of, producing, mounting, and displaying photographs for exhibition.

38. "Fotovitrina," *Sovetskoe foto*, no. 5 (1959): 22–23. On the Zorkin newspaper, see I. Pospelov, "Ot 'Zorkogo' ne uidesh!," *Sovetskoe foto*, no. 12 (1957): 14. The newspaper also supported broader efforts "in the fight against violators of social order—hooliganism, drunkenness, and rowdiness."

39. Irena Pavelek, "Vtoraia mezhdunarodnaia fotovystavka v amsterdame," *Sovetskoe foto*, no. 7 (1957): 54–55.

40. *People and Events of the USSR: An Exhibition of Dmitri Baltermants* (London: USSR–Great Britain Society, 1964).

41. Konstantin Simonov, "Ubei ego," *Krasnaia zvezda*, July 18, 1942. For a reading of the poem, see https://www.youtube.com/watch?v=fNz6fOdk7e4 (accessed May 28, 2016).

42. Kukryniksy, "Ubei ego!," *TASS*, no. 0527, July 23, 1942. See for example http://www.virtualrm.spb.ru/ru/node/26183 (accessed December 9, 2019).

43. GARF, f. 9576, op. 16, d. 185, ll. 97–98.

44. Konstantin Simonov, "O Dmitrii Baltermantse," draft of catalog essay for *People and Events in the USSR*. The Russian and the official English translation appear in "Mr. Baltermants' Exhibition," MS1499/23/6, Leeds University Library.

45. Simonov, "O Dmitrii Baltermantse." The underline was in the original English translation.

46. The archival file contains multiple drafts of Simonov's catalog essay.

47. J. L. Gordon, ed., *Pictures by Anya Teixeira*. CD-ROM of materials.

48. "Dmitrii Baltermants Exhibition," Great Britain–USSR Association Collection, Leeds University Archives, MS 1499/23/6 and 7. The comment book is file 4 of 4.

49. Roger Hill, "Dmitri Baltermants," *British Journal of Photography*, August 21, 1964, 678–83.

50. Dmitrii Baltermants, "Vokrug bol'shogo Bena," *Ogonek*, no. 48 (November 1964): 11–15.

51. Böll and Pawek, eds., *Weltausstellung der Photographie*, no page numbers but under "Anmerkungen zu den Photos, no. 23."

52. James, *Common Ground*. On winning the prize, see "Rasskaz ob odnoi fotografii," in Nikitin, *Rasskazy*, 154.

53. "Rasskaz ob odnoi fotografii," in Nikitin, *Rasskazy*, 154.

54. On Baltermants becoming *Ogonek*'s director of photography, see "Classics of Photography: Dmitry Baltermants," accessed June 18, 2013, http://club.foto.ru/classics/life/36/.

55. GARF, f. 9576, op. 16, d. 258, ll. 30, 33, 76.

56. The two films in which Baltermants is referenced are *Ne samyi udachnyi den'*, directed by Yuri Yegorov (1966, Moscow, Gorky Studios) and *Zigzag udachi*, directed by Eldar Riazanov (1968, Moscow, Mosfilm).

57. "Nikogda ne zabudem!," *Ogonek*, January 1965.

58. See for example *Ne zabudem, ne prostim: Zverstva fashistov v Kerchi* (Moscow: Goskinoizdat, 1942).

CHAPTER 5

1. Nadya Bair, *The Decisive Network: Magnum Photos and the Postwar Image Market* (Berkeley: University of California Press, 2020).

2. "Interview with Simpson Kalisher, One of American Society of Media Photographers' Founders, March 26, 1993," accessed April 20, 2018, https://www.asmp.org/resources/about/history/interview-founders/simpson-kalisher/.

3. Morris Gordon, "IPEX International Photographic Exposition," *Camera* 44, no. 5 (1965): 7–25. See also as cited in Nadine Olonetzky, "Eine kurze Geschichte der Fotozeitschrift '*Camera*'," www.fotokritik.de, January 3, 2008, accessed August 17, 2015.

4. Ibid.

5. The original agreement was known as the Lacy–Zaroubin Agreement, signed on January 27, 1958. "Text of the Joint Communiqué of US and Soviet Union on Cultural Exchanges," *New York Times*, January 28, 1958.

6. State Archive of the Russian Federation (GARF), f. 9576, op. 16, d. 219, l. 118.

7. GARF, f. 9576, op. 16, d. 258, l. 29.

8. GARF, f. 9576, op. 16, d. 258, l. 52.

9. Alfred Gescheidt, "12 Photographers: An International Show of Photography," *Infinity* 14, no 7 (1965): 2, 28.

10. Ibid.

11. Jacob Deschin, "Gallery Exhibits on View," *New York Times*, May 16 1965, X 16.

12. Helen Gee, *Limelight: A Greenwich Village Photography Gallery and Coffeehouse* (Albuquerque: University of New Mexico Press, 1997), 64.

13. *Master Photographers: Photography in the Fine Arts*, Metropolitan Museum, 1967.

14. GARF, f. 9576, op. 16, d. 258, ll. 6–11, 73–76, 99. Shakhovskoi's exhibition appeared at Trinity College in New Haven, the Davenport Municipal Art Gallery in Iowa, and the Peale Museum in Baltimore. Bodine's exhibit was shown in Kiev and Moscow.

15. "La Roma di Baltermants: Un servizio in esclusiva del piu grande fotografo sovietico," *Vie Nuove*, February 20, 1969.

16. "Dmitri Baltermants," *Fotografare*, April 1969, 50–57.

17. Vladimir Nikitin, "Rasskaz ob odnoi fotografii," in *Rasskazy o fotografakh i fotografiiakh* (Leningrad: Lenizdat, 1991), 154–55. Unfortunately, I was not able to locate the original encyclopedia of religion. For more on Nikitin, see http://www.va-nikitin.com/.

18. "The Russians are Here (A Look at USSR Photo '70)," *Popular Photography* 66, no. 6 (June 1970): 89–91.

19. A list of his solo shows generally appeared in most exhibition catalogs. This particular list comes from "Dmitrijus Baltermancas, Fotografijos Paroda/Dmitrii Bal'termants, Vystavka fotografii," Vilnius, 1983, organized by the Union of Lithuanian Journalists and the Lithuanian Society of Photographic Arts (Soiuz zhurnalistov litovskoi SSR/Obshchestvo fotoiskusstva litovskoi SSR).

20. *World Press Photo 1974* (Amsterdam: Teleboek, 1974), 107.

21. "Abgrund des Krieges," *Die Zeit*, August 24, 1979, no. 35.

22. Nikitin, "Rasskaz ob odnoi fotografii," 154–55.

23. Ibid., 155.

24. See "30 let velikoi pobedy, 9 maia 1975 god. Kak eto bylo. Glavny novosti," accessed April 29, 2018, https://www.youtube.com/watch?v=YZ0c9ow3ABs. Martyn Merzhanov's *Tak eto bylo* about the last days of "fascist Berlin" first appeared in 1971 but a second edition appeared in 1975. *Tak eto bylo: poslednie dni fashitskogo Berlina* (Moscow: Politizdat, 1971; 2nd ed., 1975).

25. Matvei Maltsin, "A denkmol in Rudnye," *Sovetish Heymland* 2 (1991): 130, as cited in Arkady Zeltser, *Unwelcome Memory: Holocaust Memorials in the Soviet Union* (Jerusalem: Yad Vashem, 2019), 167–68.

26. Memorial Park of Glory, accessed April 29, 2018, http://all-pages.com/city_photo/10/12/62/187/5.html.

27. For a close up of Novosibirsk's *Grieving Mother*, see "Life Is Photo, Mourning Mother," accessed April 29, 2018, http://www.lifeisphoto.ru/photo.aspx?id=625706.

28. Six cities were designed as wartime "hero cities" on May 8, 1965, to commemorate the twentieth anniversary. Kerch earned its "hero city" designation in 1973 along with Novorosiisk.

29. "Crimea: Kerch. Monument to the Victims of War," accessed April 29, 2018, http://krim.biz.ua/kerch-10-foto.html.

30. See Ministry of Culture of Russia, "Information from the Unified State Register of Cultural Heritage Sites (Monuments of History and Culture) of the Peoples of the Russian Federation," accessed April 29, 2018, http://mkrf.ru/ais-egrkn/, for information on its being named a cultural treasure.

31. See for example Otto Scott, "U.S. and U.S.S.R.: The Muffled Antagonists," *Los Angeles Times*, November 12, 1978, N4. The author reviewing the book *The Unknown War* by Harrison E. Salisbury mentions *Grief*: "'The Unknown War' is a

stunning book pictorially. Its collection includes Dimitri Baltermants' photograph of Crimean women searching for sons and/or husbands in a field of cadavers left by the Nazis after a slaughter of civilians."

32. Vasilii Peskov, "Introduction," in *Dmitrii Baltermants: Selected Photographs* (Moscow: Planeta, 1977). The fact that it was a bilingual Russian–English production also suggests that it was intended for an international audience.

33. Correspondence with Tatiana Baltermants, December 1, 2018.

34. Denise Bethel, "At Auction and in the Book Trade: Sources for the Photography Historian," *History of Photography* 21, no. 2 (Summer 1997): 117–28. The article traces the photography auction trade back into the nineteenth century through the antiquarian book market and argues that aside from the 1952 Swann show, there was little activity in the auctioning of photography until the late 1960s.

35. See for example the University of New Mexico's photography program's history page, accessed July 3, 2016, http://photo.unm.edu/program.php, on the relationship between university photography programs and the broader global photography market.

36. University of New Mexico Art Museum, accessed May 4, 2018, http://artmuseum.unm.edu/collections/photography/.

37. Camille Moore, "An Analytical Study of Eugène Atget's Photographs at the Museum of Modern Art," paper presented to the Museum of Modern Art's Photography and Conservation departments, *Topics in Photographic Preservation* 12, 2006, accessed May 25, 2016, http://cool.conservation-us.org/coolaic/sg/topics/v12/pmgt12-030.pdf. See also Clark Worswick, *Berenice Abbott and Eugène Atget* (Santa Fe, NM: Arena Editions, 2002).

38. "Atget at the Museum of Modern Art," December 1, 1969, accessed January 5, 2017, https://www.moma.org/calendar/exhibitions/2701?locale=en.

39. "Tax Treatment of Artists' Charitable Contributions," *Yale Law Journal* 89, no. 1 (1979): 144–67.

40. "Letter from Lee Witkin to Mrs. Cornell Capa," November 27, 1968, file 29, AG62 (Witkin Gallery Collection), Center for Creative Photography, University of Arizona.

41. Lee Witkin and Barbara London, *The Photograph Collector's Guide* (Boston: New York Graphic Society, 1979).

42. Ibid., 7.

43. Ibid., 74.

44. Ibid.

45. "Peace Pitch," Talk of the Town, *New Yorker*, March 17, 1962, 32–33.

46. M. S. Handler, "500 Americans to Study in Soviet This Summer," *New York Times*, June 26, 1966, L18.

47. CEC Arts Link, 50th anniversary book (2012). In 1981, Brainerd reorganized the CEC and changed the name to Citizens Exchange Council.

48. SPG Archives, Minutes from 1983, located at the Soho Photo Gallery, New York City.

49. Interview with David Chalk, January 30, 2016.

50. Norman Cousins, "Modern Man Is Obsolete," *Saturday Review of Literature*, August 18, 1945; also republished as a small book, *Modern Man Is Obsolete* (New York: Viking, 1945).

51. Allen Pietrobon, "The Role of Norman Cousins and Track II Diplomacy in the Breakthrough to the 1963 Limited Test Ban Treaty," *Journal of Cold War Studies* 18, no. 1 (2016): 60–71.

52. Harvard Square Library, "Cousins, Norman, 1915–1990," accessed July 22, 2017, http://www.harvardsquarelibrary.org/biographies/norman-cousins-2/.

53. "Dinner for Dmitri Baltermants, 2644 Eden Pl. June 2, 1983," Norman Cousins Papers, collection number 1385, box 958, folder 23, University of California at Los Angeles special collections. The guest list included the writers Irving and Jean Stone (Irving was the author of such popular works about artists as *Lust for Life*, about Vincent van Gogh, and *The Agony and the Ecstasy*, about Michelangelo); Michael and Deborah Viner, media moguls who went on to create audiobooks; Jerome Lawrence, a playwright and author; and Richard Colburn, a philanthropist and supporter of the Los Angeles music scene. Unfortunately for Baltermants, little seems to have come from having dinner with this array of Los Angeles notables.

54. "Soviet Photojournalist to Speak," *Los Angeles Times*, May 27, 1983, H12. See also Dinah Berland, "On Photography: Human Concerns in War and Peace," *Los Angeles Times*, June 19, 1983, S102.

55. "Press release," Citizens Exchange Council, Focus '83, New York's International Photography Workshops, and SPG, n.d., SPG Archives, New York City. See also "Focus '83," *Popular Photography*, June 1983, 164.

56. "Press release, Dmitrii Baltermants," Citizens Exchange Council, Focus '83, International Photography Workshops, SPG, SPG Archives, New York City.

57. Andy Grundberg, "Dmitri Baltermants," *New York Times*, June 17, 1983, C1.

58. Ibid.

59. *The Russian War, 1941–1945*, accessed April 29, 2018, https://www.icp.org/exhibitions/the-russian-war-1941-to-1945.

60. Jack Manning, "ICP: Where Students Can Work with Experts," *New York Times*, October 6, 1977, D33.

61. Daniela Mrázková and Vladimir Remeš, *Fotografovali válku : sovětská válečná reportáž* (Prague: Odeon, 1975).

62. D. Z., "Sovětská válečná reportáž," *Česky časopis historicky*, no. 1 (1976), 142.

63. Gene Thornton, "'Optimism' Colors Images of 20th-Century Soviet Life," *New York Times*, July 28, 1985, H25.

64. David Shneer, "Is Seeing Believing? Photographs, Eyewitness Testimony, and Evidence of the Holocaust," *East European Jewish Affairs* 45, no. 1 (2015): 65–78.

65. Jane Livingston and Frances Fralin, *The Indelible Image: Photographs of War, 1846 to the Present* (New York: Abrams, 1985), 132–33 (Baltermants); for Alpert, see 144–45; for Evzerikhin, see 146–47; for Khaldei, see 186–87. Each of these images would end up becoming the respective photographers' signature images in the global photography market in the 1990s.

66. GARF, f. 9576, op. 16, d. 153, l. 29.

67. GARF, f. 9576, op. 9, d. 24, l. 124.

68. Interview with G. Ray Hawkins, August 21, 2015, Beverly Hills, CA.

69. For more on how the antiquarian book market generated the art photography market, see Bethel, "At Auction and in the Book Trade."

70. G. Ray Hawkins Collection, AG 64, Box 1, Files 1, 4, and 5, Center for Creative Photography, Tucson, AZ. Yavno and Hawkins worked together to build up the gallery in its early years, with Hawkins initially taking a 50% cut but reducing that to 40% in 1977. His sales log shows a wide array of customers for Yavno's work, from art institutions like the New Orleans Museum of Art and the University of Michigan Art Museum to collectors and other dealers, like the Dalsheimer Gallery in Baltimore, purchasing Yavno photographs from Hawkins for their own clients

71. P. H. H., "G. Ray Hawkins, Gallery Owner," *American Photo*, January–February 1994, 93.

72. G. Ray Hawkins Gallery, Auction One, March 8, 1983. Getty Research Institute, Los Angeles.

73. Philip Gefter, "Why Photography Has Supersized Itself," *New York Times*, April 18, 2004, Arts and Leisure, 29.

74. Jeffrey Hogrefe and Paul Richard, "Getty Gets the Pictures; Photo Collections Valued at $20 Million Purchased by Museum," *Washington Post*, June 8, 1984, B1.

75. Interview with Paul Harbaugh, May 31, 2016.

76. Chris Miller, *The Struggle to Save the Soviet Economy* (Durham: University of North Carolina Press, 2016).

77. Laura Meyers, "From Russia with Love," *Art Business News*, 2002, vol, 29, no. 10 (October), 64–66.

78. On Alex Lachmann, see "Collection of Alex Lachmann," University of Leeds Special Collections, GB 206 MS 1115 (https://archiveshub.jisc.ac.uk/data/gb206-ms1115), which contains many flyers, posters, and other materials that appeared out of his gallery. Lachmann's collection is used widely, including several well-known Russian avant-garde exhibitions that took place at the Royal Academy of Arts in London in 2017.

79. Letter from G. Ray Hawkins to Michael Brainerd, n.d. [sometime in spring 1990], Paul Harbaugh Private Archive, Denver, Colorado.

80. Interview with Tatiana Baltermants, September 25, 2016.

CHAPTER 6

1. Andy Grundberg, "Dmitri Baltermants, Soviet Photographer of War, Dead at 77," *New York Times*, June 20, 1990, B8. Obituaries appeared in regional newspapers across North America, including the *Milwaukee Journal, Orlando Sentinel, Edmonton Journal*, and the *Minneapolis Star Tribune*. They all ran a one-paragraph obituary, which mentioned *Grief* as the highlight of Baltermants's career.

2. "Dmitri Baltermants," *Times* (London, England), June 28, 1990, 14.

3. Lettter from Tatiana Baltermants to Michael Brainerd, April 15, 1990. Paul Harbaugh Private Archive.

4. Interview with G. Ray Hawkins, August 21, 2015. Beverly Hills, CA.

5. Cathy Curtis, "Dimitri Baltermants, the Soviet Robert Capa," *Los Angeles Times*, October 19, 1990, accessed August 23, 2015, http://articles.latimes.com/1990-10-19/entertainment/ca-2681_1_photographer-robert-capa.

6. Steve Appleford, "The Cost of War: Pictures of the Home Front: Like Robert Capa, Dmitri Baltermants Chronicled War. But, Unlike Capa, the Horror He Photographed Was in His Own Town. The Late Artist's Work Finally Comes to Los Angeles," *Los Angeles Times*, October 21, 1990, accessed August 23, 2015, http://articles.latimes.com/1990-10-21/entertainment/ca-4049_1_dmitri-baltermants.

7. The Editors, Introduction to "Photostroika: New Soviet Photography," *Aperture* 116 (Fall 1989): 1.

8. Yevgeny Khaldei, Alice Nakhimovsky, and Alexander Nakhimovsky, *Witness to History: The Photographs of Yevgeny Khaldei* (New York: Aperture, 1997). I interviewed the couple in July 2018, and they described how they invited Khaldei to Colgate University, where they both teach, in order to introduce him to American audiences and then organized a show that resulted in this catalog.

9. El Lissitzky followed soon thereafter and became known for his photomontage and constructivist images.

10. "Aleksandr Rodchenko, Russian, 1891–1956," accessed January 19, 2019, https://www.moma.org/artists/4975. British art historian Camilla Gray did much to bring Russian avant-garde artists, including photographers, to the Western art world. See her groundbreaking book *The Great Experiment: Russian Art 1863–1922* (London: Thames and Hudson, 1962).

11. For more on this part of the story, see Erika Wolf, "The Visual Economy of Forced Labor: Alexander Rodchenko and the White Sea-Baltic Canal," in Valerie Kivelson and Joan Neuberger, eds., *Picturing Russia: Explorations in Visual Culture* (New Haven: Yale University Press, 2008), 168–74.

12. Artnet research for Alexander Rodchenko, June 3, 2016.

13. Artnet research for Dmitri Baltermants, June 3, 2016.

14. Email correspondence with Tatiana Baltermants, December 6, 2018.

15. Letter and certificate of registration from Michael Brainerd and Paul Harbaugh to the US Customs Service, January 6, 1993. Paul Harbaugh Private Archive. These details were confirmed in my interviews with Harbaugh and Hawkins.

16. Portriga Rapid thread on "Film and Darkroom User," accessed June 20, 2019, http://www.film-and-darkroom-user.org.uk/forum/showthread.php?t=6234.

17. "Listings, Photography," *New York*, April 27, 1992, 106. See also internal correspondence between Harbaugh and Cornell Capa as found in Paul Harbaugh Private Archive.

18. Charles Hagen, "Dmitri Baltermants," *New York Times*, May 8, 1992, C32.

19. Steven Rosen, "Stark Memories of the Soviet Union: Photojournalist's Belated Quest for Fame Takes Big Step with Help from Denverite," *Denver Post*, April 23, 1992, Section F.

20. "Special Section on VE Day," *Time*, April 29, 1985.

21. Interview with Paul Harbaugh, May 31, 2016. E-mail correspondence with John Loengard, May 19, 2018.

22. John Loengard, *Celebrating the Negative* (New York: Arcade Publishing, 1994).

23. Mario Cutajar, "Dmitri Baltermants," *ArtScene*, July/August 1994, accessed May 4, 2018, https://plasticregime.wordpress.com/1994/07/.

24. Ibid.

25. Theodore Von Laue, Angela Von Laue, Dmitrii Baltermants, and Tatiana Baltermants, *Faces of a Nation: The Rise and Fall of the Soviet Union, 1917–1991* (Golden, CO: Fulcrum Publishing, 1996).

26. "Ten Years in Focus: The Artist and the Camera at the J. Paul Getty Museum, the Getty Center, March 25–August 10, 2008," press release, December 13, 2007, accessed June 22, 2019, http://www.getty.edu/news/press/10th_anniversary/10_years_in_focus_release.pdf. The Getty has only a single Baltermants photograph, *Tchaikovsky*, in its permanent collection. It was acquired from a source in France when its photography department opened in 1984.

27. LACMA, accessed May 6, 2018, https://collections.lacma.org/node/194849. See also the file on the acquisitions of these ten Baltermants photographs, LACMA Photo Archives, Los Angeles. Note that I have anonymized these records, because as it turns out the archivist who showed me the records was not authorized to do so.

28. I found it strange that Hawkins, the person who coproduced the Baltermants portfolio, brought his work to the photography market, and encouraged his clients to acquire Baltermants, would also be the one to appraise those photographs. It seemed like a conflict of interest, but, of course, at this early stage in Baltermants's appearance in the photography market, who better than the dealer to know what the photograph would sell for? Hawkins's appraisal also had a proviso stating that the "fee for this appraisal is not based upon a percentage of its value." I thought that this was an odd statement to include in an appraisal. How else would an appraiser charge for an appraisal?

After working at LACMA, I did research at the Center for Creative Photography in Tucson, AZ, founded in 1975 as a central address for photography research based on the archives of several well-known photographers, including Ansel Adams and Aaron Siskind. In my research there, I learned that there *was* a reason why Hawkins included a line about the fee *not* being a percentage of the appraised value. At the birth of the photography market in the early 1970s, photography appraisers were basing their fee on the appraised value of a print. Since the 1970s, that practice of charging for an appraisal based on its value has been rendered inappropriate. See correspondence surrounding a donation of Edward Steichen photographs to the Museum of Modern Art, 1972, box 61, AG62 (Witkin Gallery Collection), Center for Creative Photography, University of Arizona.

29. L. P. Cline Gallery, accessed December 25, 2018, http://www.lpcline-russian-art.com/dmitri-baltermants-1912-1990.html.

30. Margarett Loke, "Inside Photography," July 12, 1996, https://www.nytimes.com/1996/07/12/arts/inside-photography.html. As of June 2018, the Robert Koch Gallery has a staff of twenty-one people and a vast set of photographic and other print holdings. Interview with Robert Koch, June 6, 2018.

31. The prices can be found at Artnet, accessed June 2, 2018, http://www.artnet.com/artists/dmitri-baltermants/.

32. Invitation, "Dmitri Baltermants and Aesthetic Allies," July 19–September 15, 2001. Courtesy of Tatiana Baltermants Archive.

33. James Climent, "Life Expectancy of Russian Men Falls to 58," *British Medical Journal* 319 (1999), 468.

34. Interview with Robert Koch, June 6, 2018.

35. Stephen Cohen Gallery, accessed May 27, 2018, http://www.stephencohengallery.com/cohen-exhibitions/past/2003.html. See also "Unblinking Look at War," *Los Angeles Times*, July 10, 2003, E3. Holly Myers reviewed the show for the *Times* in August.

36. Susan Adams, "Red Eye: Collector Michael Mattis Aims to Make an Obscure Dead Russian Photographer Famous. If He Can, He'll Make Himself Richer," *Forbes*, June 7, 2004, 228–30.

37. Akron Art Museum, accessed May 28, 2018, https://akronartmuseum.org/collection/4DACTION/HANDLECGI/CTN3.

38. The UMFA also holds prints by Mike Disfarmer, another photographer whom Mattis championed. This suggests that Mattis, through his collectors, helped these institutions build their collection. Shawn Rossiter, "Mike Disfarmer at the UMFA," accessed May 7, 2018, http://artistsofutah.org/15Bytes/index.php/mike-disfarmer/. Having spent a large part of his professional life in New Mexico, where Harbaugh also spent his formative professional years, Mattis was a big donor to New Mexico–based art institutions, including the University of New Mexico Museum of Art and

the Museum of Fine Arts, in Santa Fe. See for example *Remnants: Photographs from the Disfarmer Studio*, University of New Mexico Art Museum, 2016.

39. For more on European culture and its tight relationship with Europe, see Eleonory Gilburd, *To See Paris and Die: The Soviet Lives of Western Culture* (Cambridge, MA: Harvard University Press, 2018).

40. Invitation, "Dmitrii Nikolaevitch Baltermants," October 23, 1990. Courtesy of Tatiana Baltermants Archive. See also Abigail Foerstner, "Door Opens to Soviet Works, Revealing a Universal Vision," *Chicago Tribune*, December 22, 1989, accessed May 31, 2018, http://articles.chicagotribune.com/1989-12-22/entertainment/8903200858_1_contemporary-soviet-photography-soviet-union-photography-department/2.

41. See Nadya Bair, *The Decisive Network: Magnum Photos and the Postwar Image Market* (Berkeley: University of California Press, 2020).

42. Ginanne Brownell, "Russia's Photo Impresario," *International Herald Tribune*, May 29, 2010, 9.

43. William Meyers, "Free Market Exposure," *Wall Street Journal*, September 14, 2011, D7.

44. Marina Raikina, "Pochatok Khrushcheva, oskal Suslova," *Moskovskii komsomolets*, February 28, 2005, accessed May 29, 2018, http://www.mk.ru/editions/daily/article/2005/02/28/199343-pochatok-hruscheva-oskal-suslova.html.

45. Armelle Canitrot, "Photography Review," *La Croix*, April 26, 2005, accessed May 29, 2018, https://www.la-croix.com/Archives/2005-04-26/PHOTOGRAPHIE-_NP_-2005-04-26-234719.

46. Barbara Oudiz, "Patriot with a Piercing Eye," *Financial Times*, March 16, 2005, 17.

47. Sue Steward, "Russia's Red Revolution," *Evening Standard*, August 10, 2014, 42.

48. Zoe Pilger, "From Russia with Lies," *The Independent*, August 4, 2014, 4.

49. Olga Sviblova, "Dmitrii Baltermants Retrospektiv," accessed May 30, 2018, https://rosphoto.com/events/retrospektiva_dmitriy_baltermanc-784.

50. Isabal Gorst, "Art Fund a Snapshot of Russian Asset Class," *Financial Times*, April 17, 2011.

51. Ibid.

52. Agana, Collection: PhotoEffect, http://www.agana.ru/uslugi/mutual_funds/close/_photoeffect/_index.php [in Russian].

53. "Dmitrii Retunskikh: zarabotat' milliony dollarov na fotografii vozmozhno," December 29, 2011, accessed January 19, 2019, https://ria.ru/interview/20111229/529072021.html.

54. Olga Borte, "Khudozhestvennye tsennosti: Interviu s Olegom Sukharevym," April 7, 2011, accessed January 19, 2019, https://ukagana.livejournal.com/3067.html.

55. Irina Telitsyna, "Proiavlenie sprosa," *Forbes Russia*, March 11, 2007, accessed June 5, 2018, http://www.forbes.ru/forbes/issue/2007-11/12846-proyavlenie-sprosa.

56. Gorst, "Art Fund a Snapshot."

57. The word *paparazzo* was first used in Federico Fellini's 1960 film *La Dolce Vita*, as the name of the character inspired by Tazio Secchiaroli. Thanks to Rob Adler Peckerar for drawing my attention to this.

58. Interview with Dmitry Gershengorin, July 30, 2018.

59. "Auktsion po prodazhe imushchestva ZPIF "Sobranie. FotoEffekt," accessed May 30, 2018, http://pro-collections.com/index.php/filateliya/754-aukcion-po-prodage-imushest. See also http://review.imac.ru/media/?p=4297.

60. "Publichnoe predlozhenie po prodazhe imushchestva no. 216568," accessed July 30, 2018, https://www.b2b-center.ru/market/prodazha-imushchestva-zakrytogo-paevogo-investitsionnogo-fonda/tender-216568/?action=lots.

61. "Maria Burasovskaya, Photographer's Daughter, Opens the Eye Gallery," accessed July 6, 2018, https://daily.afisha.ru/archive/gorod/archive/7810/. See also www.glazgallery.ru for a brief history of the gallery.

CHAPTER 7

1. Interview with Nailya Alexander, July 19, 2018

2. Brian Wallis, *Weegee: Murder Is My Business* (New York: Prestel, 2013).

3. Barbie Zelizer, "Holocaust Photography, Then and Now," in Bonnie Brennen and Hanno Hardt, eds., *Picturing the Past: Media, History, and Photography* (Urbana Champaign: University of Illinois Press, 1999), 98–122.

4. Anne Wilkes Tucker and Will Michels, *War/Photography: Images of Armed Conflict and Its Aftermath* (Houston: Museum of Fine Arts, Houston, 2012), 416.

5. David Shneer, *Through Soviet Jewish Eyes: Photography, War, and the Holocaust* (New Brunswick: Rutgers University Press, 2011), chaps. 4 and 7.

6. Mark Feeney, "When the Revolution Was Revolutionary: A Show at Bowdoin Summons up an Era of Ferment in Art, Ideology," *Boston Globe*, October 2, 2017. Edward Rothstein, "Constructing Revolution: Soviet Propaganda Posters between the World Wars," *Wall Street Journal*, October 10, 2017. The review includes a brief description of the companion exhibition about Baltermants's war photography.

7. "Dmitri Baltermants: Documenting and Staging Soviet Reality," press packet and checklist, accessed December 26, 2018, www.bowdoin.edu/art-museum/pdf/Bowdoin-Baltermants-illustrated-checklist.pdf. See also "Johna Cook '19 speaks about upcoming exhibition 'Dmitri Baltermants: Documenting and Staging a Soviet Reality,'" accessed May 28, 2018, http://community.bowdoin.edu/news/2017/08/johna-cooks-19-speaks-about-upcoming-exhibition-dmitri-baltermants-documenting-and-staging-a-soviet-reality/.

8. Interview with Nancy Hartmann, October 2, 2015.

9. Ibid.

10. Interview with Judith Cohen, July 10, 2018.

11. Interview with Maaty Frenkelzon, July 24, 2018.

12. Renee Ghert-Zand, "Yad Vashem Stages Ambitious Show of Rare Photos Taken by Nazis and Their Victims," *Times of Israel*, January 24, 2018.

13. Tamara Zieve, "Yad Vashem Launches 'Flashes of Memory' Exhibit," *Jerusalem Post*, January 24, 2018.

14. Sam Kassow, *Who Will Write Our History:Rediscovering a Hidden Archive from the Warsaw Ghetto* (New York: Vintage, 2009).

15. Ghert-Zand, "Yad Vashem stages ambitious show."

16. Ofer Aderet, "Ha-shoah she-tsilamti be-heykhave," *Haaretz*, January 23, 2018, accessed July 24, 2018, https://www.haaretz.co.il/.premium-MAGAZINE-1.5762848?=&ts=_1532465315950 or "Secretly Photographing the Holocaust," *Haaretz*, January 27, 2018, accessed August 1, 2018, https://www.haaretz.com/jewish/holocaust-remembrance-day/MAGAZINE-secretly-photographing-the-holocaust-a-rare-exhibition-1.5762919.

17. See for example Maxim Shrayer, *I Saw It: Ilya Selvinsky and the Legacy of Bearing Witness* (Boston: Academic Studies Press, 2012), which includes a photograph of Raisa Belotserkovskaia, a Kerch Jewish survivor of the massacre, at the antitank trench in 1947.

18. Mordechai Altshuler, "Jewish Holocaust Commemoration Activity in the USSR Under Stalin," *Yad Vashem Studies*, April 2002, 1–22, translated from the Hebrew by Naftali Greenwood.

19. As Arkady Zeltser shows in his book about Soviet Jewish Holocaust commemoratives practices, "Jews engaged in the construction of the memory of Holocaust victims over the course of several decades, implementing it in the form of ceremonies and monuments, frequently outside the framework of government initiatives, and by no means always under definitive, strict state control." Arkady Zeltser, *Unwelcome Memory: Holocaust Memorials in the Soviet Union* (Jerusalem: Yad Vashem, 2019), 47.

20. See among others Yad Vashem Archives (YVA), 2503/2 (Minsk Iama Memorial, 1950); YVA, 3497/10 (Iama Memorial); YVA, 1869/6 (Ponary with Hebrew, Yiddish, and Russia, 1946); YVA, 2552/1 (Stanislav Memorial, ca. 1946).

21. Shrayer dates the Soviet obelisk to 1975–6.

22. See Mikhail Tyaglyi, "Commemoration of Jewish Victims at Two Killings Sites near Kerch," *Untold Stories*, Yad Vashem, accessed October 14, 2018, https://www.yadvashem.org/untoldstories/database/commemoration.asp?cid=676.

23. James Young, *Textures of Memory: Holocaust Memorials and Meaning* (New Haven: Yale University Press, 1994). Although the Soviet Union's memorials are not included in his book, Young argues that Holocaust memorials engage in all of these contexts, although he tends to emphasize the national context rather than the local context.

24. Recent research shows that Jews came together on the date of the killing and recited the traditional Jewish memorial liturgy extensively after the war throughout the

Soviet Union. Unfortunately, despite the hours of testimony I listened to at the Shoah Foundation Archive of witnesses recounting the massacres under the German occupation of Kerch, there was no discussion of postwar memorial practices. They simply were not a central concern to the interviewers or those being interviewed. See also Zeltser, *Unwelcome Memory*, 79.

25. "Evreiskaia obshchina Kerchi otmetila 66-iu godovshchina rasstrela v Bagerovskom rvu," December 4, 2007, accessed August 7, 2018, http://kerch.com.ru/articleview. aspx?id=6046.

26. KHC Pilot Info, http://ourairports.com/airports/UKFK/pilot-info.html#runways. Note that this page is Ukrainian and thus reflects the disputed nature of Kerch and the entire Crimean peninsula.

27. "Evreiskaia obshchina otmetila godovshchinu kholokosta," *Kerchnet TV, Novosti,* December 5, 2009, accessed August 8, 2018, https://www.youtube. com/watch?v=pxznQG2_p70.

28. Leonid Smilovitsky, *Jewish Life in Belarus: The Final Decade of the Stalin Regime, 1944–1953* (Budapest: CEU Press, 2014). Zeltser, *Unwelcome Memory.*

29. Amalek is as bad if not worse than Haman, the quintessential failed genocidal killer of Jews, whose downfall is celebrated on Purim. Later biblical passages make it clear that "wiping out" in fact meant killing every last Amalekite—man, woman, and child (Deuteronomy 25:19; 1 Samuel 15:3).

30. "V kerchenskoi sinagoge pochtili pamiat' rasstreliannykh natsistami evreev," Official photograph from the Kerch Jewish community commemoration on November 27, 2016, accessed August 7, 2018, https://kerchinfo.com/v-kerchenskoj-sinagoge-pochtili-pamyat-rasstrelyannyx-nacistami-evreev.html.

31. "V kerchenskoi sinagogie zazhgli svechi v pamiati o zhertvakh voiny," Kerchnettv, accessed August 7, 2018, https://www.youtube.com/watch?v=vKKVVAobZ2M.

32. "V oktiabrskom proshel traurnyi miting," accessed August 7, 2018, https:// kerchinfo.com/v-oktyabrskom-proshel-traurnyj-miting.html.

33. "Yad Vashem: The Untold Stories: The Murder Sites of the Jews in the Occupied Territories of the Former USSR," accessed October 16, 2018, https://www. yadvashem.org/untoldstories/database/index.asp?cid=676. Nearly all of the material on this page dedicated to the killing sites near Kerch was produced by Tyaglyi.

34. Patrick Desbois, *Holocaust by Bullets: A Priest's Journey to Uncover the Truth Behind the Murder of 1.5 Million Jews* (New York: St. Martin's Press, 2009).

35. Arieh Kochavi, "The Moscow Declaration, the Kharkov Trial, and the Question of a Policy on Major War Criminals in the Second World War," *History* 76, no. 248 (October 1991): 401–17; Michael Bayzeler and Frank M. Türkheimer, *Forgotten Trials of the Holocaust* (New York: NYU Press, 2015); for war crimes trials in central and eastern Europe, see World War 2 Crimes on Trial, 1943–1991, a project funded by the Agence National Recherche (ANR) and directed by Vanessa Voisin, http:// www.agence-nationale-recherche.fr/Project-ANR-16-CE27-0001. Vanessa Voisin,

"From the Courthouse to the Screen: Holocaust History Made Memory in Cold War USSR," talk given at "Remembering Across the Iron Curtain," York University, September 1–3, 2018.

36. See Robert Adler Peckerar, Nancy Sherman, and David Shneer, "The Landscape of Memory," and in particular "Two Jews, Two Maps," in *Pakntreger*, no. 52 (Fall 2006): 24–31.

37. Yahad in Unum photoarchives. Correspondence with Guillaume Ribot, August 2018; Aleksey Kasyanov, August 2018; and Mona Oren, September and October 2018.

38. Interview with Mona Oren, September 12, 2018.

39. I had an e-mail exchange with Sergei Nevazhin, head of Crimea Front, a research team based in Sevastopol that documents historically significant wartime sites across Crimea, who visited the antitank trench on a rainy day in July 2018. He described the trench as very visible, but not like it was when it was created: "The ravine itself is not as big or as wide as it was in the beginning. After many years of being heavily washed out by rain, the edges have become smoothed out." Correspondence with Sergei Nevazhin, August 9, 2018.

40. Correspondence with Bulat Akhmetkarimov facilitated by Liliya Karimova, August 30, 2018. Akhmetkarimov said that the headstones are not earlier than the end of the twentieth century and maybe even the twenty-first century, and the building in Ribot's image at the Muslim cemetery is a storage facility for objects used in the burial ritual—from equipment needed to dig the grave to objects used in the ritual washing of the body.

BIBLIOGRAPHY

ARCHIVAL SOURCES

France

Yahad in Unum Archives, Paris
 Photographs of Kerch killing sites, 2003, 2004, 2011
 Eyewitnesses testimonies from Kerch, U114, U115
Private Archive of Mona Oren, Paris
 Photographs of Kerch, 2004

Great Britain

Leeds University Archives
 Collection of Alex Lachmann (GB 206/MS 1115)
 Collection of the Great Britain–USSR Association (GB 206/MS 1399)

Israel

Yad Vashem Archives
 TR-4/12, Trial of Erich von Mannstein
 RG M33/ JM/19683, Lists of those killed at Kerch

Russia

Central Archive of the Ministry of Defense, Podol'sk (TsAMO), Moscow Region (digital archival located at podvignaroda.mil.ru with materials related to photographers)
Private archive of Tatiana Baltermants, Korolev, Moscow Region
Prints and archival materials of Dmitri Baltermants
 Private archive of Anna Khaldei

Prints and archival materials of Yevgeny Khaldei
State Archive of the Russian Federation (GARF), Moscow
GARF 9576, Soyuz sovetskikh obshestv druzhby i kulturnyikh sviazei s zarubezhnymi stranami.
State Archive of Cinema, Film, and Photography (RGAKFD), Krasnogorsk, Moscow Region

United States

Center for Creative Photography, Tucson, Arizona
 G. Ray Hawkins Files
 Lee Witkin Files
 Limelight Files
Getty Research Institute, Los Angeles, California
 Auction catalogs
Hood Museum, Dartmouth College, New Hampshire
 Prints of Dmitri Baltermants
Los Angeles County Museum of Art, Los Angeles, California
 Prints and acquisition records of Dmitri Baltermants
Museum of Modern Art Archive, New York
 Print of Dmitri Baltermants
Private archive of Michael Mattis, Scarsdale, New York
 Prints and Archival Materials of Dmitri Baltermants
Private archive of Paul and Teresa Harbaugh, Denver
 Prints and archival materials of Dmitri Baltermants and Yevgeny Khaldei
Soho Photo Gallery Archives, New York
UCLA Special Collections, Los Angeles
 Norman Cousins Papers, collection 1385.
United States Holocaust Memorial Museum Archives, Washington, DC
 RG22.002, Crimean Extraordinary Commission Report, 1944
 RG22.014, Crimean Extraordinary Commission Report, 1944
 RG31.018, Postwar war crimes trials related to the Holocaust
 RG31.019, Crimean Extraordinary State Commission to Investigate Nazi Crimes
University of Michigan Museum of Art, Ann Arbor
 Prints by Dmitri Baltermants
USC Rare Books and Manuscripts, Los Angeles, California
 Manuscript of Bertolt Brecht, "Kriegsfibel."
USC Shoah Foundation Institute for Visual History Archive, Los Angeles, California
 Eyewitness testimonies from Kerch

NEWSPAPERS, JOURNALS, AND PERIODICALS

American Photo

Aperture

Argumenty i Fakty

Boston Globe

British Journal of Photography

Camera

Chicago Tribune

Denver Post

Die Zeit

Ekspert Online

Evening Standard

Financial Times

Forbes

Forbes Russia

Fotografare

Fotografiia

Ha-aretz

Independent

Infinity

International Herald Tribune

Istoricheskii Zhurnal

Istoriia.RF

Izvestiia

Jerusalem Post

Jewish Telegraph Agency

Komsomol'skaia Pravda

Krasnaia Zvezda

Krasnyi Krym

La Croix

Life

Literaturnaia Gazeta

Los Angeles Times

Moskovskii Komsomolets

New York Times

New York Magazine

New Yorker

News Chronicle

Ogonek

Orlando Sentinel

Picture Post

Popular Photography

Praha-Moskva

Pravda

RIA Novostii

Sovetskoe Foto

TASS

Time

Times of Israel

Times of London

Vie Nuove

Wall Street Journal

Washington Post

INTERVIEWS

Alexander, Nailya, New York, 2018

Baltermants, Tatiana, Korolyev, Moscow Region, 2015, 2016, 2017, 2018

Chalk, David, Soho Photo Gallery, 2015

Cohen, Judith, Washington, DC, 2014

Frenkelzon, Maaty, Jerusalem, Israel, 2018

Gershengorin, Dmitry, Denver, 2018

Harbaugh, Paul, Denver, 2012, 2014, 2016, 2018

Hartmann, Nancy, Washington, DC, 2014

Hawkins, G. Ray, Beverly Hills, 2015

Kaplan, Daile, New York, 2018

Koch, Robert, San Francisco, 2018

Loengard, John, New York, 2016
Nakhimovsky, Alice, and Alexander Nakhimovsky, New York, 2018
Nevazhin, Sergei, Sevastopol, Crimea, 2018
Oren, Mona, Paris, France, 2018
Ribot, Guillaume, Paris, France, 2018
Rothstein, Daniel, New York, 2018
Sandor, Richard, Chicago, 2018
Schickler, Howard, 2018

PUBLISHED PRIMARY SOURCES

Baltermants, Dmitri. *Odesa*. Moscow: Progress, 197?.

Baltermants, Dmitri. *People and Events of the USSR: An Exhibition of Dmitri Baltermants*. London: USSR–Great Britain Society, 1964.

Baltermants, Dmitrii. *SESBren 50 urte. Dmitri Baltermantsen argazki-makinaren arabera (1939–1989)*. Bilbao: Alhóndiga Bilbao, 2011.

Baltermants, Dmitri, and Yurii Aleskerov. *Samarkand, Putevoditel'*. Tashkent: Izdatel'stvo TsK KP Uzbekistana, 1974.

Baltermants, Dmitri, and Paul Harbaugh. *Dmitri Baltermants*. Paris: Nathan, 1997.

Baltermants, Dmitrii, E. Klenov, and D. Trachtenberg. *Goroda-geroi*. Moscow: Progress, 1970.

Baltermants, Dmitrii, and Mykola Kozlovski. *Gosudarstevnnyi zasluzhennyi ansambl' tantsa Ukrainskoi SSR*. Kiev: Gosizdat izoiskusstva i muzikal'noi literatury USSR, 1960.

Baltermants, Dmitri, and Nikolai Kozlovsky. *Znovy tsvitut kashtani*. Kiev: Derzh. Vyd-vo obrazotvorchoho mystetstva i muzychnoi literatury, 1960.

Baltermants, Dmitri, and Vladimir Lidin. *Moskva: no'iabr' 1941*. Moscow, Leningrad, *Gosudarstvennoe izdatel'stvo "Iskusstvo,"* 1942.

Baltermants, Dmitrii, and Vasilii Peskov. *Dmitri Baltermanz*. Leipzig: VEB Fotokinoverlag, 1981.

Baltermants, Dmitri, and Vasilii Peskov. *Izbrannye fotografii*. Moscow: Planeta, 1977.

Baltermants, Dmitri, and Yuri Rytkheu. *Vstrecha s Chukhotkoi*. Moscow: Planeta, 1971.

Baltermants, Dmitrii, Ivan Shagin, D. Smirnov, and E. Pyli. *Moskva : Gorod-Geroi*. Moscow: Sovetskii khudozhnik, 1965.

Baltermants, Dmitrii, and Olga Sviblova. *Dmitrii Baltermants*. Moscow: Moskovskii Dom fotografii, 2005.

Baltermants, Dmitrii, Valentina Vasil'evna Volkova, V. Samsonov, E. Doron, and M. Trifonova. *Dom-muzei V.I. Lenina v Gorkakh*. Moscow: Pravda, 1967.

Böll, Heinrich, and Karl Pawek, eds. *Weltausstellung der Photographie. 555 Photos von 264 Photographen aus 30 Ländern zu dem Thema: Was ist der Mensch?* Hamburg: Nanen, 1964.

Brecht, Bertolt, and Ruth Berlau. *Kriegsfibel.* Berlin: Eulenspeigel, 1955.

Bresson, Henri Cartier. *The People of Moscow: 163 Pictures in Photogravure.* London: Thames and Hudson, 1955.

Bukov, K. I., M.M Gorinov, and A.N. Ponomarev. *Moskva voennaia, 1941–1945. Memuary i arkhivnye dokumenty.* Moscow: Mosgorarkhiv, 1995.

Chaldej, Jewgeni. *Kriegstagebuch.* Berlin: Das Neue Berlin, 2011.

da Vinci, Leonardo. *The Notebooks of Leonardo da Vinci* (http://www.gutenberg.org/ebooks/5000)

Dmitri Baltermants: Documenting and Staging Soviet Reality. Brunswick, ME: Bowdoin College Museum of Art, 2018.

Ehrenburg, Ilya, and Vasily Grossman. *The Complete Black Book of Russian Jewry.* Translated and edited by David Patterson. Piscataway, NJ: Transaction Publishers, 2003.

Ehrenburg, Ilya, and Vasily Grossman. *Chernaia kniga: o zlodeiskom povsemestnom ubistve evreev nemetsko-fashistskimi zakhvatchikami vo vremenno-okkupirovannykh raionnakh SSSR i lageriakh unichtozheniia Pol'shi vo vremia voiny 1941–1945 gg.* Jerusalem: Tarbut, 1980.

Fenyö, Imre. *Dmitrij Baltermanc: Szovjet fotómüvész kiállítása.* Budapest: Ernst Museum, 1973.

Fidel en la URSS. Havana: Comision de Orientacion Revolucionaria de la Direccion Nacional del PURSC, 1963.

Flashes of Memory: Photography during the Holocaust. Jerusalem: Yad Vashem, 2018.

Gide, Andre. *Retour de l'URSS.* Paris : Librarie Gallimard, 1936.

God 72. Olimpiiskii. Sapporo, Feb. 1-13, 1972; Munich, Aug. 26–Sept. 11, 1972. Moscow: Fizkultura i sport, 1973.

Goldberger, Ben, Geoff Dyer, and David Von Drehle. *100 Photographs : The Most Influential Images of all Time.* New York: Time, 2016.

Goroda-geroi Chernomor'ia: Sebastopol, Odessa, Kerch, Novorossiisk. Simferopol: Tavria, 1978.

Hughes, Langston. *Negroes in Moscow: In a Land Where There Is No Jim Crow.* Moscow: State Publishing House, 1933.

Jahn, Peter, *Aus dem Schatten der Erinnerung : Vergessene Opfer des Vernichtungskrieges gegen die Sowjetunion.* Berlin: Karlshorst, 2011.

Kar, Ida. *Khudozhnitsa s fotoapparatom.* Moscow: n.p., 1962.

Kerch. Moscow: Planeta, 1984.

Kerch geroicheskaia: vospominaniia, ocherki, dokumenty. Simferopol: Tavriia, 1974.

Kniga pamiati: goroda-geroia kerchi i kerchenskogo poluostrova, 3 tomy, tom I. Simferopol: Tavrida, 1999.

Levin, Deana, and Dmitri Baltermants. *Nikolai Lives in Moscow.* London: Methuen, 1966.

Lewinski, Jorge. *The Camera at War: A History of War Photography from 1848 to the Present* New York: Secaucus, 1978.

Livingston, Jane, and Frances Fralin. *The Indelible Image: Photographs of War, 1846 to the Present*. New York: Abrams, 1985.

Master Photographers: Photography in the Fine Arts. New York: Metropolitan Museum, 1967.

Moskva, Kreml'. Lenin. Moscow: Politizdat, 1969.

Moskva, 1941–1945. Moscow: Moskovskii rabochii, 1971.

Mel'kov, Leonid, *Kerch: povest'-khronika v dokumentakh, vospominaniiakh i pismakh uchastnikov geroicheskoi zashchity i osvobozhdeniia goroda v 1941–1944 godakh*. Moscow: Polizizdat, 1981.

Merzanov, Martyn, *Tak eto bylo: poslednie dni fashitskogo Berlina*. Moscow: Politizdat, 1971, 2nd edition, 1975.

Mrázová, Daniela, *Fotografovali válku. Sovětská válečná reportáž*. Prague: Odeon, 1975.

Niurenbergskii protsess: prestupleniia protiv chelovechnosti, tom 5. Moscow: Iuridicheskaia literatura, 1991.

People's Verdict: A Full Report of the Proceedings at the Krasnodar and Kharkov German Atrocity Trials. New York: Hutchinson, 1943.

Richardson, Nan. *Photostroika: New Soviet Photography*. New York: Aperture, 1989.

Rolnikaite, Masha. *Ia dolzhna rasskazat'*. Moscow: Politicheskaia literatura, 1965.

Salisbury, Harrison. *The Unknown War*. London: Bantam Books, 1978.

Trainin, A. N. *Hitlerite Responsibility Under Criminal Law*. London: Huntchinson, 1945.

Vartanov, Anri, O. Suslova, and G. Chudakov. *Antologiia sovetskoi fotografii*. Moscow: Planeta, 1986.

Volf'son, Boris. "Krovavye prestupleniie nemtsev v Kerchi." *Istoricheskii zhurnal* 1942 (8): 33–36.

Vsesoiuznaia khudozhestvennaia vystavka, 1951 goda. Moscow: Gosudarsvetnnyi izdatel'stvo izobrazitel'nogo iskusstva, 1953.

Vystavka fotoiskusstva SSSR. Moscow: Ministerstvo kul'tury SSSR, 1958.

Witkin, Lee, and Barbara London. *The Photograph Collector's Guide*. Boston: New York Graphic Society, 1979.

World Press Photo 1974. Amsterdam: Teleboek, 1974.

Zel'ma, G., and A. K. Taradankin. *Stalingrad*. Moscow: Izogiz, 1954.

Zorin, Valentin. *Protivorechivaia amerika*. Moscow: Iskusstvo, 1976.

PUBLISHED SECONDARY SOURCES

Al'tman, Il'ia. *Zhertvy nenavisti: Kholokost v Rossii, 1941–1945*. Moscow Kovcheg, 2002.

Altshuler, Mordechai. "Jewish Holocaust Commemoration Activity in the USSR Under Stalin." *Yad Vashem Studies*, April 2002, 1–22. Translated from the Hebrew by Naftali Greenwood.

Altshuler, Mordechai. *Religion and Jewish Identity in the Soviet Union, 1941–1964.* Translated by Saadya Sternberg. Waltham: Brandeis University Press, 2012.

Altshuler, Mordechai. "Russian and Her Jews: The Impact of the 1914 War." *Wiener Library Bulletin* 27, no. 30/31 (1973).

Altshuler, Mordechai. *Soviet Jewry on the Eve of the Holocaust: A Social and Demographic Profile.* Jerusalem: Yad Vashem, 1998.

Angrick, Andrej. *Besatzungspolitik und Massenmord: Die Einsatzgruppe D in der südlichen Sowjetunion 1941–1943.* Hamburg: Hamburger Edition, 2003.

Appelbaum, Rachel. "The Friendship Project: Socialist Internationalism in the Soviet Union and Czechoslovakia in the 1950s and 1960s." *Slavic Review* 74, no. 3 (Fall 2015): 484–507.

Arad, Yitzhak. *The Holocaust in the Soviet Union.* Lincoln: University of Nebraska, 2013.

Azoulay, Ariella. *The Civil Contract of Photography.* Cambridge: Zone Press, 2008.

Bair, Nadya. *The Decisive Network: Magnum Photos and the Postwar Image Market.* Berkeley: University of California Press, 2020.

Barskova, Polina. "The Corpse, the Corpulent, and the Other: A Study in the Tropology of Siege Body Representation." *Ab Imperio* 1 (2009): 361–86.

Bartram, Faye. "35mm Bridges: Cultural Relations and Film Exchange between France and the Soviet Union, 1945–1972. PhD diss., University of Iowa, 2017.

Baskind, Samantha. "Weegee's Jewishness." *History of Photography* 34, no. 1 (2010): 60–78.

Batchen, Geoffrey, Mick Gidley, Nancy K. Miller, and Jay Prosser, eds. *Picturing Atrocity: Photography in Crisis.* Chicago: University of Chicago Press, 2012.

Bazyler, Michael J., and Frank M. Tuerkheimer. *Forgotten Trials of the Holocaust.* New York: NYU Press, 2014.

Bemporad, Elissa. *Legacy of Blood: Jews, Pogroms, and Ritual Murder in the Lands of the Soviets.* New York: Oxford University Press, 2019.

Bethel, Denise. "At Auction and in the Book Trade: Sources for the Photography Historian." *History of Photography* 21, no. 2 (1997): 117–28.

Bonnell, Victoria. *Iconography of Power: Soviet Political Posters under Lenin and Stalin.* Berkeley: University of California Press, 1999.

Brandenburger, David. *National Bolshevism: Stalinist Mass Culture and the Formation of Russian National Identity, 1931–1956.* Cambridge, MA: Harvard University Press, 2002.

Brandenburger, David. "Stalin's Last Crime? Recent Scholarship on Postwar Soviet Antisemitism and the Doctor's Plot." *Kritika* 6, no. 1 (2005): 187–204.

Bronfen, Elisabeth. *Specters of War: Hollywood's Engagement with Military Conflict.* New Brunswick, NJ: Rutgers University Press, 2012.

Campbell, Craig. *The Atomic Bomb and the Origins of the Cold War.* New Haven: Yale University Press, 2008.

Cantorovich, Nati. "Soviet Reactions to the Eichmann Trial: A Preliminary Investigation, 1960–1965." *Yad Vashem Studies* 35, no. 2 (2007): 103–41.

Carrabine, Eamonn. "Images of Torture: Culture, Politics, and Power." *Crime, Media, Cultures* 7, no.1(2011): 5–30.

Confino, Alon. "Collective Memory and Cultural History: Problems of Method." *American Historical Review* 102, no. 5 (1997): 1386–403.

Damisch, Hubert. *A Theory of /Cloud/: Towards a History of Painting.* Translated by Janet Lloyd. Stanford: Stanford University Press, 2002.

Dawson, Greg. *Judgment before Nuremberg: The Holocaust in the Ukraine and the First Nazi War Crimes Trial.* New York: Pegasus Books, 2012.

Desbois, Patrick. *Holocaust by Bullets: A Priest's Journey to Uncover the Truth behind the Murder of 1.5 Million Jews.* New York: St. Martin's Press, 2009.

Dobson, Miriam. *Khrushchev's Cold Summer: Gulag Returnees, Crime, and the Fate of Reform after Stalin.* Ithaca, NY: Cornell University Press, 2009.

Efal, Adi. "Warburg's 'Pathos Formula' in Psychoanalytic and Benjaminian Contexts." *Studies in Art History* 1 (2000): 221–38.

Emmett, Arielle Susan. "Haunting Images: Differential Perception and Emotional Response to the Archetypes of News Photography." PhD diss., University of Maryland, 2011.

Estraikh, Gennady, and Anna Schur, eds. "The 1952 Trial of the Jewish Anti-Fascist Committee in the Soviet Union." Special section of *East European Jewish Affairs* 48, no. 2 (2018): 139–252

Feferman, Kiril. *The Holocaust in the Crimea and Northern Caucasus.* Jerusalem: Yad Vashem Press, 2016.

Feferman, Kiril. "Nazi Germany and the Mountain Jews: Was There a Policy?" *Holocaust and Genocide Studies* 21, no. 1 (2007): 96–114.

Foster, Kurt. "Aby Warburg's History of Art: Collective Memory and the Social Mediation of Images." *Daedalus* 105, no. 1 (1976): 169–76.

Fox, Michael David. *Showcasing the Great Experiment: Cultural Diplomacy and Western Visitors to the Soviet Union, 1921–1941.* New York: Oxford University Press, 2014.

Gatrell, Peter. *Free World?: The Campaign to Save the World's Refugees, 1956–1963.* New York: Cambridge University Press, 2011.

Gatrell, Peter. *A Whole Empire Walking: Refugees in Russia during World War I.* Bloomington: Indiana University Press, 2005.

Gee, Helen. *Limelight: A Greenwich Village Photography Gallery and Coffeehouse.* Albuquerque: University of New Mexico Press, 1997.

Gilboa, Yehoshua. *The Black Years of Soviet Jewry.* New York: Little Brown & Co, 1971.

Gilburd, Eleonora. "The Revival of Soviet Internationalism in the mid- to late-1950s." In *The Thaw: Soviet Society and Culture during the 1950s and 1960s,* edited by Eleonory Gilburd and Dennis Kozlov, 362–401. Toronto: Univesrity of Toronto Press, 2014.

Gilburd, Eleonory. *To See Paris and Die: The Soviet Lives of Western Culture.* Cambridge: Harvard University Press, 2018.

Goldin, Semion. "'The Jewish Question' in the Tsarist Army in the Early Twentieth Century." In *The Revolution of 1905 and Russia's Jews,* edtied by Stefani Hoffman

and Ezra Mendelssohn, 70–81. Philadelphia: University of Pennsylvania Press, 2008.

Gorer, Geoffrey. "The Pornography of Death." *Encounter* 5, no. 4 (1955): 49–52.

Gray, Camilla. *The Great Experiment: Russian Art 1863–1922*. London: Thames and Hudson, 1962.

Grimmer-Solem, Erik. "Selbständiges verantworliches Handeln: Generalleutenant Hans Graf von Sponeck (1888-1944) und das Schicksal der Juden in der Ukraine, Juni-Dezember 1941." *Militärgeschichtliche Zeitschrift* 72 (2013), 23-50.

Gubenko, Gitel', *Kniga pechali*. Simferopol: Krymskoe upravlenie po pechati, 1991.

Hellbeck, Jochen. *Stalingrad: The City That Defeated the Third Reich*. New York: Public Affairs, 2015.

Hicks, Jeremy. *First Films of the Holocaust*. Pittsburg: University of Pittsburg, 2011.

Hirsch, Francine. "The Soviets at Nuremberg: International Law, Propaganda, and the Making of the Postwar Order." *American Historical Review* 113, no. 3 (2008): 701–30.

Hirsch, Marianne. *Family Frames: Photography, Narrative, and Postmemory*. Cambridge, MA: Harvard University Press, 1997.

Ignatieff, Michael. "Soviet War Memorials." *History Workshop Journal* 17, no. 1 (1984): 157–63.

James, Sarah. *Common Ground: German Photographic Cultures across the Iron Curtain*. New Haven: Yale University Press, 2013.

James, Sarah "A Post-Fascist *Family of Man?* Cold War Humanism, Democracy, and Photography in Germany." *Oxford Art Journal* 35, no. 3 (December 2012): 315–36.

Jones, Polly, ed. *The Dilemmas of De-Stalinization: Negotiating Cultural and Social Change in the Khrushchev Era*. London: Routledge, 2006.

Kalkstein, Molly. "Inside the Box: Photography and the Portfolio Format." MA thesis, Ryerson University, 2013.

Kappeler, Susanne. *The Pornography of Representation*. New York: Wiley and Sons, 2013.

Kassow, Sam. *Who Will Write Our History: Rediscovering a Hidden Archive from the Warsaw Ghetto*. New York: Vintage, 2009.

King, David. *The Commissar Vanishes: The Falsification of Photographs and Art in Stalin's Russia*. London: Tate, 2014.

Kivelson, Valerie, and Joan Neuberger, eds. *Picturing Russia: Explorations in Visual Culture*. New Haven: Yale University Press, 2008.

Kochavi, Arieh. "The Moscow Declaration, the Kharkov Trial, and the Question of a Policy on Major War Criminals in the Second World War." *History* 76, no. 248 (1991): 401–17

Koenker, Diane. *Club Red: Vacation Travel and the Soviet Dream*. Ithaca, NY: Cornell University Press, 2013.

Kostyrchenko, G. V. *Tainaia politika Stalina: vlast' i antisemitizm*. Moscow: Mezhdunarodnoe otnoshenie, 2001.

Kristeva, Julia. *Powers of Horror: An Essay on Abjection*. Translated by Leon Roudiez. New York: Columbia University Press, 1982.

Kupferman, Fred. *Au pays des Soviets. Le voyage français en Union soviétique, 1917–1939*. Paris: Gallimard/Julliard, collection Archives, 1979.

Lemza, John. *American Military Communities in West Germany: Life on the Cold War Badlands*. New York: McFarland, 2016.

Lendvai, Paul. *One Day That Shook the Communist World: The 1956 Hungarian Uprising and Its Legacy*. Translated by Ann Major. Princeton, NJ: Princeton University Press, 2008.

Livshits, L. Y. ed. *Ermitazh v gody voiny*. Leningrad: Publishing Council of the State Hermitage, 1987.

Loengard, John. *Celebrating the Negative*. New York: Arcade, 1994.

Lohr, Eric. *Nationalizing the Russian Empire: The Campaign against Enemy Aliens during World War I*. Cambridge, MA: Harvard University Press, 2003.

Lohr, Eric. "The Russian Army and the Jews: Mass Deportation, Hostages, and Violence in World War I." *Russian Review* 60, no. 3 (2001): 404–19.

Manley, Rebecca. *To the Tashkent Station: Evacuation and Survival in the Soviet Union at War*. Ithaca, NY: Cornell University Press, 2012.

McClellan, Woodford. "Africans and Black Americans in Comintern Schools, 1925–1934." *International Journal of African Historical Studies* 26, no. 2 (1993): 371–90.

Melikova, Natalia. "Constructive renewal: Izvestia building, Moscow by Ginzburg Architects." *Architecture Review*, September 27, 2017.

Merridale, Catherine. *Night of Stone: Death and Memory in 20th Century Russia*. New York: Viking Penguin, 2000.

Morozov, Sergei, *Sovetskaia khudozhestvennaia fotografiia*. Moscow: Iskusstvo, 1958.

Moss, Kenneth. *Jewish Renaissance in the Russian Revolution*. Cambridge, MA: Harvard University Press, 2009.

Montier, Jean Pierre. "Henri-Cartier-Bresson, 'Public Intellectual'? *Études photographiques* 25 (May 2010): 1–13.

Mrázková, Daniela. *Masters of Photography*. London: Hamlyn, 1987.

Nakhimovsky, Alice, and Alexander and Yevgeny Khaldei. *Witness to History: The Photographs of Yevgeny Khaldei*. New York: Aperture, 1997.

Neumaier, Diane. *Beyond Memory: Soviet Non-Conformist Photography*. New Brunswick: Rutgers University Press, 2004.

Nikitin, Vladimir Anatolevitch. *Rasskazy o fotografakh i fotografiiakh*. Leningrad: Lenizdat, 1991.

Plamper, Jan. *The Stalin Cult: A Study in the Alchemy of Power*. New Haven: Yale University Press, 2012.

Penn, Michelle. "The Extermination of Peaceful Soviet Citizens: Aron Trainin and International Law." PhD diss., University of Colorado, 2017.

Petrovsky-Shtern, Yohanan. *Jews in the Russian Army, 1827–1917: Banished from Modernity?* New York: Cambridge University Press, 2009.

Pietrobon, Allen. "The Role of Norman Cousins and Track II Diplomacy in the Breakthrough to the 1963 Limited Test Ban Treaty." *Journal of Cold War Studies* 18, no. 1 (2016): 60–71.

Prusin, Alexander. "Poland's Nuremberg: The Seven Court Cases of the Supreme National Tribunal, 1946–1948." *Holocaust and Genocide Studies* 24, no. 1 (2010): 1–25.

Rasskazy o fotografakh I fotografiiakh. Leningrad: Lenizdat, 1991.

Reid, Susan. "Photography in the Thaw." *Art Journal* 53, no. 2 (1994): 33–39.

Reynolds, Michael. *Shattering Empires: The Clash and Collapse of the Ottoman and Russian Empires, 1908-1918.* New York: Cambridge University Press, 2012.

Ro'i, Yaacov. "The Jewish Religion in the Soviet Union after World War II." In *Jews and Jewish Life in Russia and the Soviet Union*, 264–89. London: Frank Cass, 1995.

Rubenstein, Joshua. *The Last Days of Stalin.* New Haven: Yale University Press, 2016.

Sandeen, Eric J. "*The Family of Man* on the Road to Moscow." In *American Photographs in Europe*, edited by David Nye and M. Gidley, 255–70. Amsterdam: VU University Press, 1994. Reprinted in Lori Bogle, *The Cold War: Cold War Culture and Society*, vol. 5, 57–72. London: Routledge, 2001.

Shneer, David. "Ghostly Landscapes: Soviet Liberators Photograph the Holocaust." *Humanity: An International Journal of Human Rights, Humanitarianism, and Development* 5, no. 2 (2015): 235–46.

Shneer, David. "Is Seeing Believing?: Photographs, Eyewitness Testimony, and Evidence of the Holocaust." *East European Jewish Affairs* 45, no. 1 (2015): 65–78.

Shneer, David. *Through Soviet Jewish Eyes: Photography, War, and the Holocaust.* New Brunswick: Rutgers University Press, 2011.

Shneer, David. *Yiddish and the Creation of Soviet Jewish Culture.* New York: Cambridge University Press, 2005.

Shrayer, Maxim. *I Saw It: Ilya Selvinsky and the Legacy of Bearing Witness.* Boston: Academic Studies Press, 2012.

Shternshis, Anna. *When Boris Met Sonia: Jewish Life under Stalin.* New York: Oxford University Press, 2017.

Siegelbaum, Lewis. *Stakhanovism and the Politics of Productivity in the USSR.* New York: Cambridge University Press, 1990.

Smilovitsky, Leonid. *Jewish Life in Belarus: The Final Decade of the Stalin Regime, 1944–1953.* Budapest: Central European University Press, 2014.

Sontag, Susan. *Regarding the Pain of Others.* New York: Picador, 2004.

Spivey, Nigel. *Enduring Creation: Art, Pain, and Fortitude.* Berkeley: University of California Press, 2001.

"Tax Treatment of Artists' Charitable Contributions." *Yale Law Journal* 89, no. 1 (1979): 144–67.

Tomoff, Kiril. *Creative Union: The Professional Organization of Soviet Composers, 1939–1953*. Ithaca, NY: Cornell University Press, 2018.

Tucker, Anne Wilkes, et al. *War/Photography: Images of Armed Conflict and Its Aftermath*. Museum of Fine Arts, Houston, 2012.

Tyaglyi, Mikhail. "Commemoration of Jewish Victims at Two Killings Sites near Kerch." *Untold Stories*, Yad Vashem (https://www.yadvashem.org/untoldstories/database/commemoration.asp?cid=676).

Tumarkin, Nina. "The Great Patriotic War as Myth and Memory." *European Review* 11, no. 4 (2003): 595–611.

Varga-Harris, Christine. *Stories of House and Home: Soviet Apartment Life during the Khrushchev Years*. Ithaca, NY: Cornell University Press, 2015.

Voisin, Vanessa. "War Crimes Footage and War Crimes Trials: The Soviet Policy, 1941–1946." In *Defeating Impunity, Promoting International Justice: The Archival Trail, 1941–2016*. New York: Springer, 2018.

Von Laue, Theodore, Angela Von Laue, Dmitrii Baltermants, and Tatiana Baltermants. *Faces of a Nation: The Rise and Fall of the Soviet Union, 1917–1991*. Golden, CO: Fulcrum Publishing, 1996.

Wallis, Brian. *Weegee: Murder Is My Business*. New York: Prestel, 2013.

Werneke, Jessica Marie. "The Boundaries of Art: Soviet Photography from 1956 to 1970." PhD, University of Texas, Austin, 2015.

White, Stephen. *The Bolshevik Poster*. New Haven: Yale University Press, 1988.

Witkin, Lee, and Barbara London. *The Photograph Collector's Guide*. Boston: New York Graphic Society, 1979.

Wolf, Erika. "When Photographs Speak, to Whom Do They Talk? The Origins and Audience of SSSR na stroike (USSR in Construction)." *Left History* 6, no. 2 (1999): 53–82.

Worswick, Clark. *Berenice Abbott and Eugène Atget*. Santa Fe, NM: Arena Editions, 2002.

Young, James. *Textures of Memory: Holocaust Memorials and Meaning*. New Haven: Yale University Press, 1994.

Zelizer, Barbie. "Holocaust Photography, Then and Now." In *Picturing the Past: Media, History, and Photography*, edited by Bonnie Brennen and Hanno Hardt, 98–122. Urbana: University of Illinois Press, 1999.

Zeltser, Arkadi. *Unwelcome Memory: Holocaust Memorials in the Soviet Union*. Jerusalem: Yad Vashem, 2019.

Zubkova, Elena. *Russia after the War: Hopes, Illusions, Disappointments, 1945–1957*. Armonk, NY: ME Sharpe, 1999.

INDEX

For the benefit of digital users, indexed terms that span two pages (e.g., 52–53) may, on occasion, appear on only one of those pages.